PUTTING ART
(back)
IN ITS PLACE

PUTTING ART
(back)
IN ITS PLACE

John E. Skillen

HENDRICKSON
PUBLISHERS

Putting Art (Back) in Its Place

© 2016 by Hendrickson Publishers Marketing, LLC
P. O. Box 3473
Peabody, Massachusetts 01961-3473
www.hendrickson.com

ISBN 978-1-61970–759-7

Printed in the United States of America

First Printing — October 2016

We extend our gratitude to *Comment* magazine for the generous permission to reprint a revision of the article "From *In Situ* Artwork to Education *In Situ*" (September 17, 2012), which serves as the first part of the introduction to this book.

Featured in the cover image, center panel: *Second Adam: Via Contemplativa* (from the series "Magnificat") ©Bruce Herman, 2007, oil and alkyd resin with 23kt gold leaf and silver leaf on wood panels, 125" x 144", courtesy of the artist: bruce.herman@gordon.edu.

Library of Congress Cataloging-in-Publication Data

Names: Skillen, John Edward, 1952- author.
Title: Putting art (back) in its place / John E. Skillen.
Description: Peabody, Massachusetts : Hendrickson Publishers, 2016.
Identifiers: LCCN 2016036209 | ISBN 9781619707597 (alk. paper)
Subjects: LCSH: Christianity and art. | Christianity and culture. |
 Christianity and art--Italy--History. | Christianity and culture--Italy--History.
Classification: LCC BR115.A8 S59 2016 | DDC 246--dc23
 LC record available at https://lccn.loc.gov/2016036209

CONTENTS

PREFACE

Readership

This book focuses on the places where art did its work in a particular historical period in Italy (roughly 1250–1550). It is written with two overlapping readerships in mind.

First, I hope *Putting Art (Back) in Its Place* will serve teachers and undergraduates engaged in the academic study of premodern European art history, of Christian ministry and church history, and of the somewhat new area of community art, as well as teachers and students in the growing number of graduate-level programs that take up the intersections of worship, theology, and the arts.

Equally, this book is intended to serve those in leadership roles in their local religious, civic, and educational communities. My hope is that a better understanding of the social practices of art in an earlier age might incite efforts to reimagine how the visual arts can enhance the work of the people in settings of faith and culture today.[1]

With that intended readership in mind, I have gone light on footnotes and references, since I am not writing for advanced scholars of early

[1] The term "the social practices of art" comes from the subtitle of Nicholas Wolterstorff's recent book entitled *Art Rethought: The Social Practices of Art* (Oxford: Oxford University Press, 2015), a book everywhere relevant for *Putting Art (Back) in Its Place*, though it was published when the body of my book was already written. Wolterstorff provides a detailed and comprehensive account of the modern mode of "engaging works of the arts as objects of disinterested attention" (13) that I address ever so briefly in the section of the Introduction entitled "The (Dis)placement of Art," and of "the emergence of the split between art and craft, between artist and craftsperson, and between aesthetic and practical concerns" (17). Wolterstorff also calls for a reengagement of the arts with "social practices," explored in chapters taking up memorial art and work songs, for instance. The two books are clearly compatible. *Putting Art (Back) in Its Place* gives a more comprehensive description of how the visual arts played a community-wide role during a particular period of European culture.

Renaissance art history, nor am I tracing the history of academic discussions of particular artworks. I have also done my best to reference sources readily available on the internet, and accessible to readers without nearby academic research libraries.

The Accompanying Website

I have maximized references to artworks in central Italy that remain in the places for which they were created—artworks still *in situ*—and where photography is openly permitted.

Working in tandem with the book is a website with dozens of photographs of the artworks discussed: www.artinitsplace.com

The asterisks (*) placed throughout the printed book indicate the presence of corresponding photographs on the website. What I imagine is that readers may enjoy reading the book with a smartphone or internet-linked tablet or laptop computer at their side, scrolling from photograph to photograph as these are referenced in the text of the printed book.

An additional element of the accompanying website is a set of discussion questions designed to help communities and their leaders assess the role that artworks might play in the places where these communities do their work—(a) the physical settings in which they perform their work and enact their missions; (b) the formal liturgical actions that celebrate and inspire that work; and (c) the stories that matter to their identity.

The Titles of Artwork

Paintings and other works of art in medieval and Renaissance Italy were not given titles in the way that paintings generally are today. Instead, they were often referred to according to the scene they illustrated or the purpose they served. Because my purpose in this book is to demonstrate the way that the visual arts played a community-wide role, and thus to show the ways in which the communities in the era thought and talked about art in their own day, I often forego using the sorts of titles that have been given to these paintings in subsequent periods, and thus do not include italics or other markers to announce the titles of these paintings or sculptures.

Consider the Siena altarpiece discussed in chapter four, which offers a good glimpse into how Italian paintings from this era were referred to at the time they were created. A painting of the Virgin Mary is called the "Madonna with the large eyes," or "Our Lady of Grace, which now hangs over

the altar of St. Boniface." The contemporary chronicle that is the source of these "titles" goes on to elaborate that "this Our Lady was she who had hearkened to the people of Siena when the Florentines were routed at Monte Aperto," or the battle of Montaperti in 1260.[2]

Thus, the painting is referred to in the chronicle not by a title that comes from the artist, but first by how it "was called" by the people and, second, by the work accomplished by the person (Mary) represented in the painting. This was commonplace.

Thus, throughout this book, I refer to many great works of art according to the scene or scenes that they depict (often an episode of the biblical narrative or a saint's life), or according to the place in which they can be found, rather than by a title in italics. The names of biblical episodes are given in capitalized words, for instance: the Annunciation, the Last Supper, and the Crucifixion.

This way of describing and referring to art should bring us one step closer to thinking about the place of the visual arts according to the habits and customs of medieval and Renaissance Italy.

Acknowledgments

This book has been long in the making. It is the fruit of almost twenty years living in central Italy, teaching the art and culture of the Italian Renaissance, and visiting the "places of art" dozens of times with my students. Indeed, it is to the students of Gordon College's arts-oriented semester program in Orvieto that I dedicate this book. With gratitude for their unflagging enthusiasm on our excursions and their patience with me in the classroom, I hope that they have been equipped and inspired from the *in situ* art of the past to enrich their own places of work and worship with new art that supports the mission of the communities to which they commit themselves. Thanks especially to three of my students, Joeli Banks, Kaira Colman, and Margaret Brooks, for permission to include their insightful comments in chapter five.

The chief photographer, and designer of the accompanying website, is the highly-skilled student intern for the *Studio for Art, Faith & History*, Gianna Scavo. I am indebted to her.

Carl Nellis, my editor at Hendrickson Publishers, has been a writer's dream. His every touch improved the book.

[2] John T. Paoletti and Gary M. Radke, *Art in Renaissance Italy* (New York: Harry N. Abrams, 1997), 96, quoted in Charles Eliot Norton, *Historical Studies of Church-Building in the Middle Ages* (New York: Harper & Brothers, 1880), 144.

Finally, I must express my gratitude to my wife, Rev. Dr. Susan Skillen, and our four daughters for allowing their own lives to be irrevocably changed when, in 1998, I proposed packing the family off to Orvieto for what we imagined would be a single semester.

Introduction: The (Dis)Placement of Art

Discovering Art in Its Place

My family heritage is mainly that of well-educated Scotch-Irish Calvinists more oriented toward the word than the image. My own interest in art in general, and that of the Italian Renaissance in particular, was sparked when, as an impressionable twelve-year-old, I camped with my brother and sister-in-law for a long summer throughout southern Europe. For me, fresh from reading Irving Stone's *The Agony and the Ecstasy*, our slow journey through Italy was a pilgrimage from one Michelangelo masterwork to another. Later, as a philosophy major in college, I came to view the arts as the media, or mediators, through which a culture's underlying religious convictions and guiding philosophical beliefs were given "a local habitation and a name" (to cite Theseus's phrase in Shakespeare's *Midsummer Night's Dream*) in the everyday practices and assumptions of the community's life. My doctoral studies and eventual career as a professor of medieval and Renaissance literature introduced me to the close interplay between the verbal arts and the visual arts of the premodern period of European history.

But the seed for this book was planted in 1993 when I accompanied a small group of artists as the diarist for a month-long printmaking workshop in Florence. Organized by the painters Bruce Herman and Edward Knippers, funded by a private donor, and administered through the organization Christians in the Visual Arts (CIVA), the group rented a printmaking studio and lodged together in the convent of the Oblates of the Assumption. The goal was for each artist to contribute three images, incised in a traditional manner into copper plates, to a joint collection marked deliberately, if loosely, by the theme of sacrifice.

Among the motivations of that project was something of a mutual discomfort with the highly individualistic model of artistic production that has marked what we call *modernity*. The initiators of the workshop

shared a sense that the modernist model of the artist living and working without connection to any community investing care in the artist and her work might not be a mode of art-making best suited to the New Testament image of the community as a body, where every part has need of the others.

Hence, we charged ourselves with an "Experiment in Artistic Community"—as I titled the essay published the following year in *Image: A Journal of the Arts and Religion*.[1] We dined together in the convent, prayed together, together visited the cultural riches of Florence, and kept common work hours together in the studio.

The workshop accomplished its purpose, in that we formed a lively and supportive community outside the actual creating of the work of art. The friendships have endured. And the product, the *Florence Portfolio* of twenty prints protected in a sculpted box designed and constructed by Ted Prescott, enjoyed a twenty-year tour before being retired in 2014 for permanent display in the monastery-home of Gordon College's arts-oriented semester program in Orvieto, Italy—the town where the *Portfolio* artists spent their first night together in 1993, en route to Florence.

I still treasure the experience of living side-by-side with a group of highly-skilled artists with big personalities, generous spirits, and liberally-educated minds. Their conversations introduced me to the challenges faced by artists of Christian faith who feel stuck in a sort of no-man's-land: held in suspicion by their church communities and ostracized by the secular art world establishment for the unironic sincerity of their convictions. But in hindsight, I am struck by the limits we placed on how far the *artistic community* was permitted to infiltrate the actual process and product. The six artists worked independently, making gracious comment while passing by one another's stations, offering a suggestion when asked for one, but careful not to interfere. Each developed his or her own prints individually. While the titles rotated around the common theme, there was no expectation of, let alone effort to impose, actual collaboration; no effort to design the prints to create purposeful sequences among them. The work produced had no role in our shared devotional life, nor did we exercise any collective effort to allow the rich body of sacred art surrounding us in nearby places such as Monastery San Marco to provide common reference points.

The community was only the group of artists themselves, and did not include the patron who funded it, nor any scholars outside the circle of artists who might have rendered their theological understanding of the common theme of sacrifice more sophisticated. We did not include anyone who might represent the church or university or private galleries that

[1] John Skillen, "An Experiment in Artistic Community," *Image: A Journal of the Arts and Religion* 6 (Summer 1994): 79–105.

we hoped would rent the Portfolio for temporary display, or the collectors who might purchase an edition for their private appreciation. The *Portfolio*'s life as a road-show exhibition has occurred mostly in galleries of educational institutions, less often in church exhibition space, and seldom if ever has it been used to focus worship or to guide the sort of devotion for which gallery exhibition is ill suited.

Herman and Knippers had selected Florence as the location for the workshop for the dense presence in the city of the premodern sacred art tradition. I arrived eager to explore the Uffizi Gallery and the *Galleria dell'Accademia* and the Bargello Museum and the museum of the Duomo. But what bowled me over was how many of the masterworks of the Italian Renaissance remained in the public settings for which they had been made. The experience cracked me out of a museum and gallery mentality, we might say, and opened my eyes to the long run of centuries in medieval and Renaissance Europe when nearly all artworks were commissioned by or for a particular group for its use in a particular location. Artworks existed entirely *in situ*—the Latin phrase used to indicate the place where the artwork was originally installed, where it did its work in a complex matrix of meanings and reverberations.

I would like to expand the meaning of the phrase *in situ* beyond simple identification of original location to indicate the artwork's intended *place* embedded in a community, the places where the "work of the people" (the meaning of the word *liturgy*) was performed and enacted. Monastic communities, for example, commissioned Last Suppers for the walls of their dining halls not for the prestige of "owning a Da Vinci" (as we would say nowadays) but for the purpose of associating their own suppers with the Lord's Supper.

My new interest in the *situated* art of premodern Italy led me step by step to a conviction that the conditions that went into the making of that period's art held valuable lessons for our postmodern time. I imagined a renewed engagement of communities of faith not just in affirming artists and appreciating art but in commissioning artworks to assist their work.

The immediate effect of my experience in Florence was to increase my use of the art of the Renaissance in my teaching of the literature and culture of the Renaissance, but the classroom experience of projecting images of artworks on the pull-down screen just didn't cut it. Sitting at desks looking at slides detaches the artwork from any relation to place or action, from any situated context. It encourages truncated attention to formal aesthetic features, partly because there is little else to look at.

I decided to take students to see the real thing, unmediated by media. So began several years of month-long summer seminars to Florence. What a blast those travel tours were for the students and for me. But soon enough they too felt inadequate.

There turned out to be less difference than I had hoped between the experience of looking at a good-quality slide of Duccio's Rucellai Madonna—scaled to actual size on the classroom wall—and viewing the painting itself on the wall of the Uffizi Gallery. Artificially set side by side with similarly-sized, enthroned Madonnas by Giotto and Cimabue, the painting was controlled by the conventions of museumized detachment: slow stroll, hands behind back, staying far enough away to avoid an embarrassing rebuke from the guards, with ne'er a thought about where such works were originally installed and whose lives and actions they enriched and served.

So I was drawn to take my students to those works that still remained *in situ*. And of course the value of Florence is that a boatload of such works can still be found in their original locations. We could experience Ghirlandaio's famous Adoration of the Shepherds on the altar in the side chapel of the Sassetti family to the right of the main altar of the Church of Santa Trinità—witnessing how the frescoed scene of the healing of a young boy directly above the altar was set in the Via Tornabuoni immediately in front of this very church.* We could feel how the painting drew us into a scene whose setting we ourselves had just walked through. My students could see the kneeling figures of the patrons Francesco Sassetti and his wife Nera Corsi frescoed into the walls on either side of the altarpiece, visually suggesting their own active participation with the shepherds in adoring the Christ child. We could begin to imagine artworks in their *liturgical* setting, guiding the appropriate response of the extended Sassetti family as they gathered over generations to celebrate the Nativity, or the feast day of St. Francis after whom the *paterfamilias* was named, or to honor in memory the Sassetti forebears, whose earthly remains were contained in the sarcophagi in the niches on each side wall.

It was certainly an improvement to see the so-called Allegory of Good and Bad Government in the Siena town hall.* Commissioned for the meeting room of the Council of Nine, that council's legislative work—their *liturgy*—would have been enacted under Ambrogio Lorenzetti's conscience-pricking figures of virtues and vices embodying the elements of the commonweal and of tyranny. But, alas, still not an absolute improvement, since no town council was doing its work *in situ* any longer. We joined the huddles of tourists shuffling after their guides with little active sense of how this Civic Museum once functioned as the town hall.

So the next step in my train of thought was that we needed to *see* artworks when a *real* liturgy was going on. This is possible in Florence. We could look at Pontormo's Deposition—the dead body of Christ being taken down from the cross by Joseph of Arimathea and Nicodemus—while attending Mass in the Church of Santa Felicità.

But not completely possible. Many masterworks are now roped off, as is Pontormo's Deposition, behind iron grating, beyond the coin-eating light box. Famous pulpits sculpted by the Pisano family in Pisa, Pistoia, and Siena exist only as art objects, no longer used for preaching. The past two decades mark the period of turning churches into ticket-charging museums, understandable in a secularized Europe where the clear majority of people entering churches are tourists, not worshippers, and both towns and dioceses are strapped for cash to maintain the cultural heritage.

I began wondering if maybe seeing a frescoed Life of Mary of secondary fame and quality (like that in the apse of the Orvieto Duomo*) but still unprotected in an active church was a more fruitful and satisfying educative experience than one's allotted fifteen minutes in the Scrovegni Chapel in Padova.

And that led to the next stage of this train of thought. Instead of just taking my students to see an *in situ* artwork when the local folk are using it in liturgy, why not be *in* the liturgy as real participants, not just observers, along with those folk—personally experiencing the intended purpose of the altarpiece ourselves?

Alas, I discovered that attending Mass one time doesn't actually a liturgy make, since liturgy is the work of a community through time, not just in space. The artworks created to enhance that liturgy were "shared and enjoyed between members of a community over the long haul," to cite a phrase in an article in which my colleague Bruce Herman argues that the "scheme" of commercialized "mystique marketing" in our own time has rendered the art object more as "the subject of an elaborate game than a beautiful or meaningful thing-in-itself *shared and enjoyed between members of a community over the long haul.*"[2]

One needs to become a member of the community, not just a drop-in spectator, in order to understand how the artworks assist their worship by focusing attention and amplifying theme and lesson. My conclusion was that my students and I needed to live long enough and substantially enough in a community to become bona fide members.

So those summer seminars evolved into the semester-long program now well established in Orvieto. Everything about the program gently urges students to experience repetition, to exercise commitment. Why not join the parish choir of San Giovenale, not just sit in the back pew to observe the Mass and enjoy the vibes of a thousand-year-old church with its palimpsest of frescos?

[2] Bruce Herman, "Art and Market: Mystique or Mystery," *Comment*, February 6, 2012, https://www.cardus.ca/comment/article/3065/art-and-market-mystique -or-mystery/. Italics mine.

The next stage inevitably follows. At some point, you're going to want, or the choir director is going to invite you, to introduce a new song into the San Giovenale repertory. As the museum-going tourist becomes a member of an *in situ* community, she experiences not only the power of old art put to work in worship, but also the urge to make new art that might take its place in an unfolding tradition.

This has been our subtle progress from "educational art history mode" to "contributive mode," from studying *in situ* art to making art *in situ* for a community.

Gradually, our students and teachers are leaving their marks around town. A series of ceramic-relief plaques of the fourteen *Stations of the Cross* made by Shelly Bradbury and her students is installed in the contemplative garden of Monastery San Lodovico, where they are used during the *Via Crucis* liturgy on Good Friday to guide the gathered congregation's devotions. Marie-Dominique Miserez, a Swiss painter deeply steeped in the traditional medium of egg tempera, joined forces with her students to paint a large-scale Last Supper now installed in the refectory of the renovated thirteenth century convent that serves as the program's long-term home.

Matthew Doll, the present director of the Orvieto program, describes the culminating event of a recent fall semester, when theatre artist Jeff Miller and ceramics artist Marino Moretti and their students joined forces to create a performance of the Nativity in the courtyard, a *Presepe Vivente* to which the townsfolk were invited as audience and participants. As Doll wrote in a private email,

> The result was a perfect synthesis of our program's desire to radiate out from the center, in grateful and charitable service, with the creative fruit of our students' lives evident in their work. Everyone participated in the process. Everyone made masks with Marino for our major set piece in the garden-courtyard of Palazzo Simoncelli [the program headquarters], and each person had a role in a theatrical performance created as an itinerant procession of the shepherds through town, looking for the Christ child. With a growing crowd of local people following along, the players eventually entered the courtyard of the Palazzo. Candles dotted the perimeter walls, surrounding the central drama of 60-plus masks, placed on metal rods, at the back of the enclosure. At the center was a small fire instead of a traditional figure of the baby Jesus. The mask figures were placed beneath a metal canopy "punched" with designs by the students, itself open to the sky above and reflecting the firelight below. It was simple and focused, and invited participation. People were moved by the quiet but deep presence of a shared expression of the mystery of the Nativity.

After the performance, the audience-now-participants were invited into the studio for an exhibition of original drawings, prints, paintings, sculptures, and masks, all for sale. The proceeds of a thousand euros were given

to needy families in Orvieto and in Bethlehem. The event reflected the very purpose of St. Francis in his original living crèche in the village of Greccio, while introducing some creative innovation to the traditionalism of exhibiting manger scenes at Christmastide, so beloved by the people of Umbria.

A Place for Art in the Church

In the meantime . . .

The two decades since the *Florence Portfolio* have brought substantial change in the Church's stance regarding art. A growing appreciation for the place of the arts and artists can be found in a broad swath of churches and communities of Christian believers, evident in support given to artists, in more intentional use of art in worship, and in the use of the arts and artists in service ministries.

The reasons for this change during the past twenty or thirty years are several. They include the gradual disappearance of a suspicion of imagery among pastors and laity in the tradition of Protestant Reform. This erasure of iconoclasm is partly the result of increasing historical and theological ignorance about the Reformers' objections to the use of imagery in Catholic worship and devotion, but it also owes something to the efforts of theologians in the Reformed tradition, Nicholas Wolterstorff and William Dyrness among them, who have mounted strong defenses of art from a Calvinist perspective. Also at work is the pragmatic view that a visually-oriented culture needs a visually-oriented church if it is to evangelize effectively and to give the congregation a culturally up-to-date experience.

Most Christian liberal arts colleges now have solid art majors and art departments. Growing numbers of students are interested not only in being independent studio-based creators but in being prepared to enter vocational fields such as art therapy, art education, community art, and communication and graphic design—fields where art is useful and not simply to be enjoyed for its own sake in galleries or museums.

A number of graduate-level programs at seminaries and schools of theology now exist to prepare effective church leaders in the new millennium. These include Fuller Seminary's program in Worship, Theology and Art; the Institute for Sacred Music at Yale; St. Andrews's Institute for Theology, Imagination and the Arts; Duke University's Initiatives in Theology and the Arts, the Toronto-based Institute for Christian Studies's summer program in Art, Religion and Theology based in Orvieto in collaboration with Gordon College's Studio for Art, Faith & History, to name only several.

Served by organizations such as Christians in the Visual Arts (CIVA), artists who for so long felt marginalized both in the secular gallery-based

art world and in the Christian subculture are no longer in desperate need of support groups, but have become more self-confident in the value of their calling in the church and for society.

An enormous number of books have been published in the last twenty years that together have presented a multi-faceted *apologia* for the arts in the church and from the church to the larger culture. Among the dozens of essays from the blogosphere in a folder on the desktop of my computer, I might cite the witty "list of ways that churches can discourage their artists" written by Dr. Phil Ryken, President of Wheaton College, including such advice as "*treat the arts as a window dressing for the truth* rather than a window into reality," and "*Embrace bad art.* Tolerate low aesthetic standards," and "*Never pay artists for their work.* Expect that they will volunteer their service, without recognizing their calling or believing that they are workers worthy of their hire."[3]

I welcome this new valuing of the visual arts for the life of the church, but what I notice is that most Christians, both in the church and in the academic settings where future leaders and laity are trained, still largely operate with a set of assumptions about art-making and art-viewing that have been current only for the last two centuries.

The focus is primarily on the personality of the artist, the self-expression of whose genius requires and deserves maximum liberty. The objects created have value and significance mainly in relation to the artist, to his psyche, her intention, her autobiography, to his admired status as one of society's innovative *creatives*. The artist is liberated from answerability to any community that is expected to be appreciative of her creative work. The model of mutual non-interference acknowledges the freedom of the appreciator by freeing him to purchase what he wishes according to his own tastes without obligation to the artist. The middleman, the agent of the exchange (the gallery owner, the organizer of the art fair), is answerable neither to artist nor to purchaser, his freedom protected by the rules of the commercial marketplace.

Yet during a very long stretch of European cultural history, the church was an active agent in defending the value of the visual arts, in funding the arts and artists, and in putting the arts to work. From 1250 to 1550 in Italy—the place and period of my own experience and expertise—almost all works of art were commissioned and designed for the use of a particular faith-informed community in a particular place. The artwork worked *in situ*, assisting the community in the performance of those actions that defined its corporate work and identity (its *liturgies*).

[3] Phil Ryken, "How to Discourage Artists in the Church," *The Gospel Coalition*, May 27, 2013 http://www.thegospelcoalition.org/article/how-to-discourage -artists-in-the-church.

That art was valued across a broad cross section of society is most obvious in the rich landscape of sophisticated decoration that marks the public and private places in which every sort of community association gathered to do its work. This pervasive *artscape* enveloped not just those performing the duties of Christian faith and piety in church buildings decorated from floor to ceiling, but the committees and councils charged with civic governance, the commercial and trade guilds, monastic communities, and associations formed for charitable service, as well as the wealthy or politically-powerful families whose private life was suffused with public consequence.

Everyone wanted art. Monks and nuns ate their suppers in front of Christ's Last Supper with his disciples, frescoed on the end-wall of the refectory by artists who could merge actual with fictive space by sophisticated use of perspective. Town councils, such as the Council of Nine in Siena, debated and decided policy under the frescoed gaze of images of the sources and effects of good and bad government, a constant reminder to the councilmen of their duty to seek the common good. People received the Eucharist before altarpieces that clarified precise aspects of the real presence of Christ to be embodied in the lives of the faithful, as in his mother and in the saints of the past. Hospitals, orphanages, ducal palaces, confraternity clubhouses, sacristies where the clergy vested for the Mass, baptisteries, and bell towers: no zone of civic and religious life was alien from the desire to decorate with imagery able to instruct, remind, inspire.

This consensus about the value of art is also apparent in the consistency across many centuries in the terms by which the usefulness of art was explained and defended.

As early as 600 A.D. church father and pope Gregory the Great articulated the idea of religious art as the Bible of the illiterate in his response to an image-breaking bishop: "You, brother, should have both preserved the images and prohibited the people from adoring them *so that those who are ignorant of letters might have the means of gathering a knowledge of history* and that people might in no way sin by adoring a picture" (italics mine). Pope Gregory's defense is still being used 700 years later (as Evelyn Welch notes) "in the Sienese painters' guild statutes of 1355 which told artists that their task was, 'by the Grace of God, the exposition of sacred writ to the ignorant who know not how to read.' "[4]

By the time of the scholastic philosopher and theologian Thomas Aquinas in the mid-thirteenth century, Gregory's single emphasis on learning

[4]Evelyn Welch, *Art in Renaissance Italy* (Oxford: Oxford University Press, 1997), 137. Gregory's letter can be found in Gesa Elsbeth Thiessen, *Theological Aesthetics, a Reader* (Grand Rapids, MI: Eerdmans, 2004), 47.

from a visual Bible of sacred images was expanded into what became a repeated threefold function of art. Aquinas defended the use of sacred images "on three grounds: first, as a *lesson* in the secrets of the faith for the unlettered; second, as visual *reminders* of the mystery of the incarnation and of the *example* of the saints; and third, as an especially effective *stimulus* to devotion."[5]

The great Dominican theologian's *apologia* was popularized in treatises such as the thirteenth century *Catholicon* of John of Genoa, where the three functions of images are explained:

> Know that there were three reasons for the institution of images in churches. First, for the instruction of simple people, because they are instructed by them as if by books. Second, so that the mystery of the incarnation and the examples of the Saints may be the more active in our memory through being presented daily to our eyes. Third, to excite feelings of devotion, these being aroused more effectively by things seen than by things heard.[6]

This formula for the purpose of religious art was applied to art in civic contexts as well, as in the description by a thirteenth-century chronicler from Genoa of art as one of the means whereby the citizen "may *learn* more about the excellent deeds of the Comune and his own predecessors; and that through their *example* and the acceptable rewards which they deservedly gained, he may be the more eagerly *inspired* to work for and maintain the honour and advantage of the Comune."[7]

This same three-part defense is still at work in a sermon published in the late fifteenth century by the Dominican preacher Michele da Carcano:

> ... images of the Virgin and the Saints were introduced for three reasons. First, on account of the ignorance of simple people, so that those who are not able to read the scriptures can yet learn by seeing the sacraments of our salvation and faith in pictures.

Then, after quoting verbatim the passage from Pope Gregory's letter to Bishop Serenus, Fra Michele continues, reversing the order of the second and third defenses:

> Second, images were introduced on account of our emotional sluggishness; so that men ... may at least be moved when they see them, as if actually present, in pictures. For our feelings are aroused by things seen more than by things

[5] Cited and translated by Peter Humfrey, *The Altarpiece in Renaissance Venice* (New Haven: Yale University Press, 1993), 57.

[6] Cited in Michael Baxandall, *Painting and Experience in Fifteenth Century Italy*, 2nd ed. (Oxford: Oxford University Press, 1988), 41.

[7] Cited by Diana Norman in *Siena, Florence & Padua: Art, Science, and Religion*, vol. 1 (New Haven: Yale University Press, 1995), 152.

heard. Third, they were introduced on account of our unreliable memories . . . Images were introduced because many people cannot retain in their memories what they hear, but they do remember if they see images.[8]

We should be wary of misinterpreting the Bible-for-the-illiterate trope as a call for simplistic Sunday-schoolish art for dummies. The theologically-astute eschatology in the San Brizio Chapel in the Orvieto Duomo, or the theology of the Trinity given visual form in Masaccio's famous fresco in the Dominican church of Santa Maria Novella in Florence, or the exposition of what money can and cannot buy performed in the frescoes of the Brancacci Chapel in the Carmelite church in Florence—these and so many other works of art demonstrate that the "expositions of sacred writ" enacted in visual form can exhibit a sophisticated visual literacy that can make us contemporary folk look like ignorant dunces.

Nor should we suppose that the instructional and inspirational purposes of art mean that the *users* of the artwork during the centuries under consideration were insensitive to its beauty, or without high expectations that the artwork had better be beautiful, or without strong criteria of judgment about what elements constituted that beauty. Far from it. Rather, the aesthetic element was evaluated for how well it did its job in helping the participants' response match the purpose of the action that the artwork served. In short, beauty was seen as functional, not as something freed from functionality and enjoyed for its own sake.

The Displacement of Art

The modernist focus on the independent artist creating autonomous objects typically dissociated from any permanent place of installation goes hand in hand with an art-for-art's-sake view that plucks the artwork out of the realm of usefulness to a community in order to preserve its self-contained aesthetic integrity. What logically follows are new arrangements for viewing art so utterly common to most of us, but unimaginable until two centuries ago: namely, the art museum or art gallery.

We typically visit museums to see famous *masterpieces* of art history in person. We usually have to make a special effort to visit the museum (with significant costs associated), arranging a Saturday trip into Boston to the

[8] Baxandall, *Painting and Experience*, 41; also in Welch, *Art in Renaissance Italy*, 137, who comments: "In attracting the viewer's attention, stories or single figures of saints were meant to remind the worshipper of past events and ideas, to encourage a re-examination of one's own life and behavior, and to prompt an appropriate emotional response."

Museum of Fine Arts or to New York to visit the Metropolitan Museum of Art. High on the priority list for crowds of art-appreciating tourists in Florence is to visit the Uffizi Gallery, with its room full of Botticelli paintings, and the room where three large paintings of the Madonna and Child by Giotto, Duccio, and Cimabue are lined up together for comparative viewing. Ironically, at least to me, the three churches where the paintings originally stood on the high altar are nearby, but no one seems interested in visiting them to understand how such paintings operated in their intended setting. The conversation that I overhear focuses on the stylistic differences that point the way to the new naturalism pioneered by Giotto.[9]

Museums present themselves as places where *highly valued objects* are safeguarded, displayed under tight security. Having given ourselves over to the very pleasure of the museum experience, we can forget that most of the old artworks in museums are no longer where they once belonged. They are orphaned, extracted from the very situatedness that once gave them their resonance for the communities of people for whom they were made.

While on a father-daughter outing to the Metropolitan Museum of Art in New York City, I came up behind several other visitors in one of the galleries devoted to sacred art of the Italian Renaissance. They were gazing at the painting in front of them in obvious perplexity about its subject, and turned to the placard* next to the painting, which gave the following information:

> Fra Carnevale (Bartolomeo di Giovanni Corradini)
> Italian, born by 1416—died 1484 Urbino
> *The Birth of the Virgin*
> Tempera and oil on wood
> Breaking with convention, the artist shows the Madonna's birth in contemporary terms. In the background the newborn baby is bathed by midwives, while in the foreground women greet each other. The imposing palace, patterned on the ducal palace of Urbino, is decorated with reliefs derived from Roman sculpture. The picture is from an altarpiece commissioned in 1467 for the church of Santa Maria della Bella in Urbino. A companion panel is in the Museum of Fine Arts, Boston.

That the painting "breaks with convention" will mean little to someone unfamiliar with the convention—although showing a biblical scene "in contemporary terms" was in fact completely conventional in the fifteenth century.

[9] What you can find on the webpage from the Uffizi's own site is typical of this discourse, with nary a mention of the original locations of the three paintings; namely, in three monastery churches: Duccio's in Santa Maria Novella, Cimabue's in the Church of Santa Trinità, and Giotto's in the church of Ognissanti, http://www.uffizi.org/halls/hall-2-of-giotto-and-the-13th-century/.

For most visitors to the Met, it doesn't help much to read that the painting was originally in the church of Santa Maria della Bella in Urbino. We are likely to know little if anything about what the original *place* was like, *architecturally* and in its identity in the city of Urbino and in relation to the palace of the Duke to which the painting may allude. Nor will it mean much to most viewers that this panel was "from" an altarpiece without knowing what purpose altarpieces served and how they functioned as centerpieces of the *liturgies* enacted around them, and why such artworks were "commissioned" and by whom. For that matter, few people today are familiar with the narrative of the Birth of the Virgin Mary or with the apocryphal gospels where the stories surrounding Mary's life before the Annunciation came from. The final reference to the "companion" piece located in another museum tells us nothing about why and when such parts of an altarpiece came to be separated from the main mother panel, and then from one another. I imagine myself wandering from museum to museum mentally piecing together disconnected fragments to reconstruct a homeless and un-housed whole.

The panel and its "companion" are no longer *in situ*. In this sense, the museum *displaces* art. Both paintings *and* visitors are displaced persons, aliens and exiles from the place where the artworks belong.

But in another sense the museum itself is its own place, and the place where, for contemporary Westerners, art *does* belong. (That museums are becoming one of the principal places for encountering even contemporary art is a topic I must leave undeveloped for the moment, but the fact implies both the high valuation of contemporary art and its dissociation from the places where we actually live and work.)

We may, of course, find ourselves so drawn to an artwork from another time and place that we want it to exercise its effect in the place where we live. So we buy a print in the gift shop of Monet's Water Lillies or (in my case, as an art-discovering teenager) of Vermeer's Milkmaid or Manet's young woman behind the bar "at the Folies-Bergere." I confess that I bought prints of Botticelli's *Birth of Venus* and *Primavera* to hang in my bedroom—as a non-lascivious way to behold with wonder the female form without feeling soiled as if I had posted a Playboy centerfold. What a poignant irony to discover years later that I was participating unwittingly in exactly the painting's original *in situ* purpose. If E. H. Gombrich's theory is correct, a cousin of the famous Medici family in Florence commissioned the painting for his adolescent son, whose tutor—none other than the famous Christian-humanist scholar Marsilio Ficino—used the painting to lead the lad through the stages of Neoplatonic ascent from earthly beauty to heavenly beauty.[10]

[10] E. H. Gombrich, "Botticelli's Mythologies," in *Symbolic Images: Studies in the Art of the Renaissance*, 2nd ed. (Oxford: Phaidon, 1978), 40–41.

While existing to safeguard and display highly *valued* objects, museums typically promote a sort of *value neutrality*. Conventions of display are carefully designed to keep at bay any of our biases that might interfere with a sort of aesthetic purity of gaze.

Gallery gray walls cancel out any distractions that might deflect our attention from the framed painting itself. Gallery lighting cancels out changes in hue and color value caused by the vagaries of natural lighting (even though artists from the age of that Birth of the Virgin painting often put to use the natural lighting or the artificial lighting of candles to cancel the distance between painting and viewer). Climate control protects the artworks but also serves the purpose of eliminating any loss of viewer's focus because she feels too chilly or too hot. In the museum, one's body is cancelled out (unless your back starts hurting because of the slow pace of strolling). Unless the exhibition is organized around a particular masterwork, the arrangement of the paintings does not privilege one painting above another.

The rules of engagement between viewer and art appropriate to the gallery and museum setting are firmly established. *Decorum* requires quiet rhythms of strolling from painting to painting, moving up close to see the brush strokes—but not so close as to set off the alarm—then moving backward to take in the whole, whispering to one's companion, and *not* sitting down on the bench to have a loud conversation on the cellphone. Rambunctious kids are not welcome.

By *value neutrality* I mean that these conventions of museum display and viewing serve to suppress any response to the artworks other than the cool dispassionate aesthetic gaze, and to limit severely the set of activities permissible to the viewers.

Certainly one of the prohibited actions would be for a group of people to kneel down in front of a "religious painting" and pray aloud in an act of devotion—to use the museum as a chapel. Pulling out your camera to take a prohibited photograph will get a stern rebuke from the guard. But gathering with your friends around an Annunciation to honor the Virgin—"Hail Mary, full of grace, the Lord is with thee; blessed art thou among women and blessed is the fruit of thy womb, Jesus"—and to seek her intercession for us "now and in the hour of our death" could get you ushered out of the Museum of Fine Art. To progress tearfully on your knees from one to another of Barnett Newman's *Stations of the Cross** in the east wing of the National Gallery of Art would bring the guards running, even though the thousands of artfully crafted Stations of the Cross in thousands of churches across Christendom were created precisely to invite the faithful to follow prayerfully in the footsteps of their Lord's *Via Crucis*.

Museum-rules (we might say) require us to leave our beliefs and convictions, and their expression, at the coat check along with our backpacks

and umbrellas. Once inside the museum, tone down all values except for the appreciation of art for art's sake.

On the other hand, even value neutrality *is* a value. Museums imply a set of values about art to which most of us have been subtly habituated. Among these is the custom of organizing and labeling artworks according to periods of art history established retroactively (and sometimes anachronistically) by art historians (Giotto didn't know he was part of the "Early Renaissance."), or the relevance of bunching together a common type even though they never would have occurred originally in such a display. Above all, museums have trained visitors' minds to think of artworks in terms of artists—the Rembrandt room in the National Gallery, the Botticelli room in the Uffizi, or the special exhibit devoted to Monet—typically arranged to clarify the artist's stylistic development, or the previous artists who shaped the artist's trademark style (or against whom he rebelled). What gets suppressed is any regard for the subject matter or the situated use which the artwork was commissioned to help a group of people perform.

The lingo almost totally informs the way collectors speak, as in this example randomly chosen from one of the annual issues of *Artnews* that identify the top 200 art collectors. Asked in an interview, "What's on your wish list?" Nathalie de Gunzburg replies "I would love to buy a Bob Ryman."[11] My artistically-astute Christian friends commonly speak in the same way. They look around at the art in my house, saying "Wow, you have a Catherine Prescott portrait," or "Hmm, is that a Knippers?"—not "Is that a Massacre of the Innocents or a Sacrifice of Isaac?"

The *Florence Portfolio*, whose importance for this book I have mentioned, has recently found a home in the main corridor of the convent in Orvieto where our undergraduate program resides. Visitors generally seem more interested in identifying the artist than in understanding the subject of the images. "Ahh, Duncan Simcoe," rather than discovering the Sacrifice of Isaac imagined in Simcoe's own neighborhood where the homeless folk keep their few belongings in grocery carts—in one of which, in Simcoe's image, we see a pair of ram's horns.

I am well aware that museums themselves are emerging from the formalism that has conditioned the existence of museums. ("Formalism" in modern usage refers to an approach to art that focuses our attention on, and grounds appreciation in, qualities of design internal to the frame with minimal reference to external contextual knowledge, except for knowledge of the artist's biography.) A newish but not dominant curatorial practice in recent decades is to reconstruct or at least to evoke the place of the artwork's original place of display. A new gallery in the Boston Museum of

[11] *Artnews,* Summer 2011, 90.

Fine Arts, for instance, recreates a fashionable nineteenth-century Salon with its walls loaded to the ceiling with paintings. A card on the wall underlines the fact that such arrangements openly expressed value judgments of their owners. Yet even this invitation to immerse oneself in an earlier manner of encountering art is deliberately ironized—interrupted—by a painting recently acquired by the MFA that depicts the room itself, but whose real subject is the act of viewing by the viewer. Visitors like to stand in exactly the point from which the painting was painted; we look at ourselves looking instead of at the paintings themselves.[12]

Yes, museums and galleries provide elegant and distraction-free settings for viewing art. But *Do Not Touch.*

I remember when, in the early years of the undergraduate program in Orvieto, I gained permission from the mother superior of the convent where we resided to mount a show of student work in the underused *sala* accessed directly from the entryway. When the paintings were moved in, Suor Teresa and Suor Franca were so excited to see the students' work that they began touching the paintings, moving their hands across the surfaces. I remember wincing anxiously, almost appalled, wondering how I could say politely but firmly, *non toccare,* don't touch. These were works of art. But I could also see that this was Teresa and Franca's way not to violate but to appreciate the paintings; not to keep hands behind back, but to reach out in embrace. In their very lack of sophistication—their ignorance of modern decorum—they were enjoying an immediate engagement with the art.

In fact, their mode of engagement *was* the decorum of an earlier age. As the historian Caroline Walker Bynum remarks in a review of a museum exhibition of medieval devotional objects, these objects displayed under glass

> were not created for the dispassionate viewing suggested by our modern museums with their boutique lighting and didactic labels identifying primarily the "artist" and the nature of the materials employed. ... [They] were made to be used—handled, dressed and undressed, censed with smoke and spices, kissed.[13]

Another experience made me conscious of how my own experience of art had been *museumized.* One of the exhibitions mounted a few years ago

[12] See "Museum of Fine Arts, Boston, to Unveil Painting Depicting Gallery in Art of the Americas Wing by Artist Warren Prosperi," *ARTFIXdaily*, June 28, 2012, http://www.artfixdaily.com/artwire/release/7365-museum-of-fine-arts-boston-to -unveil-painting-depicting-gallery-i. A less winsome instance of this ironizing of the museum is the photograph that almost covers the wall by the MFA gift shop which is simply a picture of the wall behind it; see the description in *MFA Preview*, Summer 2013, p. 10.

[13] Quoted in Agnes Howard, "Saints and Sisters," *Books & Culture*, May/June 2013.

in conventional gallery fashion by the *Studio for Art, Faith & History* for the annual *Festival of Art and Faith in Orvieto* was of Russian icons, newly painted in traditional fashion by a school of Iconography in Italy devoted to keeping that tradition vital and alive. I hoped that the exhibit might be especially attractive to Orvieto's small community of Russian Orthodox immigrants from Eastern European countries. Indeed it was, but not as I expected. During one of the opening hours, the priest of that community approached me to ask if he might bring the entire community one evening after the regular hours—and here he became awkwardly bashful—not to view the icons but to pray with them, to have a liturgy. That is, as it struck me like a ton of bricks, he wanted to use the icons as icons, not as art objects. The experience, like Suor Theresa's touching, helped disengage me from the museum culture's rules of engagement.

The very actions that artworks in medieval and Renaissance Italy (for instance) were expressly created to assist make a good list of what is expressly not permitted in the modern museums that preserve and protect such art: Don't touch . . . No food or beverages allowed . . . Don't pray . . . Don't sing . . . Don't preach . . . Don't teach . . . Don't catechize . . . Don't adore. . . .

To open a window on the much longer swath of history in which artworks did their work *in situ*, I will take up just one example in which the action of adoration is precisely the subject of the painting and the action it is designed to inspire . . . and in which we can see the actions of instructing, remembering, and inspiring set into play.

Art in Place in Renaissance Italy: the Chapel of the Sassetti Family, Santa Trinità, Florence

In Florence during the late 1400s, the painter Domenico Ghirlandaio ran a large and successful *bottega*, or commercial art workshop. We know nothing about Ghirlandaio's interior life, but we do know that among the many commissions taken on by his workshop was the decoration of a chapel belonging to the Sassetti family in the Church of Santa Trinità. Francesco Sassetti was a prominent and wealthy banker, managing several branches of the Medici family's banks in northern Europe and eventually becoming the general manager of the Medici bank. Ghirlandaio's work in the chapel was of two sorts in two different media. He painted the altarpiece, depicting the scene of the adoration of baby Jesus by the shepherds, with the procession of the three Kings in the distance making their progress toward Bethlehem, and he frescoed the walls of the chapel with scenes from the life of St. Francis.*

The altarpiece itself is recognized as a masterwork of Italian Renaissance painting, almost always featured in art history books about the period. Unlike the hundreds of altarpieces now lined up on walls in museums, Ghirlandaio's Adoration remains *in situ*, in the setting for which it was painted.

Santa Trinità is still a functioning parish church. During most days, outside the hours of Mass and the midday closure, a handful of local people kneeling in prayer in the pews share the space with groups of art tourists or students arriving with their teachers to see Ghirlandaio's masterpiece (my students and I among them). Most of these visitors know little or nothing about who commissioned this painting and why, about what kind of a church this was, about what the subject matter of the wall decoration is and why it was chosen, or why such a masterpiece is relegated to a side chapel. They crowd into the compact space of the chapel, or stand on the several stairs leading up to it, for five minutes or so, put coins in the light box, listen to the guide, take photos (permissible without flash), and depart.

The experience of a fifteenth-century visitor to the richly decorated chapel would have been quite different, operating in several dimensions at once. Perhaps first of all, the contemporary viewer would have been keenly conscious of entering the *place* of the Sassetti family. Side chapels were given in long-term lease to families for a significant contribution, in this case to the monastic community of the Vallombrosan order whose church this was. This arrangement provided a significant source of income to the monastic community in residence and ensured the beautiful decoration of the church in return for the value to the family of having made an admirable charitable contribution, of increasing their prestige and respect among their peers, of having a place for the family to arrange regular Masses in memory of their dead family members, and to celebrate the liturgies of life's sacramental passages: baptisms, marriages, funerals, and saints' days relevant to the family members' identities.

In fact, this chapel *is* the burial chapel for the *paterfamilias* who funded the lease of the chapel and its decoration. The sarcophagi in niches in the side walls contain the remains of Francesco and his wife Nera Corsi.*

This association of a private chapel with a family's identity has several aspects beyond marking the family as a sustaining member of the parish or patron of the monastic community, as in this case.

Children were often named after the saint whose celebration-day in the calendar of the liturgical church year was on or near the day of the child's birth. Children of a family might be named after saints whose intercession was felt as relevant for the meaning and vocation of the family name or identity. Hence, for example, the patron saints of the Medici family (*medici* meaning doctors) were the two famous doctor-martyrs Damian and Cosmos—after whom Cosimo de Medici was named. In the case of the

Sassetti family, the patron saint of Francesco Sassetti was San Francesco, St. Francis. Hence the decision to commission an artist to decorate the walls of the chapel with scenes from the life of St. Francis would have been conventional and appropriate.

A family's identification with their patron saint would have prompted attentiveness to episodes in the family's life that could be seen in some fashion as parallel to events in the saint's life. One can imagine an entire cultural community habituating itself to this way of interpreting their lives. In the case of the Sassetti family, scholars have pointed out that the scene of a boy raised to life by the intercessory prayers of St. Francis—frescoed on the wall immediately above the altar itself—may have been chosen by the couple to mark their gratitude for the birth of a new son after the death of their first.

We have identified the Sassetti as the patrons of the chapel, and St. Francis as the patron saint of the commissioner of the decoration. Apparent to any contemporary visitor would have been the presence in the painting of another patron, on whose approval depended the civic, social and financial standing of the Sassetti family. Lorenzo de Medici stands prominently beside the *padrone* and his sons as observers in the scene where St. Francis receives the Approval of Pope Innocent for his new Order of the Little Brothers.

Photographs in art books of the chapel's altarpiece are often cropped to eliminate a sense of its setting—keeping the book-viewer's eye turned inward, never leaving the framed scene of Adoring the Christ child. In fact the painting's border is permeable, reaching out to include the two figures frescoed into the walls on either side of the panel.* These two figures, clearly portraits of Sassetti and his wife, gaze into the painting, as it were, kneeling in adoration of the Christ child. They participate in the very action of the shepherds inside the painting on the altar. The posture and gesture of Nera Corsi, with her folded hands, imitates that of Mary. This mode of devotion of placing oneself inside the biblical scene was an utterly common mode of teaching people how to meditate on the stories from Scripture.

The shepherds are inspirational models for the patrons. That is to say, those to whom this sacred place belongs should imitate the action of the witnesses to the miracle of the Nativity of the Incarnate Son of God. But the patrons themselves, painted into the scene, also become models for those who enter the chapel, who ought to kneel with the patrons in beholding the mystery of this birth. The space of the painting expands first to include the painted effigies on the walls, then expands further to draw into its embrace the people in the space of the chapel itself. The chapel itself becomes the place of adoration, of the Nativity. Everyone in the physical space of the chapel joins the figures inside the fictive painted space of the altarpiece.

The next step in the architectural context brings us back to the Francis story. What has the Adoration altarpiece to do with the scenes from the saint's life depicted on the walls? No connection is obvious, and modern-trained folk are unlikely even to ask the question. But one of the most beloved episodes from Francis's life was his "invention" of the Christmas crèche when he invited the ordinary townsfolk of Greccio to recreate for themselves the night of our dear Savior's birth (participating in humility, like the shepherds; not in pomp and circumstance like the Magi). Saint Bonaventure, in his *Life of St. Francis* written a generation after the saint's death, describes the scene like this:

> He had a crib prepared, hay carried in and an ox and an ass led to the place. . . . The people come, the forest resounds with their voices. . . . [Francis] stands before the crib, filled with affection, bathed in tears and overflowing with joy. A solemn Mass is celebrated over the crib, with Francis as deacon chanting the holy Gospel. Then he preaches to the people standing about concerning the birth of the poor King.[14]

Perhaps that particular episode of the "Crib at Greccio" is not painted into the walls because it does not have to be. When St. Francis's namesake Francesco worships before the image of the newborn Son of God, he and his family reenact a scene from the life of their patron saint. The people worshipping *are inside* the narrative of Francis's life.

This action illuminates the central liturgical action performed at the altar in the chapel: the celebration of Holy Communion. In this particular chapel, the painting placed on the altar—in front of which the sacrament of the Eucharist is enacted—identifies the altar with the place where the Incarnate Son of God is born. Ghirlandaio's representation of the manger as a Roman sarcophagus is not a bizarre misrepresentation of the Gospel text. Rather, it serves as a visual reminder that this baby will be the One who dies for us, who must first be placed in a tomb before he rises from the tomb, who gives his body and blood as represented in the sacrament of His Body and Blood received at the altar.

<p style="text-align:center">✳ ✳ ✳</p>

With this brief case study of just one chapel, we can begin to understand how, for many centuries, artworks always operated *in situ*, in a particular place. To *view* the artwork, or better to say, to *experience* the *art at work*, we enter several overlapping places at once.

[14] Bonaventure, *The Life of St. Francis*, trans. Ewert Cousins, The Classics of Western Spirituality (Mahwah, NJ: Paulist Press, 1978), 278.

We enter an *architecturally distinct* "place" where a community (in this case, the extended family and friends and heirs of the patron Francesco Sassetti) gathered to perform particular actions important for their identity. In the case of the Sassetti family's chapel, the architectural space of the chapel is transformed by the decoration into the place both of the patron saint's activity (where scenes from the life of St. Francis are set in front of the church itself, and in recognizable places in the city) and of the patron's activities among his social circle of friends and family and business associates.

We enter the place of the *liturgy*. No one in the 1300s or 1400s or 1500s entered the places of art in the manner of modern museum-goers. Rather, people viewed artworks while they were *inside* particular patterns of action: celebrating the Eucharist, or the Baptism of the newest Sassetti, or Francis's saint's day on October 4th, or the funeral or memorial Mass of a dead family member, or perhaps the wedding of a child that further bound together the relationships among families.

We enter a story, the place of the *narrative*. To be inside the Sassetti Chapel is to be inside the Nativity story, *and* inside the story of St. Francis, who memorably reenacted the Nativity. We are *in* Bethlehem, or in the Pope's palace at the Lateran, or in the very streets of Florence where miracles are performed.

The chapters that follow explore these three places of art.

Part I

The Place of Architecture

1

The Community Gathered

During the centuries of medieval and Renaissance art and culture in Italy that provide a reference point for this book, works of art were almost always designed for specific physical locations. Artists were obliged to take the location into consideration when creating the art commissioned for that site. Every element of the artwork had to be fitting for the particular place in which it was expected to do its work—*fitting* understood both as "fitting into" and as "appropriate for." This interaction between artwork and its location had multiple dimensions, and choreographing this interplay was a positive challenge for the artist, not a limitation to be resented.

In our own time, the vast majority of artworks are not created for a known location in which they will surely be installed, and viewers are not trained to seek connections between an artwork and its place of display. When artists make artworks with the hope that they will be sold by a gallery or at an art fair to collectors who can put the art anywhere they choose, then having an eye for the future location of the work of art is simply erased as a factor in the artist's creative process.

The general approach to the exhibition of art in museums has been to enhance the viewer's focus on the individual artwork in front of her as a discrete unit, isolated from its relation to any other environment. The walls, the architectural facts of the display room, do not themselves contribute to what is contained in the painting. Nor is the artwork expected to contribute something to the architectural features of the exhibition space. Trained by the conventions of museum viewing, we feel no prompting to look back and forth from the paintings on one wall to those on the wall opposite to spot relationships between them that were intended at their making. The rooms themselves operate as discrete units. We may admire the architectural symmetry of the grand traditionalist museums, from the Louvre to the National Gallery in London to the National Gallery of Art in Washington or the Museum of Fine Arts in Boston, as we approach the grand entrance or stand under the central dome. And the architecture itself has become almost the chief work of art in stunning recent museums such as those designed by Frank Gehry for the Guggenheim Museum in Bilbao,

Spain, or the Weisman Art Museum in Minneapolis or Daniel Libeskind's design for the Denver Art Museum (among others). But once inside the sequence of galleries, our experience of the individual artworks has little felt relation to the architecture of the building.

Yes, curators commonly arrange artworks so as to prompt particular associations in the viewers' experience—perhaps changes in style among periods of history, or in the chronological sequence of a single artist's work, or the influences of one artist on another, or elements of an artist's biography (the model that was a mistress, and the like), but in general such connections are understood to be the effect of the exhibition rather than a function of the art and the location themselves.

The modern disengagement of art from the ties that bind art to a permanent location goes hand in hand with modern values. These conditions preserve the liberty of the artist, the sacredness of the studio, and the artist's answerability only to himself. They honor the freedom of the viewer to experience art with an aesthetic gaze focused on the internal formal qualities of the artwork, with little sense of moral obligation to allow the artwork to change how he or she lives life.

Counterexamples to these generalizations of course exist. To cite only one, Maya Lin won the competition for the commission to create a new memorial on the Mall in Washington, DC to honor the 58,000 members of America's armed forces who lost their lives in the Vietnam War. Lin's non-figural, minimalist eschewing of the monumental heroism evoked by its companion memorials of an earlier epoch was controversial when The Wall was first unveiled. Yet the Vietnam Memorial has proven to give voice, without nostalgia or irony, to that most traditional purpose of a work of public art: to memorialize, to honor the fallen, to evoke memory in an inspirational key. Maya Lin's Wall breaks down aesthetic distance. People from all walks of life are drawn toward it, moving their hands over the chiseled grooves of the letters in the names, openly weeping, entering into an appropriate comportment of solemnity and respect.[1]

Nevertheless, the general displacement of artworks from the places of daily community life has poorly equipped most of us to seek out, or even to expect, the relationships once understood to be at work between artworks, their architectural location, and their larger environment.

In fact, most of us are poorly trained to regard with a sensitive and discerning eye the relation of decoration to the architectural setting even

[1] Alejandro Garcia-Rivera uses The Wall as a case study for exploring the relation of artistic power and aesthetic experience to an artwork's ability to bring healing in the essay "The Tyger and the Lamb," in *A Wounded Innocence: Sketches for a Theology of Art* (Collegeville, MN: The Liturgical Press, 2003), 99–117.

in our own contemporary landscape. Few churchgoers are adept at appre-hending the meaning of any art that happens to be located in the church space, or its appropriateness and relevance for the actions that occur there.

The larger blockage to an astute perception of art in its architectural setting may in fact be the erosion in our time of the relation of human action to particular spaces. Such erosion diminishes our capacity to dif-ferentiate spaces and consciously to discern the *decorum* (to use an old-fashioned word worth recovering) between the design of space and the actions that take place in that space.[2]

One can't have artworks designed for a particular space and the actions performed in that space when there are fewer and fewer particular places or even site-specific actions. If we snack everywhere and anywhere, if fam-ily members grab a bite on the go, or eat supper in front of the TV—that is, if we don't use dining rooms—then there's no appropriate place for the painting that reminds us what dining is all about. (The art surrounding our dining is reduced to the manipulative, commercial imagery of fast-food-joint décor.)

The dissociation of designed space from designated action is a defining mark of modern civic and personal space. If we bring our Starbucks coffee cups into the classroom, why not into church? In the tract homes of subur-ban subdivisions the central front door is an empty symbol of welcoming when the family actually enters the house through the side door from the garage. We buy our medical supplies in grocery stores and our groceries in pharmacies. Banks look like houses; we use the ATM machine in the little ATM-shed alongside the gas station. When one can do one's banking any-time and anyplace on one's handheld device, the telling features of a *bank* become irrelevant, lost to view.

Indeed, the ubiquity of smartphones and other portable devices con-nected to the internet is itself a significant contributor to the leveling of spatial distinctions and the identity of place. We interrupt presence and attentiveness in a class at school or a conversation at the coffee shop or in a worship service at church with a quick check of Facebook. Students on my home campus whip out their smartphones as they exit the library onto the path around the beautifully landscaped quad, pecking away with their thumbs the entire way toward the student center, oblivious to birdcalls, flowers, or to one another. I took a surreptitious photograph of a father-son date for breakfast at a local diner on a recent Wednesday during which

[2] For an astute analysis of the erosion of place in our epoch, see James Howard Kunstler's books, *The Geography of Nowhere* (New York: Free Press, 1994) and *Home From Nowhere* (New York: Free Press, 1998), or the lengthy excerpt of the latter book in *The Atlantic Monthly* 278, no. 3 (September 1996): 43–66, http://www.theatlantic.com/magazine/archive/1996/09/home-from-nowhere/376664/.

no bonding occurred because the Dad was occupied with his smartphone while the boy ate his pancakes in silence.

That is, it isn't just artworks that have become dissociated with particular places. This book is addressed to a culture in which most human activities have been so dissociated.

My purpose in this first section of the book is to help us recover a degree of sensitivity to the relationships once operative between the physical setting of installed artworks and the particular actions performed in those settings, during an epoch when such sensitivity was fostered across all levels of society.

Masaccio's Expulsion

I enter this topic through one of the most famous artworks of the early Italian Renaissance: the painting by Masaccio of the Expulsion of Adam and Eve from the Garden of Eden after their disobedience. Masaccio was recognized then and now as a key figure in inaugurating a new attention to human emotion and in endowing figures on a flat picture plane with a three-dimensional presence in a deeply resonant space. The photographs of Masaccio's Expulsion in textbooks and guidebooks are very often cropped so as to erase any sense of its location *in situ*. In fact, in its original setting in Florence, the painting is frescoed on the top half of one of the pilasters (decorative columns) that frame the entrance into the private chapel of the Brancacci family in the transept of the church of the monastic order of the Carmelites: the church of Santa Maria del Carmine.

Frescoed on the corresponding top half of the opposite pilaster is the scene of the Temptation of Adam and Eve before the Fall, painted by Masolino.* (The two artists clearly worked at the same time on the chapel, but their formal relationship in terms of their contract has not been conclusively resolved.) Modern art-historical discussion very typically focuses on the stylistic difference, even incompatibility, between the two paintings, contrasting Masolino's as the conservative but still trendy one labeled by the historians as "International Gothic" and Masaccio's as the pioneering work of the new "Renaissance," but a formalist focus on style alone can readily underplay the obvious architectural fact spotted immediately as one enters the chapel. Masolino's Temptation and Masaccio's Expulsion clearly work as a pair, looking directly across at each other and down to the scenes below them on the same pilasters.

Masolino's Adam and Eve are distinctly *in* the Garden. In Masaccio's scene our first parents have just emerged through the archway-gate of Eden along the left side of the panel, with the angel above driving them *out* of

Paradise with raised sword. The paintings not only frame the entrance physically but would have been understood to "frame" thematically the whole *programme* of the chapel. Modern scholars still debate the matter, but how the before-and-after Garden of Eden scenes would have been understood to set the stage for the whole chapel is a discussion that any and every thoughtful visitor can join.

True enough, apart from the Temptation and Expulsion of Adam and Eve, the entire decoration of the chapel presents scenes from the life of St. Peter, the patron saint of the *paterfamilias* of the Brancacci family. Some are drawn from the Gospels and some from the Acts of the Apostles; other scenes have their sources in later legendary material. Attentive viewers will note soon enough that the episodes selected for this cycle notably relate to money.* Peter pays the temple tax with a coin found in a fish's mouth (Matt. 17:24–27). Peter heals the crippled man begging for alms, with the words, "Gold and silver have I none, but what I have I give to you; in the name of Jesus Christ of Nazareth, stand up and walk" (Acts 3:1–10). Ananias keels over dead as Peter rebukes him for having deceptively held back some of the money gained by the sale of a field (Acts 4:34—5:11). Peter is challenged to a power contest in front of Nero (a story from the apocryphal narratives) by Simon the magician, the man who had offered Peter money for the power to perform miracles granted by the Holy Spirit (Acts 8:9–24). And so forth.

These two scenes of temptation and disobedience would have adjusted the "lenses" of those entering the chapel, orienting their mental and physical demeanor as they looked forward, by liturgical habit, to the altar where Christ's redemptive sacrifice was rehearsed in the Mass. To a fifteenth-century viewer trained to expect the possibility that opposite walls may mirror one another (even if inversely), the paired scenes at the top of the entrance column would alert them to the possibility that opposite scenes elsewhere in the chapel are likewise in dialogue with each other.

The obvious parallelism in the two scenes on the same pilasters below the Temptation and Expulsion would further suggest such a pattern of design. In fact, frescoed on the lower halves of the entrance columns—closer to the level of the arriving worshipper—are two episodes involving Peter in prison.* Below the Temptation is the scene of an angel leading Peter out through an arched doorway of a building with barred windows. The scene is drawn from the episode recounted in Acts 12:5–9 of Peter's miraculous delivery from the prison in Jerusalem where he had been placed under heavy guard by King Herod. The visual design thus imitates the Expulsion located on the opposite column, above. The visual design, we might say, activates the ironic contrast between being led out of a place of freedom in the Garden into the prison-like place of exile "East of Eden," and being led

out of prison into the Spirit-empowered freedom of the new community of Christ's followers.

Directly opposite the scene of Peter's liberation from prison is another scene in which Peter is clearly *in* prison, in conversation with the figure standing outside the barred window (who turns out to be Paul). Narrative logic might readily suggest that the scenes follow in sequence to tell the story of the imprisoned Peter's visitation by the liberating angel. As it turns out, when one takes into account the sequence spread across the entire wall, the scene of Peter in prison comes from an episode from another place and a later time, narrated not in the New Testament but in the body of apocryphal legends concerning Peter. (Such legends were collected, along with commentaries from the church fathers, in the thirteenth century by the Dominican friar Jacobus de Voragine, whose immensely popular, encyclopedic *Golden Legend* was organized around the feast days of the church year.) There, King Theophilus of Antioch has imprisoned the evangelizing Peter until the visiting St. Paul convinces Theophilus to permit Peter to "restore the sick to health and the dead to life!"[3]

[3] This comes from the story in *The Golden Legend* concerning the feast day commemorating "The Chair of St. Peter" (Jacobus de Voragine, *The Golden Legend: Readings on the Saints*, trans. William Granger Ryan, vol. 1 [Princeton, NJ: Princeton University Press, 1993], 162–63):

> Paul left the jail cautiously and went back to Theophilus, to whom he said: "O good Theophilus, great is your fame, and your courtliness is the friend of honor. But a small evil counteracts great good! Think about what you have done to that worshiper of God who is called Peter, as if he were someone of importance! He is in rags, misshapen, reduced to skin and bones, a nobody, notable only for what he says. Do you think it is right to put such a man in jail? If he were enjoying the freedom to which he is accustomed, he might be able to do you some useful service. For instance, some say that he restores the sick to health and the dead to life!" Theophilus: "Idle tales, Paul, idle tales! If he could raise the dead, he would free himself from prison!" Paul: "Just as his Christ rose from the dead (or so they say) yet would not come down from the cross, so Peter, following Christ's example (it is said), does not set himself free and is not afraid to suffer death for Christ!" Theophilus: "Tell him, then, to bring my son, who has been dead for fourteen years, back to life, and I will release him unharmed and free!" Paul therefore went to Peter's cell and told him he had solemnly promised Theophilus that his son would be brought back to life. "That's a hard promise to keep, Paul," said Peter, "but God's power will make it easy!" Peter was taken out of prison and led to the tomb. He prayed, and the governor's son came to life immediately. . . . Theophilus and the whole population of Antioch, together with a great many other people, believed in Christ. They built a magnificent church and erected an elevated throne in the center, to which they lifted Peter up so that he could be seen and heard by everybody."

Two garden scenes over two prison scenes. Each pair is sequential (or at least appears to be); each pair depicts a *being in* and a *bringing out* through a gateway. But the two *being in* scenes and the two *bringing out* scenes are not stacked up on the same column but rather diagonally related on opposite columns. To be visually attentive to these inverted parallels prompts understanding of inverted themes. Adam and Eve's freedom inside the Garden *contrasts* with Peter's bondage inside the prison of Theophilus in Antioch. Adam and Eve's grief and shame, their bondage to sin outside the Garden, *contrasts* with Peter's freedom as a bondservant of Christ constrained to preach the gospel in violation of Herod's law.

We might say that the crossed-over eye-lines linking visually-parallel scenes serve to give visual form to the paradoxes of the rule in Christ's topsy-turvy kingdom (to which Peter was given the keys). These paradoxes turn out to be an informing theme of the whole cycle of images that fill the chapel. The duty of obedience creates freedom. Disobedience brings a freedom that feels more like imprisonment from which we need a liberator. Christ and his disciples are not obliged to pay the temple tax, but they pay it anyway out of their freedom as children of the true king. Ananias was free to contribute as he wished to the common purse, but in secretly holding back some of the funds, he reveals himself to be a bondservant of Mammon. The appreciative Theophilus lifts Peter up on an elevated throne, but Peter receives his true honor (in parallel position on the opposite wall) when he is crucified upside down in loyalty to his Master.

We will return to this fresco cycle to explore more of the visual strategies for articulating the inversions in the kingdom announced by Jesus (a kingdom in which all the social hierarchies based on worldly power and prestige and wealth are turned upside down and inside out, a kingdom in which the first shall be last and the humble are lifted up). Here it is enough to point out how the pilasters, functioning as a pair, mark the entry to the frescoed chapel. Masaccio's and Masolino's contrasting scenes serve as both a physical guide and a thematic prompt to encountering a space where symmetries and inverted symmetries and movements across and between walls is everywhere relevant to theme and narrative. Beginning with the use of the architectural givens of the entry into the chapel, the *work* of the art is not simply to decorate flat walls, but rather to turn the entire space into a network—a sort of dynamic cat's cradle—of linkages.

These resonances are not idiosyncratic associations but purposeful meanings shared among those for whom this space has been designed. Such relationships were almost always at work in the centuries of Italian art and culture that provide the frame for this book, but these resonances will never resonate if our attention remains focused on any one of the panels as a discrete unit. My lesson in this opening example is that modern habits of

viewing can shut us off even from basic visual understanding of relationships between individual artwork and its larger spatial and architectural setting.

We must perform an act of *historical imagination* to get back inside the mind and eye of an earlier age in order to understand how art was integrated into architecture. Art shaped the experience of the space and related that space to the actions to be performed in it. Artworks were not hung on walls, but were experienced *as* the wall. With fresco, the medium most commonly used for painting walls, this is literally the case. When the artist applies pigment dissolved in water onto a thin coat of fresh plaster, the paint is absorbed into the plaster and chemically bonded to it as the plaster dries. A fresco, we might say, is not *on* the wall, it *is* the wall. The medium itself acts to dissolve the distinction between the art and architecture.

The progress of part one of this book, "The Place of Architecture," will be to call our attention, first, to how the physical facts of the building exerted their own pressure on how the artist made the artwork, and to how the traditions of architectural design and purpose contributed to this pressure. Then, I hope to explain how the artist's design can be said to *create* architecture. That is, the *work* of the artwork was to *shape* the space as experienced by those participating in the activities for which the space was designed. In guiding the movements of the eye up-down-across-around, in giving directional signals to the mind's engagement with the storied decoration, the artwork engaged the person not just as a viewer in neutral *gallery* space but as a participant in a narrative, in a liturgy, in a purposeful corporate action. In medieval and Renaissance Italy, an artist's ability to integrate these directions into a seamless fabric was a mark of artistic excellence.

2

ARCHITECTURE SHAPING ART

To illustrate how artists made the architectural givens of a space work for them rather than against them, let me begin with a couple small-scale examples.

When Giuliano della Rovere was elected Pope Julius II in 1503 he, like popes before him, claimed space in the Vatican complex for his own private quarters, and commissioned the decoration of his apartment according to his own interests and tastes. To house his library, Julius selected a cube-shaped room with two opposing walls each pierced symmetrically by a window in the middle. The other opposing pair of walls offered greater uninterrupted wall space except for doorways. On one of these walls, dedicated to the theme of the theology of the sacrament, Raphael integrated into the actual doorframe a painted ledge used by one of the figures in the painting to peer around for a better view of the Host displayed on the altar.* The deft *trompe l'oeil* effect incorporates the intrusive doorway into the fictive scene covering the entire wall.

Another small-scale example of integrating the painted scene with the actual architecture can be found in the cycle of episodes from the life of St. Benedict frescoed in the arched walls surrounding the cloister of the Abbey of Monte Oliveto in southern Tuscany. The painter Sodoma made use of a window awkwardly piercing one of the arched panels by placing the figure of God at the top of the window-surround.* Painted in the lower right corner of the panel, the man to whom God is speaking looks up across the window, shielding his eyes from the light—a light both metaphorical and actual.

Luca Signorelli faced the same conditions on a larger scale when he was contracted around 1500 to complete the work begun a half-century earlier by the Dominican friar-painter Fra Angelico in the "New Chapel" in the right transept of the Orvieto Duomo.[1] Fra Angelico had placed the central image of Christ in Majesty, returning in Judgment, in the ceiling

[1] The chapel later became known as the Chapel of the San Brizio Madonna in reference to a beloved painting of the Virgin and Child transferred to the altar of the chapel—hence the *San Brizio Chapel* in most guidebooks.

directly above the tall narrow window on the southern-exposed altar wall. By painting the shadows cast by the figures on the side walls (notably in the scene of the Resurrection of the Dead) so that the shadows seem to be made by the light shining from the window, Signorelli creates a visual experience of both window and Christ as the source of light.* By ingenuity of design, the artist, we might say, makes the architectural fact answerable to the painted scene. The artist uses real windows and real light to help transform the space of the Chapel into the present *place* of the Last Judgment.

When the roofs of churches, or other grand public buildings, were vaulted in stone—with either the barrel vaults in what came to be called the Romanesque style, or the pointed-arch vaults in the so-called Gothic style—the ribs were based on the columns anchored in the foundation. The crossing of the ribs to strengthen each section of the roof created X-patterns in the ceiling, each with four triangular sections within these linked ribs. For a culture disposed to see all elements of a building as possible zones of decoration, these patterns of triangles-in-fours running the length of the ceiling lent themselves to thematic groupings of fours.* The four evangelists and the four doctors of the church are common elements in these ceiling compartments.

When such groupings serve not just as space-fillers but contribute something directly relevant for the main decorative *programme* on the walls of the room below, then we can see the artist making a thematic virtue of an architectural necessity.

In the lower church of the double-decker Basilica of San Francesco in Assisi, for instance, the four sections directly over the altar depict Francis in one, and his "mystical marriage" to the Ladies Poverty, Chastity, and Obedience in the other three.[2]

Another example of using the architectural facts of the ceiling to advance the theme and liturgical action of the room is found in the frescoed ceiling of the baptistry of the Siena cathedral. There, unusually, each clause of the Apostles' Creed is illustrated in one of the triangular sections created by the ribs of the vaulting, each containing the same figure with the word *Credo* ("I believe") coming from his mouth.* The figure represents the one newly baptized who, as part of the liturgy of baptism, has declared his or her faith by reciting the Creed.

Another fascinating example of ceiling decoration that overarches the space thematically as well as architecturally is found in the north transept in the Orvieto Duomo. This Chapel of the Holy Corporal serves as the reli-

[2] Photographs of the ceiling can be found variously on the internet, including this page in the Web Gallery of Art: http://www.wga.hu/frames-e.html?/html /g/giotto/assisi/lower/crossing/index.html.

quary chapel of the altar cloth on which drops of blood fell miraculously from the host during a Mass offered in the 1260s by a priest skeptical of the real presence of Christ in the sacrament. For the local Orvietani, this relic became associated with the inauguration in Orvieto by Pope Urban IV in 1264 of the annual holy-day of Corpus Christi (the body of Christ) and to the liturgy prepared for that festal day by Thomas Aquinas, then a resident in the Dominican monastery in Orvieto. Frescoed in the four sections of the vault directly over the altar are four Old Testament episodes concerning sacred meals: Abraham's offering of bread and wine to Melchizedek, Abraham's meal with the three angelic messengers, the provision of manna during the exodus from Egypt to the Promised Land, and the bread brought by the raven that sustained Elijah in the wilderness.* These very scenes are referred to in Aquinas's liturgy as prefigurations or foreshadowings of the Eucharistic feast celebrated on the altar directly below.[3]

Tradition Shaping Architecture

These several examples show how a *programme* of artistic decoration developed by an artist had to be responsive to the architecture of its intended location. Artists were not starting from scratch, *ex nihilo*, with a blank canvas that they could fill as the creative spirit moved. But the pressure exerted by architecture came not simply through material facts of ribbings in the vault or windows and doorways on the walls, and so forth. The artistic work had to be answerable to a cultural community's historical *traditions* in the design of buildings, so that the form and furnishings suited the actions enacted in the space.

Hence, to understand the role of decoration in defining a space as a particular place for a particular action, one must be attentive to the individual zones and elements of buildings, each with its own purpose, each with its own traditions of decoration, of furnishings and furniture. Artists were not commissioned to paint or sculpt or decorate in general. They were contracted to make or decorate something *in situ*: the baptismal font of a church; a pulpit, an altarpiece; the doors, the façade, the nave, the sacristy, a family side chapel; the refectory or chapter house of a monastery; meeting rooms in the town hall, public fountains, guild and confraternity halls and chapels; the chapel of a prominent family's palazzo. Any list of great masterpieces of the Italian Renaissance will include artworks created for such places.

[3] Dominique Surh's doctoral dissertation entitled "Corpus Christi and the Cappella del Corporale at Orvieto" (University of Virginia, 2000) remains the chief study of the relation of Aquinas's liturgy to the chapel's decoration.

In the section that follows, my purpose is not to provide a complete reference manual to all these places. Rather, I will draw on a variety of examples (all from sites in central Italy) to illustrate how the *work* of art was to articulate the *purpose* of the place. The work of the artist was to help orient those in the space physically, mentally, spiritually—to line up their hearts and bodies for the "work of the people" performed in that space. The art was doing its job if it exerted shape and pressure on the site-specific actions of instructing, remembering, inspiring, honoring, exhorting, praising, praying, singing, contemplating, eating, legislating. . . .

Apse

The place most common for representing the momentous events in the fulfillment of all things in God's scheme of salvation history was the apse of a church—the space at the end of the nave behind the altar, the church's culminating, east-facing end. If a church was dedicated to a particular saint, then the decoration of the east wall typically depicted the *end*, the fulfillment, of the saint's life, in his martyrdom or in her reception in heaven.

The Orvieto Duomo, for example, is dedicated to the Virgin Mary, and its apse is decorated with an entire cycle of episodes from the life of Mary, arranged to rise from the walls to the vault above.* Scenes from both the Scriptures and the legendary apocryphal narratives include her presence at Pentecost, her death and Assumption into heaven, and her Crowning at the hands of her Son—the scenes depicted in the vaulting at the culminating point of the church.

Piero della Francesca's frescoed cycle of the Legend of the Holy Cross was commissioned for the apse of the church of the Franciscan convent in Arezzo.* The legend imagines the very wood of the tree that brought about the death of Adam as providing, in the fullness of time, the wood of the cross. The climax of the story—the glorious Exaltation of the Cross upon its recovery and return to Jerusalem by the Christian emperor Heraclius—is a figure of the Crucified Christ's exaltation in the heavenly Jerusalem, and brings full circle the entirety of salvation history. Because of St. Francis's devotion to the cross, the narrative was especially dear to the Franciscans.

Nave

Just as the apse concludes the architectural progress of the nave, its decoration may suggest the culmination of the narratives in historical time common in the decoration of the nave itself. In Joachim Poeschke's phrase, "the hierarch[y] of the pictorial themes to be articulated by the church interior" expresses at the same time "its specific architectural character."

Narrative paintings on the subject of the history of salvation, which depicted the events and served as memory aids, were usually placed on the walls of the nave [while] the symbols of divine omnipotence and the glory of the heavens, which look toward the future—that is, to the Second Coming of Christ, the Last Judgment, and the Kingdom of Heaven—were . . . reserved for the apse and entrance wall.[4]

Or as Timothy Verdon explains, "every church structure represents the entire history of the relationship between God and humankind, offering itself as a figure of that 'edifice of salvation' that St. Irenaeus believed God had designed 'as an architect would do.'"[5] Verdon gives the example of Santa Maria Maggiore in Rome, decorated in the fifth century, in which

forty-three mosaic scenes above the nave colonnade narrate "structural" episodes of Judeo-Christian faith: the stories of Abraham, Moses, Joshua. Thus believers, as they advance toward the altar, perceive themselves inserted in a historical and meta-historical process that leads them toward the "city founded, designed, and built by God" (Heb. 11:10).

The nave plays its part in creating an experience of movement through the space of the church as a condensed experience of the movement of the believer through life in the *ship* of the church. To speak of the nave as ship-like is not idle metaphor. The sense of a ship's hull given by the beams and rafters of the ceiling is the very source of the name "nave." It gives the sense of the church as a ark-like vessel of protection amidst a corrupt and tempest-tossed world as well as the vessel that carries us to the safe port of that city "made not with human hands" (Heb. 9:24).

And the entry of the believer into this ship of the church comes first through the sacrament of drowning!—through the water of Baptism that signifies both our death in Christ and our rising again into new life. Hence, a typical placement of the baptismal font is just inside the door of the church. (More on baptismal fonts in chapter six.)

Baptistries

It was not unusual for cities to construct a separate building dedicated to the sacrament of Baptism, but the enterprise required the status of a diocesan cathedral, financial means, and civic will. Such separate baptistries are typically located across from the entrance to the cathedral, as is the case for the two most notable baptisteries in central Italy, those of Florence and Pisa. Those who have been newly baptized exit the doors of the

[4] Joachim Poeschke, *Italian Frescoes: The Age of Giotto 1280–1400* (New York: Abbeville Press, 2005), 17–18.

[5] Timothy Verdon, *Art and Prayer* (Brewster, MA: Mount Tabor Books, 2014), 73.

baptistry facing the cathedral, cross over the space between, and then enter into the church. The procession evokes the new believer's own exodus-journey: freed from bondage to sin in "Egypt," passing through the waters of death into Christ, and traversing the wilderness before entering the Promised Land.

The baptistry in Florence is one of the oldest public buildings in the city, constructed in its present form in the eleventh century.* Its striking form as an octagon is in fact "typical of early Christian baptisteries," as Timothy Verdon explains:

> This shape had a precise symbolic meaning, connected—in the writings of the Fathers of the Church—with the sacrament of Baptism. It evoked the *octava dies*, the "eighth day" outside the cycle of the week and, consequently, outside the limited span of earthly life. . . . in Baptism, believers pass from the death caused by sin to new life in Christ; they already experience the "eighth day" of eternity, through their faith.[6]

The entire ceiling inside is covered by an immense *programme* of mosaics, created in the thirteenth century, whose narratives unfold against a background of gold.* The commanding central figure, located over the altar, is that of Christ exercising judgment. It follows the traditional design of a Last Judgment. The prophets and apostles are on Christ's left and right; below his feet the dead emerge from their sarcophagi-tombs, with the damned led by demons to the enormous mouth of hell, while the saved are directed to the heavenly kingdom. Four concentric strips of scenes that circle the rest of the ceiling narrate the stories of Creation and Fall in Genesis; of Joseph, sold by his envious brothers to traders only to rise to become the right-hand man of the pharaoh; of the life of Christ beginning with Mary's youth; and, in the outermost ring, the life of John the Baptist. In the shimmering golden light of these mosaics, those being baptized, and the community gathered around them, experience the sacrament of Baptism against the narrative framework of our original sin and of God's constant action of redemption from the beginning of Creation to the Final Judgment and the Eternal New Kingdom.

Doors

But what draws a crushing crowd of tourists to the baptistry in Florence are its doors—at least the third set famously deemed fit by Michelangelo for use as the Gates of Paradise.

[6] Timothy Verdon, *Art, Faith, History: A Guide to Christian Florence* (Florence: Studio Editoriale Fiorentino, 1999), 21–22.

In fact, doors were objects of decoration to a degree almost incomprehensible to a modern American used to the same nondescript glass doors with pushbar handles found in every mall, public school, hospital, and many churches as well. The major artists of the age received, or even competed for, commissions to decorate the doors of a town's most significant buildings.

All three sets of doors for the baptistry in Florence are notable masterworks of storytelling bas-relief cast in bronze.* The creation of the doors began in the 1330s when Andrea Pisano was commissioned to create a new set of doors for the east side of the baptistry with the traditional subject: scenes from the life of John the Baptist.

Pisano narrates the story in twenty episodes, each in a quatrefoil-shaped panel. The panels are arranged on the doors so as to "read" like the two pages of an open book, from left to right down the left door, and then the same down the right door—rather like an architectural illuminated manuscript. The left door begins with the announcement of the angel to John's aged father Zechariah that he and Elizabeth will bear a son, and concludes with the culminating scene of John's vocation: the baptism of Jesus. The right door presents the episodes leading to John's own death: his rebuke of Herod for marrying his brother's wife, John's imprisonment, Salome's dance, John's beheading, and the burial of his body by his disciples.

At the bottom of Pisano's doors, below the narrative panels, are two rows of four panels that function similarly to the lower zone in frescoed rooms, more subject to wear and tear from those entering and exiting. They contain decorative material that does not carry on the narrative but contributes something to the thematic frame of the story. In this case, female figures represent virtues (as in the floor-level zone in the chapel of the Scrovegni family in Padua, painted by Giotto). Here the virtues are a very traditional grouping of seven: the four *cardinal* virtues from classical tradition (prudence, justice, temperance, and fortitude) and the three theological virtues in Christian tradition from their source in 1 Corinthians 13: "faith, hope, and love, but the greatest of these is love." But what to do with the remaining fourth panel? The extra virtue chosen by Pisano (or by whomever may have been his advisors for the commission) was humility—perfectly appropriate as the virtue marking the man who said "as he grows greater, I must grow lesser" and "I am not worthy to untie the thongs of his sandals." In fact, the presence of this additional virtue perhaps prompts us to consider how the others, too, were exhibited in the character of John the Baptist, with courage to rebuke Herod after seeing the injustice of his marriage, with prudence to see the future fulfillment of his cousin as the Messiah awaited by the prophets of the past, with ultra-temperance in his manner of life.

In an obvious sense, the doors are *entry* doors. We enter our own Baptism through the Baptism of Christ. Pisano's doors are splendidly fashioned to frame the family's and community's ceremonial entry into the place where another of their children will be marked by the sacrament as one of Christ's own forever. At the same time, the doors are also *exit* doors. They frame the ceremonial action of the newly baptized now going out of the building, traversing the space between, welcomed to enter the cathedral as a new participant in the full life of sacraments and fellowship of the body of Christ.

Sixty years later in 1401, the cloth-finishers guild in charge of the upkeep and decoration of the baptistry announced a competition among artists skilled in bronze-casting for a new set of doors to be installed on the east side of the baptistry. (Pisano's doors would be moved to the south side, where they remain today.) The seven finalists seemed to have been boiled down to two, Brunelleschi and Ghiberti, with Ghiberti winning the commission (or receiving it by default when Brunelleschi left to study the architectural ruins of ancient Rome). It took Ghiberti twenty-one years to complete the project, creating scenes from the life of Christ—of course including the Baptism. Ghiberti followed Pisano's template, with twenty narrative scenes over eight panels at the bottom (the four Gospel writers above the four doctors of the church), using the same quatrefoil-shape squares for each scene. But Ghiberti turned Pisano's principle of arrangement upside down. Ghiberti's scenes move from bottom to top, with each row crossing both doors from left to right, beginning with the Annunciation and ending with Pentecost.

The discussions of modern art historians have focused primarily on the stylistic advances and daring of Ghiberti's work over Pisano's. Ghiberti increases the drama of scenes, with the action sometimes spilling out of the quatrefoil frame, using skill in perspective to give a sense of action receding back into space—all the marks, in other words, of the advent of the "Renaissance." With the doors acclaimed by all, bringing honor to Florence, the Calimala guild kept Ghiberti on the payroll to produce yet another set of doors, those that Michelangelo would consider worthy to serve as "the gates of Paradise."

With these doors, completed in 1452, twenty-seven years after beginning the project, Ghiberti broke with all the rules governing the previous two sets. He created ten much larger panels, dispensing with the quatrefoil shape, deftly arranging in each panel multiple episodes from an Old Testament narrative, moving chronologically from top to bottom, left to right. These included Creation and the Fall and Expulsion of Adam and Eve; the story of Cain murdering his brother Abel; the story of Noah and the Flood; Abraham's hosting the three angelic messengers under the oaks of Mamre

as well as the Sacrifice of Isaac; Esau and Jacob competing for their father Isaac's blessing; Joseph's dealings with his brothers who come to Egypt for food; Moses in Egypt; Joshua and the battle of Jericho; David's battle with Goliath; and Solomon receiving the visiting queen of Sheba.

This third set of doors was then given the featured place on the east side facing the Duomo façade, with Ghiberti's earlier Life of Christ doors moved to the north side. In one sense, with no theme or narrative directly related to baptism, Ghiberti's Old Testament doors may seem to run contrary to the purpose of the east doors to serve as both entrance (through the Baptism of Christ himself) and exit (having been prepared in Baptism for entry into the Church). In another sense, Ghiberti's doors may be seen as broadening the narrative scope of the sacrament of Baptism. In entering through Pisano's doors, new converts were entering into John the Baptist's story. In entering through Ghiberti's doors, new converts were entering into the grand sweep of God's saving work of his chosen people throughout history.

Whether the place of Baptism is a separate building facing the church or a font placed inside the door of the church, it is the door of the church that marks the believer's entrance into the "edifice of salvation" designed by God "as an architect would do" (in the phrase of St. Irenaeus cited by Verdon). Such a door deserves to be framed by a fitting façade.

Façade

The grand façades typical of the great cathedrals and churches of medieval and Renaissance Europe set the stage for the community's entrance into the house of God (the literal translation of *Duomo* from Italian) where they will encounter God in both word and sacrament. The design of the façade signals and helps to activate the appropriate demeanor—the proper attentiveness—of those about to participate in the liturgies that define the peculiar work of the people of God. To enter the cathedral is to join the company of saints, prophets, apostles, and evangelists figured, in many cases, in the sculptures on the façade. Typically the façade features the saint to whom the church is dedicated, or the sacred event or theological mystery which the church's particular work is to honor and remember. The decoration of the façade places the action of entering or exiting in a particular narrative or thematic context.

The façade of the Duomo in Orvieto, for example, is marked by several notable elements.* Complex geometric patterns in mosaic decorate even the columns and piers. Extending dramatically from the façade are four bronze statues of the creatures traditionally taken to represent the four evangelists (the eagle of John, the bull of Luke, the lion of Mark, and the

angel-man of Matthew, drawn from the images in Ezekiel 1:10 and Revelation 4:6–7). The outstretched talons of the eagle seem ready to pluck the one standing below. Placed in the arch immediately above the main portal is a marble statue of the Virgin Mary, with her child Jesus on her lap, revealed yet enclosed by a bronze-cast pavilion whose curtains are pulled back by three angels on either side. These three elements—the intimations of the shimmering glory of heaven in the mosaics, the fearfully awesome figures of the evangelists, the maternal warmth of the Mother of God in her tent—set us up for the grand yet human scale of the interior. I have often overheard residents and visitors alike trying to describe a sense of being embraced without loss of the majesty of the one who embraces.

The larger decorative programme of the façade is defined by two main elements, each fashioned in a distinct artistic medium. The architectural elements of the upper zone of the façade serve as frames for a series of scenes from Mary's life. The Annunciation is of course drawn from the gospel accounts of the birth of Jesus, while circumstances of her own birth and girlhood are drawn from the apocryphal gospels not recognized as part of the canon yet deeply rooted in Catholic imagination and devotion. Created in mosaic against a gold ground, these scenes become almost blindingly splendid when struck by the sun's rays in late afternoon. The central and highest scenes represent those Catholic doctrines of Mary as the model and forerunner of the Church, crowned by her Son, surrounded by shimmering rays of light in the triangle above the central portal.

In the lower zone, punctuating the entire width of the façade at ground level and framing the three doors, four wide marble pilasters are carved in bas-relief with scenes from scriptural narrative from Creation to Last Judgment. The sequence moves from left to right (as one faces the façade), with the scenes arranged chronologically from bottom to top in pairs that read from left to right.

On the left-most pilaster are scenes from the first chapters of Genesis: the story of the Creation (with God shaping the figure of Adam like a sculptor in clay, their two faces identical), the Temptation and Fall and Expulsion of Adam and Eve, concluding with Cain's murder of his brother Abel. At the top of the panel are two scenes, not so much narrative as thematic, of the origins of fruitful human enterprise: grammar, music, geometry. Although scholars and commentators labor to interpret these small panels exactly, they clearly represent the continued possibility of human making that expresses our status, however fallen, as image-bearers of a God who informs by his spirit the things that he makes of the earth.

To the right (framing the central portal), the second panel indisputably presents eighteen scenes from the prophetic books that point to the coming Messiah, but the exact references and their choice continue to

challenge scholars, residents, and tourists alike.[7] On the third panel (to the right side of the central door) are sixteen readily identifiable scenes from the life of Christ, but with a clear bias to the selection. Half are given to his birth and boyhood, from the Annunciation, Visitation, and Nativity to his Teaching in the Temple at age twelve; followed by scenes of Jesus's Baptism and Temptation that mark the beginning of his ministry. But then the sequence jumps—with nary a single scene from his years of teaching and preaching and miracle-working—to six scenes from Holy Week: from the Triumphal Entry to the scene where the resurrected Jesus, recognized by Mary Magdalene, says "Do not touch me." The proportional emphasis keeps us focused on the bodily life of Christ, born, crucified, resurrected—of a Word embodied in human flesh, not one who reveals the Father by word alone. And finally, the right-most pilaster is carved with the Last Judgment: the general resurrection of the dead from their tombs, the saved ascending toward Christ enthroned in majesty at the top of the panel, those who rejected Christ herded by demons downward to the place of wailing and gnashing of teeth. No disembodied souls but resurrected, or damned, bodies.

Framed by the four narratives on the pilasters, the statue of Mary over the enormous central door is readily seen in this same key. Protected yet revealed as the angels draw open the curtains of her tent or tabernacle, the virgin is highlighted as the vessel of the incarnation, in whose womb the Godhead clothed himself in human flesh and "dwelt among us"—as the King James Version translates the phrase that means "pitched his tent" or "tabernacled" among us.

In sum, the entire programme of the façade reminds those who enter that God did and does his work of Creation and Redemption by creating his image-bearers as bodies, by "taking the very nature of a servant, being made in human likeness . . . being found in appearance as a man, humbling himself by becoming obedient to death" (Phil. 2:6–8), enacting the new covenant through his own body and blood, and by raising resurrected bodies, not disembodied souls, into his eternal kingdom.

The façade, in fact, is in theological harmony with the special holy-day inaugurated from Orvieto itself in 1264 by Pope Urban IV: the Solemnity of the Body of Christ, *Corpus Christi* (or *Corpus Domini*). This holy-day—and the liturgies prepared for it by St. Thomas Aquinas—celebrates the sacrament of Holy Communion as reflecting every aspect of the mystery of the real presence of God who works by incarnation.

[7]Michael Taylor's doctoral dissertation entitled "The Iconography of the Façade Decoration of the Cathedral of Orvieto" (Princeton, 1969) remains the most thorough study.

Interestingly, the most recent element of the cathedral decoration—the enormous central doors commissioned in the 1960s from Emilio Greco—maintains the focus on a Word made flesh. The subject of these bronze relief panels is that of the seven works of corporal mercy: feeding the hungry, giving drink to the thirsty, clothing the naked, providing shelter for the homeless, caring for the sick, visiting those in prison, burying the dead.* The Church, as St. Paul emphasizes, is now the body of Christ in the world, a body made present to the world through the love shown by his followers in care and compassion. In a sense, Greco's panels mark the door not so much as entrance but as exit. Having received the body of Christ in the sacrament, the faithful now exit the church with their marching orders as the body of Christ sent out into the world "to do the work you have given us to do." (I have heard this theme highlighted several times by a recent beloved bishop of Orvieto, Padre Giovanni Scanavino.)

Private Family Chapels

I have already said something of the themes typical in the decoration along the main axis of the church from entrance to apse. The decoration invites the worshippers to experience their physical progress through the church as a condensed movement through the history of salvation, representing, in Timothy Verdon's phrase, "the entire history of the relationship between God and humankind, . . . a figure of that 'edifice of salvation' that St. Irenaeus believed God had designed 'as an architect would do.'"

Unusual to most modern visitors will be the small chapels that often line the sides of the nave and transepts of medieval-Renaissance Italian churches. These side chapels are the product of a social practice deeply rooted in Catholic Christendom of the period. Families with the financial means could take out a sort of long-term lease on a space in a church to use for private Masses, family events, and liturgies and often as the burial place for family members. Church architecture was adapted for the custom, often by creating a series of indented chapels around the interior walls of varying degrees of depth and separation from the public area of the church. The lease of these chapels, as well as the funds contributed to the clergy to offer private Masses on behalf of the family, provided a significant source of income for the church—whether parish church, cathedral, or the church of a monastic community.

This arrangement of allowing private family chapels on church property also served as a means of distributing the costs of decorating the entire church, since it was an expected responsibility of the families to commission the decoration of their own chapels. In fact, a notable proportion of paintings, both wall frescoes and altarpieces, now on any short list of masterworks of the Renaissance were commissioned and created for such pri-

vate chapels. Among these are a number of the artworks featured in the discussions in this book, such as the altarpiece and frescoes by Domenico Ghirlandaio in the private chapel of the Sassetti family in the monastery church of the Vallombrosian order, and Masaccio's and Masolino's frescoes in the private chapel of the Brancacci family in the monastery church of the Carmelite order in Florence.*

The highly purposeful decoration of family side chapels articulated the family's identity and memorialized its past. The decoration commonly featured the patron saints after which family members were named, who became models, keys to personal identity and calling. The family sought the patron saint's intercession on their behalf, often because the saint had a vocation like that of the family, or an experience the family could identify with.

To be sure, the motivations for contributing to the pious work of the church or monastery via the lease of a chapel could be as mixed as the motives behind the artistic decoration. Art in the Renaissance (just as it is nowadays among the wealthy collectors) served as an important currency of social prestige, for the demonstration of wealth, of turf, of cultural sophistication and political and economic power.

Two of the wealthiest banking families in Europe at the turn of the fourteenth century—the Bardi and Peruzzi—both sought the side chapels in the most prestigious location in the Franciscan church of Santa Croce in Florence, those immediately to the right of the altar. The Bardi family gained the chapel closest to the altar; the Peruzzi the one adjacent. But both hired the most prestigious Florentine artist of the time, the great Giotto, to fresco the walls of their chapels. We may be struck by the irony of exhibiting such concern for social standing in the church of the very monastic order founded by the one who divested himself of all concern for power and prestige for the sake of embracing Lady Poverty. I have earlier suggested such tension in the decoration of the Sassetti family chapel, where the patronage enjoyed by Francesco Sassetti from the Medici banking family is as prominently featured in the family chapel as the benefits received by the family through its spiritual patron, St. Francis.

As I've noted, the family chapels I have just mentioned are all located in monastic churches. Indeed, a significant proportion of the art during this period, including many of the signature masterpieces, was commissioned for some location in a monastery.

Monasteries

In fact, the enormous role played by monastic communities over many centuries not only in the production and use of art but in the society as a whole may be difficult for us moderns to imagine (perhaps especially for

those shaped by American Protestantism). From the sixth century on, the Benedictine-inspired network of monasteries held together the fragments of civil society during the long aftermath of the collapse of the Roman Empire. The monasteries modeled new forms of community life, grounded in scriptural values and virtues, that provided the ground for the recovery of towns—economically, socially, and spiritually.

The new peripatetic, outward-focused "mendicant" orders established by Dominic and Francis in the early thirteenth century spread like wildfire throughout Europe. New communities typically set up shop at the edges of towns, in the neighborhoods of the poor laborers and of those in need. With their schools, hospitals, orphanages, and hostels for those on pilgrimage, the monastic communities became major providers of social service, as we might say, as well as of pastoral and spiritual care. Monasteries were educational centers, seats of learning, preserving the intellectual traditions of the classical as well as the Christian world. The doctors of the church and most of the major figures of medieval scholastic and mystical theology were all members of monastic orders or closely associated with an order: Bernard of Clairvaux, Bonaventure, Aquinas, Hugh of St. Victor; Scholastica and Clare, Julian of Norwich, and Catherine of Siena, just to start a long list. What we know as the ancient universities of Europe began as monasteries, where the scholarly monks gave lectures.

Every town had its monasteries. The very bells of the monasteries, rung at regular intervals every day to call the monastic community together for the daily office, were the timekeepers of all peoples' lives. Various liturgies were open to the laity in the neighborhood; monasteries served as places of retreat, of confession. Laypeople who could not take on the vows of full membership in the order could still adapt the rhythms and purpose of their own lives to that of the local monastic community, becoming "third order" members.

In appreciation for their services, and in support of their various missions, the monastic orders were the recipients of bequests and financial gifts—the beneficiaries of "charitable contributions," as we say now. Monasteries and abbeys often became immensely wealthy in land and buildings and expendable funds, exercising enormous influence in the political and economic lives of the towns. Yes, the irony that orders bound by the vow of poverty and grounded in humble withdrawal from worldly concerns and desires could become major players in worldly governance was not lost. But these contexts give sense to the close association of local families with their neighborhood monastery, and helps explain why an influential if largely behind-the-scenes business and civic leader such as Cosimo de Medici would pour enormous funds into reconstructing a monastery in his family's neighborhood, and lobby the pope to bring in a group of notably earnest activist and reform-minded Dominicans to inhabit it.

In terms of this chapter's topic, most of my readers will have to exercise their historical imagination to capture some sense of the gravitational pull exercised by the monasteries both through their work and mission in the community, and through their physical presence as beacons, or orientation markers, in the architectural fabric of the town. By the fourteenth and fifteenth centuries, the physical and psychological coordinates of the city of Florence, for example, were established by the Dominican monastery of Santa Maria Novella and the Franciscan monastery of Santa Croce at the west and east ends, and by monasteries of San Marco and Santo Spirito at the north and south corners of the city, with San Miniato guarding the city from its perch across the river Arno. Generations of Orvietani in cliff-top Orvieto spoke of the "ring" (*annello*) of eight monasteries situated at intervals around the edge of the cliff, felt to be the sentinels, guard towers, places of prayer, and markers of protection for the town.

Cloisters

In the traditional layout of a monastic property, the church, the chapter house, the guest house, the refectory, and the dormitory on the floor above were organized around a central cloister or garden, which was surrounded by a covered walkway. The cloister was the hub, and members of the community walked these covered walkways many times a day, thousands of times during their residence in the monastery. On the courtyard side, these porticos would be open to the elements, but the protected back walls were commonly decorated with subject matter that lent itself to sections and sequence, taken in while passing back and forth on foot. Typical might be scenes from the life of the founder that provided a constant reminder of the original motivations that called their order into existence.

The cloister of the abbey of Monte Oliveto in southern Tuscany provides a typical and instructive example. The origins of the Olivetan order date to 1313, when Bernardo Tolomei, a prominent lawyer of a wealthy Sienese family, experienced a profound spiritual conversion and left behind the worldly life of power and prestige to become a hermit in a wooded spur of the dune-like landscape of eroded clay south of Siena. Others were inspired by his example, and within a few years the hermit found himself head of a Benedictine-inspired new order. Nearly two centuries later, the artists Sodoma and Luca Signorelli shared in the commission to fresco scenes from the vastly influential biography of Benedict written around 600 (less than a century after Benedict's death) by Pope Gregory the Great.*

Sodoma completed three of the four walls—first, second, and fourth in terms of the chronology of Benedict's life; Signorelli the third—but

the exact dating and sequence of each artist's work remains inconclusive. While their styles are notably different, the two artists clearly worked with a shared plan for selecting episodes from the source text. The scenes frescoed in each of the arched sections determined by the architecture of the cloister begin at the beginning of Gregory's *Life of Benedict* and take up just about every episode, in order. Modern tourists, serious enough to walk around the cloister with the *Life of Benedict* in hand, may justifiably conclude that the short shrift given to representation of later episodes in Benedict's life is simply a matter of the artist having run out of wall space, yet there's no reason to suppose that the progress of the painters' work matches the chronology of the episodes in the life.

To modern readers unfamiliar with the early Christian genre of hagiography—biographies of the saints that give high profile to the miraculous deeds of those more perfect in faith and sanctification—Gregory's *Life of Benedict* may come across as an overloaded string of often peculiar miracles. The miracles are there in the frescoed cloister of Monte Oliveto.* But Sodoma's and Signorelli's visual narrative focuses not so much on the melodrama of the action as on the character of the people involved. As in Gregory's *Life*, the action concerns the moral and spiritual discernment exercised by Abbot Benedict in his care of souls. Making the sign of the cross, he breaks a goblet of poisoned wine offered him by a group of monks who are resisting the yoke of the disciplined life under his care. But the focus of Sodoma's scene is on the faces of the monks, and Benedict's discernment of their insincere and recalcitrant hearts beneath the mask of false obedience. A similar action occurs in the side of the cloister painted by Signorelli when Benedict discerns the false identity of a "double" sent by Totilla, king of the Goths, to test the man of God. In another place, Abbot Benedict discerns that the inattention of a young monk at daily prayers is caused not by hardness of heart but by the harassment of a demon. And so on. Sodoma's and Signorelli's visual presentation of Abbot Benedict is entirely in keeping with the attention given to the responsibilities of abbots in the *Rule* composed by St. Benedict for the ordering of community life (especially in chapter two):

> They should reflect on what a difficult and demanding task they have accepted, namely that of guiding souls and serving the needs of so many different characters; gentle encouragement will be needed for one, strong rebukes for another, rational persuasion for another, according to the character and intelligence of each. It is the task of the superiors to adapt with sympathetic understanding to the needs of each.[8]

[8]Quoted from a translation of the *Rule* in contemporary English by Patrick Barry, in *The Benedictine Handbook* (Collegeville, MN: Liturgical Press, 2003), 18.

The care and discernment of good abbots like Benedict nurture the growth of the entire community into the full stature of Christ, shaping the community as a "school of conversion" (in Benedict's phrase). In the conclusion of his Life of Benedict, Pope Gregory adds that "Anyone who wishes to know more about his life and character can discover in his *Rule* exactly what he was like as an abbot, for his life could not have differed from his teaching" (chapter thirty-six).

One could well argue that for the monks passing back and forth under the gaze of these frescoes, the exhortative lesson of the cycle is to offer a daily reminder that transparency is everything, that to the discerning eye of the abbot (as to the Heavenly Father), *all hearts are open, all desires known, and no secrets are hid.* And, as depicted in so many of the scenes, the exhortation comes with the good news that humility and penitence brings not judgment but compassion and forgiveness.

Last Suppers in Monastery Dining Halls

Most of us have been habituated (if only by countless reproductions of Leonardo da Vinci's famous composition) to the conventional pictorial arrangement of the Last Supper.* The disciples are arranged on the outer side of the table, Jesus sits in the center, and Judas is very often seated alone on the opposite side of the table. If we look at photographs that crop the scene out of context, or even if we view such paintings *in situ* but with a museum gaze amidst other tourists, we may never realize that this seating arrangement imitates that of the monastic communities gathered in the refectory for their meals.

The seating arrangement had the practical purpose of assisting efficiency of serving and promoting undistracted focus on the sacred literature typically read during mealtimes, often from a pulpit-like niche placed high on the side wall. But the new skill of perspectival drawing developed in the Renaissance allowed the *trompe l'oeil* effect—the visual fiction—of making the painted wall appear to be an extension of the actual space. The effect, of course, is to transform the dining hall into an extended Last Supper, placing the monks or nuns themselves "in the place" of the disciples. The devotional intent is to invite every meal to be partaken in response to Jesus's final discourse.

In describing how Leonardo's Last Supper creates "the illusion of a spacious hall that seems to continue the real space of the friars' dining hall," Timothy Verdon cites a handbook of the Dominican order from 1505 that describes the typical rite of entrance into the refectory. When the friars have entered the refectory, "they should genuflect before the cross or the image painted where they have gathered, and, making the sign of the cross, seat

themselves at the table." The image painted on the wall, comments Verdon, "would have given a deep meaning to an action apparently ordinary . . . giving a religious sense to the act of eating, inviting those at table to read into their meal a spiritual significance beyond the physical action as giving not only sustenance to the body but sustaining the interior life."[9]

The Decoration of Chapter Houses

Another purpose-specific room typically found in the architectural design of monasteries was the so-called chapter house. Here, the community gathered regularly for exhortation and encouragement from the abbot or abbess, and to make decisions about matters concerning the whole community—to set the agenda and maintain the focus on their mission, as we might say. The importance of such meetings is underlined in the *Rule of St. Benedict*, and in fact the origin of the name comes from the custom in Benedictine monasticism of reading in these meetings a "chapter" from the *Rule*. These spaces, too, were richly and purposefully decorated. The Crucifixion was the common subject for the principal wall, as well as something that reminded the gathered monks or nuns of their order's mission.

The chapter house in the Dominican monastery of Santa Maria Novella in Florence exemplifies this pattern.[10] Each of the four walls in this large cube of a hall takes up a key theme.* Entering from the cloister, one faces the Crucifixion, a scene with additional resonance for the Dominican order—the "order of *preachers*"—for whom St. Paul's "we preach Christ crucified" gives the marching orders. The wall is large enough to allow the artist, Andrea di Bonaiuto, to include the entire cast of characters from the Gospel accounts. Christ's "way of the cross" to Calvary is illustrated on the left side of the wall, and in the bottom right corner is depicted the so-called Harrowing of Hell, the episode between Christ's death and resurrection which the phrase in the Apostles' Creed, "he descended into hell," obliges us to imagine.[11]

[9] Timothy Verdon, *Attraverso il Velo: Come leggere un'immagine sacra* (Milan: Ancora, 2007), 47, 51–53: ". . . la parete di fondo del refettorio con l'illusione di una stanza spaziosa . . . sembra continuare lo spazio reale della sala da pranzo dei frati." . . . "E quando sono in mezzo al refettorio, devono fare un inchino alla croce o all'immagine dipinta ivi collocata, e, fatto il segno della croce, devono andare a sedere a tavola." . . . La "croce o immagine dipinta" nel refettorio, . . . doveva riportare al senso profondo di un'azione apparentemente ordinaria. . . . [p. 52] la croce o immagine dipinta sulla parete del refettorio dava un senso religioso all'atto di mangiare, invitando i commensali a leggere nel pasto un significato spirituale oltre quello fisico: non solo sostentamento del corpo, ma sostegno della vita interiore" (translation mine).

[10] The room is now typically referred to as the Spanish Chapel for its use in the sixteenth century by the Spanish community for private devotions.

[11] The Harrowing of Hell and its origins are discussed more fully in chapter nine.

The frescoes on the walls on either side of the Crucifixion work as a pair. The defining work of the Dominicans is as preachers and teachers; their mission is to defend the faithful against the attacks of heretics. Hence the aptness of the decoration on one wall, where the entire educational program necessary to fulfill their calling is laid out in diagrammatic fashion—a sort of visual course catalog, one might say, for what we would think of as a seminary education nowadays.

At the apex of the fresco sits the greatest of the order's intellectual giants, St. Thomas Aquinas.[12] Winged figures representing the theological virtues of faith, hope, and love, source of divine wisdom, are depicted over his head, with figures of the four cardinal virtues of classical tradition (prudence, justice, temperance, and fortitude) below them. Three heretics crouch at his feet, their arguments defeated. On either side of Thomas sit the great teachers from the Old and New Testaments: Moses, David, Solomon, Isaiah, Job, the Gospel writers, and St. Paul.

Below, to the viewer's right, seated in stalls rather like those in the choir area of a monastery chapel, are seated female figures representing the seven liberal arts (the *trivium* of grammar, logic, and rhetoric, and the *quadrivium* of arithmetic, music, geometry, and astronomy, the grounding skills of the curriculum of the university). To the viewer's left are figures representing what we might think of as the training received at seminary.[13] Seated below each of these fourteen arts and sciences involved in the training of a well-equipped Dominican teacher and preacher is a famous practitioner from the past, a reminder of the ancient grounding of the discipline.[14] The scene of Pentecost in the section of the vaulting directly above the fresco places the mission of the Dominicans in the context of the founding of the church, while suggesting that effective preaching and teaching comes not by human intellectual argumentation alone but through the Holy Spirit.

On the opposite wall is an allegorical narrative of the vocation of the Dominicans, of putting that education into practice. Modern scholars still fuss over the interpretation of various aspects, but the gist is clear enough,

[12] The book held open by St. Thomas, likely the Book of Wisdom, is inscribed with the verse *"Optavi, et datus est mihi sensus: et invocavi, et venit in me Spriritus sapientiae, et preposui illam regnis et sedibus"* (Wisdom 7:7–8: "And so I prayed, and understanding was given me; I entreated, and the spirit of Wisdom came to me. I esteemed her more than scepters and thrones; compared with her, I held riches as nothing.").

[13] This curriculum includes civil and canon (or church) law, philosophy, Scripture, theology, contemplation, and preaching.

[14] Priscian the grammarian, Cicero the rhetorician, Aristotle for logic, and so forth: Tubalcain, Ptolemy, Euclid, and Pythagoras; Justinian, Aristotle, Jerome, Dionysius the Areopagite, and Augustine, among them.

and the narrative movement signposted by visual signals. The viewer's eye is led in a big reversed-Z pattern that begins at the bottom left with a line-up of civil and religious authorities seated in front of a cathedral, clearly that of Florence itself. The scenes at the bottom right feature the three great Dominican saints, Dominic himself plus two great thirteenth-century Dominicans, St. Peter Martyr and St. Thomas Aquinas, engaged in convincing the unconverted, teaching the faithful, and refuting the heresies that threaten the flock.[15] Thus placed on the pathway toward heaven, and equipped to pass by the threats and temptations met along the way, the faithful make their way up and across toward St. Peter's Gate.

The entrance wall—viewed of course by the friars as they *exit*—features the life of an inspirational hero of the order from the mid-thirteenth century, Peter of Verona. Peter was a great defender of orthodox Catholic doctrine, particularly against the Cathar heresy—a contemporary form of gnostic dualism incompatible with the doctrine of the incarnation. For opposing it, Peter was axed in the head by a hired Cathar assassin on the road to Milan (hence becoming "Peter the Martyr").

The decoration of the chapter house offers a rich condensation of all three of those principal *works* or powers of art often cited during the period: to inform and instruct, to remind and memorialize, to inspire and motivate.

As this rich presence of art typically found throughout the monastery would suggest, the monastic communities believed as keenly as anyone in the efficacy of art in lining up hearts and bodies for the "work of the people" performed in a particular space, exerting shape and pressure on the appropriate actions of instructing, remembering, honoring, exhorting, praising, praying, singing, contemplating, and eating.

Confraternity "Club Houses"

Monasteries were a principal, but not the only, place of charitable care for those in need.

During the Middle Ages, a network of what we might call social-religious clubs provided the chief means for laypeople to engage in a wide variety of pious works of mercy. Called *confraternities*, these voluntary associations operated outside the ecclesiastical system of church governance but required approval by the church hierarchy. The confraternities eventually became thoroughly interwoven into the social fabric.

[15] Black-and-white hounds chase away wolves at the bottom of the scene in a visual pun: the Dominicans, protectors of the sheep of the Great Shepherd, and clothed in their habit of a white robe under a black cloak, were, in Italian, the "*dominicani*," a perfect homonym for "the dogs of the Lord."

Each confraternity had a particular mission, and these were remarkably diverse, everything from providing dowries for orphaned girls, caring for the sick, serving as the equivalent of today's ambulance corps (of which they were the origin), and burying the dead. Some were defined by devotion for the proper celebration of a particular holy-day in the church year (reenacting the journey of the Magi on Epiphany, for instance), or for a particular aspect of pious devotion, to the sacrament or the rosary, for example, or for particular practices of penitence, such as the confraternities of the flagellants. Some were dedicated to the performance of sacred dramas that brought the events of the liturgical year out of the formal church space into the streets and piazzas of the populace. Other confraternities provided care and solidarity for fellow members of a particular ethnic immigrant population of a city. And so forth.

A confraternity typically looked to a particular patron saint whose life provided a model and inspiration for its own purpose. A confraternity with the mission of tending to the sick, especially during times of widespread illness from communicable diseases like the plague, might look to St. Roche (*San Rocco*), known for his selfless care for the sick and for the power of his prayers or touch to heal. One of the six major (and well-funded) confraternities in Venice, called the Grande Scuole, was dedicated to San Rocco.

Some confraternities were highly class conscious, such as those of Venice, with their elite membership among the wealthy merchant class. The membership of others crossed the divisions of social class.

Confraternity members experienced solidarity and fellowship certainly while performing the particular social or religious tasks of their mission, but also through the liturgical activities enacted in their own chapels, celebrating, for instance, the saint's day of their patron saint. But a sense of belonging to a community also came through the socializing, the planning of events, the appointment of officers, the care for equipment, and so forth at the association's regular meetings throughout the year.

Indeed, the medieval confraternities are the origins of the network of organizations, now generally in decline, such as the Lions and Kiwanis clubs, the Knights of Columbus and the Shriners orders, volunteer fire and ambulance departments, and societies like St. Jude who raise support for those with particular diseases and raise funds for their cure.

We might see the confraternities as providing a different way of structuring the same activities diversified differently in the Christian subcultures of our own day: fellowship groups, parachurch organizations, outreach and service through organizations like World Vision or Cure International or Doctors without Borders, the teams of church volunteers who run soup kitchens or provide Saturday morning breakfasts served up at the church, and so on.

But why have the confraternities received a section in a book about who made art work in premodern Europe?

The confraternities, like everyone else in the period, looked to art for providing inspiration to do their work, for memorializing their founders or heroes, even for self-promotion in the larger community. And what we might call their *club houses* were another major site of purposeful and well-funded decoration, commissioned to the finest artists the confraternity could afford. The palatial headquarters of the confraternity of San Rocco in Venice, for instance, on which no expense was spared, would mark the most extravagant end of the spectrum with its acres of immense canvases by Tintoretto.

Timothy Verdon describes the role of art in the confraternity's life of prayer and devotion in the building of the Confraternity of Mercy in Florence:

> In addition to various charitable activities, the members of this confraternity in effect dedicated themselves to prayer, and the ground level of their head-quarters had an oratory with a portico open to the street, at the corner be-tween Cathedral Square and the main city street connecting Cathedral Square and Piazza della Signoria, the square of the town hall. Thus for those coming from the town hall, the porch of the confraternity's oratory marked the pas-sage from the civic to the spiritual center of Florence—to the square where the old baptistery and the (then) new cathedral stood. . . .

He goes on to elaborate,

> This way of looking at it—the Confraternity of Mercy as a portal connecting the world of power, on one side, with the world of faith, on the other—helps us grasp the function of this edifice and the character of the association that built it. Together with the oratory and meeting rooms, the new structure con-tained a hospice for abandoned children on the upper floor; a fresco done in 1386 for the exterior of the building (now inside) shows the confraternity's captains (directors) entrusting abandoned children to women paid to look after them. A second fresco, in the main meeting room, evokes the group's other activities: the care of the sick and burial of the dead, suggested by twelve scenes from the life of Tobias, the biblical personage who, notwithstanding an official prohibition, gave religious burial to his Hebrew brethren during the Babylonian exile.
>
> But the masterpiece of this iconographic program is the fresco of the *Madonna of Mercy* with the men and women of the confraternity in prayer. At the center is Mary, clothed in a cope and with a headpiece that looks like a bishop's mitre, as if she were that *sacerdotissa justitiae* of whom Saint An-toninus Pierozzi would speak in the fifteenth century—a "priestess of social justice" with a ministry to the needy.
>
> The ministry is illustrated in roundels adorning the border of her cope, where the seven works of corporal mercy are represented. And around this

figure of Mary, as if she were speaking to us, are words that describe these works: *visito, poto, cibo, redimo, tego, colligo, condo*. On behalf of the confraternity, that is, Mary says: "I visit the lonely, feed the hungry, and give to drink to the thirsty, ransom prisoners, give a roof to the homeless."[16]

Verdon's example illustrates the job of the artworks to help orient those in the space mentally, physically, and spiritually—in fact, the members of the confraternity are depicted *in* the fresco itself. The decoration instructs the members in the works of corporal mercy, reminding them of exemplars in the past in a way clearly intended to inspire them to do likewise. The work of the artist was to line up their hearts and bodies for the "work of the people" performed in that space; to exert shape and pressure on the appropriate actions of their confraternity.

Meeting Rooms in Town Halls

Siena's town hall, the Palazzo Pubblico, was constructed in the late 1290s to serve not only as the seat of its republican government but as the focal point of the city. Its soaring tower punctuates the profile of the city seen from the surrounding countryside; the central piazza fans out from its central portal. Built during the same decade, the cathedral serves as the other pole and pivot of the life and identity of the Comune (the word for town as political entity). As was typical in town halls of the epoch, every square inch of its walls is frescoed with scenes that promoted "the beauty, harmony and honor of the republic," and, in the appreciative phrase of one official, are "a delight to the eye, a joy to the heart, and a pleasure to all the senses."[17]

One of the most notable frescoes in the Palazzo Pubblico provides another clear example of the pressure exerted by the decoration on the action performed under its "eye." The so-called Allegory of Good and Bad Government was frescoed in the late 1330s by Ambrogio Lorenzetti on the walls of a committee conference room. The *Sala dei Nove* was the meeting room of nine "good and lawful merchants" who served brief two-month terms as a sort of central executive committee in the town government structure in place from 1287 to 1355. They represented a distillation of the large Council of Three Hundred that met in the adjacent great hall. There, the main wall was frescoed with an image of the Virgin in Majesty, seated under a ceremonial canopy and surrounded by saints, a masterwork of another notable Sienese painter of the period, Simone Martini. Presiding, as

[16] Verdon, *Art and Prayer*, 66, 70.

[17] Randolph Starn, *Ambrogio Lorenzetti: The Palazzo Pubblico, Siena* (New York: George Braziller, 1994), 12.

it were, over the meetings of the three hundred, this imposing figure of Mary reminds these representatives of the people that theirs was the "city of the Virgin." (Inscribed on the shield held by the central figure in the adjacent *Sala dei Nove* is the phrase, "The Virgin protects Siena, which she has long marked for Favor.")

The programme of the frescoes in the meeting room of the nine unfolds in two mirroring sequences around three of the four walls of the council chamber.* (The windowed fourth wall looks out over the countryside.) The narrow but principal wall opposite the windowed wall establishes the theme and serves as focal point, with a precisely ordered but asymmetrical arrangement of symbolic figures, each clearly identified by a caption. The largest figure, off-center to the right, represents the city of Siena as a Commonwealth whose governors ought to be ever concerned with the common good. Winged figures over this male figure's head are labeled as the three so-called theological virtues of Faith, Hope, and Charity—the latter in the highest central position as "the greatest" of the three in St. Paul's account in 1 Corinthians 13. Seated by threes on either side of the main figure are female figures that contemporary folk would have identified immediately as the four so-called cardinal virtues from classical tradition—Prudence, Justice, Temperance, and Fortitude—along with an additional two of Humility and Magnanimity (the virtue emphasized in the tradition deriving from Aristotle's *Ethics* as a generosity for the public good). The second largest figure commands the left side of the wall: the female figure of Justice, with the winged figure of Wisdom over her head, and ropes from her two scales twined together in the hand of the female figure of Concord below her. Figures of the twenty-four town councilmen take up this cord as they walk in pairs toward the seated Commonweal, around whose wrist the rope of Concord is tied.

In my brief discussion here, I will not offer an explanation of the possible sources of this programme of virtues and how it hangs together conceptually. I only need to underline how these frescoes create the entire architectural surrounding for the Council of Nine deliberations. The system of interlocking virtues clearly identifies the motivating ideas and ideals that must be on the minds and tongues and hearts of those who govern if there is any hope of fostering a truly *common* commonweal. In fact, the important lessons are not left to deduction or speculation. Banners and border areas are filled with explanatory statements, as this, for example:

> This holy Virtue [of Justice], wherever she rules, induces to unity the many souls [of citizens], and they, gathered together for such a purpose, make the Common Good their Lord; and he, in order to govern his state, chooses never to turn his eyes from the resplendent faces of the Virtues who sit around him. Therefore to him in triumph are offered taxes, tributes, and lordship of towns;

therefore, without war, every civic result duly follows—useful, necessary, and pleasurable.[18]

The long wall adjacent to this allegorical presentation of the virtues of good government presents the wholesome effects of such good governing for the sake of the common good, first inside the walls of the city and then in the countryside governed by the Comune. An angel in the sky above the countryside holds a banner that says: "Without fear every man may travel freely and each may till and sow, so long as this commune shall maintain this lady [Justice] sovereign, for she has stripped the wicked of all power."

The inverse rule of Bad Government, when the common good is despised as each individual looks out for his own interests, is treated on the opposite long wall. The same three elements, although occupying a third less wall space, unfold in mirrored relation to the Good Government walls. An arrangement of vices around the central figure, labeled as "Tyrannus," leads to a crumbling and violent cityscape, with a countryside laid waste outside the walls. The chief lessons are written around the border in banners held by the guardian angel-demon:

> There, where Justice is bound, no one is ever in accord for the Common Good, nor pulls the cord [i.e., of civic concord] straight; therefore, it is fitting that Tyranny prevails. She, in order to carry out her iniquity, neither wills nor acts in disaccord with the filthy nature of the Vices, who are shown here conjoined with her . . . Because each seeks only his own good, in this city Justice is subjected to Tyranny; wherefore along this road nobody passes without fearing for his life, since there are robberies outside and inside the city gates.[19]

I have described this visual pattern of arranging two parallel sequences (even if inversely parallel) from a common starting point as mirror-like. In the Siena town hall, the starting point—the visual hinge—is the corner of the end wall from which extend the allegorized concepts, then the cityscape, then the landscape of the two contrasting towns. The pattern is a common one in the art of the age; I have noted it in the Brancacci Chapel, for instance. If one were to follow the pattern from either of its outside endpoints, then we see a sequence of elements repeated in reverse order, C-B-A-A-B-C.

The rhetorical term for this pattern is *chiasmus*. (The pattern is exhibited, for a modern example, in John F. Kennedy's memorable phrase "Ask not what your country can do for you, but what you can do for your country.") A fancy word nowadays, it was one of many such stylistic strategies commonly learned in rhetoric, one of the basic subjects in the *trivium*

[18] Ibid., 100.
[19] Ibid., 99, 100.

(grammar, logic, rhetoric) of the liberal arts curriculum of schools. In fact, this very curriculum is laid out in labeled medallions along the decorative border at the bottom of the Good Government side. Educational training allowed folk at the time to spot and to expect common patterns in both verbal and visual design—a sort of visual rhetoric. Remember Alberti's advice, cited earlier, that "artists should associate with poets and *orators who have many embellishments in common with painters*."[20]

The exhortational purpose of Lorenzetti's frescoes is everywhere transparent, not arcane; everything is labeled. But neither is the programme of these frescoes unsophisticated. They draw on what Quentin Skinner identifies as the "pre/early humanist treatises" that would have been available to educated town leaders, but which applied the classical framework of Aristotle's and Cicero's treatises on government and civic duty in a new (post-scholastic) Christian-humanistic interpretive key.[21]

My point here is that the *chiasmus*-form of the murals shapes the experience of the architecture of the room. As the Council of Nine sits at its table in the middle, the walls wrap around the councilors, holding them sandwich-like in the embrace of the two arms. The final scenes of the two opposite countrysides lead to the window that looks out over the actual countryside. Which is it going to be: desolate or fruitful?

Libraries

The walls of libraries were not covered floor to ceiling by bookshelves in this age before Gutenberg. The hand-copied manuscripts were kept safely in cabinets. The walls were typically available for decoration directly relevant to the theme of the room. The Piccolomini library, accessed directly from the nave of the Siena Duomo, honored the city's most significant native son of the fifteenth century, Aeneas Silvius Piccolomini, the humanist scholar from a wealthy noble family who took on the name Pius when elected Pope in the late 1450s. The painter Pinturicchio was commissioned to fresco the walls with scenes from Pius's life.*

One of the most oft-reproduced and still-fascinating masterworks of Italian Renaissance art is Raphael's so-called School of Athens, with its staging of the cast of great thinkers of ancient Greece in various huddles around the central figures of Plato and Aristotle. Reproductions and notes

[20] This sensitivity is explored in Michael Baxandall's fine book, *Giotto and the Orators* (Oxford: Clarendon Press, 1971).

[21] Quentin Skinner's two masterful essays on the frescoes, "Ambrogio Lorenzetti and the portrayal of virtuous government" and "Ambrogio Lorenzetti on the power and glory of republics" are found in *Visions of Politics: Volume 2; Renaissance Virtues* (Cambridge: Cambridge University Press, 2002), 39–117.

in tourist guidebooks almost always isolate the painting from its *in situ* context, namely, in a cube-proportioned room that was one of a linked suite of rooms reconfigured by Pope Julius II as his private apartment—this room as the library.[22] The scene of the philosophers is one of four wall murals clearly operating as a single coordinated unit.

The frescoed decoration of the ceiling and the four walls can be understood to serve the very useful purpose as a sort of visual card catalog for the four main sections of the Pontif's collection: theology, literature, law, and philosophy. The complex ideas developed visually in the mural of the great intellects of ancient Greece are apprehended only in relation to the opposite wall—that of Theology, where the focus (and perspectival focal point) is on the wafer of the Host displayed on the altar, the Eucharist as the sacrament of the real presence of the invisible God in the visible person of Christ.

Although the wall given to Theology picked up the misleading title of the *Disputà* (meaning discussion rather than argument), the opposing frescoes do dramatize one of the principal intellectual debates of the age: whether the dualistic language of eternal form and contingent matter found in the Hellenistic heritage can ever do justice to revealed Christian theology. We might say that Raphael's frescoes themselves provide the prompt for the central job of the Christian humanist scholars of the age: namely, to determine whether the intellectual heritage of Athens can or cannot provide an adequate framework for understanding and explaining the central dogmas of Christian faith, of the heritage of Jerusalem. Although modern interpretation of these immensely sophisticated frescos is itself a *disputà*, a credible position is that they do dramatize a conclusion to the debate, namely, that the "disputes" of the Greek philosophers are finally unable to overcome dualities. They can only point to the true merger of body and spirit, human and divine, in the Incarnate Christ and in the sacrament of this *hypostatic* union in the Eucharist itself.

Public Fountains

As a final example of how artistic decoration helped those working in a space to remember their purpose and to feel the significance of their work, I turn to a place with overtly utilitarian purpose: the public fountains commonly located in some central civic location in premodern towns. Such

[22]The room is now referred to as the *Stanza della Segnatura*, so-called since the mid-sixteenth century when it was used by the highest court of the Vatican—for which use Raphael's decoration remained thematically relevant, given the wall dedicated to the theme of Law.

public wells were of course the source of water for daily needs in an age when most of human labor was under the direct influence of seasons, of the "elements" of earth and sky and water and fire. Fountains were the daily gathering places for neighborly gossip, and conversation about seasonal conditions and activities experienced collectively in their annual cycles.

But they were typically sites of significant decoration, commissioned to skilled artisans and artists. Siena's Fonte Gaia, carved by the greatest Sienese sculptor of his generation, Jacopo della Quercia, stands at the apex of the scallop-shell-shaped piazza in the town center that slopes down to its focal point in the town hall at the bottom center-point.* The series of bas-relief panels placed in niches around the sides provides daily reminders for the gathered citizens both of the legendary civic origins of their city (namely, as founded by the son of Remus, Senius, who fled Rome after Remus was murdered by his twin brother Romulus) and of the origin of their toil in the Temptation, Fall, and Expulsion from Eden of our first parents Adam and Eve.

And yet the main central panels present the Virgin Mary, patron and protectress of Siena and bearer of the Second Adam, surrounded by figures of the seven cardinal and theological virtues. The perseverance born of courage, the temperate use of the products of the earth and their just distribution for the needs of the whole community, generous care for those without means of sustenance, and so forth: these represent the virtues of character, some cultivated by human will and others by divine grace and mercy, by which human labor is restored to dignity in the age of grace and sanctification.

The lesson of these beautifully-crafted sculptures is clearly similar to that found on the first pilaster on the Orvieto cathedral. There, as we've seen, the labor of Adam and Eve and their children and descendants, expelled from Eden for their disobedience, is clearly the result of the Fall. And yet, still bearing the image of their Creator, humans continue to exhibit the inventiveness of a godly intellect, strengthened by the virtues of the will, in creating arts and sciences of worth and dignity.[23]

The lesson is developed to fullest possible extent in the remarkable public fountain in Perugia, placed in the open piazza exactly between town hall and cathedral and punctuating the long wide boulevard which serves as the axis of the town. Sculpted bas-relief panels encircle the entire foun-

[23] This view is amplified in contemporary treatises such as the widely known and stupendously long *Speculum Maius* (The Great Mirror) by the Dominican friar Vincent of Beauvais: "*Manual labor delivers man from the necessities to which since the Fall his body is subject, while Instruction delivers him from the ignorance which has weighed down his soul*" (from Book 1 of the *Speculum doctrinale*, I, ix).

tain on two levels, representing a sort of ideal model of the decorative art-work typical in fountain. The work of Fra Bevignate of Cigoli, the panels form a sort of civic clock of the cosmos, a visual encyclopedia (or farmer's almanac) of the annual cycles of work and time.

The scenes on the lower basin of the fountain unfold in three parts. Framing the whole are scenes of the fall and the Expulsion of Adam and Eve from Eden, followed by other culture-shaping labor from scriptural and classical history such as Samson overcoming the lion and then sleeping with Delilah, David killing Goliath, and Romulus and Remus hunting with falcons while waiting for a sign from the gods about where to lay the foundations of Rome. Then follows a fascinating series of twelve diptychs, one for each month and correlated with the signs of the zodiac. Each pair features the labors of the farmer (along with his wife or friend) typical of that month of the season: sitting around the fire in January, fishing in February, pruning the vines in March, reaping the wheat in June, threshing it in July, crushing the grapes in September, casking the wine in October, and slaughtering the fattened pig in December. A thread through the whole is the laborious process of making bread and wine, perhaps locating the labors of humans with the fundamental elements transformed into the body and blood of Christ in the Eucharist. The third section represents the labors of the intellect presented through the liberal arts and philosophy.

In short, gathered around the fountain, the community is helped to experience the down-to-earth labors of daily life in a cosmos-sized framework of moralized purpose, located squarely in God's grand scheme of salvation history. Timothy Verdon spoke of the portico of the confraternity in Florence as a "portal connecting the world of power . . . with the world of faith."[24] The fountain in Perugia, poised between town hall and cathedral, serves as a meeting point of the two spheres of the community's life—the water supplied by civic government for the common good is brought into the same frame of reference as the water of eternal life supplied through the sacraments of Christian faith.

The purpose of part one of the book, The Place of Architecture, is to show how the *work* of the artwork was to clarify and remind and inspire the *work* of the particular community gathered in the space designed for that work. In the first chapter, I outlined a variety of ways in which the artistic decoration of a space is answerable to the physical facts of the space. (You can't put a fountain where there's no source of water.) I suggested that the excellence of the artwork was measured in part by how the artist fitted the artwork to its *in situ* circumstances, able to turn constraints into opportunities.

[24] Verdon, *Art and Prayer*, 70.

In this chapter, I have given a variety of illustrations of how both architecture and artistic decoration were answerable to traditions of use by the communities that built the buildings and designed the space. The purpose of the artworks commissioned for these places was to exert pressure on the particular actions housed in these places, whether of instructing, remembering, honoring, exhorting, praising, praying, singing, contemplating, eating, legislating, and so forth.

3

ART SHAPING ARCHITECTURE

In this final chapter of part one, we reverse the direction of influence, focusing not on how the physical and historical space shaped the art, but on how art shaped the experience of the space by those who did their work within it. We continue to consider how artworks themselves operated as spatial and architectural entities, designed by the artist to guide the viewer's eye up and down or back and forth across walls. The artwork itself, like good architecture, moves the "viewer" through the space in order to reach certain conclusions about the themes or ends of the narrative.

A simple yet subtle fresco depicting the Last Supper offers a window into the topic. The painting is found in one of the friars' rooms in the dormitory on the upper floor of the Dominican monastery of San Marco in Florence. This is the monastery entirely renovated in the 1440s through the generous financial support of the neighborhood's leading citizen, Cosimo de Medici. Cosimo pulled strings to have the earnest friars from the Reformed Dominican community in nearby Fiesole transferred to San Marco. One of these transferred friars was the order's gifted painter, Fra Angelico.

Fra Angelico and his workshop assistants painted small frescoes in each cell of the dormitory that wraps around three sides of the cloister. The Last Supper in one of them covers much of the wall whose window looks out over the cloister.* The windows painted in the wall of the Upper Room are identical to and in perfect visual continuity with the actual window in the room and with the windows across the cloister directly visible through the actual window in the cell. The effect is to create the illusion that the space and action of the event of the Last Supper is continuous with the space of the friar or lay brother sojourning in the cell. The architectural space of the painted room in the fresco forever modifies how someone in the room experiences the space of the cell and performs his private devotions.

We may marvel at the rapidly-mastered skill of the fifteenth-century painters for using the mathematical techniques of perspective to create a sense of three-dimensional space. But a modern formalist focus on paintings as self-contained units can blind us from seeing how painters used this

technique not only to create illusory space inside the frame of the painting, but to create a seamless visual fabric between painting and actual space. The painting opens up to the actual space of the room. When we crop a painting in a photograph, even to admire its fictional window-like quality, we can rob it of its purpose to relate the depicted scene to the surroundings, to erase the "frame."

Just down the stairs from Fra Angelico's small Last Supper is another Last Supper, this one frescoed by Domenico Ghirlandaio on the end-wall of the friars' dining hall.* In fact, this is one of two Last Suppers painted in the 1480s by Ghirlandaio and his *bottega* in the refectories of two monasteries in Florence. The other is in the Franciscan Monastery of Ognissanti (All Saints) down along the river Arno. A quick look at photographs of these two Last Suppers gives the impression that they are almost identical, surely following the same template. But the patterned tile floors are tilted, or foreshortened, at different angles. Why? Simply to stand *in situ* in these dining halls gives the answer. Ghirlandaio was adjusting the recession into space to the actual dimensions and height of the viewing angle; the San Marco refectory is shorter than that of the Ognissanti. The perspectival recession of space is coordinated with spatial experience of those moving through and around the actual dining hall.

Yes, the painter's rendering of the fictive space made it answerable to the actual space. But we might say this in reverse as well: the artist used his skill to render the actual space and the actions performed in it as answerable to what was happening in the painting. It is the architectural place created by the painting that transforms the "mere dining hall" into a place where the community's meals, day after day, are devotionally and theologically identified as "Last Suppers."

Brancacci Chapel

To explore further the ways in which art shapes the experience of architecture, I return to an example discussed in chapter one, the chapel of the Brancacci family in Florence, painted jointly by Masolino and Masaccio. The paintings on the pilasters that frame the entrance to the chapel also frame our experience of the entire chapel. They set up expectations for a parallelism between the two sides of the room.

The Temptation and Expulsion are depicted in the top half of the pillars—Adam and Eve in and out of Eden. Directly below them, but reversing the order of in and out, are scenes of Peter inside prison and being let of prison. Together, the scenes introduce the visual matter of the chapel's decoration, and also introduce the likely visual pattern of parallelism between scenes on opposite walls throughout the chapel.*

Since Peter exits into freedom while Adam and Eve exit out of freedom and into bondage, the scenes also keep us alert for other thematic patterns of inversion evoked by side-to-side symmetry and parallelism. To describe the experience of art in these terms may sound strange nowadays, living as we do in a period of cultural history when artists and their viewers no longer operate with a shared repertory of patterns of visual design. What Michael Baxandall describes as the "period eye" is the shared habits of visual training that shape *Art and Experience in Fifteenth-Century Italy,* as Baxandall's influential book is titled.

Given the training of that period's eye to look back and forth, or almost instinctively to compare the endpoints of symmetrical or *chiasmus* patterns, we may suppose that most people in the 1420s would have quickly spotted the parallels in the two large scenes that fill the lower level of the side walls in the Brancacci Chapel.* Depicted on the left side (facing the altar) is the scene of Peter raising Theophilus's son, and on the right the contest of power between Peter and Simon Magus (the magician mentioned in Acts 8 as offering to buy the spiritual power he envies in Peter) before Nero.[1]

Each fresco unfolds in three visual components, moving in parallel fashion from back entrance wall toward the altar. First, a ruler enthroned, (second) beholding an action performed in front of him, and (third) exercising judgment on the one performing that action.

Theophilus, king of Antioch, watches Peter bring the king's dead son back to life through the power of Christ. Moved to belief, Theophilus honors this man with godlike powers by lifting up Peter on a throne-like chair (painted to appear rather two-dimensional like a tapestry). The line of witnesses standing in a concave curve behind the scene of the son's resurrection is reversed to a convex curve of witnesses facing Peter in his throne.[2] Some of these admirers are clothed in the habits of the Carmelite order in whose monastery church the chapel stands.

[1] When Simon saw that the Spirit was given at the laying on of the apostles' hands, he offered them money and said, "Give me also this ability so that everyone on whom I lay my hands may receive the Holy Spirit." Peter answered: "May your money perish with you, because you thought you could buy the gift of God with money! You have no part or share in this ministry, because your heart is not right before God.

[2] My attention to convex and concave forms follows fifteenth-century usage and attentiveness to geometric form. In his treatise *On Painting*, for example, Leon Battista Alberti describes in painstaking detail the geometry of concave spherical surfaces and the effects of concavity on the reception of light, concluding his discussion of spherical forms with the statement, "I want us to be convinced that he alone will be an excellent painter who has learned thoroughly so to understand the outlines and all the properties of surfaces" (London: Penguin Books, 1991), 39, 44, 59.

On the right wall, the sequence is repeated. Nero sits in his imperial throne beholding, with unjust bias, the competition between his own magician Simon and the apostle Peter to see whose god has the most power. Peter's victory is indicated by the broken idol at his feet. In response to which, Nero orders Peter to be lifted up, not on a chair of admiration but on a cross of humiliation. Peter is nailed upside down on the cross at his own request (according to the apocryphal account in the Acts of Peter): "Crucify me head downwards, for I am not worthy to die as my master died."[3] The three-part sequence in the design of each fresco is clear: king / action / result.

The parallel disposition of the sequence places Peter's crucifixion directly opposite his enthronement. Nothing remarkably sophisticated or arcane is required of the viewer to observe the thematic inversions of Peter's two rewards. The image of Peter crucified upside down serves as a sort of visual concentration of all the moments of upside-down-ness in the fresco.

These scenes on the lower sections of the side walls exhibit an obvious parallelism in their three-part arrangement. But there are scenes above them, and in these it is the absence of any obvious visual parallels that strikes the eye, at least at first glance.

The scene on the top of the left wall, directly above the Raising of Theophilus's Son, is drawn from the episode in Matthew 17 concerning the obligation of paying the temple tax, The Tribute Money. Like the Expulsion, The Tribute Money is all too often cropped in photographic reproductions as an example of the new three-dimensionality and emotional expressiveness that marks the Renaissance in general, highlighting its singular worth in art history but cancelling out the resonances set up by the painting's relationship with the other elements of the chapel.

Particularly admired is Masaccio's treatment of the clump of figures in the center, depicted not in the house-setting of Matthew's account but outdoors in a deep and rather barren mountainous landscape, the lake at the left, the façade of a building at the right edge. The three-dimensionality bestowed by Masaccio on the tightly packed group creates a kind of visual thickness (we might say) at the center of the panel. Masaccio's treatment of the episode marks as secondary the two episodes relegated to the right and left edges of the panel: Peter drawing the coin out of the fish's mouth, and Peter putting the tax into the hand of the collector.

Described in these terms of visual geometry, the panel on the top of the opposite wall is the precise obverse of The Tribute Money in its design. Here Masaccio places two episodes—recorded in the Acts of the Apostles

[3] The Acts of Peter is available online; the citation here is from the New Advent website, a rich archive of texts from the early church and church fathers: http://www.newadvent.org/fathers/0815.htm

as occurring in two different cities at two different times—on opposite sides of a single Florentine street.

On the left is the healing of the crippled man described in Acts 3:1–10, to whose begging for money at the door of the temple in Jerusalem Peter responds, "Silver and gold have I none; but such as I have give I thee: In the name of Jesus Christ of Nazareth rise up and walk." On the right side of the panel is a depiction of Peter raising Tabitha from the dead in an upper room of a house in Joppa, recounted in Acts 9:36–41.[4]

Masaccio takes liberties with the source by placing the scene not in an upper room but at street level, with Tabitha's friends beholding the miracle, rather than being sent away as they are in the original story. Is there a reason why the fresco brings the miraculous raising of Tabitha down to the streetside across from the raising up of the crippled man, putting these two episodes in particular into the same thematic, as well as visual, frame of reference?

Both scenes concern money, or more precisely, what money can't buy. With no money in his pocket, Peter freely gives the crippled beggar the priceless gift of healing through the power of Christ. Tabitha uses the money from selling her woven cloth to "help the poor." The choice of the cloth-making Tabitha references the trade of the Brancacci family itself, whose financial success in the silk industry made it one of the wealthiest families of the city.

The visually thick sections of the panel are thus on the edges, whereas the visually thin part—the open space of the street and piazza behind it—is in the center. Yet precisely in this center Masaccio has placed two elegant men dressed in the highest and most expensive fashion of the time, one with a cloak and the other with a hat made from the sort of richly brocaded silk purveyed by the Brancacci.* The empty space around them accentuates their central position, activating the training of the period eye to expect the most important figures in the center of the painting's stage.

[4]In Joppa there was a disciple named Tabitha (in Greek her name is Dorcas); she was always doing good and helping the poor. About that time she became sick and died, and her body was washed and placed in an upstairs room. Lydda was near Joppa; so when the disciples heard that Peter was in Lydda, they sent two men to him and urged him, "Please come at once!" Peter went with them, and when he arrived he was taken upstairs to the room. All the widows stood around him, crying and showing him the robes and other clothing that Dorcas had made while she was still with them. Peter sent them all out of the room; then he got down on his knees and prayed. Turning toward the dead woman, he said, "Tabitha, get up." She opened her eyes, and seeing Peter she sat up. He took her by the hand and helped her to her feet. Then he called for the believers, especially the widows, and presented her to them alive.

Masaccio's deft design of the scene is, as we might say nowadays, socio-logically spot-on. The beggars, the old women, are relegated to the edges of our status-focused social vision. We focus in on the stylish wealthy folk (like the cameras following the celebrities in their designer gowns emerg-ing from their limos on Oscar night). The faces of the two men are turned in on themselves, perhaps interpretable innocently enough as being en-gaged in conversation. But when does the viewer, responding consciously or not to the visual strategies activated by skilled artists, sense the irony that these two fellows, looking very cool (sure to have caught the eye of *The Sartorialist*), are so self-absorbed that they are oblivious to the two remark-able miracles occurring on either side: a crippled man being lifted to his feet and a dead woman rising from her cot to new life?

We can see the possible themes emerging: absorption with worldly pres-tige blinds us both to the needs of the poor around us and to the miraculous power of a Christ who heals the crippled, raises the dead, and gives sight to the blind—all with no money passing hands at all. Or, said inversely, pre-cisely as the design of the panel in fact draws our eyes away from the center toward the truly momentous actions occurring at the edges, so the center recedes, becomes empty, offering nothing to hold the eye except for the fas-cination with *haute couture*. Our sociological and ethical focus is changed, our values turned inside out, our social hierarchies turned upside down.

The concave shape of the whole panel inversely mirrors the convex form of The Tribute Money on the opposite side of the room. The two walls, we might say, spoon one another to give two sides of the same lesson. The temple tax—like the taxes owed to Caesar (or the luxury tax applied even in Renaissance Florence)—may be payable in the kingdoms of this world, but in the kingdom of heaven money has no currency at all. And this kingdom is already at work among us, acting through those who can say "gold and silver have I none, but what I have I give to you. In the name of Jesus Christ, rise." Peter and Tabitha are ministers in that kingdom. Simon Magus is not.

The artists at work in the Brancacci Chapel knew how to bring opposite walls or vertical layers into visual and thematic relation to each other, and to alert the viewers to pay attention to these visual parallels as clues to the les-sons of the whole. The conversation set up between walls allows the scenes on each wall to *say* more than if each stood alone as a self-contained unit.

These strategies of visual design were used skillfully and intentionally by medieval and Renaissance Italian artists, and shared between artists and their publics. Habituated by the exercise of the "period eye," audiences could quickly spot the parallel three-part sequences between Theophilus and Nero in the Brancacci Chapel, or the parallel lives between Moses and Jesus across the walls of the Sistine Chapel, or the inverse parallels between the Damned and the Elect in Luca Signorelli's frescoes in the San Brizio Chapel.

Piero della Francesca and the Legend of the Holy Cross

How highly skilled artists could shape the viewers' experience of the architectural space by choreographing their experience of the painted space is demonstrated masterfully by Piero della Francesca in the fresco cycle covering the apse in the Franciscan church of San Francesco in Arezzo. Narrating the Legend of the Holy Cross (the story of the journey from the wood of the tree of our Fall from the garden of Eden to the "tree" of our redemption on Calvary), Piero arranges the scenes using the same technique of parallel design used in the Brancacci chapel, creating links between panels on opposite sides of the walls. Every panel speaks across space to its opposite.

Two battle scenes are placed across from each another on the bottom layer on the walls.* Yet through another convex/concave pairing like the one we saw in Masaccio's work in the Brancacci Chapel, a chaotic mass of soldiers and horses overfills the center of the left panel, while on the right panel, the two warring factions are separated by a serene meadow through which the river recedes deeply into the distance. Highlighted against the visual background of the meadow, Constantine holds up a small white cross at whose power the enemy takes flight.

The panels directly above the battle scenes feature the two great women of the narrative: the queen of Sheba (in the era before Christ) and Empress Helena (in the era after Christ). The panels mirror each other in arrangement. Each panel depicts two episodes; each episode is given half of the space, with one episode in the countryside and the other in a setting defined by architectural elements. Yet the overall space of each panel feels contiguous; no painted frame separates the episodes.

Both frescoes painted on the arched areas at the top of each wall are visually punctuated by trees. The lower scenes on either side of the window on the east wall depict two Annunciations: angels appearing to Mary and to Constantine with momentous news. When looking at the entire space with eyes attentive only to form, one gets a strong sense of walls mirroring one another from top to bottom.

But the Legend of the Cross is clearly a *story* with a single narrative trajectory (terms we will explore in more detail in part three of this book). Through a linked sequence of episodes, it traces the varied peregrinations (that is, pilgrimages or journeys) of the tree that marked the Fall of humankind in Eden *and* the redemption of the world from sin on the cross.[5]

[5] The story is celebrated in two summer holy-days in the church year, organizing the plot around the two pivotal episodes of the Finding of the Cross and the Exaltation of the Cross.

Because of St. Francis's devotion to the cross, the Legend of the Cross entered deeply into the imagination of the order he founded.[6] The Franciscan-oriented folk who gathered for Mass in the Church of San Francesco in Arezzo would have been completely familiar with the plot, and with the numerous variations among the versions collated in *The Golden Legend*, Jacobus de Voragine's compendium of sources for the church year.

Thus we can imagine anyone looking at Piero della Francesca's cycle of frescoes for the first time making a quick scan to orient himself, seeing where the story began and where it ended, which episodes were included and highlighted, picking up the directional cues for moving the eyes. I have suggested that the parallelism, the mirroring, between sides would have quickly announced itself. But where does the story begin?

The initial episode is narrated at the top of the right wall: the scenes of the death of Adam and of the angel telling Seth that healing will come but not for many, many years. Given the cultural training at the time in basic conventional types of arrangement of scenes we might imagine the medieval Italian viewer taking a split second to check out whether the story follows one of those typical patterns of arrangement, namely, a big U-pattern of "reading" down one wall and up the opposite. A quick glance at the second panel down: yes, the next stage of the story, scenes concerning King Solomon and the queen of Sheba. Confirm the pattern by looking at the top of the left wall. Yes, clearly the concluding episode of the return of the stolen cross to Jerusalem.[7]

To continue dramatizing the experience of a Franciscan in 1450 when the fresco cycle was unveiled and put to work, imagine that, having seen these first two episodes, we are comfortably ready to "follow the story." We look down to the bottom panel on the right side for what will almost certainly be the next episode, chronologically. As people familiar with Voragine's account of the story, we could expect Solomon's burial of the wood, or, skipping that, perhaps Constantine's dream of the cross. Precisely at this point in the spatial unfolding of the narrative, our expectations are foiled. What we find is the scene of Constantine defeating his enemy—at least two steps ahead in the narrative.

[6]The two major fresco cycles depicting the legend are both in the apses of Franciscan churches: Piero's in Arezzo and Agnolo Gaddi's earlier cycle in Santa Croce in Florence.

[7]The principal study of the standard patterns of arranging the episodes in narrative fresco cycles is Marilyn Aronberg Lavin's *The Place of Narrative: Mural Decoration in Italian Churches, 431–1600* (Chicago: University of Chicago Press, 1990). My discussion of Piero's Legend of the Holy Cross is indebted to Lavin's treatment (167–92).

We begin to glance about, hunting for the next scene. We find it: the men burying the beam at Solomon's order, but over on the altar wall on the same level as the Solomon and Sheba scenes. The predicted and predictable order has been disrupted. We are momentarily confused as to where to move our eyes next. The beam itself, raised at a forty-five-degree angle by the laborers struggling to slide it down into the pit, points diagonally down and to our left, perhaps directing our eyes to a scene on the opposite side of the east-wall window: clearly that of the Annunciation. Surprisingly, the Annunciation is not even mentioned in the source accounts of the story that we would know.

By now we realize that the artist has both activated a typical arrangement for a story and subverted it. We have to engage in a more active search, using what clues may be provided, to follow the narrative as it unfolds around the walls of the apse.* Their parallel right-angle structure links the Annunciation with another annunciation, that of the angel appearing to Constantine in a dream with a cross in hand, back across to the right side of the window (an episode occurring three hundred years later). Then back to the left and up a level is the scene of the Jew who knows where the cross is buried being drawn out of the dry well, now ready to divulge the information to Empress Helena. Then the narrative goes straight around the corner to Helena's finding of the cross. Then down to the Christian emperor Heraclius defeating (two centuries later) the wicked king Chosroes, who had stolen the cross from Jerusalem. Then a final jump of the eyes two levels up to the Exaltation of the Cross upon its return to Jerusalem—the concluding episode of the Legend.

The story ends (in space) where we expected it, but via a visual journey rendered entirely unpredictable; a journey whose course follows none of the standard patterns of visual storytelling customary at the time. The sequence of events is not laid out in the patterns shared by artists and their publics in Renaissance Italy.

But here's the clincher—which cropped photographs in books train us *not* to see. And here we have to mention to readers what is obvious from the get-go to people visiting the fresco cycle *in situ*. The Legend of the True Cross unfolds in the space behind the altar, above which hangs a stupendous cross. Instead of a U-pattern that would have led the eyes of those in the nave to cross over from right wall to left wall under the great hanging cross, Piero's expectation-disturbing design forces the viewer's eyes to cross over the cross no fewer than three times (and never under or above or around) in the course of following the sequence of images that make up the Legend. That is, one cannot "read" this visual story of the cross's peregrinations through history without crossing the cross.

In fact, the one episode not narrated in the Legend of the Cross itself is the climax of the story in "real time and history"; namely, the Crucifixion.

Piero incorporates the object that defines the space and defines the Mass performed there into his own painted narrative.

The question, of course, is why did Piero (working with his advisors?) activate a common visual pattern of organizing a story and then upset the pattern? Is Piero toying with the viewer (a proto-modernist who takes pleasure in overthrowing conventions rather than abiding by them)? Did he allow the visual pleasure of spatial mirroring to override logical sequence through time? Or is this precisely a visual strategy for making a point, of *doing theology* (as we might say)?[8]

Every episode in the written Legend of the Holy Cross is an upsetting of expectations, involving God's foiling of human intention, only to accomplish that intention in a completely unexpected and wildly alternative manner.[9] In every episode of Piero's visual telling of the Legend, the pride of men, and their intention to control history, is undone by the cross. For instance, Piero leaves out an episode of the beam-that-refuses-to-cooperate with Solomon in order to highlight the wisdom of a woman, Sheba, and the foolishness of the wisest man in the world. The episodes of the Legend are like pearls on the string that leads from the old Adam to the new Adam. The Second Adam undoes the prideful act of disobedience by the First Adam through the humiliating act of obedience on the cross—which in the topsy-turvy divine economy becomes the glory of the one crucified.

The theology of the cross given visual form in this fresco cycle is that God accomplishes his ends through upending worldly expectations. Piero's strategy is, in part, to involve the viewer in a process of Solomon-like frustration; the beam refuses to be placed where the builders put it. In Piero's

[8] The cross, of course, does turn topsy-turvy the conventional notions of justice, of power, of reason. It is, as St. Paul writes to the Corinthians, a scandal to the Jews and an absurdity to the Greeks. "But we preach Christ crucified: a stumbling block to Jews and foolishness to Gentiles" (1 Cor. 1:23). Marilyn Aronberg Lavin addresses the "'out of order' order" of Piero's purposeful arrangement of episodes, but gives more attention to its political and cultural implications than for a theology of the cross (see *Place of Narrative*, 188–92).

[9] The episodes of the original story proceed as follows: the dying Adam sends Seth to ask God for the oil of mercy that could save his life; God's delayed response is not to provide an oil of mercy for just one man but a chalice of blood with the power to heal all of Adam's progeny who are willing to drink it. Every effort of Solomon to use the beam to build his country palace house (or the temple in other versions) is strangely subverted, only for the beam to become the beam that holds up the body of the true temple so that all who look to that beam become living bodily temples of the Holy Spirit. Constantine supposes that the symbol of the cross will give him power to defeat his enemy in battle, but the cross effects the victory through no power of Constantine at all. Chosroes tries to become like God by gaining the cross, which becomes the very instrument of his undoing.

visualized Legend, all things, all movement, finally point to the cross: not only the fulcrum of salvation history unfolding (if one has eyes to see) through historical time, but also the hinge of our visual experience of the space of the apse, seen from the nave.

The use of visual design to tell the story is the specific topic of the later chapter on the place of narrative. Here, note that the guiding of the eye across and around the space of the chapel purposefully defines the space as a crossing back and forth through the hanging cross on which Christ hangs. The apse becomes the space, we might say, of the great *chiasmus* (which means *cross pattern*) of God's design on history.

In medieval and Renaissance Italy, art completely choreographs the experience of architectural space, or, we might even say, it *creates* our experience of space. Artists like Masaccio and Masolino and Piero della Francesca use all the tools and skills of their trade not simply to illustrate the story but to move us through it in as physical a way as the elements of good architecture move us through the space of a well-designed building. Space and time are placed in dynamic play. Parallels across space invite thematic reflection; sequential movements around the space suggest narrative sequence, the plot of a story. The work of the artist is to transform architectural space into the place of liturgy, the place of narrative—the places addressed in the following sections of this book.

Part II

The Place of Liturgy

4

The Community at Work and Worship

During the several centuries that provide the historical reference point of this book, the vast majority of artworks did their work as elements of a liturgy. For the moment I use the word *liturgy* to indicate a rite or ceremony performed together by a group of people according to a well-established script, but as we go forward I will want to activate the ancient sense of liturgy as "the work of the people."

The many paintings and sculptures used in the celebration of the sacraments of Holy Communion in the Mass or Baptism, for example, would never have come to exist except for the *liturgy* of these sacraments. They were of course visually present in people's lives outside an actual performance of the liturgy of Baptism, perhaps admired for their beauty and high craftsmanship, and certainly evoking rich memories among families who for generations had been baptized, married, and buried in settings marked by such artworks. But the artworks would have been understood as serving the purpose for which they were made only while they were being used for the action of baptizing, of reenacting the Last Supper, and so forth.

Hence we can speak of the *place of the liturgy* as the place of the *work* of art. We can say that artworks were commissioned and created for the purpose of assisting a particular group of people in doing some work, or taking some action, central to their sense of identity and mission.

The Installation of a New Altarpiece in the Siena Cathedral

A window into the place of liturgy in medieval and Renaissance society, and the role of art in a richly liturgical culture, is provided by an account from the fourteenth century of the installation of one of the great masterworks of European art in its appointed place.

In 1311, the local Sienese artist Duccio completed a commission begun three years earlier: an enormous painting of the Virgin Mary seated on an elaborately decorated throne-like chair, with young Jesus sitting upright on her lap, and a company of saints surrounded them. The back of this panel

was itself painted with the story of Christ's passion and resurrection, from the triumphal entry into Jerusalem to his meeting with the two disciples on the road to Emmaus, in no fewer than twenty-six individual scenes.* The church and town authorities declared a holy-day so that the entire town could participate in the celebratory procession of the painting from Duccio's workshop to its intended place on the high altar in the cathedral. A contemporary chronicler describes the scene:

> At this time the altarpiece for the high altar was finished, and the picture which was called the "Madonna with the large eyes," or Our Lady of Grace, that now hangs over the altar of St. Boniface, was taken down. Now this Our Lady was she who had hearkened to the people of Siena when the Florentines were routed at Monte Aperto [the battle of Montaperti in 1260], and her place was changed because the new one was made, which is far more beautiful and devout and larger, and is painted on the back with the stories of the Old and New Testaments. And on the day that it was carried to the Duomo the shops were shut, and the bishop conducted a great and devout company of priests and friars in solemn procession, accompanied by the nine *signori*, and all the officers of the commune, and all the people, and one after another the worthiest with lighted candles in their hands took places near the picture, and behind came the women and children with great devotion. And they accompanied the said picture up to the Duomo, making the procession around the Campo, as is the custom, all the bells ringing joyously, out of reverence for so noble a picture as is this. And this picture Duccio di Niccolo the painter made and it was made in the house of the Miciatti outide the [city] gate. . . . And all that day they stood in prayer with great almsgiving for poor persons, praying God and His Mother, who is our advocate, to defend us by their infinite mercy from every adversity and all evil, and keep us from the hands of traitors and of the enemies of Siena.[1]

We talk about art appreciation, but surely it is unusual to read about a time and a place when a work of art could be so appreciated, so honored that the installation of "so noble a picture as this" could prompt a town-wide celebration with "all the bells ringing joyously." Present society offers no parallels.

What can we note about this description?

Someone with a sociological eye might notice the presence of medieval social hierarchy in the ordering of the procession: "conducted" by the bishop and clergy and religious, followed by the leaders of government, the chief town Council of Nine and the officers of the Comune, and behind them "all the people" down to the women and children. But the account also testifies to a society in which every group within the community was included in the use and value of art in their collective life.

[1] John T. Paoletti and Gary M. Radke, *Art in Renaissance Italy* (New York: Harry N. Abrams, 1997), 96, quoted from Charles Eliot Norton, *Historical Studies of Church-Building in the Middle Ages* (New York: Harper & Brothers, 1880), 144–45.

And how unusual for us is the connection between the celebratory procession of a treasured object and the acts of mercy—"great almsgiving for poor persons"—that it prompted. (The image given in our time of the "unveiling" of an important artist's work on opening night at the gallery is more one of waiters circulating with trays of champagne for the well-heeled guests—those who have enough money to become collectors.)

Nor was the installation a matter of hiring the moving crew to pull the truck up to the delivery door in the back of the building and lug the painting into the church. We're talking not about a light-weight canvas strung on a wooden frame but about a panel seven feet high and thirteen feet wide constructed from substantial boards, whose frame was itself an intricately carved masterpiece of the joiner's and wood-carver's arts.

What is described is a procession that, far from taking this immense and heavy object the shortest distance from point A to point B, deliberately winds its way through town so that every neighborhood can be marked by its presence, processing around the perimeter of the central public square, which would have been the symbolic and actual gathering point of the entire citizenry, a piazza whose focal point is the town hall.

This description helps us imagine a work of art designed for a precise spot, atop the high altar, but whose *in situ* influence was felt in every square foot of the town. Imagine the kid standing outside his own house watching the enormous painting being carried by, gaining thereby the bodily sense of connection between his neighborhood and the altar in the Duomo. (He could always say, "I remember the day when. . . .")

One might wonder whether many in the procession or along the way felt a parallel between carrying this altarpiece, weighty with significance, to its final resting place and the story of David joyously accompanying the tabernacle to the temple. Or of the inverse parallel between this joyously solemn procession of a panel decorated with the Way of the Cross on the back side and the grievously solemn procession to Golgotha of the one who bore the cross.

In fact, it is possible that an apparent error in this contemporary account describes the panel as "painted on the back with the stories of the Old and New Testaments" when it is only painted with scenes from the story of Christ, reflects the broadly-trained habit, engrained through the liturgy and the lectionary and the visual art together, to seek and find parallels between episodes in the Old Testament, New Testament, and contemporary life—a "typological" eye whose history and training will be explored in detail in the next chapter.

We can also note that the chronicler of the procession demonstrates what we might call "aesthetic consciousness" in naming three aspects of the comparative excellence among works of art. The previous painting of

the Madonna "was changed because the new one was made, which is far more *beautiful* and *devout* and *larger*." Neither we nor the scholars will be able to extrapolate from this phrase an exact sense of what the writer might mean by "beauty," or what might be meant in describing a painting as "devout," or why "larger" implies being better. Nevertheless, the fact that the writer comfortably joins these terms together is notable, and we can offer some reflections.

Our own "supersize me" age may lead us to suppose that "larger" expresses the value that bigger is always better, and there is evidence that size mattered to the Sienese in a similar way. Siena's was the first of several enormous cathedrals built in the thirteenth century in central Italy, with those in Florence and Orvieto coming later. Apparently the even larger cathedral constructed by archrival Florence was a contributing factor in the "supersizing" scheme of the Sienese to build an even larger nave stretching out perpendicularly from the existing structure, thus changing the existing nave into the transept. Before the project was completed it was clear that the Sienese had overreached themselves. Engineers warned that the structure was too large for the landmass on one of the town's ridges to bear, and the project came to an abrupt and permanent halt when the Great Plague of 1348 struck.

Generally in the period, however, the value of size was a matter of the relative proportion among all the elements and the fittingness of any one element to the whole. One can readily imagine how the "Madonna with the large eyes" (painted long before the new cathedral was built), beloved by the populace as it was, would have been dwarfed by the space and comprehensible only to those standing nearby. The virtue of the larger scale of the new altarpiece would thus be in its more appropriate proportion to its architectural context. The new painting was of a size to command the space it was to occupy, large enough to be seen and to exercise its effect from anywhere in the nave.

Clarifying a Few Doctrinal Distinctions

For readers of this book who bring an earnest Protestant set of concerns about art created entirely in and for a Catholic Christendom, I can imagine two features of this description giving doctrinal pause.

First, the apparent association of the *painting* of the "Madonna with the large eyes" with Mary *herself*—"she who had hearkened to the people of Siena"—might suggest an idolatrous equation of a created artifact with the power and presence of the divine. This very issue led to the iconoclastic breaking of images by impassioned early communities of Reform

throughout Europe. Secondly, the phrasing may suggest that Mary herself was the agent of the divine power, in this case, to defeat the Florentines in battle—an example of a Mariolatry that sets up Mary alongside Jesus as agent herself of our salvation and care.

Certainly the description, and the altarpiece itself, reflects the pervasive presence of the figure of Mary in the faith of the age, especially in popular piety—this is another aspect of its typicality. But we can clarify a couple of possible misconceptions.

That "our Lady who hearkened to us" is not strictly identified with a particular painting is evident if "her place" can be "changed" to a new painting. That is, the painting itself is not understood to bear power, but rather represents the one who has power. But what is the power of Mary, as suggested in the account?

The chronicler says that "All that day" the people were "praying God and His Mother, *who is our advocate.*" Mary-as-advocate identifies her as the intercessor on our behalf before God (and not as the one who herself has power to defeat the Florentines). The doctrinal rub concerns intercession.

Few church communities or individual Christians even nowadays question the injunction that we should intercede on behalf of one another in prayer. We openly beseech God to protect, heal, deliver, and bless those whom we set before him in prayer. But how we understand the efficacy of such advocacy, or whether the prayers of some have more efficacy than those of others, or—as concerns Mary—whether those who have gone before us are in a condition of continuing that action of intercession (or vice versa, whether the living can continue to intercede for the dead): these are matters of doctrinal difference and division.

Nor does the writer's judgment that Duccio's painting is a better painting ("*more* beautiful and devout and larger") imply that the new painting will be any more effective than the old one in arousing the Virgin Mary's advocacy on our behalf. That is, the one prayed *to* is not more or less inclined to action on our behalf by the aesthetic quality of the artwork. Rather, the likelier sense is that the chronicler, thinking in categories typical of his time, is supposing artistic excellence to be a factor in focusing the prayers of those praying, in rendering more fully appropriate the attitude of the one praying or worshipping. And in this *work* of art, some artworks can be said to be better or worse than others in instructing, reminding, and inspiring those who behold them. This may be the sense in which we are to understand how a painting can be "devout," and one painting more "devout" than another.

Pope Gregory's response to an image-breaking bishop (often cited in the medieval period) is relevant: "You, brother, should have *both preserved the images and prohibited the people from adoring them* so that those who

are ignorant of letters might have the means of gathering a knowledge of history and that people might in no way sin by adoring a picture."[2] Gregory's defense of images is that their capacity to teach about the true faith is precisely what can keep people from an idolatrous worship of the image itself.

These issues are important for understanding the role of artworks in liturgy. The paintings on or behind the altar play an important and powerful role in making Jesus or the Trinity or the Virgin or a beloved saint present to us (or of helping us make ourselves present to God) as we perform the sacramental actions focused on the altar.

A third aspect of the chronicler's focus on Mary which may be discordant to believers in our own time is its reflection of the "inseparable connections between civic and religious life in European cities during the Middle Ages and Renaissance."[3]

Siena represents an extreme case of a Marian devotion that took on a civic dimension. The cathedral was dedicated to her; hence the inevitability of a Marian-focused decoration, beginning with the altar. Only a couple years after Duccio's altarpiece was installed in the cathedral, the other great Sienese painter of the period, Simone Martini, frescoed Siena's other great Maestà in the *sala* of the town hall where the Council of the five hundred met.

Even the visual story of Jesus's Passion on the back of Duccio's altarpiece has a strongly political bent, with eleven of the twenty-six panels narrating every episode of the tossing of Jesus like a hot potato between four religious and political leaders: Ananias, Caiaphas, Herod, Pilate.

This civic dimension of Mary in Sienese consciousness is reflected in how the chronicler focuses on Mary's intercession on behalf not of individuals but of the body politic: ". . . keep us from the hands of traitors and of the enemies of Siena." The description, that is, locates the work of the altarpiece in the realm of the collective community rather than in the place of private devotion. (That individual identity was experienced in this epoch through one's membership in a collective familial, social, civic whole is a theme of this chapter, since the place of liturgy is always the place of community gathered to do its defining work, as we will see.)

As unusual as this mutual permeation of religious and civic life may be in contemporary Western society, the point relevant for this book is that Christian faith was free and expected to have a place in the various arenas

[2] Gesa Elsbeth Thiessen, ed., *Theological Aesthetics, A Reader* (Grand Rapids, MI: Eerdmans, 2004), 47.

[3] Paoletti and Radke, *Art in Renaissance Italy*, 96, commenting on the contemporary account of the procession of the Maestà.

of social and political life. As we saw in the first chapter, a large portion of what we think of as the sacred art tradition in medieval and Renaissance Europe was in fact commissioned to exercise an inspirational role in civic space—from Simone Martini's Maestà in the hall of the Council of Five Hundred to the statues of saints placed in niches around the outside of the guild hall in Florence to the David of Michelangelo, first installed at the entrance into the town hall.

And where was the artist in all this?

The committee responsible for the cathedral's repair and decoration certainly hired one of the town's best artists because they wanted an altarpiece of the highest possible craft and quality. We know from the records of the commission that the painting took Duccio three years to complete; his work and the subject and purpose of the panel—an altarpiece—was no secret. But only at the end of the account is the artist named and the address of his workshop given—but as the starting point of the procession (rather than as the goal of a "pilgrimage" like those made by art lovers nowadays to the museumized houses and studios of famous artists). The whole town had been waiting patiently, knowing that an artwork of highest complexity, and built to last, takes a long time to make, and that artists deserve to be paid during the entire time of their making.

The account focuses on the artwork, not the artist. The one honored is not the artist but the Madonna. The procession is not about the artist—this is no ticker tape parade through the city feting the town's baseball team after winning the World Series—but about the artwork. The goal of the procession is not the museum where the work will be taken out of circulation to protect it, but rather the church where the painting can finally be put into place, put to work as the backdrop that elucidates the daily action of the liturgy performed before it.

In sum, here is a work of art intended entirely for use in the liturgy, whose installation was itself a *liturgical* action of the whole body of people in ceremonial ritual. The account describes a work of art that is already doing its work even as it is processed to its permanent place: inspiring devotion and almsgiving along the way, evoking patriotism and civic pride, prompting collective memory of the big events of the community's past when God was seen to be at work.

And this introduces the thesis of part two, The Place of Liturgy: Although not every work of art was so ceremonially installed, and few accounts exist of the physical installation of artworks, the role of Duccio's Maestà and its valued importance in the community for which it was made is completely typical. People experienced artworks almost entirely while enacting a liturgy. Every installation of a new work of art was a big

deal for the community who had ordered it, and who would be view-ing it not in *gallery mode* for a few minutes of aesthetic appreciation, but in a manner that would allow the artwork to accrue manifold layers of meaning and significance over generations of invested prayers, intentions, memories, and more.

5

RECOVERING THE SENSE OF LITURGY

First, let's get our usage of the terms straightened out.

The word *liturgy* is now used—as I did at the beginning of the previous chapter—mainly in reference to a highly scripted service of public worship with a formal sequence of elements.

In the circles and subcultures of my own upbringing and vocational life, I have often heard the word used more generally to indicate a rote formality of worship *versus* informal forms of worship deliberately oriented toward the unscripted and spontaneous—as in comments such as "This Episcopal church is way more liturgical than the Pentecostal church that I'm used to." I suggest that this usage doesn't quite get at the issue, even though the patterning of various churches' time together in worship may have degrees of visibility or obviousness.

The English word "liturgy" (like the Latin *liturgia*) is a transcription of the Greek "leitourgia."[1] The simple definition of the word is "the work of the people," suggesting reference to a job (not a feeling) that can't be done by one person privately, but an action taken on by a group, with customary rules and expectations for performing that action.

The word was used in the civic world of Greco-Roman society to indicate "a public office"—something done on behalf of the larger community—"which a citizen undertakes to administer at his own expense." ("Service done by someone in an honorary religious or civic office, leaving a significant impact on the *community*," as defined in Strong's

[1] Adrian Fortescue, "Liturgy," in *The Catholic Encyclopedia*, vol. 9 (New York: Robert Appleton Company, 1910), http://www.newadvent.org/cathen/09306a .htm. The essay in *The Catholic Encyclopedia* provides a reliable account of the word and its history and use in Christian tradition, with bibliography for further reading, and is readily accessible online. From the "Liturgy" entry in *The Catholic Encyclopedia*: "Its elements are *leitos* (from *leos* = *laos*, people) meaning *public,*and *ergo* (obsolete in the present stem, used in future *erxo*, etc.), *to do*. From this we have *leitourgos*, 'a man who performs a public duty,' 'a public servant,' often used as equivalent to the Roman *lictor;* then *leitourgeo*, 'to do such a duty,' *leitourgema*, its performance, and *leitourgia*, the public duty itself."

Concordance.)[2] It was expandable to mean "any service, such as of military service, or of workmen," perhaps those in charge of road repair.

Most students of theater have learned about the custom in ancient Athens of expecting wealthy people to take turns funding the theater competition that formed an essential part of the religious festivals of Dionysius. The "liturgy" of these so-called *choregoi* was precisely to use their private wealth on behalf of the commonweal; in this case, underwriting the costs of the chorus, costumes and masks, scenery, and the like.[3]

To seek modern-day equivalents for this usage, the service offered by volunteer firemen might be called their "liturgy." Or the action of the wealthy person who offers to foot the bill for installing benches in a downtown piazza to make it more inviting and attractive. In ancient Greek usage, he could be said to be performing his *liturgy*.

The sense of obligation to contribute to the public good of the whole community (as distinct from the private action of giving alms to a beggar) by willingly undertaking some action became an element in the ethical philosophy of the age as the civic virtue of *magnanimity*. Influential elaborations of magnanimity were provided in Aristotle's *Ethics* and developed for the Roman context by Cicero in *On Duties*. The concept became newly active in the moral and political philosophy of the humanist writers in the fourteenth and fifteenth centuries. It is certainly the context for including Magnanimity as one of six key virtues whose presence was deemed indispensable for the commonweal of Siena, as expressed visually in the fresco cycle of Good and Bad Government that surrounded the members of the Council of Nine when they met together.*

Wealthy people were expected (an expectation not always delivered on) to spend money in ways that benefited the community corporately, and not just for their individual pleasure and comfort. A prominent exemplar of such civic magnanimity in fifteenth-century Florence was Cosimo de Medici. He put up what might be called nowadays the "matching gift" to rebuild the neighborhood Church of San Lorenzo, approaching (or twisting the arms of) his wealthy neighbors to contribute their fair share. And he hired the finest architects and artists for the work. He bankrolled the reconstruction of the neighborhood Dominican Monastery of San Marco, assigning his own trusted architect Michelozzo to do the work. The

[2] See "Leitourgia," *Biblehub*, http://biblehub.com/greek/3009.htm.

[3] "At Athens the *leitourgia* was the public service performed by the wealthier citizens at their own expense, such as the office of *gymnasiarch,* who superintended the gymnasium, that of *choregus,* who paid the singers of a chorus in the theatre, that of the *hestiator,* who gave a banquet to his tribe, of the *trierarchus,* who provided a warship for the state. The meaning of the word liturgy is then extended to cover any general service of a public kind" (*The Catholic Encyclopedia*).

monastery came to include what has often been called the first public library in Europe when Niccolò de' Niccoli as well as Cosimo housed their enormously valuable collections of manuscripts in the library, available to the humanist scholars supported by Cosimo. And perhaps most magnanimously, Cosimo offered to underwrite the costs of bringing a major ecumenical church council—whose purpose was to seek the unity of the Eastern (Orthodox) and Western (Catholic) Churches—from plague-stricken Ferrara to Florence. Hosting what is now called the Council of Florence (1439–1445) of course brought honor and prestige to the Medici family as well as to the city of Florence, but the financial burden of hosting the hundreds of dignitaries and scholars and secretaries in the entourages was enormous. It could never have been borne without the "magnanimity" of Cosimo, modeling the duty of the wealthy—their *liturgy*, in the old sense of the word—to contribute to projects that sustain and enrich the collective life of the city. One can say with a degree of pragmatic cynicism that Cosimo consolidated his behind-the-scenes grip on political power by means of such acts of public generosity. Perhaps so, but the fact remains that Cosimo earned the trust and respect of his community honestly by spending a notable proportion of the vast wealth he gained as a businessman on projects benefitting the people in both religious and civic realms.

But I must back up and sketch—and not as a trained scholar in these matters—how the Greek concept of liturgy was adapted for use in Jewish and early Christian contexts. As *The Catholic Encyclopedia* notes, the term is used in the Septuagint "for the public service of the temple (e.g., Exod. 38:27; 39:12). Thence it comes to have a religious sense as the function of the priests, the ritual service of the temple (e.g., Joel 1:9; 2:17)." This same religious meaning as temple service occurs in the New Testament in the episode when Zachariah goes home after "the days of his *liturgy*" (*hai hemerai tes leitourgias autou*) are over (Luke 1:23).

In the five other uses of the term in the epistles (three by Paul and two in the letter to the Hebrews) the word is expanded beyond the narrow sense of temple service in order to deal with the new High Priest Jesus of the New Law who "'has obtained a better *liturgy*,' that is a better kind of public religious service than that of the Temple" (Heb. 8:6; 9:12), and, by Paul, to refer to the actions of service that should mark all believers in their life of faith. As Paul writes to the Corinthian church:

> This *service* [liturgy] that you perform is not only supplying the needs of the Lord's people but is also overflowing in many expressions of thanks to God. Because of the *service* by which you have proved yourselves, others will praise God for the obedience that accompanies your confession of the gospel of Christ, and for your generosity in sharing with them and with everyone else. (2 Cor. 9:12–13; see also Phil. 2:17 and 2:30)

The New Testament epistles, we can say, activated the ancient Greek sense of the word as a generous action done by and on behalf of a community (in this case, the followers of the new Way) in their public life together and in society. The word fits into Paul's sense of the priesthood of all believers, all with various jobs to do in their new and expanded *temple service* as the body of Christ now embodied in the Church—some as teachers, some as evangelists, and so forth. They do this work voluntarily for the good of the whole and as the followers of the one who has once and for all performed the High Priestly sacrifice. This is the new "work of the people."

At his Last Supper with his disciples, Jesus explains his *liturgy*—his appointed priestly work to suffer and die on the cross. And he introduces the *liturgy* of his followers to remember and rehearse the body given and blood shed by their Lord until he comes again. Saint Paul establishes the liturgical formula for rehearsing the perpetual remembrance in 1 Corinthians 11:23–26 not in private devotion but as the corporate work of the Church:

> For I received from the Lord that which I also delivered to you, that the Lord Jesus in the night in which He was betrayed took bread; and when He had given thanks, He broke it and said, "This is My body, which is for you; do this in remembrance of Me." In the same way *He took* the cup also after supper, saying, "This cup is the new covenant in My blood; do this, as often as you drink *it*, in remembrance of Me." For as often as you eat this bread and drink the cup, you proclaim the Lord's death until He comes.

Christian communities (certainly those in Catholic tradition) who understand Jesus's and Paul's instructions as an imperative—as a work that the people must "do" and do "often" in order to remain people of the Way—make Holy Communion the centerpiece, the climax of the action, of their worship together (but more on this later).

With this sense of the word, we might speak of the *liturgical* application in Matthew's account of Jesus's Sermon on the Mount: "Therefore if you are presenting your offering at the altar, and there remember that your brother has something against you, leave your offering there before the altar and go; first be reconciled to your brother, and then come and present your offering" (Matt. 5:23–24). This is not an option to be done if you feel like it. It is a "work," a duty that you must do in order for the body's worship to be honoring to God and without the stain of hypocrisy. Jesus's injunction found its place in the Catholic liturgy of Holy Communion as the "Passing of the Peace"—not so much a time of fellowship but an opportunity to "make the peace" before receiving Communion.

This sense of *liturgy* can be felt in Luke's description in Acts 2:42 of what the very earliest gatherings of the church did: "They devoted themselves to the apostles' teaching and fellowship, to the breaking of bread,

and the prayers." That is what they understood as their "work" as the followers of Christ. Or when Paul instructs the church in Corinth (in 1 Cor. 14:26–33 NRSV), "When you come together, each one has a hymn, a lesson, a revelation, a tongue, or an interpretation. Let all things be done for building up" the body.

This brief summary allows us to distinguish two dimensions of the sense of *liturgy* as activated in the early church. The liturgy is the work that a given community is called to do. But it can also apply to the formalized occasions when its members remind themselves in inspirational mode who they are and what their mission is and why it's a valuable work that they have been called to do.

I vividly recall a visit with friends in lower Manhattan on the tenth anniversary of the attacks on the nearby Twin Towers on September 11. The firehouse adjacent to our friends' apartment had lost a dozen of their fellows. All that day of remembrance, the doors were open to families and neighbors. Long tables full of food took the place of the engines; an altar-like shrine of photographs and mementos of the fallen stood just inside the doors, with lines of visitors waiting to write personal notes and remembrances in the big folio album on the table. A sober occasion to be sure, but marked by celebratory pride, punctuated by solemn laughter, tearful embraces. It was a moving liturgical commemoration in honor of community members who performed their liturgy with bravery and devotion unto death.

The liturgy of Holy Communion operates in both dimensions. The solemn yet celebratory rehearsal of the Lord's Last Supper is itself the "work of the people" that Jesus himself announced to his disciples as a work to be done until he comes again: "Do this in remembrance of me. . . ." But followers of the Lord don't just sit around perpetually celebrating Holy Communion. They follow the Lord by following in his work of "proclaiming the good news to the poor, proclaiming freedom for the prisoners, restoring sight to the blind" (Luke 4:18), by feeding the hungry, giving drink to those who thirst, clothing the naked, sheltering the homeless, caring for the sick, visiting the imprisoned, burying the dead, and so forth, remembering his words that "as you do this for one of these, you have done it for me" (Matt. 25:41–46).

The celebration of Holy Communion is both a work itself, and an exhortational and inspirational work that gives the worshippers their marching orders and fires them up to go out and do the Lord's work of service in the world. The concluding prayer of the liturgy of Holy Communion in Anglican tradition makes this point. Having done the work of remembering and rehearsing our Lord's final instructions before he went out to complete his own work on the cross, the congregation recites together the

concluding prayer: "And now send us out into the world to do the work you have given us to do, as faithful witnesses of Christ our Lord."

Interestingly (as noted in chapter two), the work of art most recently created for the Orvieto Duomo is the set of main doors, cast in bronze relief in the 1960s by Emilio Greco, representing the seven acts of mercy.* Several times while attending services in Orvieto I have heard Bishop Scanavino refer to the doors in his homilies to make the point that to receive devoutly the sacrament of the body of Christ in the Eucharist should drive us out to be the body of Christ now in the world, feeding the hungry, visiting those in prison, sheltering the homeless, and so forth.

I have clarified these two dimensions of liturgy because both senses will apply when we consider that people's experience in premodern Italy was more thoroughly *liturgical* than that of our own contemporary culture. More of life was shaped and organized in the context of belonging to various groups, each with a collective identity based on a particular, well-defined, mutually understood work. Life was more thickly punctuated by ceremonies that rehearsed and inspired and celebrated that work. Art was called upon to do its work in both settings.

We can observe that Duccio's altarpiece was carried in procession from workshop to its place on the high altar of the cathedral in a highly festive civic-religious *liturgy*, where it would serve as the focus of the *liturgy* of the Mass, reminding the gathered citizenry of their *liturgy* as loyal Sienese who honor their city's protectress.

Here I observe that what a denomination or wing of the Church does in its liturgy—in the first sense of the regular actions and sequences that mark its formal gatherings—always reflects and reveals what the group sees as core elements of their belief and their appropriate expression. This holds for a charismatic Pentecostal church just as much as for a Lutheran church. It has little or nothing to do with some sense of formality versus informality.

We can say of Protestantism in general that the sermon is typically the central, essential, and often climactic, element of the Sunday liturgy of worship. It functions *liturgically* as the occasion of hearing the word and exposition of that word for a tradition committed to *sola scriptura*. But the sermon, and the service as a whole, models and inspires the "work" of studying the Scriptures that should mark the lives of community members throughout the week. "Grant us so to hear them, read, mark, learn, and inwardly digest them," as a collect in the Anglican liturgy puts it.

Whereas in those wings of the Church in Catholic tradition (including the Anglican) who understand Jesus's and Paul's instructions as an imperative—as a work that the people must "do" and do "often" as faithful followers of Christ—Holy Communion is the centerpiece, the climax of the action, of their worship together. The sermon is important but it exists as

an opportunity to comment on the word as delivered systematically in the programmed sequence of readings from Scripture called the lectionary. In this tradition the dramatic movement of the liturgy leads to the Eucharist.

Moreover, communities of faith in every period of church history have felt the urge (with varying degrees of intentionality) to design the architecture and decoration and vestments and choreography of action of their place of worship to provide a fitting setting for the *work of the people*; a setting that clarifies and encourages that work. Protestants of the Reformation removed visual imagery of the Virgin and the saints and erased the depiction of saintly behavior prominent in Catholic art because such imagery was understood to deflect the devoted soul from the primacy of the atoning work of Christ, *sola grazia*. The Reformers' central principle of *sola scriptura* inspired a purposeful sparseness in ornament designed to eliminate visual distractions that might interfere with a focused attention on hearing the word—a simplicity that can have an artful beauty. It is no accident that the central piece of furniture in the architecture of Protestantism is the pulpit. In Catholic tradition, the altar is front and center.

The historical focus of this book is on a time and place when the visual arts were understood not as a key means for distracting the people from their work but as essential aids in performing it.

The Lapse from Ceremony

Here I can repeat the same proposition made in chapter one, replacing "architecture" with "liturgy."

> *Most of us remain poorly equipped by our own cultural training to seek out, or even to expect, let alone to understand, the relationships once at work between artworks and their liturgical setting.*

For some of us, this cultural training includes the Protestant tradition whose suspicion of images has provided weak soil for the cultivation of an interest in the visual arts in general, and certainly not in the *liturgy* of art-oriented worship. For most Western societies, the past couple centuries of cultural modernism have served to withdraw the creative work of serious artists from religious liturgy, considered as violating the artist's independent creative freedom, as too utilitarian, as demeaned by serving as propaganda for religion. And as I noted in the introduction to this book, the gallery and museum context for experiencing art effectively erases the possibility of experiencing art in liturgical action.

Few Christian believers nowadays are adept at apprehending the meaning of artworks installed in their churches in generations past—art

once intended to resonate with the actions performed by the congregation gathered for worship. Nor are most churchgoers adept at assessing the fittingness of art (old or new, if there is any) or of the visual field in general for the actions presently performed in their own work of worship, catechism, devotion, and service.

In fact, another blockage to an astute perception of art in its liturgical setting may be that of the general erosion in our time of festively celebrated corporate work of a community.

Interestingly, students in the *in situ* program in Orvieto described at the beginning of this book often experience a recovered consciousness and appreciation of *liturgical participation*. The four-month sojourn in Orvieto provides our mainly Protestant students with a regular experience of liturgically-shaped worship in churches rich with artwork, with opportunities to join the cloistered Franciscan sisters as they chant the services of the daily office, in a small town where more rhythms are shared by a large part of the community (the evening *passeggiata*—the slow collective stroll before the evening meal, for example), where the great festivals of the Church are celebrated with large civic participation (St. Joseph's Day, Good Friday and the Easter Vigil, Pentecost, Corpus Christi), and where, in the autumn, they can participate in the ancient shared *liturgies* of the harvest: the collective work of neighbors helping neighbors with the grape and olive harvest, the festive sharing of the first oil out of the olive press, the tasting of the new wine.

In one of the brief personal essays assigned in a class I teach for the semester in Orvieto, a recent student, Joeli, demonstrates a perfect understanding of *liturgy*—and of its loss—when she writes:

> In the summers spent as a girl at my grandparents' house along the coast of North Carolina, I would wake up early, go out on the boat with my Grandfather, spend the day fishing Bogue Sound, and return home in time for my Grandmother to cook our catch for dinner. Alongside the fish would sit corn, grown on my great-uncle's farm and shucked by my siblings and me on our back porch, biscuits, made with love by my Grandmother, and sweet tea, my Mother's handiwork. We all had our part to play in the preparation of the meal. Not only the cooking but the catching and shucking as well. Because of this *the food holds more significance* than it would out of a supermarket, into the microwave, and consumed. Obviously, my family is not able to have this much "hands on" connection with all the food we eat. In our time that is unheard of and, even in my small town, uncommon. However, the amount of contact that we are sometimes able to have *helps us to appreciate more the work that goes into a meal on a daily basis. Preparation and cleanup are always group endeavors and no one is left without a part to play.*[4]

[4] Joeli Banks, Spring 2013, course assignment.

Joeli gets it: the liturgy of a meal enjoyed together as a family endeavor where everyone has a part to play. The person loading the dishwasher by himself is not experiencing a liturgy; but when siblings gather in the kitchen with their weekly rotations of scraping, washing, drying, and putting away because that's just what this family does, then it's a *work of the people.*

On another occasion after returning home from a month of teaching in Orvieto, I received a note from a student catching me up on the news. Margaret instinctively links the high and holy day in the Church with the low and earthy holy-day working at Roberta's organic farm in the country:

> Easter weekend was an incredible experience. The procession on Good Friday was quite an experience [referring to the town-wide candle-lit procession of the *Via Crucis*, the Way of the Cross, in which many hundreds of people wind their way through the oldest quarter of the town, stopping at each station to read the relevant passage in scripture, to sing a hymn and pray a prayer appropriate for that station]. Even though it was all in Italian, I felt like I could follow along rather well and it provided a time for contemplation that needed no words. The highlight for me was definitely singing with the choir Easter morning. The songs sounded really great thanks to our extra rehearsals. The priest came up to us [students in the semester program] afterwards to tell us all how much he appreciated our presence within the church. It was very special. [5]

And then she writes:

> The day we spent at Roberta's farm has easily taken place among my favorite Italian moments. The day could not have been more beautiful, nor the weather more perfect. Growing up on a farm, I felt very much at home laboring in the soil. *Between the good work and company, the sun and the delicious feast*, I was reluctant to leave at the end of the day and waited until the last vehicle came to shuttle us back. I wish you could have joined us for that day!

Margaret's description of farm day as moving from "good work" done in "company" leading to a "feast" offers, I might say, a *sacramental liturgical* parallel to the very intent and arc of the Mass: joining together as a *company* to understand our *work* encapsulated and culminating in a *feast.* What caught my eye in her description was precisely how she brought into one sequence, one field of vision, the in-church formal liturgies of Good Friday and Easter morning and the in-field liturgy of working together as a group that concludes with a feast that celebrates their work and provides a fitting conclusion, and is itself composed of the fruits of their labors— eating a portion, a tithe, of what they have just harvested.

[5] Margaret Brooks, private email, April 30, 2014, my italics.

Interestingly, Roberta not only teaches our students about tending the garden, but always gives them lessons in how to arrange the fruits and vegetables attractively in the baskets that she takes to the market. The work of taking the vegetables to the market deserves the labor of presenting it beautifully. I sense the parallel to the artful "liturgical" care exhibited through the centuries in bringing the bread and wine, the fruits of our labors, to the altar to become (or make present to the eyes of faith) the body and blood of Christ.

Margaret's and Joeli's experiences may be common enough during our students' sojourn in Italy. Indeed, such students are part of a growing minority of young people who express the desire to recover a life rich with the *work of the people*. But they represent a still-uncommon counterculture in a contemporary American culture less and less shaped by willing membership in various sorts of intentional communities with common purposes and collective actions.

I am among those who believe that we live in an age generally marked by the "eclipse of liturgy." Ours is a society, we might say, of "flatlanders" for whom purposeful collective actions have been largely leveled.[6] One of philosopher and cultural critic George Steiner's many prescient phrases in his small book *In Bluebeard's Castle* serves as the section title for this part of the chapter: *"The lapse from ceremony and ritual in much of public and private behavior has left a vacuum."*

The vacuum is often filled in youth culture by the anti-liturgies of "hanging out," of vegging out rather than willfully and decisively *doing* something together. The vacuum fosters the language of "whatever" to mark an attitude of purposeless passing of time, as in "Waddya wanna do tonight, it's Friday?" "Oh, *whatever*. . . . Just hang out."

The gestural expression of "whatever" is a pervasive posture of slouching, of a body seldom called to attention and rendered alert to perform an action choreographed for a community to do in harmony. When we are doing something that a "we" believes to be important, the community inevitably develops ritual or ceremonial forms that help the community do justice to the work, to render our behavior, our comportment, our clothing, our attitude appropriate for and commensurate with the importance of the action: in short, a liturgy.

W. B. Yeats's poem "The Second Coming" is as relevant as ever: "Things fall apart; the centre cannot hold . . . everywhere the ceremony of inno-

[6] The first phrase alludes to Hans Frei's book *The Eclipse of Biblical Narrative* (1974); the second to Edwin Abbott's 1884 novel *Flatland*, in which Abbott imagines a world that exists in only two spatial dimensions, not three. *In Bluebeard's Castle* (New Haven: Yale University Press, 1971), 121.

cence is drowned . . . the best lack all conviction, while the worst are full of passionate intensity . . . what rough beast . . . *slouches towards Bethlehem*." Yeats captures a sense of the lethargy and purposelessness that renders a people vulnerable to—weak to resist and willing to be seduced by—any new totalitarian demagoguery that imposes order and goal and mission to life. (I write as Midwestern teenagers are seduced by the rhetoric of ISIS promulgated through social media.)

The "ceremony of innocence" is drowned not only in the demoralizing and numbing sexual rituals of "hooking up," but in the trend in fashion magazines to choreograph the chic young models, vested in *haute couture*, in blasé attitudes of utter detachment from the sensual and sexual implications of their arrangement. The "passionate intensity" side of Yeats's astute verse can have a well-meaning side in earnest but unsustained protest movements. *Occupy Wall Street* eventually peters out if the principles don't find a collective "liturgy" both for the protests themselves and for an alternative manner of living that undermines the greed being decried. A student-friend recently back from a study-abroad semester was struck by a counterexample:

> While in Buenos Aires I had the amazing opportunity to march with "Las Madres de la Plaza de Mayo"—mothers who lost their children during the dictatorship of 1976–1983. They called these lost family members "los desaparecidos" or "the disappeared" because anyone who was looked at as a threat to the government would either disappear themselves or would find one of their loved ones gone without word of why, what happened, or when they would return. They never returned. These courageous women began in 1976 to march around the plaza everyday at 12 pm in a single file line, and those mothers who are still alive have marched every Thursday since for 38 years around the Plaza de Mayo.[7]

That's a liturgy.

Yeats's "passionate intensity" can take on an addictive aspect in the so-called online communities of gamers and hobbyists and chat rooms that provide settings not for long-term committed, accountable, embodied relationships, but all too often for predators and asocial narcissism.

Sure, loyal fans of their city's professional sports teams create a sort of community-with-shared-work, with plenty of festive *bonhomie* in the bleachers and around the tailgates: the fellows gathered on the sofa watching Monday Night Football, passing 'round the snacks and beer, leaping to their feet in unison, high fives all around, as their team scores a touchdown. (This typical scenography of so many commercials for Budweiser

[7] Kaira Colman, from an essay written for a course taken by students returning from a semester of study abroad.

and Doritos and the like is weirdly like that of a profane version of so many paintings of the Last Supper.)

We fiercely protect the private rituals that help us cope and recharge— the ritual of the Sunday morning hour over the Sunday *Times* at Starbucks, and so forth. Lots of people may be doing the same thing at the same time, sitting in rows on the elliptical trainers in the health club, out jogging on Saturday morning. But these are mainly collective activities of individuals rather than corporate activities of a group of people conscious of sharing a common mission, of doing a "work of the people" in collective service. And they don't typically illuminate or suffuse with grace the work of our individual jobs during the rest of the week.

I think of such sort-of-communal-but-really-individual activities as ersatz liturgies, filling the vacuum that Steiner speaks of, and sort of satisfying the yearning for belonging to a community. They are seldom the sign of works that foster solidarity among the workers and meet the needs of those served.

I don't wish to overgeneralize, nor to ignore the many church and civic groups who willingly give a Saturday morning to prepare a tasty and filling meal for the needy of the neighborhood, or a Tuesday evening to tutor the local immigrant community in English, or to work together to sponsor a refugee family, and so on.

Indeed, I am attentive to the positive signs of new interest in corporate activities informed by a liturgical ethos. A growing number of house-dorms are occupied not by fraternities but by intentional communities with a clearly defined purpose, dining together, doing projects together, holding one another accountable to a collective commitment, perhaps setting aside the cell phones, working with children in an inner-city neighborhood, eating farm-to-table, and the like. The increasingly well-attended outdoor market on Sunday morning at a central location in our own town, filled mainly with booths of local people bringing organically-grown produce and "artisan" products, has become a gathering place for people who sense a common identity, who are encouraging one another in the work of healthy living and environmental sustainability.

But I also suspect that even well-intentioned desires to "create community" are undermined and sidetracked by the ubiquity of lives lived in cyberspace, on the internet, looking into the screens of our smartphones. Our collective addiction to our handheld devices has contributed to the erosion and dissolution of a sense of what "we" are "doing" now, of what our work is, and hence the ability to stay focused on it. When, for example, a text message about our date for the evening interrupts the church service, or when we turn from note-taking in class to do a quick bit of shopping on-line at JCrew or Anthropologie, then the "work of the student"—the liturgy

of a community of students and teachers—becomes blurry at the edges. When every action is interruptible, the concept of a discrete action with its own innate trajectory and purpose is jeopardized.

We create "virtual" private worlds, earbuds pumping in our favorite music to the exclusion of the actual world around us, with its smells, its birdcalls, its sights, its fellow humans who might want to make contact. We whip out the smartphone to take a photo of the famous place so that we can post it instantly to our artificial constructions of the self on Facebook— sabotaging opportunities to have real encounters with real people in real place and time, without which a solid sense of collective belonging and shared purposeful action is thwarted.

In sum, before we can understand the place of art in liturgy, we have to recover some sense of what this largely-unfamiliar term *liturgy* even means, since not only is the term foreign in settings of religious faith, but the cultural and social context in which the word could find its place has largely dissolved.

6

LIFE, LITURGY, AND ART IN PREMODERN ITALY

In the medieval-Renaissance period, life was much more *liturgically* shaped than it is now. This was made possible by the much greater extent to which people's lives were organized by their membership in socially cohesive groups: their extended families, their neighborhood, their parish, the monastic orders to which almost every family had an invested personal connection, and the confraternities and guilds which provided frameworks for giving and receiving social and religious and economic service. Individual identity was simply more thoroughly experienced and rendered secure as part of a "we." People had a sense of belonging. Because they lived more collectively, there was more opportunity for the rituals and "rules" for ordering the work of the people. In this sense, one can say that people's lives were more thoroughly experienced through liturgy.

To be sure, the network of groups and communities broadly sharing common values and beliefs was made possible by the simple fact of a common religion in the epoch of European Christendom. Inversely, a pluralistic society such as our own presents fewer opportunities to experience a common work that glues together everyone in sight. And of course a number of other conditions have fostered the privileging of individual freedom and identity above shared action and community identity. For one, liberal democratic principles of the Enlightenment focus on the individual as the fundamental unit of society, rather than the community as the fundamental framework for individual identity.

Children are encouraged to seek out a life path that suits their own interests rather than sticking around home to carry on the family business. Christians in America typically feel free to "shop around" for a church that suits their own tastes, whether in worship style or doctrinal preferences. Long-term loyalty to the local parish is a low priority—and of course a difficult commitment to make in an age when Christians change jobs and homes at the same rates as society in general.

My intention here is not to invite nostalgia. It is simply to begin a list of modern factors that create poor conditions for cultivating the "work of the

people." Efforts to renew liturgically-rich communities will by necessity be countercultural—at least for the foreseeable future.

To help us understand "the place of liturgy," I provide in this chapter a basic survey of the zones in medieval-Renaissance Italian culture that can be marked as *liturgical*. I continue to use the word in the twofold sense as the actions through which a group performs its mission or purpose, and as the strictly-scripted actions performed ceremonially by a group to rehearse its identity and confirm its purpose. These actions can overlap, as when the very work of the people (sense number one) *is* to reenact regularly the ceremony (sense number two) that Jesus performed in celebrating the Passover with his disciples on the night before his death, when he told them, "as often as you do this, do it in remembrance of me."

The final purpose of this survey is to help us understand how *visual art* played an indispensible role in the liturgies that so pervasively framed and punctuated people's experience. In almost every case, the *work* of art was to assist a liturgy (and never to provide aesthetic pleasure for its own sake). The architectural form and decoration of a building was designed to create a conducive setting for instructing and reminding and inspiring the community to do its work well.

The reason for art's intrinsic relation to liturgy, universally felt during most of human history, may boil down to a simple deep urge. Families and neighborhoods and communities large and small who have something to celebrate, a history to remember, a corporate identity to maintain, always seem to want to fence off and gussy up the occasions of celebration, to wear special clothes, to reenact the occasion in the same way, to purify and concentrate the rhetoric (prayers with crafted syntax and no filler), to sit up straight and eliminate distractions that break communal concentration on the action at hand. (The ring of someone's cell phone is more seriously annoying when it occurs during the Mass, at the concert, in the museum, at the moment when the birthday girl is cutting the cake, etc.)

At the Thanksgiving Dinner with guests, we bring out cloth napkins instead of paper, the best china, silverware instead of our daily stainless steel tableware, the reserved sherry. We bring out the suit for special occasions, the dresses worn once a year (or hear a clamor for a new dress). Even color coordination matters for seasons that matter to our community: orange at Halloween; red and green at Christmas; red, white, and blue for the Fourth of July. The vestiges of such sensitivity to color provide a window into understanding the intensified importance of color for communities whose lives are lived according to the liturgical calendar, with red for Pentecost, purple during penitential seasons, and so forth.

Communities with something or someone or some event to celebrate inevitably do so with things of higher levels of craftsmanship, stuff with

greater personal care in the making, things that themselves bear the signs of the community's history: a great-grandmother's china, wine in the etched glass carafe that should never be thrown in the dishwasher, the silver tea set, the wedding chest painted with scenes from the Bible, the hand-sewn baptismal gown handed down through generations.

And yet (as George Steiner and a growing chorus of commentators have suggested) it is precisely the gradual erosion of impetus to mark particular moments, occasions, and life passages with festive trappings that character-izes our own age—an age when jeans are proper attire for all occasions.

This book harkens back to a long period when artistically-crafted ob-jects of the highest manual skill, made from the most valued and enduring materials affordable to a community, whose costliness needed no apology, inevitably accompanied actions of high value and lasting importance, of eternal significance. Artfulness always accompanied actions that marked a group of people *as* a community.

The sacraments were such actions.

Sacraments and Their Furniture

Five of the seven sacraments recognized in Catholic tradition occur as one-time markers of the definitive passages of human life as understood in the light of eternity: Baptism, Confirmation, Marriage, Holy Orders, and Extreme Unction at the hour of our death. Holy Communion and Confes-sion are the two oft-repeated sacraments that keep the Christian believer progressing in maturity and sanctification. (Extreme Unction has been re-focused in recent Catholic tradition from the single anointing at the time of death to the Anointing of the Sick that may occur throughout life.) Each sacrament was and is celebrated with its particular liturgy.

One sort of evidence of the shared importance of the seven sacraments in medieval-Renaissance Italy is their frequent representation in art as a whole collection. A famous instance is the great Campanile, or Bell Tower, adjacent to the Duomo in Florence, decorated on all four sides with sets of medallions, conceived in groups of seven.* Together these present a sche-matic mapping of the entirety of civic and religious life. Small scenes carved in marble relief by some of the chief sculptors of the age depict the seven virtues (the three theological virtues and the four cardinal), the seven lib-eral arts (the trivium and the quadrivium), the seven planets, the worthy and essential professions, scenes from the account in Genesis of the ori-gins of human beings, and, yes, the seven sacraments.[1] Holy Communion,

[1] The "essential professions" include building, medicine, hunting, farming, wool-working, legislation, seafaring, music, painting, sculpture, theatre.

represented by a priest raising the Host at the high moment of the Mass, is the central medallion, flanked by the others.

Inside churches, painted altarpieces—like the immense panel by Duccio discussed in chapter four—frequently provided the backdrop for the sacraments. For us modern viewers, such paintings are more readily susceptible to being co-opted by the habits of museum-viewing. Lined up along the walls in the "Early Renaissance" gallery, altarpiece panel paintings become so many *objets d'arte*, some created by famous artists, but all abstracted from tangible use as furniture for a physical action. Duccio's Maestà itself is now displayed in a darkened, climate-controlled room in the Cathedral Museum, with the front and back sides facing each other from opposite sides of the room. A recording sternly announces "stand back," in several languages, if an unwitting visitor reaches over the top of the plexiglass half-wall that protects the paintings. Nothing in the placards helps visitors to imagine the centuries of life the altarpiece lived when it was doing its work atop the high altar in the Duomo.

Perhaps a more ready window into the role of art in the liturgy is provided by the physical objects—the utensils—so obviously *used* by hand in performing the sacraments, but on which such obvious care and expense was bestowed. Christianity is not a gnostic or cerebral religion where one enacts the faith in the mind. The Last Supper is a meal, requiring plates and tableware and cups. Baptism is a washing, and needs a bowl and water. Prayer for the sick, and for those perhaps sick to the point of death, is not just a mental or verbal prayer, but a physical anointing like that exercised by Jesus in many of his acts of healing.

The sacramentality of Christianity means that physical things are vessels, not just symbols. The material world is freighted with spiritual significance and the eternal mysteries of a God who descends to earth, to creatures of clay made in his image, to a created and visible world that witnesses to the *invisibilia Dei*, the invisible things of God (Rom. 1:20).

The significance of the physical objects that carry this sacramental burden and blessing has been demonstrated through most of the human history of religious ritual by the extraordinary artistic care given to their making and handling. On the one hand, we can make do with any container in a pinch—the plastic cup for the wine that makes present to us the blood of Christ—but the sentiment shared by Christian believers in most wings of the Christian Church through history is that the most significant blood ever shed "for the life of the world" deserves the most precious container that the community at hand can come up with.

In the period that serves as the source for this book's argument, objects used in the sacraments, and in the liturgy in general, were the occasion for the highest levels of craftsmanship.

Among the many objects given high care in the making were the chalice (the cup) and paten (the plate) used in Holy Communion, the tabernacles used to hold the consecrated elements of Communion remaining for later use, the monstrances used to hold the consecrated wafer for adoration outside the Mass itself, reliquaries for holding relics of the saints and martyrs, the bishop's staff (crozier), and so forth. The vestments worn by the clergy and the altar cloths, designed with colors and symbols of the various seasons of the church year (purple for Lent, red for Pentecost, and so forth) occasioned the highest artistic skills of embroidery.

The distinction between art and craft, that is, between objects made for viewing and objects made for helping us do our work (and therefore subject to possible wearing out or breakage), has been operative only for the last couple hundred years. The art-for-art's-sake movement in the nineteenth century privileged the "Fine Art" of freely made objects without useful purpose above objects constrained by use. (The arts and crafts movement countered the distinction.) This distinction was not operative in medieval-Renaissance Italy. Artists were artisans. No artwork was outside the realm of usefulness in a community's work. One of the explicit criteria for the excellence of an artwork was the presence of artisanal mastery of technique and materials.

The functionality of a chalice is easy to see. More difficult for most of us to grasp is the equal functionality of paintings. For two examples of paintings with obvious functionality, we turn to two masterworks of the Dominican painter-monk Fra Angelico, both now in the museum room of Monastery San Marco in Florence.

One is a painting of the Last Judgment on a wood panel about a meter and a half wide, with curved scalloping along the top that might be found on a piece of furniture.* And that's exactly what it was. Commissioned in the 1420s by the Camaldolese order in Florence for its newly-elected abbot, the painting served as the back of the bench in the altar area for the officiating priest in the Mass. In his sacramental role, the priest sits in the place of the Christ in Majesty depicted directly behind him, with the elect-sheep at his right hand, the lost-goats on his left hand. The decorated furniture itself gives physical form to the eternal life-and-death importance of the actions performed at the altar in the liturgy.

A second example, mounted next to the Last Judgment in the museum, is a set of large square and rectangular panels, each containing smaller panels painted with scenes from the life of Christ.* One can imagine the large panels as the sides of an enormous chest—and so they once were. Piero de Medici, chief patron of the order in the mid-fifteenth century, commissioned Fra Angelico to paint the movable shutters of an enormous cabinet built to safeguard precious objects crafted in silver, offerings of pious visitors who flocked to the Florentine church of Santissima Annunziata

(dedicated to the "most holy Virgin of the Annunciation") to see a fresco of the Annunciation supposedly completed by an angel.

Fra Angelico decorated this *Armadio degli Argenti* with small scenes from the life of Christ. Written across the bottom of each small square panel is the source text of the episode in the Gospels, and across the top a reference to a passage from the Old Testament that prophetically prefigures the event (an example of the "typological" principle of scriptural interpretation to be explained in detail in chapter eleven). The reference in the scene of the Annunciation, for instance, is Isaiah's prophecy, "Behold, a Virgin shall conceive and bear a son, and his name shall be called Immanuel" (7:14).

Even the altarpiece paintings attached to the back of an altar or to the wall behind the altar were not just prettified background decoration. They functioned, not unlike seat-backs or cabinets, as pieces of furniture whose decoration elucidated the action for which the furniture was used.

Altar

For the traditions of Catholic Christianity that provided the soil and impetus for the sacred art discussed in this book, the sacrament of Holy Communion is the action or work of the people that marks them as the church. In celebrating the Eucharist together, believers of all times and places take their place with the disciples in the upper room of the Last Supper, are gathered around the cross, have their lives located in the grand story of salvation history narrated in the Eucharistic Prayer.

Hence the Eucharist is the climactic action of the liturgy of the day of the Lord's resurrection after his death on our behalf—Sunday. In medieval and Renaissance Italy, Holy Communion was enacted many times during the week, whether in parish churches, monastic churches, cathedrals, or chapels in civic buildings. There was no way a citizen-Christian of this period could walk through a week without witnessing or participating in (or scheduling other activities around) the liturgy of the Eucharist. As the sacrament in which the laity proclaim the good news of the resurrection that follows death, Holy Communion also served as the central liturgy for remembering the dead; hence the common bequest of money to endow a regular "saying of Mass" in memory of a loved one.

The altar is the *locus* of this work, the central piece of furniture in the household of faith where the gathered people rehearse, reenact, and remember their Lord's final instructions ("This is my body and blood given for you . . . As oft as you do it . . .").

Hence it is no surprise that the altar became the visual focal point of the entire architectural fabric of the church building, and the goal of the congregant's movement through that space—and that it was given the highest

degree of craft and artistic attention. Along with the elements of intricate design work in wood or stone or enameled glass or mosaic bestowed on altars themselves, the altar typically served as the base (or physical reference point) for a painted panel—the altarpiece—that served as the backdrop of the actions performed at the altar.*

Every altarpiece thus provides the visual frame of the liturgy of the Eucharist, presenting aspects of, and exemplary models for, the action of "receiving Christ." We must see these artworks not as so much added-on decoration but as pieces of furniture intrinsic to the work done at the altar.

Images of the Madonna and Child, for example—her womb the place of incarnation, of the real presence of Christ, of a Holy Communion— serve as reminders that, in receiving the body and blood of Christ, we ourselves, like Mary, are agreeing to become the tabernacles in which Christ is clothed in flesh for the life of the world. (John 6:56: "Whoever eats my flesh and drinks my blood dwells in me, and I in them.") When the altarpiece represents the Annunciation, the action of receiving the sacrament can become our own "*ecce ancilla dominus*," "behold the handmaid of the Lord; be it unto me according to thy word." The sacrament becomes our own action of undoing the prideful egoism of Adam and Eve in Eden, with their implicit "be it unto me according to MY word."[2]

When Fra Angelico (as well as other painters) tucks a small depiction of the Expulsion of Adam and Eve from Eden into the top left corner of an altarpiece centrally occupied by the Annunciation, we apprehend the inverse parallelism of the two scenes. An angel expels our first parents from the Garden through an arched gate into exile. That exile ends when another angel comes through another arched doorway to a new Eve who, by her *Yes* to the Lord, becomes the bearer of a new Adam. Our undoing in the Expulsion is undone by the Annunciation. The locked door prohibiting return into the first Garden is opened by the key of the Virgin, who opens herself to the Holy Spirit without being violated. The Virgin's womb becomes the *Hortus Conclusus*—the "Enclosed Garden" of the Song of Solomon, one of several scriptural images associated in medieval Catholic tradition with the inviolate Virgin whose locked womb bore fruit.

Receiving Communion before such an image marks the action as sign and token of the communicant's homecoming after the exile. In communion we move from excommunication, brought on by disobedience, into the community of the Lord made possible by the obedience of Christ. The altar is the place of that pilgrimage.

[2] A favorite medieval pun, or palimpsest, is to see the disobedience of Eve— *Eva* in Latin—reversed in the Angel Gabriel's *Ave*—his "Hail" to the new Eve who is obedient.

An altarpiece depicting the Nativity like that in the Sassetti family chapel in Santa Trinità, discussed in the introduction, is deliberately designed to draw in the communicant as a participant in the Adoration of the Shepherds.* In that light, the real presence of Christ experienced in the sacrament is associated with the Godhead who humbled himself and became really present in the baby born in the humble stable. In the Sassetti chapel altarpiece, Ghirlandaio has represented the manger as a Roman sarcophagus, resonant with several overlapping meanings, one of which is to remind us that this baby will be crucified and buried before he rises from the tomb. The scene of the Nativity on the altar of the private chapel of the Medici family seems deliberately dark and empty, the baby Jesus lying alone on the ground with no one but his parents nearby.* He is of course waiting for the arrival of the three kings, who are on their way, processing around the walls of the chapel toward the manger. To receive the Eucharist there (before a darkened stable in a windowless chapel lit only by candles) *is* to arrive as one of the Magi, offering our gifts in gratitude for the gift of the body and blood shed on our behalf.

Altarpieces depicting the Deposition—the lowering of the dead Jesus from the cross to prepare the body for burial—heighten the resonance for the communicant between the Host (the consecrated wafer of bread) and the dead body sacrificed for us, and then of offering our bodies as the sepulchre of Christ so that we become the place of his resurrection.

Altarpiece paintings could represent not only an event in the life of Christ, but a doctrine or a saint important for the particular family or community, perhaps the doctrine or "mystery" after which the church might be named. The altarpiece on the high altar of Santa Trinità in Florence is a visual representation of the Trinity (unsurprisingly), with God the Father holding up the cross bearing the Son, with the Holy Spirit as dove descending from Father to Son.*

Painters of altarpieces could exploit the technique of perspectival drawing, developed in the early 1400s, which allowed the sense of rational continuity in the recession of space. Masaccio's groundbreaking use of perspective in his fresco of the Trinity in the Dominican church of Santa Maria Novella would give a sense of the physical presence of Father, Son, and Holy Spirit to those celebrating Communion at the altar once placed in front of the painting. In every case, the altarpiece introduces a devotional-theological dimension or an inspirational model to the action of Communion. Through a sort of visual merging of the actual space of the altar with the fictive space of the altarpiece, the artist could all the more powerfully associate the action of the communicant with the action unfolding in the altarpiece.

Baptism

Holy Communion sustains the life of the believer, and is a regularly-repeated work of the people, of the Church's *liturgy*. The sacrament that marks the person's entrance into the Church and inaugurates her life as a member of the community of faith is of course Baptism, the rite whereby the newly-catechized is "marked and sealed as one of Christ's own forever." It is the sacrament that constitutes membership in the church, understood in Protestant as well as Catholic tradition as having been instituted by Christ himself.

The baptismal font is the site of this sacrament, often placed just inside the entrance to the church to mark the entrance of the newly baptized into the community of faith. Baptismal fonts represent another piece of carefully-crafted furniture, whose form and decoration is designed to elucidate the liturgy enacted in it.

The stories decorating the font invite those being baptized to insert their own life story into the narrative of salvation. In the side chapel dedicated to John the Baptist in the Siena Duomo, for example, the fifteenth-century marble baptismal font features scenes from the Fall of Adam and Eve, associating the event that brought death into the world with the death from which we are saved by Baptism. And as St. Paul makes clear in Romans, Baptism is itself a death since in Baptism we enter into the death of Christ from which we are given new life: "We were therefore buried with him through baptism into death in order that, just as Christ was raised from the dead through the glory of the Father, we too may live a new life" (Rom. 6:4).

Not surprisingly, the narrative most commonly found on baptismal fonts is that of the life of John the Baptist and his baptizing of Christ in the Jordan River. An example well worth discussion is the baptismal font in the baptistery of Siena, notable for how not one but five prominent artists accepted commissions in the late 1420s to contribute to the series of panels cast in bronze relief that surround the font.* Modern art historians typically single out a panel by Donatello as a remarkable early example of the mastery of perspective accomplished by a circle of Florentine sculptors and painters in the early decades of the fifteenth century, with figures like Masaccio and Donatello leading the way.

Usually referred to as The Feast of Herod, Donatello's panel features the climactic scene of the episode in the foreground; namely, the presentation to King Herod of the head of John the Baptist on the platter. Herod raises his hands in apparent horror; one guest around the table covers his face at the sight. Depicted in the middle distance through the archways of the dining hall is the scene that launches the narrative: the dance of Salome, so

pleasing to Herod that he grants her whatever she might ask. Seen through yet another set of arches—the viewer's eye now drawn further into space—is the chronologically-middle scene of the Baptist's severed head being presented to Herodias and Salome. The sense of spatial depth, rationally consistent with visual experience, unfolds in a panel whose actual depth is only an inch or so. Yes, a revolutionary technical accomplishment drawing on sophisticated tools of geometry to recreate a sense of complex three-dimensionality in a flat panel.

All too often, modern textbook discussions and photographs isolate Donatello's scene from its place in a larger sequence and in a piece of furniture in a larger room devoted to a single sacramental action. We are not encouraged to apprehend the chronological sequence of the panels as they wrap around the font, nor how they have been arranged so that the big event in John's life is placed front and center as the worshippers enter the door of the baptistery. This is the scene (created not by Donatello but by Giovanni di Turino) of John Baptizing His Cousin Jesus as the Messiah for whose coming John had been called to "prepare the way."

When we experience, *in situ*, how the story of John's life begins on the opposite side of this enormous font, the side facing the altar, we comprehend visually how the episodes of John's life reach their climax in the moment when God the Father proclaims, descending in the form of a dove, "This is my beloved Son. . . ." From a storytelling point of view (the topic of part three of this book), we might say that the choice and placement of the scenes unfolding sequentially around the sides of the font give narrative coherence to the story of the Baptist's life. It brings plot and theme (not just Donatello's depiction of space) into single point perspective, focused not on the poignant episodes concerning John's miracle-marked birth, nor on the tragic melodrama of his death, but on the episode which was the culmination of John's life and the event for which he had gone into wilderness training to prepare. The event marks the hinge-point between the importance of his own calling to reveal Jesus as the long-awaited Messiah and his secondary importance afterward. "He must increase, but I must decrease," says the Baptist (John 3:30)—which illuminates precisely the proper effect of our own Baptism into Christ.

The design of the artwork itself helps the community gathered for the liturgy of Baptism to experience our Baptism in Christ in the same way. Any experience or discussion of the font that focuses on the technical wizardry of Donatello and does not include a discussion of its function in the liturgy simply misses the purposeful design of the whole font.

Focus on a single panel such as Donatello's is likely to inhibit an informed perception of the hexagonal form of this baptismal font. The shape is highlighted by six elegant statues of female figures placed between the

panels at the angles of the hexagon, each representing one of six virtues.* Basic cultural literacy of the age would have allowed a fifteenth-century viewer—spotting any one or two of the figures, say of Faith or Prudence or Courage—to expect to find another instance of the Christian integration of the four cardinal virtues of classical ethics with the three so-called theological virtues highlighted in 1 Corinthians 13: faith, hope, and charity. But therefore noting at the same time a problem of design and theme: we've got seven virtues and only six statues. The six virtues around the baptismal font are faith, hope, charity, and prudence, justice, and fortitude. Temperance is absent. Why?

Are we, perhaps, to consider the virtues on display as marking the character of the Baptist: his courage in standing up to Herod's immoral marriage to his brother's wife; or his keen sense of justice? If so, what about John's life was not an expression of temperance?

The classical view of temperance was the virtue of a mean between extremes, eating neither too much nor too little; for instance, drinking wine moderately, but not avoiding it in total abstinence. This was not John's way. John's life was marked by a radical asceticism—living in the wilderness, dining on locusts and wild honey, dressing in camel's hair, drinking no wine at all, waiting intently for the arrival of the Messiah "whose sandal I am unworthy to untie." His life was not one of temperance, but of radical intensity in every aspect. On the baptismal font, the absent temperance is an enrichment, not a confusion, of meaning. The newly baptized are invited into a radically transformed life.

In sum, the decoration of the baptismal font contributes to the action of Baptism.

The Mass

I have given examples of art at work in the two main sacraments of the Church, Communion and Baptism. Now I turn attention to the "shape of the liturgy" of the Mass that frames or contains the sacraments. The Mass is an ordered, (theo)logical sequence of elements that lead the gathered communicants to the culminating action of Holy Communion. A simple summary might go like this:

We begin by invoking God, acknowledging his holiness and majesty. To do so is to recognize penitentially our unworthiness to stand before him. To be in his presence is to desire to know him more deeply, so we turn to his word in the Scriptures, receiving an application of that word to our own lives in the homily. We declare the summary of the Scriptures in a creed shared by the whole Church. We demonstrate in collective prayer

that we have understood the teachings and seek to apply them to the circumstances of our community's life. We prepare to follow the instructions given by our Lord at his Last Supper, following the formula of the early church, by making peace among ourselves. We bring forward our offerings, preparing ourselves for receiving these gifts back as Christ's own body and blood. In the light of the summary of God's work of salvation in the Eucharistic Prayer, we receive the sacrament, remembering his death, proclaiming his resurrection, and awaiting his return in glory. Thus confirmed and comforted in our faith, we are sent out as Christ's body in the world to do the work he has given his people to do.

The Lectionary

The part of the Mass given to a systematic reading of the Scripture—the *lectionary*—brings together passages from the Old Testament, the Psalms, and the Epistles of the New Testament. These are selected and collated so as to shed light on the culminating reading of a passage from the Gospels that contains the words of Christ himself. Said in reverse, the Gospel passage illuminates the life and work of Christ as a fulfillment of a work of God that unfolds through history past, present, and future.

The sequence of readings trains the congregation to have eyes to see how the figures and events of the Old Testament narratives point ahead to the deeds of Christ, sometimes prophetically foreshadowing them. (Explained in detail in part three of this book, this attentiveness to parallels between the Old and New Testaments is the matter of *typology*.) The Psalms give human voice to the core emotions of those who, like David, seek God, lament injustice, grieve over their own sinfulness, and so forth. The Psalm, we might say, sets up our interior to receive the Gospel. The Epistle amplifies the lessons, providing the Church with the authoritative responses of the apostles to the life and teachings of the Lord they knew in the flesh.

As the written word that testifies to the Word who came to dwell in our midst, the passage from the Gospel has customarily, in Catholic tradition, been read in the midst of the congregation, attended by signs and signals (incense, chanting, decorated Gospel book, and so forth) that help the gathered company to hear the words of the Lord with all ears.

For us folk of the Gutenberg age (and now of the generation of the electronic book, and of Bible apps on our smartphones), it will take a diligent effort of the historical imagination to digest the fact that our own experience of Bible reading—from inexpensive copies in multiple versions chosen according to individual preference, available for private reading at any moment of the day—is a distinctly modern phenomenon. In the longer sweep of the history of the Church, people received the Bible by hearing it

in the corporate reading of the Scriptures in the context of a liturgy. For the scholars, most often members of monastic communities themselves, who shared precious manuscripts of Scripture and commentary among their community, the Scriptures were all the more associated with their corporate liturgical life, chanting the entire Psalter, for instance, in a repeated weekly or monthly cycle.

Modern readers (certainly those in the Protestant tradition) are more likely to study the Scriptures with an *exegetical* orientation toward word studies, perhaps with a concordance or study Bible in hand that links texts where the word "grace" is used, and so forth. Kids from earnest Protestant evangelical families and churches (at least until recent generations) were set to memorize passages according to "chapter and verse," rather than by the story sequences by which the Catholic lectionary is organized. For the premodern Church, associations among passages were much more the effect of the lectionary, highlighting narrative parallels between the Old Testament, Psalms, and the Gospels. The laity were trained in what we might identify as the method Jesus used when talking to the two discouraged disciples on the road to Emmaus: "And beginning with Moses and all the Prophets, he explained to them what was said in all the Scriptures concerning himself" (Luke 24:27).[3]

It is important to underline that these associations among passages, and of passages with particular holy-days and seasons of the church year, were shared by a community rather than being idiosyncratically personal. That is, we're not talking about an individual just happening to read the passage in Mark during her morning quiet time about the signs of the end times and calling to mind Paul's word in Romans 13.[4] The connection is

[3] For a single example, among the readings available for Epiphany would be Isaiah 60:1–9 (". . . the Lord rises upon you and his glory appears over you. Nations will come to your light, and kings to the brightness of your dawn . . ."); Psalm 72 ("May the kings of Tarshish and of distant shores bring tribute to him. May the kings of Sheba and Seba present him gifts. May all kings bow down to him and all nations serve him"); Ephesians 3:1–13 ("his mystery is that through the gospel the Gentiles are heirs together with Israel, members together of one body, and sharers together in the promise in Christ Jesus"); and one of the Gospel passages recounting the journey and adoration of the Magi, such as Matthew 2:1–12. In the light of the other readings, we see the Three Kings—following the star, bearing their gifts—not as a strange one-off event but as signaling the inauguration in humility of a King of kings long prepared for, from whose merciful scepter no peoples are excluded.

[4] Mark 13:24 and 13:33 read, "'the sun will be darkened, and the moon will not give its light; the stars will fall from the sky, and the heavenly bodies will be shaken. . . . Be on guard! Be alert! You do not know when that time will come. . . .'" Romans 13:11–12 includes Paul's exhortation that "the hour has already come for

made for everyone, every year of their collective lives on the first Sunday of Advent, as they hear together the passages in the Gospels and the Prophets and Epistles and Revelation concerning the end times and the second coming. Why in Advent? As a perennial reminder to the flock that its preparations to celebrate Christ's first coming ought to be in a penitential mode of remembering why he came as a babe, and preparing (like the wise virgins with their lamps trimmed, and not the foolish virgins) for his second coming in glory to judge the living and the dead.

The Sermon

The opportunity for the priest or bishop to preach a sermon in the Catholic-tradition liturgy comes immediately after the lectionary readings. The homily is not a liturgically-necessary element of the Mass (in contrast to the tradition of Protestantism in which the sermon is *the* necessary element in the typical "shape of the liturgy"). The four elements of the lectionary are understood to be sufficient for the hearing of God's word; they are allowed, we might say, to "speak for themselves," to comment on one another. When a passage from one of St. Paul's letters is presented by the lectionary as thematically related to the Gospel passage, then the sense is that St. Paul is "doing the preaching."

The importance of the lectionary readings is evident in the architecture and furniture that physically framed the "liturgy of the word" in the Mass. Pulpits occasioned the same attention to craft in their construction and decoration as did altars and baptismal fonts. They could be enormous freestanding structures, or attached to one of the supporting columns of the nave, reached by a stairwell attached to the pulpit.

Acoustics were an issue in huge and high spaces without amplification systems; the preacher had to be located where the crowds of people could hear. Pulpits were often installed not near the altar but in a more central location down in the nave. To preach from the word of God while in the midst of the people added resonance to preaching about a Word of God who became incarnate and lived in the midst of the people.

The waist-high wall surrounding the lector (the reader of passages from the lectionary, often a deacon as well as a priest) would typically be divided into paneled sections according to the circular or polygonal form of the pulpit. In one notable pulpit sculpted by Giovanni Pisano for the Church of Sant'Andrea in Pistoia, its liturgical function is highlighted by the small stat-

you to wake up from your slumber, because our salvation is nearer now than when we first believed. The night is nearly over; the day is almost here. So let us put aside the deeds of darkness and put on the armor of light."

ues placed at the angles between the panels.* These statues depict the figure of the deacon along with the figures of the evangelists and Epistle-writers.

The intense decoration often bestowed upon these panels does not typically focus on Jesus himself as preacher and teacher (as one might expect, perhaps delivering the Sermon on the Mount, or explaining parables to his disciples). Rather, what is featured are episodes concerning Christ's Nativity and his Death, Resurrection, and Return in Judgment. That is, the depicted episodes underline the *incarnation* of a God who saves us not only by the words of his mouth but also by the deeds of his flesh.

This is certainly the case with the series of four remarkable pulpits, including the one in Pistoia, created over five decades from the 1250s to 1311 by Giovanni Pisano and his father Nicola. While quite different both in the form of their construction and in the design of the narrative panels, all are similar in the scenes chosen.

The first of these commissions was the pulpit in the baptistry in the cathedral complex in Pisa, completed by Nicola around 1260, hexagonal in form.* The five available panels (the sixth being the entrance from the stairwell into the pulpit) depict the Annunciation, the Nativity, and the Adoration of the Shepherds all squeezed into the first panel, followed by separate panels depicting the Adoration of the Magi and the Presentation of Baby Jesus in the Temple. But then comes the big jump in time over the years of Christ's ministry, to the Crucifixion and the Judgment. These last scenes frame the lectern immediately above them.

In Nicola Pisano's next commission—the pulpit for the Siena cathedral—his son Giovanni assisted in the work.* The seven panels available on this octagonal pulpit depict, respectively, the Visitation of Mary and Her Cousin Elizabeth along with the Nativity; the Journey and Adoration of the Magi; the Presentation of Baby Jesus in the Temple and the Flight into Egypt; the Massacre of the Innocents (a vivid reminder of the costliness of this flesh-and-blood immersion of God in human history); and finally the Crucifixion and the Last Judgment. This final scene unfolds over two panels with a statue of the figure of Christ at the corner between the damned to his left and the saved to his right.

After his father's death, Giovanni Pisano came into his own, first completing the pulpit in the church of Sant'Andrea in Pistoia in 1301, and then the monumental circular pulpit in the cathedral of Pisa during the following decade.* There the passion narrative is expanded with scenes of the Betrayal of Christ and his Mocking and Flagellation.[5]

[5] The five scenes in the hexagonal pulpit in Pistoia are: the Annunciation and Nativity; the Adoration, the Dream of the Magi, and the Angel Warning Joseph in one panel; the Massacre of the Innocents; the Crucifixion; and the Last Judgment.

The altar may have served as the central piece of furniture in a Mass whose primary movement is toward the Eucharist, but the pulpit was hardly neglected. Although the sermon was an optional supplement to the lectionary, this did not mean that preachers and preaching were undervalued during the age that frames this book. Quite the contrary. Certainly for the Franciscan and Dominican orders, preaching was at the heart of their mission.

A number of the highest-profile figures of the age were the great preachers from the mendicant orders. Saint Bonaventure gives an entire chapter of his *Life of St. Francis* to the power of the saint's preaching, a power that did not come from fancy human rhetoric. Golden-tongued St. Anthony of Padova (who preached to the fish as well as to throngs of people) and San Bernardino of Siena were enormously popular Franciscan preachers. Saint Dominic, the founder of the order of preachers, was followed by St. Thomas Aquinas, St. Peter Martyr, among others, and by the controversial and reformist Dominican Fra Girolamo Savonarola. While Savonarola was abbot of Monastery San Marco in the 1480s and '90s, crowds filled the enormous cathedral of Florence to hear his charismatic sermons denouncing corruption in the church, decrying the exploitation of the poor and despotism among rulers, and exhorting the wealthy to bring their "vanities" to bonfires on the piazza of the town hall.[6]

Several recent scholars have highlighted the skillful use of visual imagery by the great preachers of the period. And the close relation of the visual arts to preaching went in both directions, with artworks influencing how preachers approached the scriptural episode, and sermons influencing how the artists represented scenes from Scripture.

This effect is addressed by Michael Baxandall in his thin but highly influential book, *Painting and Experience in Fifteenth-century Italy.* Baxandall takes up the example of a widely popular preacher, Fra Roberto Caracciolo da Lecce, noting that "in the course of the church year, as festival followed festival, a preacher like Fra Roberto moved over much of the painters' subject matter, explaining the meaning of events and rehearsing his hearers in the sensations of piety proper to each."[7] Baxandall follows in detail a sermon preached by Fra Roberto in Florence on the Annunciation (Luke 1:26–38). The final of the three "mysteries" of the Annunciation, as explained by Fra Roberto, is called the Angelic Colloquy, wherein the exchange between Gabriel and Mary unfolds in a five-part sequence. Her reactions exhibit the five "Laudable Conditions of the Blessed Virgin," namely, her initial *disquiet* followed by her *reflection, questioning,* and *sub-*

[6] One of the most controversial figures of the age, Savonarola was eventually burned at the stake on the same spot for heresy and inciting schism.

[7] Baxandall, 49.

mission, signaling her *worthiness* to conceive the Son of God.[8] Baxandall refers to a number of paintings of the Annunciation to show that these stages in "Mary's response to the Annunciation . . . very exactly fit the painted representations."

> Most fifteenth-century Annunciations are identifiably Annunciations of Disquiet, or of Submission, or—these being less clearly distinguished from each other—of Reflection and/or Inquiry. . . . The last of the five Laudable Conditions, *Meritatio,* followed after the departure of Gabriel and belongs with representations of the Virgin on her own, the type now called *Annunziata.*

Baxandall's conclusion: "The preachers coached the public in the painters' repertory, and the painters responded within the current emotional categorization of the event."[9]

I would like to underline a more general lesson illustrated by Fra Roberto's sermon about the Annunciation and the scores of altarpieces depicting the scene. And that is simply that people's individual and collective experience of the Scriptures and of Christian faith was organized—to an extent no longer at work in our own age—by episode: by short sequences of narrative that were easy to identify.

[8] Fra Roberto's summary is as follows (Baxandall, *Painting and Experience,* 51, 55, italics original):

> The first laudable condition is called *Conturbatio;* as St. Luke writes, when the Virgin heard the Angel's salutation—*"Hail, thou art highly favoured, the Lord is with thee: blessed art thou among women"*—she was troubled. . . . Her second laudable condition is called *Cogitatio*: she *cast in her mind what manner of salutation this should be.* This shows the prudence of the most Holy Virgin. . . . The third laudable condition is called *Interrogatio.* Then said Mary unto the angel, *How shall this be, seeing I know not a man? . . .* The fourth laudable condition is called *Humiliato.* . . . Lowering her head she spoke: *Behold the handmaid of the Lord.* . . . And then, lifting her eyes to heaven, and bringing up her hands with her arms in the form of a cross, she ended as God, the Angels, and the Holy Fathers desired: *Be it unto me according to thy word. . . .* The fifth laudable condition is called *Meritatio . . .* When she had said these words, the Angel departed from her. And the bounteous Virgin at once had Christ, God incarnate, in her womb, according to that wonderful condition I spoke of in my ninth sermon.

[9] Baxandall, *Painting and Experience,* 55. A similar circularity occurred at times between theater scenography and representations of episodes in paintings. Sometimes the staging of scenes in the popular street theater of "sacred representations" followed the depictions of the episodes typically found in paintings; and painters sometimes imitated the theatrical scenography of episodes in their paintings. See Timothy Verdon's essay, in Italian, "Scenografia ed effetti speciali," *Vedere il Mistero: il genio artistico della liturgia cattolica* (Milan: Mondadori, 2003), 124–36.

One can imagine how this pervasive and shared lens was habituated in the folk of the age. When everyone grows up (a) seeing *image after image* of Mary's encounter with the Angel Gabriel, images with manifold variety in style but following a typical format (namely, Gabriel on the left, Mary on the right, enclosed by but not shut behind an arched portico); and (b) listening to *sermon after sermon* that reflects on this frameable event, because the sermon is a response to the *reading of this episode* year after year as the featured passage of Scripture in the *lectionary* established for the liturgical feast day of the Annunciation (on March 25, nine months before Christmas); (c) all the while celebrating this event year after year with customary meals and clothes and processions and theatrical enactments among family, neighborhood, parish, town—well, one can imagine that the event can be *named.* The episode of the "Annunciation" takes on clear borders in the eye, the mind, the devotionally-oriented heart, and in the gestures of the body itself.

Now multiply this one event in the life of Mary and Jesus—and in the believer's life—by dozens of other identifiable episodes rehearsed systematically in the lectionary of the Mass and the holy-days celebrated annually during the church year:

> Annunciation—Visitation—Nativity—Adoration of the Shepherds—Adoration of the Magi—Presentation in the Temple—Flight into Egypt—Massacre of the Innocents—Baptism—Triumphal Entry into Jerusalem—Last Supper—Betrayal—Arrest—Scourging—Crucifixion—Deposition—Burial—Resurrection—'Noli me Tangere' (the "Do not touch me" scene of Mary Magdalene meeting Jesus in the garden, first mistaking him for the gardener)—Ascension—Pentecost . . .

Here I have simply begun the list of the customary names given to the episodes that (a) are framed in the lectionary readings associated with particular days in the church year, (b) are common in thousands of paintings and sculptures, (c) were dramatized in the cycles of "mystery" plays performed in towns throughout Europe for centuries, (d) were celebrated with special devotion by various confraternities, and hence became fundamental categories of the period mind during many centuries of Christian history and culture.

I've wanted to help us understand how the lectionary, lectionary-based preaching, and lectionary-linked visualization together trained people to "learn by episode." For centuries of Christendom, the Scriptures were experienced and remembered not by chapter and verse but as a series of episodes that, together, form a narrative that unfolds over the course of the year, and is repeated year after year.

7

THE CHURCH YEAR AND THE DAILY OFFICE

During the centuries of Europe-wide Christendom, a liturgical calendar common to everyone brought communities large and small into a collective experience of a shared set of rhythms. To use the distinction which will be developed further in the next chapter, this liturgical calendar framed the passage of time not as *chronos*-time but as *kairos*-time—time experienced not as flat sequence but rather with narrative direction, with opportunities to be grasped and occasions to be celebrated.

Such a society-wide experience of a shared annual cycle has largely eroded in modern Western societies, or is maintained only on a much smaller scale among tight-knit ethnic or religious communities. As our contemporary Western society digests the fact of its increasing ethnic and religious pluralism, we introduce an increasing variety of holidays into the annual school and civic calendars to promote respect and appreciation for a vast array of events, values, and people. Such holidays resonate thinly with individuals and subcommunities whose identity is not deeply marked by the histories embedded in them. In fact, most of us nowadays operate in the midst of overlapping and often competing calendars: the "calendar year" beginning with New Year's Day, the academic year, the professional sports year, the work year with its own internal rhythms (often experienced in terms of looking forward to the vacation period), the tax year, and so forth. Conflicts between these years are felt when, for example, some of us are sorely tempted to miss church when the Wimbledon final is televised Sunday morning!

Living in this context, it is difficult for us to imagine a culture of shared liturgical rhythms, shared civic celebrations, shared emotions of anticipation and satisfaction, shared senses of slowness or accelerated density of time or significance that affect the entire community.

In medieval and Renaissance Italy, communities shared the time and rhythms of a single *liturgical calendar*. The liturgical "seasons" during the first half of the church year (from the four Sundays prior to Christmas

until June) helped worshippers relive the events of Jesus's incarnate life among us.[1] The second half of the year (from June through November) begins with Pentecost (the birth of the Church) and sets before the Church the so-called ordinary time of the life and work in the present age between the times of Christ's first and second coming. The church year concludes with liturgical focus on the resurrection of the dead, and on Christ's reign as the eternal king whose return in righteousness and judgment is ever imminent. Anticipation of Christ's Second Advent dovetails with the return to his First Advent. Worshipers are led to be penitentially mindful that it is our sin and disobedience that is the cause of the adorable babe lying in the manger. The liturgical cycle begins again.

The liturgical year served as a common social calendar of the passage of time, and a pervasive influence on the "telling of time." To be sure, varying degrees of resonance and weightiness among holy-days operated at the localized level of the family, the neighborhood, and the town. Each family's set of births, weddings, confirmations, and deaths were associated with the season or holy-day that framed the event. In much of European Christendom, the annual celebration of the holy-day of the saint after whom one was named was as important as the calendar date of one's birthday.[2]

The holy-days focused on Mary, for instance, took on a higher profile in towns for whom the Virgin was the patron saint. The holy-day of Corpus Christi (celebrated the eighth Thursday after Easter, with processions on the Sunday after Trinity Sunday) was and remains huge in Orvieto, a sort of pivot point of the town's experience of the annual cycle, because the Holy-day was inaugurated in Orvieto in 1264 by Pope Urban IV. The two holy-days concerning the Holy Cross (the now-minor feast day of the Finding of the Cross on May 6 and the major feast day of the Exaltation of the Cross on September 14) were close to the hearts of the Franciscans, as they followed in their founder's devotion to the cross. The two most prominent Italian fresco cycles about the Legend of the Holy Cross are found in the Franciscan churches in Florence (Santa Croce) and Arezzo (San Francesco).

[1] Advent, Christmas, Epiphany; Ash Wednesday, which begins the forty-day season of Lent; Holy Week from Palm Sunday to Maundy Thursday, Good Friday, and Holy Saturday; Easter to Christ's Ascension.

[2] One of the first questions asked of me by the mother superior of the convent where our semester program was first housed was "Which John are you named after?" Appreciating that we shared the same name—Giovanna/Giovanni; *John* in feminine and masculine form—she was curious whether I was named after John the disciple and evangelist, as she was, or John the Baptist.

Chapel Decoration and Holy-Days

We return again to the theme of part two of this book: that artworks were constantly experienced through sacramental and devotional actions in the time, the space, and the practice of the liturgies associated with particular events and holy-days. The altarpiece of a church or chapel almost always highlighted the "patronal" feast of the church, as could the surrounding wall frescoes and other elements of the decoration. Particular days in the liturgical year were celebrated with greater pomp and circumstance in churches dedicated to the great mysteries of the faith (the Trinity, Pentecost, All Saints, Corpus Christi, and so forth) or to the apostles whose significance concerns the whole Church.

For example, the frescoes about the life of St. Peter in the Brancacci Chapel have personal significance for the family (since Peter is the "patron saint" of its *paterfamilias* Pietro Brancacci, who funded the chapel), but the choice and arrangement of the episodes also are distinctly associated with the holy-days that honor St. Peter and are celebrated by the entire Church. As Steffi Roettgen explains, one of the principles of arrangement—the guide for deciding where on the walls of the chapel to locate particular episodes from Peter's life—is to bring together the scenes that "clearly relate to the saint's major feast days":

> On the left are the events that took place in Antioch and that are remembered on the day of Peter's enthronement (February 22): the awakening of the son of Theophilus, his visit from Paul in prison, and Peter in Cathedra. On the right are scenes associated with the saint's other two feast days, his liberation from prison (June 29) and his crucifixion (August 1), as well as his previous dispute with Simon Magus. Aronberg Lavin . . . has spoken of this arrangement as "festival mode," by which [s]he means that these events relating to feast days have been placed as close as possible to the viewer. They could thus be integrated into the annual celebrations of these festivals, a function enhanced by the fact that it is in these scenes that portraits of living contemporaries appear.[3]

I underline: the liturgies of the church year (and not only the source texts and the themes to be highlighted) have an influence on which scenes are selected for inclusion and on their placement in the larger design of a space. We enter the story through the liturgy—through the transparent membrane between the liturgical action occurring on the floor of the

[3] *Italian Frescoes: The Early Renaissance 1400–1470*, trans. Russell Stockman (New York: Abbeville Press, 1996), 94. Marilyn Aronberg Lavin's definition of "festival time" and her discussion of the Brancacci Chapel itself are found in *The Place of Narrative* (Chicago: University of Chicago Press, 1990), 107, 131–38.

chapel on particular holy-days and the action occurring on the walls surrounding the worshippers.

Another example of the same thing occurs in the private chapel in the palazzo of the Medici family in Florence.* The frescoes depicting the journey of the Magi to offer their gifts to the Christ child cover every square inch of the walls, creating a three-dimensional experience for the gathered worshippers even more "embodied" than the "virtual reality" that we now passively experience at the cineplex. One of the Kings is featured on each wall, and, following an ancient tradition that they represent the three ages of man, the oldest one leads the way, the middle-aged king comes second (on the rear wall of the chapel), and the young king takes his place at the rear. He is followed by an enormous company of folk, dressed in contemporary garb, with many clearly identifiable portraits, including three generations of the Medici family (Cosimo, his son Piero, his son Lorenzo). The family participates both on the walls and through their own actions on the floor.

The space and its decoration would have entered into the highest degree of resonance—of layered parallel actions—every January 6 in the liturgy of Epiphany. The frescoes assist the liturgy of the Mass, and the holy-day of Epiphany itself, by placing the worshipping family and their friends inside the action of processing to adore the baby Jesus. Bringing gifts to the altar parallels the action of the Magi. Secondly, the frescoes depict the journey itself as a liturgical procession—not three cold and muddy men trekking from the East following the star, but a splendid procession with an entourage of hundreds, dressed to match the importance of the occasion of the Epiphany—of the revelation of the Jewish Messiah to the gentiles. These kings come to adore The King; a King of the Jews, but a Savior for those called and invited from the ends of the earth.

Thirdly, the frescoes surely also depict the confraternity of the Three Kings, whose "liturgy" (work) was to reenact the journey of the Magi. As Steffi Roettgen explains,

> The caravan presented in these wall paintings is also frequently associated with the processions regularly staged in Florence by the brotherhood of the Holy Three Kings, which had its headquarters in San Marco. These took place on Epiphany, and in them the many prominent Florentine patricians who were members of the brotherhood publicized their readiness to share their wealth with the Church. The Medici had special ties to that fraternity. . . . We know from descriptions of those processions that they were marked by an almost unimaginable display of color and precious fabrics. On their surface, at least, as filled with priceless objects and splendid costumes as they are, Gozzoli's paintings surely do reflect feast-day processions of that sort and help us to imagine how splendid they must have been. . . . Cosimo even had a cell in

the monastery reserved for his own use, to which he would retire for prayer and atonement [*sic*]. It can hardly be coincidental that this particular cell is adorned with a painting of the Adoration of the Kings.[4]

Such a tapestry of interwoven connections between the feast of the Epiphany, the devotion of the Medici to the Magi, the confraternity of the Magi, the procession through Florence with Medici participation, the cell fresco in Monastery San Marco of Cosimo, and the palazzo chapel painted by Gozzoli provide a rich example of a liturgically-ordered society and the role of art in linking liturgy, family, confraternity, and town.

Corpus Christi Day and the Chapel of the Holy Corporal in Orvieto

The Chapel of the Holy Corporal in the left transept of the Orvieto Duomo provides another powerful example of art at work in the *place of liturgy*. In this case, the chapel is associated with the feast of Corpus Christi, a "moveable feast" celebrated on the eighth Thursday after Easter (hence sometimes in May, other times in June). This is the holy-day established in Orvieto itself in 1264 through Pope Urban IV's bull *Transiturus*. In this "Solemnity of the Body of Christ," the faithful are invited to step back from the daily or weekly performance of the Mass, and to behold the sacrament of the real presence of Christ in the Eucharist ("This is my body, this is my blood . . .") as reflecting the mystery of God's *incarnational* mode of operation, as we might call it, from start to finish.[5]

The art in the Chapel of the Holy Corporal works as a constant reminder that the people of God are the body of Christ in the present age, framing the Eucharist as a foretaste of the banquet of the Lamb in an eternal kingdom where we enjoy not gnostic escape from the flesh but new and redeemed and perfected bodies.* Old Testament "meals" long interpreted in Catholic tradition as prefiguring the Last Supper and Holy Communion are illustrated in the four triangular sections of the ceiling immediately above the altar. Abraham makes his offering of wheat and wine with

[4] *Italian Frescoes: The Early Renaissance 1400–1470*, 331. See Franco Cardini, *The Chapel of the Magi in Palazzo Medici* (Florence: Mandragora, 2001), 27–36 for a good discussion of the Medici involvement in the Epiphany processions.

[5] Here is one passage from *Transiturus de Hoc Mundo*: "As [Jesus] was about to ascend into heaven, he said to the Apostles and their helpers, I will be with you all days even unto the consummation of the world. He comforted them with a gracious promise that he would remain and would be with them even by his corporeal presence. Therefore he gave himself as nourishment, so that, since man fell by means of the food of the death-giving tree; man is raised up by means of the food of the life-giving tree. Eating wounded us, and eating healed us." Accessed on May 30, 2016. http://the-american-catholic.com/2015/06/07/transiturus-de-hoc-mundo/.

Melchizedek (foreshadowing Christ's Eucharistic offering). Abraham hosts the three angels for dinner under the Oaks of Mamre, at which he receives the good news that he and Sarah will have an only-begotten son. God provides manna to the Israelites in the desert. God sends a raven to provide food for Elijah waiting in the desert for God to act.

Dominique Surh was the first modern scholar to point out the correlation of all these scenes with the examples of Old Testament "types" of the Eucharist given by Thomas Aquinas in the set of liturgies that he prepared for the feast of Corpus Christi at the pope's request, while he was a resident at the Dominican monastery in Orvieto.[6] Depictions of Aquinas before the pope and of his presentation of the finished text, are among the scenes frescoed on the wall of the Chapel.*

Especially for the local Orvietani, the holy-day that began in their own town has another very powerful resonance. As the story is traditionally told, in 1263 a priest from Prague was making a penitential pilgrimage to Rome to reconcile his conscience with the doctrine of the real presence of Christ in the elements of Holy Communion, formally articulated as official doctrine fifty years earlier (at the Fourth Lateran Council in 1215). Following the standard pilgrims' route from northern Europe through east-central Italy to Rome, he stopped at the hostel-church of Santa Cristina in the lakeside town of Bolsena, only a few miles from Orvieto. While celebrating Mass, at the elevation of the Host, drops of blood miraculously dripped from the wafer onto the corporal (the small tablecloth placed on the altar under the chalice and paten), seeping through even to the stone-topped altar itself. Pope Urban IV, in residence in Orvieto, called for the corporal to be brought for inspection and adoration to Orvieto, meeting it ceremonially at the bridge down in the valley below the city.[7]

Within a few decades, Orvieto's still-majestic cathedral was under construction, and for centuries the "relic" of the stained cloth has been displayed above the altar of the transept chapel "of the Holy Corporal." By 1330, a splendid gold and silver reliquary had been crafted for the safe-

[6]Dominique Surh, *Corpus Christi and the Cappella del Corporale at Orvieto* (University of Virginia, 2000). Complete versions of the liturgy, in Latin and English, of all three main variants now held in several European libraries are found, along with an extensive introductory essay, in *The Feast of Corpus Christi*, edited by Barbara R. Walters, Vincent J. Corrigan, and Peter T. Ricketts (State College, PA: Penn State University Press, 2006).

[7]This is the traditional account, although there's a gap of half a century between the presumed date of the events and the first time the story was put into word and image. Saint Christina is the young local teenager martyred for her faith before the legalization of Christianity, whose burial place was extended with a network of catacombs.

keeping and display of the cloth, containing small panels of enameled glass depicting the narrative. By the 1360s the local painter Ugolino di Prete Ilario had completed the commission to decorate the chapel with scenes from the same narrative (and with scenes from other so-called Eucharistic miracles frescoed on the opposite wall).*

Imagine the resonance, the intense and condensed emotions still experienced by faithful Catholics, of celebrating Holy Communion in the chapel dedicated to celebrating a salvation history punctuated by meals marking the real presence of God among us, following a liturgy enacted according to a script written in their town and represented visually on the ceiling, framed by frescoed walls depicting liturgies: of the Mass in Bolsena that vividly illustrated the real presence of Christ in Communion, of the liturgical process of the corporal from Bolsena to Orvieto, of the liturgical delivery of the finished "work" of St. Thomas to the pope. Painted liturgy within painted liturgy within actual liturgy!

The Holy-Days of the True Cross and Piero della Francesca's Fresco Cycle

Although no longer high profile church holy-days, the liturgical celebrations of the Finding of the Cross (May 3) and the Exaltation of the Cross (September 14) served for many centuries as occasions for Church-wide focus on the cross, both as the physical bearer of the crucified Jesus and as the metonym for the great mystery of Christ's atoning sacrifice for humankind. (The feast day of the Exaltation of the Cross has occasioned hymns such as "Lift High the Cross," still sung with gusto in many churches that follow the church year.)

The historical prompt for the holy-day is not the scriptural account of the Crucifixion but rather the stories surrounding Emperor Constantine's dream of the cross (*in hoc signum*, through this sign you will gain victory) and then his mother Helena's efforts to find the True Cross itself, thought to be buried in Jerusalem. The stories were collected in all their variations and amplifications by a Dominican scholar-friar from Spain, Jacobus de Voragine, in his encyclopedic compendium of sources for the church year. Referred to as *The Golden Legend*, Voragine's book became the "go-to" reference manual not only for clergy and scholars but for artists and their advisors as well, as they plotted out the visual design of narratives linked to the liturgical calendar.[8]

[8] *The Golden Legend* collates material from the three sources of Scripture, commentary from the church fathers, and extra-biblical apocryphal writings, organized according to the liturgical calendar of all the holy-days that comprise the church year. While initially entitled *Legenda sanctorum* (*Readings of the Saints*), it

The Golden Legend was almost certainly the immediate sourcebook for Piero's visual telling of the Legend of the Holy Cross. As Voragine indicates, the stories of Helena's Finding and then the Byzantine Emperor Heraclius's Exalting of the stolen-and-recovered Holy Cross were amplified into a coherent (if apocryphal) narrative of how the wood of the tree of our fall became, through its peregrinations through history, the wood from which the cross of the crucifixion was fashioned. The tree of our fall became the "tree" of our redemption. The tree whose fruit bore the poison becomes the tree whose fruit provides the antidote.[9]

Saint Francis's devotion to the cross marks a sort of framing of his life, from the beginning of his mission when the crucifix in the dilapidated church of San Damiano speaks to him ("Repair my Church") to the time near the end of his life when the marks of Christ's wounds on the cross appeared on his own body during a retreat on Mount La Verna. Thus it is not surprising that, in St. Bonaventure's official *Life of St. Francis*, he receives the stigmata "on a certain morning about the feast of the Exaltation of the Cross."[10]

The holy-day of the cross thus carried a double reverberation for Franciscan communities: a day to celebrate the devotion of their founder for the cross of Christ, and the day when their founder was given the gift of sharing the wounds of the cross. Hence, it makes sense that the two monumental fresco cycles commissioned to narrate visually the Legend of the Holy Cross are located in the churches of two Franciscan monasteries. Agnolo Gaddi's fourteenth-century treatment decorates the apse of

can be understood as an encyclopedic reference book not so much for the laity as for clergy and the scholars in the monastic communities—and very useful for the artists called to give visual form to the stories of Scripture and Christian history. *The Golden Legend* was designed for those people involved, as we might say, in "packaging" the liturgy for the laity, writing homilies, doing catechesis, preparing the visual imagery that surrounded the worship experience of the people. Within decades after its compilation in the 1260s, Voragine's compendium had spread throughout Europe. Hundreds of manuscripts still exist, and in the period after the invention of the printing press, it was printed in more editions than the Bible itself.

[9] Although without grounding in the canon of Scripture, the legitimacy of the *idea* lies in its parallel with Paul's discussions in Romans 5:12–18 and 1 Corinthians 15:20–22, 45–48 on the old Adam and the new Adam, how through one man came sin and through one man salvation on the wood of the cross. The mystery of the cross invites us to reflect on the paradox from the wood's point of view of bearing a common criminal who in fact is the Son of God who comes to redeem the whole world and becomes King of the Universe. In fact, the personification of the cross occurs in early medieval poems such as the Anglo-Saxon "Dream of the Rood."

[10] Chapter thirteen; cited from the Classics of Western Spirituality edition of Bonaventure's works (Mahwah, NJ: Paulist Press, 1978), 305.

Santa Croce—*Holy Cross*—in Florence. Piero della Francesca's version, introduced in chapter three, was made in the mid-fifteenth century for the apse of the church of San Francesco in Arezzo, a work of art recognized as one of the supreme masterworks by one of the great masters of the Italian Renaissance.

The fact that this famous fresco cycle was directly associated with two paired holy-days in the liturgical calendar goes unnoticed by most contemporary art tourists, and is typically given scant attention by the art historians whose books modern readers turn to for photographs of Piero's work.

Plenty of scholars and art historians, however, have attempted to describe the ethos of attentive stillness and pregnant silence often recognized as a hallmark of this remarkable artist's style, evidenced especially in the rapt gazes of the principal figures. The liturgical setting of Piero's frescoes helps us comprehend the effect.

By "liturgical setting" I mean not only the church setting in which the frescoes exist, or their correlation with a holy-day in the liturgical year, but how Piero has depicted the demeanor of the characters in the frescoes.

In chapter five, which began part two of this book, I referred to the bodily disposition of slouching, of slovenliness, that often marks the demeanor of contemporary youth culture, or of any community that is uncertain or disdainful of its work, or lethargic because they are not convinced of its purpose and value. I am reminded of T. S. Eliot's phrases in *Four Quartets* about "the general mess of imprecision of feeling, / Undisciplined squads of emotion" ("East Coker," lines 181–182). By contrast, when the "work of the people" is clear, *choreography* sets in—graceful precision of movement without waste, sloppiness, or extraneous action. Another passage in *Four Quartets* about poetry applies equally well to liturgical action:

> The word neither diffident nor ostentatious,
> An easy commerce of the old and the new,
> The common word exact without vulgarity,
> The formal word precise but not pedantic,
> The complete consort dancing together. ("Little Gidding," lines 119–123)[11]

We witness such highly-controlled coordination of the body—every muscle engaged, not a fiber of laxity—among highly skilled athletes (Usain Bolt running the 100 meter dash; the soccer player executing the bicycle kick into a corner of the net); among professional performance artists (the dancers in the ballet; the entire corps moving in precise synchronicity); in the master-chef whisking the sauce, slicing the vegetables, arranging the dish on the plate.

[11] T. S. Eliot, *Four Quartets* (New York: Harcourt, Brace, Jovanovich, 1971).

And we hope to see it in the priest lifting first the paten of wafers and then the chalice of wine as he or she says the Great Prayer of Thanksgiving at the culminating moment of the Eucharist, or when the congregant joins her voice with that of the entire company, saying or chanting "Christ has died, Christ is risen, Christ will come again." This is not of the same order as reciting one's intentions for the weekend ("Yesterday I cut the grass. This morning I bought bagels. This afternoon I will watch the big football game"). It is a weighty and solemn declaration of the fundamental events on which the outcome of history and the hope of humankind depend. It is not to be mumbled, but said together as one clear voice, standing up straight—no slouching, no hands in pockets, no ringing of the cell phone. The work of the liturgy is to express and embody the maximally appropriate response to the truth of the event being rehearsed.

Piero della Francesca's figures—their faces and postures—exhibit (and model) this sort of concentrated attention to the implications of the event, to the momentousness of what they are beholding. In their rapt concentration, we can see that in the silent stillness all worldly static has been eliminated. We can speak of their *liturgical* demeanor.

In his depiction of the queen of Sheba kneeling before a large yet ordinary-looking trunk-sized beam of wood placed across a stream to serve as a footbridge, hands folded in prayer, Piero evokes a sense that she is beholding that beam according to its past and its future, its destiny of bearing the Savior of the world.* As the scene is described in the *Golden Legend,*

> When the queen of Sheba came to hear Solomon's words of wisdom and was about to cross this bridge, she saw in spirit that the Savior of the world would one day hang upon this very same wood. She therefore would not walk on it but immediately knelt and worshiped it.[12]

When the Empress Helena bows in rapt adoration as one of the three dug-up crosses, passed over the body of a man on his way to be buried, raises the man to new life, the subtle tilt of her head indicates a gaze that sees the power of the cross making its way backward and forward through the vast reaches of history, mainly underground, not seen because it was not looked for.*

The very sequence of the gestures of Helena's attendants may signal the stages of appropriate response to a miracle. The lady-in-waiting on the left opens her arms in the gesture of amazement at witnessing a stunning and unprecedented event. The next lady has crossed her arms on her chest, the

[12] From the edition translated by William Granger Ryan (Princeton, NJ: Princeton University Press, 1993), 1:278.

appropriate demeanor of humble reticence as one begins to conceive the momentousness of an action that one is not worthy of witnessing. Empress Helena kneels before the cross, her hands folded in prayer—the proper end of beholding the unfolding of a stupendous and unfathomable mystery. The women model for us the comportment appropriate to every enactment of a sacrament—if we are fully attentive.

As a lover and teacher of Dante's *Divine Comedy*, I am reminded of Dante's description in the *Purgatorio* of one of the penitent souls focused on completing his sanctification: "When he had slowed the hectic pace / that mars the dignity of any action . . ." (canto 3, lines 10–11). The phrase encapsulates the demeanor both of the saved souls in purgatory and of the women in Piero's frescoes.[13]

[13]I cite Robert and Jean Hollander's translation, *Purgatorio* (New York: Anchor Books, 2004). Dante's liturgical framing of the *Divine Comedy* is everywhere apparent. hell is described as a cacophonous din of anti-liturgies. The work of the lukewarm souls who never made a commitment either to good or evil is to run aimlessly behind a meaningless flag. The greedy are divided into opposite groups of those who spent their lives hoarding the money they earned, and those who spent their money to acquire stuff. Their antiphonic "work of the people" is an infernal and eternal daily grind of rolling boulders in opposite directions around the ledge of the great funnel of hell until the two groups meet not in a passing of the peace but smashing into each other, only to turn around and do it again. And so forth.

But in Purgatory (understood by Dante and the church of his day as the place and time when the sanctification of those justified in Christ is brought to completion), the action is largely liturgical.

On each cornice of the imagined Mountain of Purgatory, the gathered souls of the redeemed sing together hymns appropriate to the work of cleansing a particular one of the old habits of the heart. Those who have arrived on the shores immediately kneel down and sing together Psalm 113: "*In exitu Israel de Aegypto*, When Israel went out of Egypt, the house of Jacob from a barbarous people: Judah made his sanctuary, Israel his dominion . . ." They do their spiritual exercises while reciting together the great prayers of the Scripture and the Church (Ps. 51, the Lord's Prayer, and so forth). They recite the Beatitudes with keen sense of the appropriateness of each blessed state for undoing its opposite. "Blessed are the poor in spirit . . ." is the chant of those who recognize the pride that has marred their single-minded love of God and neighbor. "Blessed are those who hunger and thirst after righteousness"(rather than after their next big helping of the succulent eels of Lake Bolsena stewed in Vernaccia wine, as Pope Martin IV openly confesses was his downfall [canto twenty-four]) "for they shall be satisfied" is the chant of those being cleansed from the last vestiges of gluttony, and so forth. All practice utterly transparent confession; none of the self-serving, self-deceptive rhetorical spin-doctoring that Dante the pilgrim witnesses in hell. In Purgatory, we have sinners who know they are sinners greeting each other with kisses, hugs, and smiles as they encourage one another on their way up, *passing the peace*.

Piero della Francesca highlights appropriate demeanor in part by the contrast between the *decorum* of those who are truly tuned in and the *in-decorum* of those who, without eyes to see, miss what is right in front of them.* The slovenly appearance of Solomon's workmen undertaking the bothersome work of digging a hole for a worthless tree—the socks of one down at his ankles, his underpants barely covering his private parts; vine leaves on the head of another indicating the morning-after hangover—highlights their blindness to the unbearable value of this log destined to bear the Savior of the world. I am reminded of W. H. Auden's ekphrastic poem, "Musee des Beaux Arts," about a painting by Peter Breughel in which the mythological figure of Icarus is plummeting into the sea—yet none of the figures in the scene are taking any notice of the momentous event:

> . . . even the dreadful martyrdom must run its course
> Anyhow in a corner, some untidy spot
> Where the dogs go on with their doggy life and the torturer's horse
> Scratches its innocent behind on a tree. (lines 10–13)[14]

The scene on the opposite side of the central window in the San Francesco sanctuary presents a stark visual contrast. If the grave diggers are an unkempt mess, Piero has clothed the Jew who can tell Helena where to dig up the True Cross in his Sunday best, appropriate for the occasion even if he is being pulled up after spending six days in a dry well.[15]

The use of such visually contrasting parallels to guide the viewer (and the worshipper) is a principle of Piero's design. The scene on the lower part of the right wall depicts Emperor Constantine's bloodless defeat of his rival Maxentius. At the head of his processing troops, Constantine holds out a tiny cross, framed at the exact center of the panel against a serene landscape in the background, a river running through it, trees in the meadow. Maxentius and his troops flee to the right, looking back with fearful faces.

The scene depicted directly opposite on the left wall offers a stark contrast in design.* The battle to defeat the grossly-pagan Persian emperor Chosroes is a chaotic mass of wild movement. Compressed against the right side of the panel is the staging of Chosroes's own egocentric posing as the God the Father of a false and blasphemous Trinity—a sort of inverse anti-liturgy with a black rooster substituting for the dove of the Holy Spirit and the stolen cross set up next to his throne.

[14] *Selected Poetry of W. H. Auden*, 2nd ed. (New York: Vintage Books, 1971), 49.

[15] In the *Golden Legend* account, when this Jew came to the place where the cross was buried and "prayed there, the earth suddenly quaked and a mist of sweet-smelling perfumes greeted their senses [a liturgical note!]. Judas, filled with wonder, clapped his hands and said, 'In truth, O Christ, you are the Savior of the world!'" (vol. 1, 282).

Saints' Days

The major seasons of the liturgical year were themselves punctuated by the holy-days devoted to particular saints, a sort of birthday calendar of the inspirational heroes and heroines of the faith. How high the liturgical temperature of the celebration was turned up (one might say) was influenced by the importance the saint held for the local community.

In Orvieto, the feast day of St. Joseph, the town's patron saint, is celebrated in March with religious fanfare and civic gusto. The statue of Joseph (holding the baby Jesus tenderly in his arms) is carried in procession from the Church of San Giuseppe to the Duomo for a town-wide mass in his honor. Then the statue is processed back to the church, with the civic band leading the way, stopping for a little concert in the little piazza beside the church where the crowd gathers around tables loaded with fried dough fritters and jugs of wine.

Nearby Bolsena is the hometown of the courageous teenager St. Christina, martyred for holding fast to her faith in Christ during the persecutions of the early church. Santa Christina is remembered in a sacred drama, and the main street is covered with mosaic-like scenes made from millions of colored flower petals, gathered and arranged with devotion and immense skill by the local people themselves.

Saint Juvenal, a "minor" saint of the late fourth century, has a high profile in the region of Umbria which looks to him as the evangelist who brought Christian faith to this central part of Italy. He is recognized as first bishop of Narni. Several churches are dedicated to San Giovenale, including the beloved thousand-year-old parish church in Orvieto, where he is, of course, featured in the frescoed decoration on the ceiling above the altar.

It was common in medieval and Renaissance Italy to name children after the saints celebrated on or near their birthdays, or after saints with strong familial associations. The Medici family in Florence provides a well-known example. Cosimo (the first of the three generations of fifteenth-century Medici bigwigs) was named after one of the pair of doctor brothers martyred under the early persecutions: Cosmas and Damian. Hence the reason for these two saints being placed on the left side of Fra Angelico's wall-sized Crucifixion in the chapter room of Monastery San Marco, whose renovation was underwritten by Cosimo.* Beside the brothers in the same fresco stands St. Lawrence; the family name given to Cosimo's grandson Lorenzo de Medici. One can readily imagine the enriched density of associations activated when the celebration of one's individual birthday is caught up in the citywide liturgy of honoring a saint. Imagine being a Francesca or Francesco Sassetti celebrating St. Francis's day on October 4 in the Sassetti chapel.

One of my favorite altarpieces is still *in situ* in the chapel sponsored by the noble Pesaro family in the Church of the Frari (the Franciscan friars) in Venice. One of the supreme masterpieces of Gentile Bellini (painted in 1488), Saints Peter and Nicholas, and Saints Mark and Benedict, are fitted tightly into alcoves on either side of the Virgin, sitting with baby Jesus standing on her knee. Why these saints? The three sons of *Pietro* Pesaro very likely commissioned the work and other paintings decorating this chapel dedicated to the Virgin Mary. Their names: *Niccolò, Benedetto*, and *Marco* Pesaro—their patron saints and their father's featured in the triptych.

The lineup of altarpieces on the walls of the medieval and Renaissance rooms in art museums—with two or three saints placed on either side of the Virgin Mary in what was often called a *sacra conversazione* ("sacred conversation")—offers today's viewer very little help in grasping the precise and particular significance of these saints in the personal lives of the families and organizations who commissioned them.

Confraternities and Guilds and Their Saints' Days

I described in chapter two the civic and social organizations of the confraternities and guilds, and their role as major commissioners of arts. Their highly-decorated headquarters were usually principal monuments in the architectural fabric of the city.

In the *place* explored in this chapter, the confraternities most clearly exhibit the original sense of the word *liturgy* in ancient Greece as indicating a work of public service done freely and not as paid employment. The *work* of these fraternal societies often took the form of what we now think of as social service, but was performed as an action of piety: the care of the sick, of plague victims, of the orphans, of the hungry and unemployed, of unwed mothers, and the duties of what we might call the EMT corps (in modern parlance). The ambulances of the *Misericordia* stand ready to this day in front of their headquarters beside the Duomo in Florence.

Every guild and confraternity had its own patron saint, chosen for the associations of the saint's life for the *work of the people* of that group, and with a sense of the particular relevance of that saint's intercession on the organization's behalf.

Not surprisingly, the patron saint was featured prominently in the decoration both inside and outside of the headquarters, with scenes from the life of the saint frescoed on walls or represented in altarpieces either as a central figure or prominently flanking the main figure. They might appear as statues on the exterior (functioning something like, in our commercialized landscape, the corporate logos of the golden arches, or Colonel Sanders, or the giant apple on the Apple headquarters, and so forth).

Certainly one of the most well-known and artistically significant of such buildings is Orsanmichele (the name deriving from the much earlier use of the site as the garden of the Monastery of Saint Michael the Archangel). In the 1330s a handsome rectangular building was constructed on the site for use as the town grain market. In the final decades of the fourteenth century the large open arches of the ground floor *loggia* were filled in and the building was reconfigured as a chapel for use by the guilds for their liturgies and celebrations. Prominently located on the main boulevard that connects the town hall with the Duomo, Orsanmichele helps us even now to sense the place of the guilds *between*, linking religious and social purposes in the political and economic life of the town.

In 1401, the guilds were earnestly exhorted by the town government to complete the program begun a decade earlier of placing statues of their patron saints in the tall niches that punctuate the exterior of the building. The order came at the time of the rise of the remarkable company of skilled artists of the blossoming Renaissance. Hence the exterior is not only a sort of liturgical procession of saints, but a gallery of sculptural works from the great masters: Donatello's St. Luke (commissioned by the linen-makers guild) and his St. George (patron saint of the armorers guild), the Four Crowned Martyrs of the stone-carvers guild (so-called because they were executed during the Diocletian persecutions for refusing to sculpt idols for the temple), Ghiberti's statue of St. Matthew (the tax-collector-become-disciple chosen as the patron saint of the bankers), Brunelleschi's statue of St. Peter for the guild of the butchers (Peter's deft but misguided use of his knife to slice off the ear of the high priest's servant as an apt anti-model of their craft), and so forth.*

Orsanmichele is just one example of how, when people gathered as a defined group with a particular work to do, they decorated their *place* with artworks that were overtly instructive, memorial, and inspirational (to cite once more the purposes of art oft-repeated at the time). Art-tourists sure to visit the Uffizi Gallery in Florence will admire the line of tall panel paintings of women with allegorical trappings representing the seven virtues, six painted by Piero del Pollaiolo, with Botticelli completing the set with his depiction of Fortitude.* Few take notice that the paintings were commissioned by the merchants guild as the decoration in the judicial court where financial irregularities or violations of business ethics would have been adjudicated.[16]

[16] Many of my readers might lament that prudence, justice, temperance, and fortitude, along with faith, hope, and charity, are unlikely to frame the ethical discourse of the investment bankers and hedge fund managers on Wall Street, nor are they the subjects of the generously-funded collections of artworks displayed in their offices. For a fascinating account of the difficulty encountered by the committee appointed to select the decoration for the Federal Courthouse in Boston—

The trade guilds and charitable associations of course celebrated with gusto the feast days devoted to their own patron saint, or the holy-day that some confraternities existed to enhance, such as the confraternity of the Magi, of which the Medici were leading members. In this, we can see the influence of the liturgical calendar in shaping the annual rhythms of these civic and religious associations.

Of course, the influence was circular. These civic organizations were typically major participants in, and shapers of, all the major feasts and festivals of the liturgical calendar that marked the annual rhythms of the entire community. The procession of the Holy Corporal in Orvieto's celebration of Corpus Christi Day, for example, included every trade and social and charitable organization at work in the town. And it still does, with the dignitaries from the Opera del Duomo, and the Red Cross volunteers and the Boy Scouts falling in behind the banner-carrying and costumed representatives of the medieval crafts.

To illustrate his own discussion of such great civic-religious processions in Western Christianity as a mode of collective liturgical prayer and celebration, Timothy Verdon gives the example of the enormous twenty-five-foot-long painting commissioned to Gentile Bellini in the 1490s for the meeting hall of the Venetian confraternity of the *Scuola di san Giovanni Evangelista* (of which Bellini was a member). Among the treasured relics owned by the confraternity was a fragment of the True Cross, associated with many miracles, including the one featured in Bellini's canvas. The painting depicts "the brothers of the confraternity in procession in their white habits, carrying the miraculous cross under a canopy." The figures march around the grand piazza of San Marco, with crowds of citizens and civic dignitaries leading the way and falling in behind—"organized in Renaissance fashion."[17]

able to agree in the end only on the significance-empty colorfield paintings of Ellsworth Kelly—see Brian Soucek, "Not Representing Justice: Ellsworth Kelly's Abstraction in the Boston Courthouse," *Yale Journal of Law and the Humanities* (no. 24.1 [2012]), 287–305. Soucek writes, "Judith Resnik and Dennis Curtis, in their magisterial survey of the iconography of justice, turn to Kelly's work in a section on 'The Safety of Abstraction.' *The Boston Panels*, they claim, can be seen as a 'safe haven,' a 'conservative' artistic choice, because it *allows the state and its courts to 'avoid the question of what Justice might, could, or does look like'*" (289, my italics). The modern trade unions and social service clubs—the descendants in direct line of the medieval and Renaissance trade guilds and confraternities—certainly no longer use members' dues to commission artworks for the inspirational decoration of their headquarters.

[17] Verdon, *Art and Prayer*, 142: "The canvas shows an event that took place about 50 years earlier, on 25 April 1444: while the members of the Scuola were processing the fragment through the Piazza San Marco (the square of St. Mark's),

These examples clearly demonstrate that liturgical presence and practice extended well beyond the walls of the churches, operating not only in the guilds, confraternities and other social-religious organizations, but in neighborhood and town-wide activities as well. All these groups had their work to do, and their times of celebrating and reinforcing their identity as a group, as a social body, as a neighborhood. Finely crafted art objects were at the center of this work for all of these communities, focusing their minds, modeling behavior for their bodies, and expressing their values, their history, and their sense of purpose.

The Daily Office and the Monastic Imprint on Society

Liturgical practice was a way of life beyond the walls of the church, but of all the places within church settings where life was experienced through particular *works of the people* performed collectively, the clearest example of life saturated in liturgy are the monastic communities.

For monastics, no moment of time or square meter of space lay outside their carefully scripted work. Meals were taken together, and not in cafeteria style as times of chatting casually with one's favorite buddies, but quietly, typically while someone read aloud from the church fathers, saints' lives, and other edifying texts. Chapter meetings brought the whole community together under the abbot or abbess's direction for encouragement, exhortation, and rehearsal of the order's central calling.

Members of the community labored variously according to the mission of the order, the aptitudes of individual members, and the means by which the community supported its needs: working in the fields or the herb or vegetable garden or brewery, studying and copying manuscripts in the scriptorium, serving in the infirmary or guest house, teaching and preaching. Chores and household duties were divided among the members. As described in chapter two, every area of the monastery received its own decoration, art that brought the work of that place into spiritual focus: a Last Supper in the refectory, a Crucifixion in the chapter house, and so forth.

Even the individual cells in the dormitory could be the site of such purposeful decoration, as exemplified in the programme of scenes frescoed by Fra Angelico and his assistants in each of the cells in the dormitory zone of Monastery San Marco in Florence. Most but not all of the episodes concern the narrative of Holy Week. An Annunciation in one of the cells parallels

Jacopo de' Salis, a tradesman from Brescia, knelt before the relic in prayer that his dying son might recover. When he returned home, he discovered that the boy was completely well again."

the large Annunciation at the top of the stairs.* The cell reserved for Co-
simo de Medici's monastic retreats features the Adoration of the Magi.*
The fresco in one cell depicts the Sermon on the Mount, an unusual scene,
but quite appropriate given the teaching mission of the Dominican order.

While the cells were decorated for the obvious purpose of directing
each friar's individual private meditation and *lectio divina* during the few
hours of time alone, the effect was to draw even private time into the col-
lective liturgy of the whole community. Certainly in most monasteries the
individual cells were sparely furnished, perhaps with only a wooden cru-
cifix on the wall, but Monastery San Marco underlines the foundational
sense that no place in a monastery was deemed outside the zone of using
visual images to instruct, remind, and inspire the work of the people in the
community.

By the thirteenth, fourteenth, and fifteenth centuries one succinct and
remarkable book had long served as the principal guidebook for such com-
munity life. Saint Benedict wrote his *Rule* in the early 500s for the growing
number of monastic (or cenobitic) communities that he had launched in
central Italy, first from his initial hermitage in Subiaco, in the hills east of
Rome. Confirmed in his vocation to extend the work, he moved to Monte
Cassino, high in the hills overlooking the route between Rome and Naples,
the community established there became the mother house of the Bene-
dictine order. But the *Rule of St. Benedict* quickly became the template (we
might say) for the daughter houses that spread rapidly and widely through-
out Europe.

No aspect of community life was left outside Benedict's quite practical
instruction: mealtimes, cleaning, and hospitality given to guests, as well as
specific duties explained for the abbot, the cellarer, the guest manager, and
even the artists:

> If there are any in the community with creative gifts, they should use them
> in their workshops with proper humility, provided that they have the per-
> mission of the superior. If any of them conceive an exaggerated idea of their
> competence in this sort of work, imagining that the value of their work puts
> the monastery in their debt, they should be forbidden further exercise of their
> skills and not allowed to return to their workshops unless they respond with
> humility to this rebuke and the superior permits them to resume their work.[18]

As codified and explained in Benedict's rule of life, the core work of the
community was the *Liturgy of the Hours*: the sequence of eight daily gath-
erings for corporate prayer that established the pulse and organizational

[18] From the edition of the *Rule* in *The Benedictine Handbook* (Collegeville,
MN: Liturgical Press, 2003), 79.

framework for all other works of the day. *Ora et Labora*, prayer and work, captures the Benedictine rhythm.[19]

[19] Each service of this daily office followed an ordered sequence of chanted recitation of Psalms, readings from Scripture, and prayer for all aspects of the life of the community and the church. For readers unfamiliar with the liturgy of the hours, a helpful introduction is Lauralee Farrer and Clayton Schmit's *Praying the Hours in Ordinary Life* (Eugene, OR: Cascade Press, 2010), first prepared for use in Fuller Seminary's program in "worship, theology and the arts" in Orvieto. Farrer and Schmit outline the Liturgy of the Hours as follows (60–61):

VESPERS. As in Jewish practice, the monastic day begins at sundown. From the Latin for evening, Vespers is prayed as the new day begins. Its traditional focus is on Christ as the Light of the World.

COMPLINE is prayed before bedtime. The simple life of monastic communities makes it possible for its members to retire around 9:00 p.m. The purpose of Compline is both to prepare one for sleep and to reflect on our final sleep in death.

VIGILS is the night office, requiring people to rise from sleep at midnight. This is the time for earnest wakefulness, where we learn to trust God in the darkness.

LAUDS is the early morning time of praise. It may fall anywhere from 3:00 a.m. to just before sunrise. It is a time of prayer for the coming of the sun and with it the possibilities of the dawning day. Matins (from the Latin word for morning) is a term sometimes associated with this time of day and it is often used as a synonym for Lauds.

PRIME is prayed at the beginning of the workday, about 6:00 or 7:00 a.m. The worker is fully awake, ready to set his or her sights on the tasks ahead. Traditionally, Prime is a meditation on Creation. It also reflects upon the appearance of Jesus before Caiaphas in the Passion narrative, an event that took place before dawn (Matthew 26:57–68).

TERCE, the third hour. The workday is well underway. Yet the worker pauses to remember that there is a purpose greater than the task at hand; it is an awareness of God. The traditional meditation of Terce is on the Holy Spirit, who appeared at this hour on the day of Pentecost (Acts 2:1–15).

SEXT, midday, is the sixth hour of the workday. The pause to pray reflects upon the awareness that half of the day is spent. Because this was the time of day during which Jesus hung on the cross (Mark 15:33), Sext is a time to reflect on his anguish, even as we meditate upon the crosses with which we are burdened.

NONE occurs at mid-afternoon. The workday is nearly spent, as is the energy of the worker. Even so was the vigor of Christ, who died at this hour (Mark 15:34–38).

If we speak of eight brief services punctuating the twenty-four-hour day, we moderns who do everything by the clock may suppose that they were scheduled punctually every three hours. Maybe we imagine, anachronistically, the monks out in the fields looking at their watches, seeing 11:55, and thinking that they have five minutes to dash to the chapel for noontime prayer. Not so. In fact, the rhythm was tied to the seasonal cycle: Prime and Vespers occurred at sunrise and sunset, with the other services timed proportionately during the longer or shorter daytime and nighttime periods. I mention this to help us imagine how the daily office represents not an artificial imposition on time that violently disrupts the "natural" flow of our working and sleeping hours (although having to rouse oneself out of a deep sleep in the middle of the night to go to the chapel for prayer in the candlelit darkness will likely strike most of us now as violently artificial!).

Rather, the Liturgy of the Hours disciplines the natural rhythms by a training of the heart. At the same time, the themes and prayers of each hour of prayer align our experience of the passage of quotidian time with the events of the life of Christ.

Nowadays we experience the afternoon after-lunch lethargy as signaling time for a sugary high-caffeine pick-me-up—or, for those of us in academic communities, as the time when one hopes not to be scheduled for a class. Medieval monastic culture spoke of the "demon of noontide," a lethargy that can lead to sloth and spiritual despair. The daily office locates it in a moral-spiritual context as the period of weakness, of vulnerability to temptation, of slothful loss of motivation and hope, and aligns it with the hours when Christ hung on the cross. In short, the purpose of the daily office is to help us order our daily life in tune with God's priorities.

The hours of prayer were apparently set by Benedict in correlation with the bells in the Rome of his day that sounded the changing of the guard. But in medieval society, the monastery bells that called the community in for the next service of the daily office became the timekeepers of the entire society. Those of us shaped by American history and experience (especially those from non-Catholic communities of worship and faith) are likely to have little sense of the enormous impact of the monastic orders on every aspect of social, economic, cultural, artistic, as well as religious life in medieval and Renaissance Europe. More of life was *more profoundly* framed and shaped for *more* people by liturgy and liturgical patterns, and monasteries were the places most overtly and rigorously informed by liturgy.

Part III

The Place of Narrative

8

A COMMUNITY WITH A SHARED STORY

During the centuries of art-making that serve as the touchstone for this book, art was pervasively *narrative* in form. Art told stories. The opposite generalization can fairly be made about the art that has characterized European and American modernism: it is not typically narrative in form. Hence modern training in *art appreciation* does not prepare us well for an art of the past designed precisely to place us inside a story.

The general depreciation and sometimes suspicion of narrative in art reflects a general "eclipse of narrative" in our age (notwithstanding the tidal wave of storytelling television and movies). We can speak of a general erosion of differentiation among the episodes of life that leaves us less attuned to narrative patterns. We live, that is, in a society where the leveling of space is matched by a leveling of time.

The ancient Greeks developed two distinct words for "time," *chronos* and *kairos*. *Chronos* is the temporal realm of mere sequence, devoid of whatever would indicate priorities of value among different moments in time. *Chronos* is measured in the value-free units of the clock (or *chronometer*). To my digital watch, there is no difference in value or meaning between the 10:19 A.M. and the 7:38 P.M. dispassionately indicated at two moments of the day. *Kairos*, on the other hand, is time experienced precisely according to value and purpose. It is shaped time, whereby the present is experienced in the dimension of where it might be headed in the future, its trajectory or *telos*. It is related to *occasion* or *opportunity*.

Today, for more people more of the time, the experience of time is shaped more strongly by *chronos* than *kairos*. *Chronos*-time answers the question "What time is it?" (It's 4:15 in the afternoon.) *Kairos*-time answers the question, "What time is it *for*?" (It's time for a good long chat over a cappuccino. It's time to apologize and ask forgiveness. It's time for you to make a commitment and propose. It's time to bear down on that research paper or it'll never get done.)

The figure of Occasion or Opportunity—*Kairos*—is common in classical culture, a figure bald on the back with a lock of hair on the front. If you don't seize Occasion as she passes, you'll not be able to grab her from

behind. The plot of Shakespeare's Hamlet unfolds as a series of missed op-
portunities, of hesitation on Hamlet's part to confront his uncle. Oedipus,
inversely, is depicted by Sophocles as a fellow whose over-readiness to seize
an opportunity short-circuits mindfulness of the trajectory of a life-story
prophesied about him.

In one sense *kairos* may be the more difficult dimension to understand,
at least as it operates with low-grade energy during most of our ordinary
experience of the passage of hours, days, weeks, years. Our quotidian life
unfolds in anticipation of the next opportunity to seize, the next event
which will give purpose and meaning to the mere sequence of passing
time, whether the vibration on the smartphone indicating a new email or
text message, or the coffee break, or the weekend, or *NCIS: Los Angeles* on
Tuesday evening, or Sunday afternoon football, or the next binge. In our
addictions we experience *kairos* time turned nightmarish.

Prominent features of contemporary American culture subtly sabotage
a life rich with narrative and *kairos*. We live by the clock. Rushing to the
next appointment is given priority above following a conversation to its
proper conclusion, or stopping to allow a conversation in the first place.
The glut of distractions creates a cafeteria approach to entertainment with-
out trajectory. Clicking through channels and moving through Facebook
feeds is a mode of living in *chronos* time, not *kairos* time.

When any action is interruptible to check the smartphone, then no
action is permitted an authority to unfold to its proper end, to achieve its
telos. When sex is a matter of moving from one hook-up to the next, made
simple with an app on the smartphone, when no encounter involves any
moral commitment that requires constancy through the ups and downs
that make up a story, then we can speak of sex being subsumed under *chro-
nos*. One never has to think about what an encounter means for the future;
it has no future.

A profound action now unfolding in our age may be the gradual dis-
solution of *kairos*. We are losing our grip on *kairos*.

Kairos lends itself to liturgy, which, as treated in the previous section,
is the formalization of an action so that every component is relevant for
the action, enhancing its significance and befitting its importance, and all
distractions are cut away.

If the Death and Resurrection of Jesus is the hinge point of history,
then we surround the sacramental memorial feast of that Body Given for
the Life of the World with solemnity, with special clothes, with washing of
hands, with cell phones turned off, with kisses of peace so that we eat the
feast without the stain of malice among sisters and brothers in the faith. If
Jesus's second coming is the *telos* of human history, then we are called to
live in anticipation of his return, keeping our lamps trimmed, eliminating

things that distract us from attentive waiting for the hour of the bride-groom's arrival, unknown but sure to come. *"Now* is the day of salvation," writes Paul to the Corinthians (2 Cor. 6:2).

I have spoken in the previous section of the loss of liturgical time when communities do not engage in regular *occasions* together that mark and give narrative shape to a shared life. Such liturgical actions less and less mark the passage of time in our age. Weddings are thinned down, if they occur at all—or maybe gussied up with great expense precisely as icing over a cake that has gone stale, a recipe no longer trusted. Funerals are events we take off an hour from the office to attend, not the days-long af-fair which brings together an entire extended family and community for leisurely storytelling about the one we've lost.

The vestiges of *kairos* can be found in the ersatz liturgies marking a so-ciety that seeks relief and distraction in entertainment. Think of the lead-ups before the "big events" that we grab onto for a sense of broad social solidarity. During the week before the Super Bowl, the journalists fill in the biographies of all the players. The television coverage of the Kentucky Derby begins two hours before the two minutes it takes the horses to run the race. The church year gives us four weeks in Advent to prepare our hearts and souls for the second as well as the first coming of the Savior— but our society's commercialized preparation for Christmas begins at Thanksgiving. The old liturgy of a generous Thanksgiving, sharing out of gratitude for what God has given us, competes weakly with the new liturgy of lining up early on Black Friday at StuffMart to buy, buy, buy.

We follow devotedly a sort of secular liturgical calendar of major sport-ing events and entertainment extravaganzas. The "red letter" days on our calendars are the World Series, the World Cup, the Super Bowl, the four Majors in golf and tennis, the Emmys, the Academy Awards, the MTV Video Music Awards, and so forth.

Ordinary language serves as a barometer of the high or low pressure of *kairos* in a cultural community. When the answer to the question "Waddya wanna do tonight?" is "whatever;" when we just want to "veg out" or "hang out;" when our pastimes are deliberately brain- and will-numbing, that is, when purposeless action is valued; when there are no opportunities to seize or worth seizing—these are indicators of a weak sense of *kairos*.

Kairos might also be called *plot time*, or time experienced in the nar-rative dimensions of beginnings, middles, and ends (following Aristotle's discussion in the *Poetics*).

Margaret Visser provides an apt definition in *The Geometry of Love*:

A narrative—a story recounted in time—organizes events into meaningful se-quences. When "the plot" in a story is told to us, we demand not just a jumble

of facts, but a string or connecting line to join them, disclosing causes, consequences, even form. Often the "line" of connection in stories is pictured as a thread. (The word "line" itself comes from the Latin *linea*, a flaxen thread for making linen.) We speak of "spinning a yarn," and, if we become distracted, of "losing the thread" of the tale or argument. The word "text" is cognate with "textile" because a narrative is thought of as woven, out of threads.[1]

We experience the temporal unfolding of a well-told story as one in which every episode counts and every scene is (or turns out to be) an ingredient of a single trajectory of action toward a goal, toward a *telos* anticipated or feared. Against this overarching story line we apprehend episodes as occurring at the beginning, middle, or end. The action of a kiss on the big screen may be the kiss at the beginning of the movie that launches the romance, or the kiss in the middle of the movie that complicates the relationship, or the kiss in the final fade-out that satisfyingly resolves and concludes the story. The kiss of Mary's parents Joachim and Anna at the Golden Gate launches the life of the girl who will bear the Savior of the world; the kiss of Judas in the garden marks the beginning of the end of that Savior's life—or is it the end of the beginning? Well-crafted stories exhibit *kairos* to us.

What we might call *narrative capability* is the ability to distinguish episodes for their relevance or irrelevance to a larger action to which they contribute. It's what allows us to narrate to friends in story-fashion various dimensions of our lives: how we finally found a satisfying job (or how we still haven't found what we are looking for) or how we met and "fell in love" with our spouse. In the evangelical Protestantism of my own upbringing, for instance, one conventional narrative (often called "giving your testimony") that exercised a strong grip on autobiographical narration was that of a dramatic moment of "conversion," of "coming to Christ" that unfolded as a sudden cleansing from sin and turning from corrupt desires or behavior. Forgiveness of sin (justification by grace through Christ) was closely allied with sanctification (with a quick new purity of life). I remember the youthful angst caused by the mismatch between this "plot" and my own experience.

In order to narrate a set of events linked by a common thread—like pearls on a string—we must be able to select out from the chronological mass of bits and pieces of our experience those episodes that comprise a coherent action. I see signs that we are losing this capacity. My father-in-law, in his mid-nineties now and declining physically and mentally, can still narrate gripping and coherent tales of his time as a chief airplane mechanic in the South Pacific during World War II, with nary a stumble in the syntax and sequence of sentences. Such powerful storytelling seems increasingly

[1] Margaret Visser, *The Geometry of Love* (New York: North Point Press, 2000), 31.

uncommon. Many of us begin our stories clumsily, trying to find the right starting point, with sentences full of "hmms" and "likes" and other filler as we root around for the relevant details, the proper sequence. Yes, at the risk of sounding nostalgic, in the days before television people *told* stories instead of sitting passively watching them. The skilled storyteller was an essential and admired figure in ancient cultures from the time of the bards in Homeric Greece. A sign of recognition of this loss and desire for recovery is the surprising popularity of the recent National Public Radio hour, *The Moth*, where people, after long hours of practice, simply tell a well-crafted and thematically-sturdy story drawn from their lives.

Erosion of such narrative capability understandably shows up at times of personal crisis or psychological depression, when *kairos* becomes suspect, and the specter of *chronos* rears an ugly head. (My life is going nowhere. This job is pointless. My husband just told me he's having an affair. God is absent.) In such circumstances, one can no longer narrate one's life as a coherent and purposeful narrative. People in states of depression or emotional illness may be inclined to ramble, with no particular point to the narrative. And that's the point: plot has disappeared. Such depression, aimlessness, will-less going with the flow, can be diagnosed (and receive prognosis) at the level of the individual, but one can also speak of plotless aimlessness as a psychological malaise at the broader social level.

This "eclipse of narrative" is a prominent feature of the modern and postmodern treatment of time and story in the arts. Key literary writers have dismissed story as wishful thinking ungrounded in reality, or have deliberately subverted conventional plots so as to pull the rug out from under any search for trajectory to the story, or—in a sort of literary parallel to Cubism—have told the story from the varying and incompatible points of view of the characters in a way that radically subjectivizes what used to be called the plot. Witness the anti-narrative plays of Samuel Beckett, for example, where waiting in perpetual dashed hope for the arrival of Godot is doomed to disappointment and yet keeps Vladimir and Estragon going, or where the landscape described in *Endgame* matches the flattened experience of time: "light black from pole to pole."[2]

My comments are not disdainful. The arts have continued to play the role of giving "a local habitation and name"[3] to the deep hunches or fears of the society, dramatizing the dissolution of those sets of values and virtues, those hierarchically arranged beliefs, and those shared communal traditions within which life and cosmos and history once were seen as having a purposeful direction, a plot.

[2] *Endgame* (New York: Grove Press, 1958), 32.
[3] Shakespeare, *Midsummer Night's Dream*, 5.1.

If narrative feels like an unwarranted imposition of meaning to an artist, then one can readily imagine that the grand tradition of narrative painting that lasted well into the nineteenth century could lose its grip, could feel like so much wishful thinking, so much smoke and mirrors—a tradition from which the artist as truth-teller must break free. In this case, the artists have done their part in courageously pointing out that the emperor has no clothes, raising doubts that any ground exists for narrative, distrusting stories as weapons of indoctrination or as meta-narratives imposed by those in power to justify acts of aggression to their own people.

The general discrediting of "narrative" is reflected in the absence or ironizing or discrediting of narrative painting among the artists of our own epoch who have gained star status, at least in comparison with the long history of storytelling art which it left behind.

From this point of view, recent box-office-smashing epic films, The Lord of the Rings and the Harry Potter series among them, represent a surging thirst for the recovery of narrative—for grand plots unfolding over long stretches of time, and for virtuous but imperfect characters courageously facing enormous challenges. Consider the Bourne trilogy as paradigmatic of the present condition. The disjointed and fractured form of what is presented to the viewer matches the efforts of the main character Jason Bourne (is that even his "real" name?) to piece together the half-remembered and untrustworthy bits and pieces of a forgotten past and an uncertain identity, of *chronos*, into a coherent narrative of his past—a narrative that will both recover and call deeply into question the moral validity of Bourne's life. The ending of the trilogy unsettlingly provides the viewer with satisfying closure—a confirmation that there *is* a narrative that holds everything together—but one that disallows the deep catching of breath for an audience of a plot that has achieved its *telos*.

One might pose the question in this way: Which sort of "time" is the most "real" or fundamental or original? Is time fundamentally *chronos*, empty of plot, with no apprehensible trajectory by which we can be oriented toward a goal? In this case, every instance of narrative represents an *imposition* of order on what is essentially mere plotless sequence. I would guess that most of us have had those unnerving experiences of listening to narratives that feel "imposed," that arouse our suspicion that the speaker may be putting a falsifying "spin" on a sequence of events, either deliberately to deceive, or as a mode of evasion or coping with subterranean blues. The story line may not match what actually happened. But even if we accept that plot is an imposition, we can acknowledge a sort of clear-eyed courage in those who purposely create a story line to their lives.

Or is time truly *kairos*? In which case, the deepest truth about time is that it is indeed a "story" with a beginning, middle, and end; that mere se-

quence is the "appearance," not the reality. (If we see only sequence without *telos*, then we're missing the story.) When a person or a community fundamentally believes in the reality of *kairos*, experiences of absence or uncertainty of kairotic order and purpose are sometimes explained as the fallout of something gone wrong—of a trajectory sidetracked from its proper *telos* or goal. Or, the murkiness of *kairos* can be understood as marking a narrative whose plot is just not clearly visible to us yet—as in the peculiar pleasure of a detective story in which the moment of "ah, now I see how all the pieces fit together" is deferred until the last page.

The possibility of *narrative despair*—of doubting that history (personally or collectively) may be unfolding as a story—is not an exclusively modern phenomenon. It is explored with eyes wide open in key texts of medieval and Renaissance literature. Boethius' sixth-century *Consolation of Philosophy* begins as an exasperated cry about the apparent absence of any divine presence that can be trusted to orchestrate the events of history and the author's own biography, to which Lady Philosophy mounts the defense of Providence in the midst of contingency. In his graphic account of the Black Plague in the preface to *The Decameron*, Boccaccio describes the demise of "morals" among a society suddenly bereft of hope and purpose. Framed by this gruesome reality, the retreat to a country villa by the ten well-to-do young people, passing the time by telling stories, comes across as so much escapism from reality.

Dante gives a memorable statement in the *Purgatorio* of profound doubt in a divine *kairos* leading things to their *telos*, of a sense that an entire age might have lost its plot. In canto six, after lamenting the political and civic chaos and viciousness that seemed to mark his country's history, the poet wonders:

> And if it is lawful to ask, O Jove on high,
> You who were crucified on earth for us,
> are Your righteous eyes turned elsewhere,
> or, in Your abyss of contemplation
> are You preparing some mysterious good,
> beyond our comprehension?[4]

Nevertheless, even Dante's moment of doubt (about Italy) occurs in an epic which is itself the monumental and encyclopedic defense of *telos*, of God's "mysterious good" in working his just and merciful purposes out in history and the cosmos itself.

The culture of the Italian Renaissance fostered a rich tradition of art that told stories precisely because it assumed the fundamental reality of

[4]Lines 118–123, Hollander translation.

narrative, of *kairos*, in creation and history. God's narrative construction of the cosmos, and the divine design guiding the trajectory of history was the assumption behind the pervasive presence of story-telling in art.

Here I can repeat the same proposition set forward in the book's earlier chapters, replacing "architecture" and "liturgy" with "narrative."

> *Most of us remain poorly equipped by our own cultural training to seek out, or even to expect, let alone to understand, the relationships once at work between artworks and their narrative setting.*

My opening riff on the narrative flatness of our own time may not ring true in every circumstance, but the rest of this chapter will describe how visual narrative worked in a culture where engagement with narrative was much more commonplace than in our own, illustrating how painters dealt with the written sources of their stories to explain what approaches to narrative were shared by artists and their publics.

Drawing the Viewer into the Story

For centuries in Italy people expected significant rooms to be places of narrative. We must imagine the people of that age as entering a chapel or town hall or guildhall or baptistry with eyes and minds expectant for the decoration to tell stories. There are few public places in our own time where such narrative alertness occurs, other than the cinema complexes at the shopping mall, where we walk past the posters and popcorn into the darkened theater, settle into the seats, ready in body and imagination to exercise "willing suspension of disbelief" and be transported into a story.

Certainly a central purpose of a narrative work of art in the Renaissance was to invite those who gazed at the story to become participants in it—particularly in those acres upon acres of story-telling frescoes that filled the walls of every place where communities and associations large and small gathered to do or to renew their defining work. The viewer was inside the architectural place where the story was being told, inside the liturgy that the story served, *and* inside the story itself. Hence the title of part three of this book: the place of narrative.

Nowadays we might reach for an analogy with the newish experience of 3-D movies now in vogue: sitting in the multiplex with the very chairs wired to move and rumble as the action explodes all around you. In chapter seven I said we may be inclined to see the fresco cycles as a sort of primitive form of the "virtual reality" now under development in the high-tech industry. That comparison is worth considering, but there remain significant differences between sitting passively in a cinema and performing a real action (not a vicarious one) with other people. Being cocooned in

the world of the PlayStation car race, headgear and earphones eliminating the external world, is not the same as the bodily experience of continuity between the surrounding fresco cycle and performing a Mass or a Baptism or holding a town council meeting or dining together with real people with whom one rubs shoulders outside the chapel or refectory or guildhall.

Readers of C. S. Lewis's Chronicles of Narnia can draw on what is perhaps a more apt analogy for how the physical space becomes the place where the story reaches out and grabs the viewer. At the beginning of *The Voyage of the "Dawn Treader"*, the Pevensie children are visiting their stuck-up cousin Eustace whose modern education leaves him insensitive to things of the imagination. Disparagingly, Eustace asks Lucy why she likes the "rotten picture" of a sailing ship on the wall of the room where she is staying. "I like it because the ship looks as if it were really moving," replies Lucy, "and the water looks as if it were really wet. And the waves look as if they were really going up and down."[5] But the waves in the painting on the wall begin really to go up and down, and a moment later Eustace and his cousins are soaked with ocean spray spilling out into the room and, holding hands, they are drawn up into the painting. Rendering literal the common metaphor of being drawn into a story, of losing oneself in a good novel, the painting on the wall becomes a permeable membrane between this world and another.

This "spilling out" of the action into the space of the viewer is exactly the effect of the big scenes up on the middle register of the San Brizio Chapel, when, for example, a hell-bent figure tries to sneak out of the *frame* of the painting onto the ledge, only to be yanked back by the hair by a guardian demon.* The people subject to the fiery blasts of the angels of destruction at the end of the world try to escape from the fictive space into the actual space of the chapel.

The effect implies movement in both directions: if the characters in the paintings can move into *our* space, then we can move into their space. We feel this in the San Brizio Chapel in the frescoes on the altar wall. Opposite the damned soul being dragged by the demon back into infernal space, an angel leads the now-crowned saved, her hands ushering them upwards to join the companies of the Church Triumphant in eternal praise of the one now enthroned. But the angel's wings overlap the painted ribs of the vaulting, placing her in "our space."* Her gesture includes those in the chapel; the painting on the wall becomes a permeable membrane between this world and the next.

Theater folk speak of the plane of the curtain that separates the audience from the action on a stage as the "fourth wall," a wall often purposely

[5]C. S. Lewis, *The Voyage of the "Dawn Treader"* (New York: HarperCollins, 1980), 8–9.

violated in contemporary theater. This tearing of the curtain—creating permeability between actors' space and audience space—may be seen not as avant-garde but as a return to principles of staging firmly in place for a much longer premodern period. Medieval theater was performed in the streets, spilling out from the liturgy in the church, when brief skits dramatizing the readings of the lectionary were expanded into *sacra rappresentazioni*, or sacred performances.

I am suggesting the analogous strategy of the narrative painting of the earlier epoch. With all sorts of tricks of the trade, painters created a sense of interaction between the world of the characters in the painting and the world of the "real" people at work in the space overlooked by the painting. Artworks vivified the lectionary by staging it in our midst, by amplifying the story in contemporary settings, by allowing people in modern costume (both in the congregation and up in the painting) to rub shoulders with characters in "Bible times" or in other earlier periods of Christian history.

I have earlier described the chapel of the Sassetti family as a place where the artist Ghirlandaio blurs the boundary between space in the painting and space occupied by the congregant. The Sassetti couple at times stood in the chapel. But their portraits are frescoed on the wall on either side of the altarpiece, kneeling in a way that imitates the action of the shepherds adoring the baby Jesus. They themselves serve as models to be imitated by those gathered for liturgies in the chapel.

The Sassetti chapel is one of the private side chapels in the monastery church of Santa Trinità on Via Tornabuoni in Florence, the elegant boulevard of the wealthy business families who made their fortunes in banking and in the Florentine cloth-finishing trade. The scene frescoed immediately above the altar depicts a little boy being raised to new life through the intercession of St. Francis.* The carefully rendered background of this scene is obviously and exactly that of the street in front of the church, with the façade of the church itself on the right, the Santa Trinità bridge straight ahead, the Palazzo Spini Feroni on the left (now home of the Ferragamo fashion family), all oriented around a window in which the little boy is falling. The painting of a sacred event in the past dissolves all differences between the place of the action and that of the viewer-now-participant in the action. The effect is to influence the parishioners' experience of the actual space in their own neighborhood as everywhere and always potential turf for the miraculous work of God's mercy. The job of the artwork is to modify the way in which actual space is experienced, apprehended, interpreted.

I have already noted how the Last Suppers on the end wall of monastery dining halls are typically painted to give the effect of being extensions of the actual space in which the community is gathered to eat, drawing the sisters or brothers into the narrative of Jesus's final evening with his dis-

ciples. Typically in such Last Suppers, one of the episodes that compose the story is dramatized. In Ghirlandaio's two very similar Last Suppers in the Ognissanti refectory and in Monastery San Marco, it's the moment when Judas is about to dip his bread into the cup.[6]

Another example is found in the cells of the dormitory in Monastery San Marco, where the painters in Fra Angelico's workshop have included figures in Dominican habit in the paintings on the walls.* The gestures and attitudes of the friars in the paintings model the demeanor of devotion for the friars living in the cells. In fact, one scholar has pointed out a precise correlation between the various postures of prayer depicted in the cell frescoes and the nine "modes of prayer" described in an illustrated manual of prayer—*De modo Orandi*—based on St. Dominic's own practice.[7]

In several cells one of the Last Words of Christ is painted as text into the picture, moving across the wall from the speaker to the hearer, such as Christ's words to the penitent thief, "today you will be with me in paradise" (Luke 23:43). In the anteroom to Cosimo's cell, Christ's words to his mother and the beloved disciple—"woman, behold your son; son, behold your mother" (John 19:26–27)—are painted on the wall from Jesus's mouth to the woman and man standing below the cross. But in the phrase directed to the disciple, the words are personalized for the meditations of Cosimo himself: the name inscribed in the halo reads not John, but "Cosmas," Cosimo.

The action moves in both directions. We see contemporary people placed "up" in the painting as participants in the action occurring there.

[6] As described in John's Gospel:

> After he had said this, Jesus was troubled in spirit and testified, "Very truly I tell you, one of you is going to betray me." His disciples stared at one another, at a loss to know which of them he meant. One of them, the disciple whom Jesus loved, was reclining next to him. Simon Peter motioned to this disciple and said, "Ask him which one he means." Leaning back against Jesus, he asked him, "Lord, who is it?" Jesus answered, "It is the one to whom I will give this piece of bread when I have dipped it in the dish." Then, dipping the piece of bread, he gave it to Judas, the son of Simon Iscariot. As soon as Judas took the bread, Satan entered into him. (John 13:21–26)

[7] William Hood, "Saint Dominic's Manners of Praying: Gestures in Fra Angelico's Cell Frescoes at S. Marco," *Art Bulletin* 68 (1986): 198. The manual assumes that to take on a bodily posture will itself stimulate the spiritual attitude, and names precisely the postures and gestures associated with nine attitudes: A deep bow from the waist with Reverence; Prostration with Humility; Flagellation with Penitence; Repeated Genuflection with Compassion; Standing upright with hands before chest with Meditation; Standing with arms outstretched with Imploring God; Standing with arms held directly overhead with Ecstasy; Reading with Recollection; and Conversation with Enthusiasm for Preaching.

But the effect of the painting is to place the action "down" in the space of the "real" people eating or singing or debating or worshipping. (The more aware we are of this exchange, the more we can imagine how distressing a viewer or artist from 1300 or 1400 or 1500 would find the experience of looking at artworks in a modern museum. The painting, lined up on the wall with others of the genre, is silenced, rendered impotent—at least according to a Renaissance judgment—even if it is being admired for this or that aesthetic property.)

This confluence of two spaces into a single place is experienced in dramatic totality in the chapel in the palazzo of the Medici family in Florence previously described in chapter seven.

In the 1450s the *paterfamilias* Cosimo de Medici commissioned the painter Benozzo Gozzoli to fresco the walls with the Journey of the Wise Men to Bethlehem to worship the baby Jesus. The Magi make their way in splendid ceremonial procession around the chapel, one king on each wall, toward the altar—whose altarpiece is a Nativity, but unusually dark and empty of figures, as though waiting for their arrival for its own completion.

As noted in chapter seven, the two narratives of the journey of the Magi itself and the vicarious (moral-spiritual) journey of the Medici family to the baby Jesus, laying their riches at his feet in imitation of their patron saints the Magi, overlay two other narratives. The fresco also evokes the reenactment of the journey of the Magi every two years with great pomp and circumstance by the confraternity of the Magi, of which the Medici served as chief officers during the fifteenth century. And it commemorates the journey of the "kings" and leaders of the Eastern Church to the Western Church for the Council of Florence in the 1430s, an event whose enormous expenses were underwritten by the Medici.

The story unfolds *around* the gathered worshippers of family and guests, who must themselves turn around the chapel to follow the story, imitating in some fashion the procession on the walls. In doing so, they take their place, as it were, in the large entourage following the Magi. Indeed, various members of the Medici family and visiting dignitaries could look up and see themselves *in* the paintings, depicted among the entourage. The frescoes transform the physical space of the chapel into a place where those present become participants in the scriptural narrative.

9

THE SOURCES OF VISUAL STORYTELLING

My intention is to frame the discussion of visual narrative in keeping with the terms and categories used in medieval and Renaissance Italy. The first thing to digest is that pretty much all storytelling artworks of this period existed as "translations" from written form into visual form. That is, artists did not *make up* stories in the way that we generally expect of modern fiction writers. Moreover, the artworks retold stories already well-known by the communities for which they were made. Artists interpreted stories to address contemporary circumstances, bestowing on existing stories a present timeliness for a precise audience.

In previous chapters I have noted several examples of deep familiarity with narrative. As the Olivetan Benedictine friars in the order's mother house in southern Tuscany made their daily courses around the cloister—from dormitory to chapel, from refectory to chapter house—their daily life was *framed* not only architecturally but by the narrative of the life of St. Benedict frescoed on the walls. The episodes depicted were taken from a text that the friars would have known by heart: the *Life of Benedict* written by Pope Gregory the Great around 600. Similarly, the friars residing in the Franciscan monastery in Arezzo would have been utterly familiar with the Legend of the Holy Cross frescoed by Piero della Francesca in the apse of the church. Familiarity with the compilation of various versions of the legend in Voragine's *Golden Legend* would have equipped them to spot the choices Piero made in his selection of scenes, following one version and not another, leaving possible episodes out (such as the episode of the beam that refused to fit) and including others (such as the ceremonial meeting of Sheba and Solomon) not even mentioned by Voragine.

We can imagine their experience of viewing, or "reading," visual narratives to be like that of the careful student and lover of Scripture who reads every episode in each Gospel, considering how the episode is expanded or condensed or left out or rearranged in the other Gospels. Just as a reader might note that Mark and Matthew tell the same story, but with differences in how it is told, so a medieval or Renaissance Italian

might contemplate the differences between two Annunciations, or two Journeys of the Magi. These kinds of comparative readings came out of a regular engagement with the enormous body of visual narrative in the medieval-Renaissance period that was primarily organized according to categories and genres of the source stories as they were understood at the time.

Scripture

The Scriptures of Christian tradition were the fundamental source. Artists were hired to translate into visual form the narratives from the Gospel accounts of Jesus, the lives of the apostles in Acts, the book of Revelation, the Old Testament stories, and others. As was addressed in the previous chapter, we must remember that most people did not read the Scriptures as a private action of individuals, flipping at will through the pages of their own printed copy of the Bible. Except for the clergy and those in monastic communities with manuscripts to study (such as Lectionaries, Psalters and Gospels, books for the daily office of prayer, and commentaries by the church fathers), the majority of the population received the Scriptures almost entirely in the setting of the liturgy. The lectionary trained people in the practice of spotting parallels between the stories of the Old Testament and Psalms and the Gospel episodes. Strong associations were established between passages in Scripture and the days of the church year when they were read.

In fact, the one genre of books intended for wider circulation among ordinary folk was the so-called *Biblia Pauperum* (Bible of the Poor), collections of woodcut prints illustrating Bible stories with captions from the Scriptures. Each was arranged with a central image of a scene from the life of Christ, flanked by two images of episodes in the Old Testament understood to "prefigure" Christ.

For only one example from the forty plates typical in such books, the scene of the crucifixion is framed on the left by an image of Abraham about to sacrifice Isaac, and on the right by an image of Moses lifting up the Brazen Serpent. The caption of the first cites the episode in Genesis 22, adding "Abraham prefigures the Heavenly Father who sacrificed His Son Christ, on the cross for all of us that He might show through this even a sign of His Father's love." Two other verses are quoted, Psalm 21:18 ("The have dug my hands and feet") and Job 40:20 ("Can you catch a leviathan with a hook?"), together with an additional caption that reads "The father sacrifices the boy signifying Christ." The caption for the second image cites the source of the episode in Numbers 21:4–9, adding the phrase "The serpent that was

suspended and beheld by the people prefigures Christ on the cross whom all the faithful should behold to be free from the serpent, the devil."[1]

The wide circulation of images like these cultivated a comfort with having an eye out for such parallels according to the principle of *typology*, an idea that will to be explained in more detail in chapter eleven. Here it is worth stating that we may understand the artistic depiction of scenes from Holy Scripture as a visual Bible for the illiterate. This was the first of the purposes of art emphasized in defenses of sacred imagery ranging from Gregory the Great's treatise in the year 600 to sermons and treatises in the fifteenth century.[2]

Even so, as I noted earlier in the introduction, we mislead ourselves if we equate *illiterate* with being intellectually "challenged" and suppose that visual narration of Scriptures is a sort of simplified *Bible for Dummies*. One intended lesson of part three of this book, The Place of Narrative, is to help us understand the *sophistication* of the art that constituted visual sacred narratives in medieval and Renaissance Italy.

Sophisticated work assumed the sophistication of the viewers. Medieval Italians were certainly equipped to recognize characters, to spot connections, to follow the story, to fill in what was left unsaid. We demonstrate a similar sort of training in our movie-watching, when we respond to the cues of conventional film editing that permit the viewer to sense passage of time or changes in place between scenes abruptly juxtaposed. These sorts of devices in film train us to know that when the opening helicopter pan of the bustling city slowly zeroes in on two individuals on opposite sides of the street, their coming together will be at the center of the plot.

We must understand, too, that the visual representation of Bible stories was not guided by a strict fidelity to the exact sequence of the original, and did not always include the full details of the scriptural source. Rather, episodes were chosen and arranged, perhaps juxtaposed, according to the lessons important for the audience, the occasion, and the time of the liturgical year when they were read and highlighted. (Again consider this process of narrative arrangement as not fundamentally different from how the four Gospel writers themselves, however harmonious we may find their collation together, gave different emphases, even different sequences to their accounts of their Lord and Messiah's life, prepared for different audiences with varying familiarities with the Jewish past.)

[1] *The Bible of the Poor: A Facsimile and Edition of the British Library Block-book C.9 d.2*, trans. and commentary Albert C. Labriola and John W. Smelts (Pittsburgh, PA: Duquesne University Press, 1990), 124.

[2] See my discussion in the Introduction, pp. 9–11.

To return to two previous examples, the scenes from the life of Christ on the Orvieto Duomo façade include nothing from the few years of Jesus's ministry. Instead, they highlight the deeds and events that underlie the doctrine of the incarnation, of God the Father becoming fully human in the Son: the Annunciation, the Birth, the Baptism, the Passion, the Resurrection, and so forth.

The visual account of the Passion Week on the reverse side of Duccio's altarpiece for the Siena cathedral is striking for its detail in presenting just about every moment of Christ's progress from his Triumphal Entry on Palm Sunday to his appearance to the two disciples on the road to Emmaus. Each of Peter's three betrayals is distinguished, with the rooster crowing on the third. What the visual account highlights, by the proportion of scenes and how these are given formal design, is the political context. We see, center stage, Jesus as political football, or hot potato, tossed from Caiaphas to Ananias to Herod, back and forth between Herod and Pilate, who washes his hands of the whole affair in the scene before the Betrayal.

This way of retelling biblical stories was common. While obviously treated as authoritative lessons and examples from God's word, scriptural episodes are taken out of precise textual sequence and arranged in different patterns to clarify theme, plot, or purpose for the audience at hand.

In the scenes from the life of St. Peter frescoed in the Brancacci Chapel by Masaccio and Masolino, for example, no disrespect is intended to the Scriptures when the painters place together in the same scene the healing of the crippled man by Peter on one side of the street (Acts 3) and the raising of Tabitha (Acts 9:36–41) on the other. The two biblical episodes occur at different times and in different cities, one in Jerusalem and one in Joppa. Similarly, there is a change in setting. The raising of Tabitha is described in Acts 9 as a private action between Peter and the beloved cloth maker alone in an upper room. In the fresco, the scene is set in a ground floor room with people gathered around. The choice to change the setting in the fresco, as described in chapter three, brings together two biblical episodes and uses them to frame the two well-dressed gentlemen who walk down the street absorbed in their own conversation.

To explore this storytelling mode in more detail, consider one of the small frescoes painted by Fra Angelico in the cells of the dormitory in Monastery San Marco.* The main episode is that of Jesus praying in the garden of Gethsemane on the night before his Crucifixion. This scene takes up only the left side of the painting. Immediately above Jesus an angel holds a chalice, a reminder of Jesus's prayer: "O My Father, if it is possible, let this cup pass from Me; nevertheless, not as I will, but as You will." Below Jesus sleep his three closest friends, Peter, James, and John ("Could you not watch with me one hour?" Matt. 26:40).

The entire right side of the fresco is given to a vaulted room in which two women sit, one reading with rapt attention the Bible open on her lap; the other, wearing a red gown, with hands folded in prayer. Their identity is not in question, because their names are written around their haloes. The lady praying is Martha, and the one reading is Mary (a figure that early Catholic tradition commonly conflated with Mary Magdalene).

A widespread association of the sisters during the medieval period was as paired representatives of the active and contemplative modes of life. In Fra Angelico's painting, the association is clear. Martha, the one who was busy with the kitchen duties when Jesus came for dinner, is engaged actively in praying—unlike the disciples. Mary, who sat at Jesus's feet listening attentively to his words, continues that contemplative action in her manner of reading the words of Christ in the book of the Gospels.[3]

Of course, no reference to Mary and Martha occurs in the Gospel accounts of the night before the crucifixion. Fra Angelico has violated strict fidelity to the source. But the sisters were there at the cross, and (given the conflation of Mary Magdalene with Mary of Bethany) Mary Magdalene was among the first to encounter the resurrected Christ. Fra Angelico's scene masterfully and economically contrasts the sleepyheaded Peter, James, and John, spiritually inattentive to the narrative unfolding around them, with the two wide-awake sisters, whose *lectio divina* prepares them to stand loyally at the cross and ready at the tomb.

The scene is designed to inspire and direct meditation on Scripture, and to model the prayer, the contemplation, and the action of the Dominican friar resident in the room.

Apocrypha

During the early centuries of the church, lots of stories amplified what was written in the Scriptures about the heroes of the new faith, the apostles and martyrs and evangelists whose lives inspirationally marked the spread of faith in Christ. Saint Thomas journeyed to India to preach the gospel. Saint James traveled to Spain. Mary Magdalene concluded a long life of penitence and love for her Savior as a hermit on an island off the coast of France.

These stories, along with many others, gained strong currency in the popular religious imagination, and exercised their resonance in the liturgies

[3] For one example of "the active life in comparison with the contemplative life," see St. Thomas Aquinas's discussion in Question 182 in the second part of the Second Part of the *Summa Theologica*, readily found online: http://www.newadvent.org/summa/3182.htm.

of their saints' days in the liturgical calendar. By 1300, Jacobus de Voragine's *Golden Legend*—the encyclopedic companion to the church year to which I have often referred—had become the most widely available sourcebook for these stories. In these apocryphal narratives biographies for the various figures of great importance to the Church were filled in—some might say *embellished*. (Consider that preachers and storytellers of every age—even Protestant *sola scriptura* pastors—feel the urge to imagine more than the text itself gives us about the compelling characters so briefly described in the Gospels.)

It was one of the jobs accomplished by the church theologians and councils to discriminate between the authoritatively grounded narratives that became the canon of Scripture and those discerned as having no such grounding. The latter sort came to form the *apocrypha*.

To fill in the history of this process is not within the scope of this chapter, but to refer to it is important. Apocryphal literature provided a fertile storehouse of stories about the figures of sacred history for visual representation in art. Although these legends were excluded from the *canon* of Scripture, many were adopted to varying degrees into what we might call the canonical *experience* of ordinary people. One may speak of a circle of influence: the popular interest in these non-canonical embellishments encouraged their visual narration; the compelling power of visual art on the imagination and memory solidified their presence in popular religious consciousness.

The figure who received the most significant amplification was the Virgin Mary, mother of Jesus. Stories surrounding her own miraculous birth to the elderly and childless couple Joachim and Anna—celebrated in the holy-day of The Birth of the Virgin—and the circumstances of her childhood and espousal to Joseph took deep root in popular devotion.

The apocryphal gospels of Pseudo-Matthew and the Protevangelium of James were the principal sources of stories about Mary's birth. Saint Jerome's *History of the Birth of the Virgin* is a translation of the Protevangelium, and is the main source referenced by Voragine in the *Golden Legend*.[4] The frequency of the story in Italian visual art, and the likelihood that many of the readers of this book will be unfamiliar with the Mary narrative, make its main features worth summarizing.[5]

[4] Jerome makes his distrust of the authority of the source clear. He objects in particular to the explanation that the brothers of Jesus were sons of Joseph by an earlier marriage. Voragine describes the more broadly-accepted account that Mary was just one of three daughters, all named Mary, of Anna, with three different fathers.

[5] Voragine, *The Golden Legend*, vol. 2, 151–53.

At the beginning of the story, Mary's aged and barren parents parallel the other elderly parents in the Bible: Abraham and Sarah, the prophet Samuel's parents Hannah and Elkanah, and Elizabeth and Zechariah, the parents of John the Baptist. As Voragine recounts, Joachim and Anna "were both righteous and walked without reproach in all the commandments of the Lord. . . . They lived for twenty years without offspring and made a vow to the Lord that if he granted them a child, they would dedicate it to the service of God."[6]

Once when Joachim goes up to Jerusalem to perform his temple service at the feast of the Dedication, the chief priest angrily expels him on the assumption that his barren marriage is evidence of a curse from God. Joachim, ashamed to return home, goes into the wilderness to live with shepherds, where an angel appears to him with the promise that he and Anna will bear a daughter, and that, miraculously, "the Son of the Most High will be born of her."[7] Citing the long-barren mothers of Joseph, of Samson, of Samuel, the angel says,

> Believe these reasons and examples, which show that delayed conception and infertile childbearing are usually all the more wonderful! So then, your wife will bear you a daughter and you will call her Mary. As you have vowed, she will be consecrated to the Lord from infancy and filled with the Holy Spirit from her mother's womb. . . . Miraculously, the Son of the Most High will be born of her. His name will be Jesus, and through him all nations will be saved. And let this be a sign to you: when you arrive at the Golden Gate of Jerusalem, Anna your wife will be there waiting for you.[8]

Meanwhile, Anna grieves, not knowing where Joachim has gone. To her the same angel appears, announcing that she will bear a daughter, and that she should go to the Golden Gate of Jerusalem and await Joachim. When he comes, they are "happy to see each other and to be sure they were to have a child. They adored God and went to their home, joyfully awaiting the fulfillment of the divine promise."[9]

When Mary is born, Anna and Joachim dedicate her to God and take her to the temple at the age of three (a parallel with the dedication of young Samuel by Hannah and Elkanah). There, precociously, Mary walks up the steep stairway "without help from anyone, as if she were already fully grown up"—a scene almost always included in the many frescoed cycles concerning the life of the Virgin.

[6] Ibid., 151.
[7] Ibid., 152.
[8] Ibid., 152.
[9] Ibid., 152.

When Mary is a young teenager, the high priest sends the temple virgins home to their families to be married, but Mary refuses, saying that her parents had "dedicated her to the service of the Lord and because she herself had vowed her virginity to God."[10] After consulting with the elders, and praying earnestly, the high priest receives the word that

> Each unmarried but marriageable man of the house of David is to bring a branch to the altar. One of these branches will bloom and the Holy Spirit in the form of a dove will perch upon its tip, according to the prophecy of Isaiah. The man to whom this branch belongs is, beyond all doubt, the one who is to be the virgin's spouse.

Joseph was reluctant to bring his branch along with the other younger bachelors, but when he did, "it flowered at once. . . . So it was clear to all that Joseph was to be Mary's husband."

The many fresco cycles that treat the life of Mary almost always include this scene, and Mary's espousal to Joseph, before they turn to the canonical Gospel stories about the Annunciation, the Visitation, the Nativity, and so forth.

The most significant of these frescoes, art-historically, is the cycle by Giotto in the freestanding family chapel of the Scrovegni family in Padova, where scenes from the lives of Mary and Jesus spiral downward around three levels of panels. The topmost level is given to Mary's life up to the birth of Jesus, the middle zone to Jesus's life and ministry, and the lower level to the events of the Passion and Resurrection, beginning with the Last Supper.

Another well-known fresco cycle about the life of Mary is in the chapel of the Baroncelli family in the Franciscan church of Santa Croce in Florence, consecrated to the Annunciation and painted by Taddeo Gaddi around 1330. The cycle in the apse of the Dominican church of Santa Maria Novella across town was painted much later in the 1480s by Ghirlandaio. Scenes from the life of Mary are placed on the left (or "north") wall, with scenes from the life of John the Baptist on the right. The longest and most extensive of these Marian cycles, with thirty-two scenes, is the one in the apse of the Duomo in Orvieto, commissioned in the 1370s to the local and otherwise un-noted painter Ugolino di Prete Ilario.[11]

These frescoes demonstrate that the stories of Mary's birth and childhood and marriage to Joseph, as well as the stories of her death and im-

[10] Ibid., 153; the remaining quotations in this paragraph are taken from the same passage.

[11] The fullest account of the Orvieto cycle is that of Sara Nair James, "The Exceptional Role of St. Joseph in Ugolino di Prete Ilario's Life of the Virgin at Orvieto," *Gesta* 55, no. 1 (Spring 2016): 79–104.

mediate "assumption" into heaven, profoundly influenced the devotional experience of laity, clergy, and members of the monastic orders even though they were recognized as non-canonical. Plenty of visual narratives about the saints, martyrs, and heroes of the faith exhibit this same mix of canonical and extra-canonical sources, with narratives from both sources presented with equal authority in the final artworks.

This mix is found in scenes from the life of Peter frescoed on the walls of the Brancacci Chapel. There, for example, the apocryphal encounter of Peter with Simon Magus before Emperor Nero is the subject of the painting on the lower section of the right wall. The scriptural ground for associating the two figures is found in Acts 8:9–23, an episode not included in the fresco cycle:

> When Simon saw that the Spirit was given at the laying on of the apostles' hands, he offered them money and said, "Give me also this ability so that everyone on whom I lay my hands may receive the Holy Spirit." Peter answered: "May your money perish with you, because you thought you could buy the gift of God with money! You have no part or share in this ministry, because your heart is not right before God. Repent of this wickedness and pray to the Lord in the hope that he may forgive you for having such a thought in your heart. I see that you are full of bitterness and captive to sin."

One can easily feel the aptness of keeping Simon in the picture. His story reflects the perennial temptation to allow the love of money to poison the exercise of spiritual office. (The word for any effort to buy and sell spiritual gifts—simony—comes from the figure of Simon.) Whatever the reason, Simon the Sorcerer's resentment or jealousy of Peter did not end with Peter's rebuke, and he was endowed with a rich and perverse afterlife in the apocryphal narratives.

The rather lengthy story of the ongoing conflict between Peter and Simon is told in *The Golden Legend*, where Voragine cites sources from Clement, Jerome, and Popes Linus and Leo, among others.[12] Voragine narrates several

[12] Voragine, *The Golden Legend*, vol. 1, 341–45:

At the time there was in Jerusalem a conjuror named Simon, who claimed to be the source of all truth. . . . "I am the word of God, I am the beautiful one, I am the Paraclete; All that God is, I am!" At his command bronze serpents moved, bronze and stone statues laughed, and dogs sang. According to Pope Linus, this Simon wanted to debate with Peter and to prove that he was God. . . . But Peter refuted him point by point and exposed all his magical hoaxes. Then Simon, seeing that he could not prevail over the apostle and for fear of being exposed as a sorcerer, threw all his books of magic into the sea and went to Rome, where he might be accepted as a god. But Peter learned of this and followed him, and this brought him to Rome. . . . Then the Lord appeared to

stories of competitions between Peter and Simon—evoking parallels with Elijah's contest with the prophets of Baal. In the Brancacci Chapel, these are condensed into the scene of Peter and Simon standing before Nero, a pagan idol dashed to the floor to signal the power of the true God, and Nero's angry gesture to have Peter taken away to be crucified.[13]

This narrative of Simon the Magician is one example of the amplification of the biographies in the apocryphal literature of characters figuring in the New Testament. The influential apocryphal *Gospel of Nicodemus* is likewise known for putting a name and a story on several minor characters in the Passion narrative, such as Longinus, the centurion who pierces Jesus's side with his spear, as well as the two thieves crucified with Jesus, named as Dysmas and Gestas.

The story from the *Gospel of Nicodemus* that (for reasons not obvious) became most widely rooted in popular piety and visual decoration was that of Jesus's harrowing of hell. This episode narrates the idea that the first action of the resurrected Christ—before emerging from the tomb and making his appearances to the women and the disciples—was to liberate from hell, or Hades, the crowd of those people from the past whose faith would be "counted as righteousness," to cite the phrase from Hebrews.

The event is framed by the story that the Simeon who had waited so long for the birth of the Messiah had two sons, Karinus and Leucius, who were among those mentioned in Matthew's Gospel whose tombs were opened at the Resurrection ("The tombs were opened, and many bodies of

Peter and said: "Simon and Nero are plotting against you, but have no fear, because I am with you and will shield you! I will also give you my servant Paul as a solace." ... Meanwhile Simon Magus was in high favor with Nero, and people thought without a doubt that he was the guardian of the emperor's life and welfare and that of the whole city. ... Pope Leo affirms that Peter and Paul went to Nero and exposed all the mischief Simon was doing.

[13] The concluding episode in the Brancacci Chapel is the crucifixion of Peter. He is nailed upside-down on the cross, as in all visual depictions of Peter's martyrdom. For this, too, the *Golden Legend* cites his sources (vol. 1, 345–46):

Pope Leo and Marcellus assert that when Peter came to the cross, he said: "Because my Lord came down from heaven to earth, his cross was raised straight up; but he deigns to call me from earth to heaven, and my cross should have my head toward the earth and should point my feet toward heaven. Therefore, since I am not worthy to be on the cross the way my Lord was, turn my cross and crucify me head down!" So they turned the cross and nailed him to it with his feet upwards and his hands downwards. ... According to the same Hegesippus, Peter began to speak from the cross. "I chose to imitate you, Lord, but I had no right to be crucified upright. You are always upright, exalted, and high. We are children of the first man, who lowered his head to the earth, whose fall is signified by the manner of man's birth."

the saints who had fallen asleep were raised; and coming out of the tombs after His resurrection they entered the holy city and appeared to many" Matt. 27:52–53). In the *Gospel of Nicodemus*, Karinus and Leucius describe their experience this way:

> Now when we were set together with all our fathers in the deep, in obscurity of darkness, on a sudden there came a golden heat of the sun and a purple and royal light shining upon us. And immediately the father of the whole race of men, together with all the patriarchs and prophets, rejoiced, saying: This light is the beginning (author) of everlasting light which did promise to send unto us his co-eternal light.[14]

Confounded by this light, Satan and the personified figure of Hell argue about whether they need to fear this Jesus until they are interrupted by a voice of thunder saying " 'Remove, O princes, your gates, and be ye lift up, ye everlasting doors, and the King of glory shall come in.' When Hell heard that he said unto Satan the prince: . . . 'if thou be a mighty man of war, fight thou against the King of glory.' "

Satan is powerless to stop Christ. When Satan is crushed, the figure of Hell is stricken with fear and cries out:

> "Who art thou that settest free the prisoners that are held bound by original sin and restorest them into their former liberty? Who art thou that sheddest thy divine and bright light upon them that were blinded with the darkness of their sins?"

The Harrowing of Hell, as told in the Gospel of Nicodemus, and retold again and again in medieval and Renaissance Italian art, is worth considering precisely because the episode appears in the visual representations of the Passion and Resurrection of Christ with a frequency for which there is no clear accounting. To name artworks elsewhere mentioned in this book, it is one of the scenes on the back panel of Duccio's Maestà, the altarpiece created for the Siena Duomo. It takes up the bottom right corner of the immense Crucifixion frescoed by Andrea da Firenze in the chapter house of the Dominican Monastery of Santa Maria Novella in Florence.* It is one of the scenes frescoed in the dormitory of Monastery San Marco by Fra Angelico and his team.[15]

[14] I cite a somewhat archaic English translation because of its ready availability online, "The Gospel of Nicodemus, or Acts of Pilate," in *The Apochryphal New Testament*, trans. M.R. James (Oxford: Clarendon Press, 1924), http://www.early christianwritings.com/text/gospelnicodemus.html.

[15] Ibid. The account of the Harrowing of Hell in the Gospel of Nicodemus is also the source of one of the apocryphal stories concerning the death of Adam that entered the Legend of the Holy Cross:

The idea of Christ's descent into hell is an element of the Apostles' Creed: "He was crucified, died, and was buried. *He descended into hell* and on the third day rose from the dead"(Latin, *descendit ad ínferos*). The phrase echoes that in Ephesians 4:9: "he descended into the lower parts of the earth" (KJV, the Latin Vulgate reads, *descendit in inferiores partes terrae*). The event is described by a number of the early church fathers, including Cyril of Alexandria: "When the gatekeepers of hell saw him, they fled; the bronze gates were broken open, and the iron chains were undone."[16]

And when father Adam that was first created heard this, even that Jesus was baptized in Jordan, he cried out to Seth his son, saying: Declare unto thy sons the patriarchs and the prophets all that thou didst hear from Michael the archangel, when I sent thee unto the gates of paradise that thou mightest entreat God to send thee his angel to give thee the oil of the tree of mercy to anoint my body when I was sick. Then Seth drew near unto the holy patriarchs and prophets, and said: When I, Seth, was praying at the gates of paradise, behold Michael the angel of the Lord appeared unto me, saying: I am sent unto thee from the Lord: it is I that am set over the body of man. And I say unto thee, Seth, vex not thyself with tears, praying and entreating for the oil of the tree of mercy, that thou mayest anoint thy father Adam for the pain of his body: for thou wilt not be able to receive it save in the last days and times, save when five thousand and five hundred (al. 5,952) years are accomplished: then shall the most beloved Son of God come upon the earth to raise up the body of Adam and the bodies of the dead, and he shall come and be baptized in Jordan. And when he is come forth of the water of Jordan, then shall he anoint with the oil of mercy all that believe on him, and that oil of mercy shall be unto all generations of them that shall be born of water and of the Holy Ghost, unto life eternal. Then shall the most beloved Son of God, even Christ Jesus, come down upon the earth and shall bring in our father Adam into paradise unto the tree of mercy. (section III [XIX])

Piero della Francesca depicts Seth's visit with Archangel Michael deep in the background of the first panel of his cycle in the Church of San Francesco in Arezzo.

[16] Cyril's comment, as well as others from the writings of the church fathers, are cited by Joel Miller in "The harrowing of hell and the victory of Christ," *Patheos* (blog), March 30, 2013, http://www.patheos.com/blogs/joeljmiller/2013/03/the-victory-of-christ-and-the-harrowing-of-hell.

Clear references to Christ's descent to hell are made by two fourth-century hymn-writers. Prudentius describes how "The door [of hell] is forced and yields before Him; the bolts are torn away; down falls the pivot broken; that gate so ready to receive the inrush, so unyielding in face of those that would return, is unbarred and gives back the dead. . . ." As Ephraim the Syrian speaks to Christ: "You released the captives of Your captivity. Your body You stripped off, my Lord, and as you lost it, among the dead You descended and sought it. Death was amazed at You in Sheol . . ." See "Hymn 30" in *Ephraim the Syrian: The Hymns*, Classics of Western Spirituality (Mahwah, NJ: Paulist Press, 1989), 397.

Indeed, the notion of Christ's "harrowing of hell" was understood to be grounded in Scripture, with the principal source being the passage in 1 Peter 3:18–20, where the apostle declares that "For Christ also suffered once for sins, the just for the unjust, that He might bring us to God, being put to death in the flesh but made alive by the Spirit, *by whom also He went and preached to the spirits in prison . . .*"

Several recent commentators have revisited the episode of the Descent to Hell as worthy of consideration by the contemporary church. Timothy George, for example, in his essay "Let's Not Get the Hell Out of Here," lists the scriptural sources relevant for the issue, citing the passage from 1 Peter as "only one of several passages referring to Christ's mission between Good Friday and Easter Sunday."[17] He goes on to note that

> This teaching must be understood in light of both Jewish apocalyptic traditions, of which it is a part, and many other New Testament passages which prompted its (admittedly late) inclusion in the Apostles' Creed. These include: Colossians 2:9–15, a proto-Apostles' Creed *in nuce*; 1 Peter 4:5–6; Romans 10:6–9; 14:8–9; Philippians 2:5–11; Acts 2:24–36; Matthew 12:29, 40; 27:51–54; Luke 23:43; and Revelation 1:18.[18]

One clear example of how pervasive this episode was in medieval thought is that it came to be regularly included in the mystery play cycles in a form clearly drawn from the already-melodramatic account in the *Gospel of Nicodemus*, and that shows mutual influence between theatrical scenography and visual art in the medieval period. Some painters' depictions of the mouth of hell seem to be influenced by theatrical sets, and sets at times give the sense of following paintings as models. The influence was probably circular. The experience of many viewers of a painting of the Descent of Christ into Hell would have been suffused by the memory of the narrative as vividly performed in the streets of their own town, and vice versa: any experience of a religious drama, or *sacra rappresentazione,* about *la discesa di Gesù agli inferi* (the descent of Jesus into hell) would have evoked the liturgical and theological context of the painted version.

[17] Timothy George, "Let's Not Get The Hell Out of Here," *First Things*, April 21, 2014, http://www.firstthings.com/web-exclusives/2014/04/lets-not-get-the-hell-out-of-here.

[18] Readers interested in learning more about the traditions of this idea of Christ's Descent into Hell can find several recent essays accessible on the internet, including Laura Gibbs, "Jesus's Harrowing of Hell in the Christian Apocryphal Tradition," *Journey to the Sea* (blog), July 1, 2009, http://journeytothesea.com/harrowing-of-hell/; and David Arias's essay for a Roman Catholic readership on *Crisis Magazine*'s website, "The Harrowing of Hell," *Crisis Magazine*, April 17, 2014, http://www.crisismagazine.com/2014/the-harrowing-of-hell.

A final set of associations for a medieval Italian: Christ's "descent into hell" to liberate his beloved people took on additional resonance when placed side by side with the stories of "descents into the underworld" that figure prominently in classical literature, such as those of Orpheus (to retrieve his beloved Eurydice), of Aeneas, and of Hercules. Attentiveness to such parallel stories—a topic to be explored at greater length in chapter eleven—is relevant for understanding the art in places like the San Brizio Chapel in the Orvieto Duomo where several of these classical descents into the underworld, including Orpheus's failure to bring back Eurydice, are depicted directly beneath Signorelli's fresco of the Damned Being Herded into Hell.* Those many viewers familiar with Ovid and Virgil would have caught the parallels, and the implied differences, with Christ's successful descent into the underworld.

The apocryphal literature exercised an influence on the church year itself, since several holy-days included in the liturgical calendar celebrate events whose only sources lie outside the canon of Scripture. I have referred to several of these in earlier chapters, holy-days such as the Presentation of Mary in the Temple (September 8), celebrated at least since the sixth century; the Chairing of Peter, referred to in the fourth century and associated with Antioch, the city where Theophilus placed Peter on a throne to honor his power to heal[19]; and the Finding and Exaltation of the Holy Cross. All these feast days of the Church figured significantly in the artworks of the age. The same can be said of the holy-days devoted to particular saints that punctuate the main feast days of the liturgical calendar, where many of the associated episodes in the lives of the saints find their origin in the apocryphal literature. Here as well, the sourcebook for all of these narratives by 1300 came to be the widespread compendium of Jacobus de Voragine's *Golden Legend*.

My discussion in this section has moved in several directions. What links these various observations together is the importance of apocryphal texts, stories that are the sources of a number of episodes in the narrative painting of the period. Rather than independent manuscripts of original scriptural or apocryphal or hagiographical sources, it was almost certainly the *Golden Legend* that was the reference book in the artists' workshops.

Hagiography

I have just used the word *hagiographical* in reference to another important source for the stories given visual form by the artists, namely, the body

[19] Anton de Waal, "Chair of Peter," *The Catholic Encyclopedia*, vol. 3 (New York: Robert Appleton Company, 1908), http://www.newadvent.org/cathen/03551e.htm.

of popular literature about the lives of the saints. The focus of hagiographical stories was miracles, martyrdom, aspects of the saint's life that testify to holiness and courage, confession of faith, the presence of God, and the likeness to Christ, all with a clear purpose of inspiring and edifying the reader.

Bonaventure articulates this intention in the prologue to his life of Saint Francis. He writes that "all who are truly humble" can "be taught by [Francis's] example to utterly reject ungodliness and worldly passions, to live in conformity with Christ and to thirst after blessed hope with unflagging desire." He goes on to write that even while "this messenger of God . . . lived among men, he imitated angelic purity so that he was held up as an example for those who would be perfect followers of Christ."[20] It was this example that he offered to his readers in retelling Francis's life.

We misinterpret hagiography if we expect the dispassionate narration of modern biography, but reference to eyewitness accounts became important in works such as Bonaventure's and Celano's lives of Francis, written only decades after Francis's death, and when those who knew Francis were still alive. As Bonaventure underlines in his prologue:

> In order to have a clearer and more certain grasp of the authentic facts of his life, . . . I visited the sites of the birth, life and death of this holy man. I had careful interviews with his companions who were still alive, especially those who had intimate knowledge of his holiness and were its principal followers. Because of their acknowledged truthfulness and their proven virtue, they can be trusted beyond any doubt.[21]

Hagiographic "saints' lives" like Bonaventure's *Life of St. Francis* were the essential sources of several of the fresco cycles. The cycle painted by Sodoma and Signorelli in the Abbey of Monte Oliveto was drawn from Pope Gregory's Life of Benedict. The cycles about Francis by Giotto's workshop in the basilica in Assisi, and by Benozzo Gozzoli (painted in the 1450s in the monastery of San Francesco in Montefalco) likewise relied on hagiography for their source material.

When an altarpiece features a saint, the series of small panels decorating the base of the painting—called the *predella*—typically depicts episodes drawn from the hagiographic narratives of the saint's life. While single sculptures can't "tell the whole story," many clearly evoke, or assume familiarity with, particular episodes drawn from hagiography.

Donatello's Mary Magdalene, for instance, carved in wood in the 1450s for a place among the sculptures in the baptistry, is clearly the Magadalene

[20] *The Life of St. Francis*, trans. Ewert Cousins, Classics of Western Spirituality (Mahwah, NJ: Paulist Press, 1978), 179–81.

[21] Ibid., 183.

of the hagiographic literature, not the Gospels.* Her gaunt features and sunken eyes, her only clothing the never-cut hair once used to wash and dry the feet of her Lord, indicates the penitent Magdalene supposed to have lived the final years of her life as a hermitess on an island in southern France, eating only the Host brought to her by birds.

Classical, Medieval, and Renaissance Literature

As a final category in this survey of the main sources of visual storytelling during the period of Italian culture from 1250 to 1500, I must mention what we could call the *secular* literature. This constitutes a much smaller proportion of the whole than the narratives drawn from the sacred history of the Christian faith, and no fresco cycles exist devoted entirely to scenes from the lives of classical heroes or to a classical epic such as Virgil's *Aeneid* comparable to those featuring Peter or Benedict or Francis.

Even so, as was noted in the first chapter, figures of classical myth and legend do appear in art of the period, for instance finding a place on the large public fountains, where seasonal and zodiacal themes have a natural place. But visual narration of the stories from the classical world more commonly appear, along with favorite scenes from the literature of courtly love, in the private settings of wealthy households. They show up in the decoration of expensive furniture and furnishings—from ceramic platters to dowry chests to birth trays that were given as gifts to combs and the backs of mirrors, where they were carved in ivory. The moralizing of classical stories—drawing wholesome instruction compatible with Christian teaching from the pagan myths of Greece and Rome—was certainly an important element of late-medieval culture, but books such as *The Ovid Moralized* were not direct sources of large-scale public artworks commissioned by distinct communities to articulate their identity and inspire their work.

Certainly the renewed interest in the classical world among the humanist scholars and poets of the Renaissance fueled attention to the literature and visual art of the ancient world. Boccaccio's magnum opus was not *The Decameron* but his *Genealogy of the Pagan Gods*, an encyclopedic work of scholarship on the entire body of classical myth and legend, Book IV of which constitutes the age's major defense of poetry as revealing the truth under the veil of fiction.

In the third book of his influential treatise *On Painting*,[22] Leon Battista Alberti discusses at some length the education of artists: "I want the painter, as far as he is able, to be learned in all the liberal arts." Of first im-

[22] First published in Latin in 1435, afterward in a version in Italian.

portance is the study of geometry, but then Alberti names familiarity with the great literature of the past, emphasizing the rhetorical skill of the poets that can be translated into visual form. "Next, it will be of advantage if they take pleasure in poets and orators, for these have many ornaments in common with the painter. Literary men, who are full of information about many subjects, will be of great assistance in preparing the composition of a 'historia' . . ."[23] Alberti later underlines the point:

> I therefore advise the studious painter to make himself familiar with poets and orators and other men of letters, for he will not only obtain excellent ornaments from such learned minds, but he will be assisted in those very inventions which in painting may gain him the greatest praise. The eminent painter Phidias used to say that he had learned from Homer how best to represent the majesty of Jupiter. I believe that we too may be richer and better painters from reading our poets.[24]

As his example, Alberti quotes at length the description by the Roman poet Lucian of a painting on the subject of Calumny (or Slander) by the Greek painter Apelles, a description which itself "excites our admiration when we read it." Apelles's painting was long lost by Alberti's time, known only through Lucian's description. Indeed, such poetic descriptions of works of art—*ekphrasis*, in ancient Greek rhetoric—were admired in the classical world.

Alberti's point is that artists are indebted to the poets, but he also reverses the priority, or makes it circular, when he then asks the rhetorical question: "If this 'historia' seizes the imagination when described in words, how much beauty and pleasure do you think is presented in the actual painting of that excellent artist?"[25] The implication is that the impact of a visual image can be more powerful than that of a verbal description.

In fact, the primacy of the visual artist over the poet becomes a common trope in the Renaissance, captured in the phrase *ut pictura poesis*: "as is painting, so is poetry," or "as does the painter, so does the poet." Powerful poetry is a matter of creating "visual" images in words that imitate the images of the artists. Hence painting was not a weaker version of the written text; the visual artist was not the lesser figure, the lowly illustrator of

[23] Leon Battista Alberti, *On Painting* (New York: Penguin, 1991), 88. The term *historia*, clearly important for Alberti, is so controversial as to its proper sense that the Penguin translator leaves the Italian word untranslated. See Michael Baxandall's *Giotto and the Orators* (Oxford: Clarendon Press, 1986) for the magisterial study of how the categories of verbal "rhetoric" were translated into visual design.

[24] Alberti, *On Painting*, 89.

[25] Alberti, *On Painting*, 89.

poetry.[26] This interplay between word and image, poetry and painting, was a conscious and prominent motif during the Renaissance, inspiring play in both directions of the equation. An artwork inspires a poetic response. But how about reversing the direction: a poem inspiring a visual response? A famous example of such "reverse *ekphrasis*" is Botticelli's painting about Calumny, almost certainly prompted by Alberti's citation of Lucian's *ekphrasis* on a no-longer-existing painting.

The process is directly relevant for one of the masterworks of the age: Luca Signorelli's fresco cycle in the Orvieto Duomo treating the end times and the Last Judgment. In the lower, more decorative zone, Signorelli imitates bas-relief sculptural medallions in small paintings that depict scenes from classical literature. The largest stretch of such reverse *ekphrasis* is the group of eleven medallions illustrating the first eleven cantos of Dante's *Purgatorio*.* The tenth canto includes one of the most famous examples of *ekphrasis* in European literature: Dante's poetic description of the work of art of God himself, who carves the cliff face of one section of Mount Purgatory with bas-relief scenes of exemplars of the virtue of humility (the Virgin Mary, King David, and a figure from the classical world, Emperor Trajan). By reproducing this passage in the Orvieto Duomo, Signorelli creates a reverse *ekphrasis*, a work of art described in powerful poetry inspiring a second work of art.

In any case, by the latter half of the fifteenth century, the new humanism of the Renaissance had created the conditions for bringing the classical world within the embrace of Christian faith, theology, and philosophy. This included not only its narratives but also its principles of design in painting and architecture, its skill in depicting the human form, and the skills to represent three dimensions in two-dimensional space. Signature artworks of the first decade of the sixteenth century alone include Signorelli's frescoes in the San Brizio Chapel, Raphael's frescoes of the poets and philosophers of the so-called *School of Athens* in Pope Julius's library, and Michelangelo's frescoes of the story of creation on the ceiling of the Sistine Chapel, framed not only by the prophets of the Old Testament but by the female sibyls of ancient Greece.

The literature written during that time also makes its appearance in the visual art of the age. Dante's schematic organization of sin in *The Inferno* provided a model followed in several mural-sized representations of hell. Nardo di Cione's frescoes of the Last Judgment (1350s) in the left

[26] An influential account is that of Renssaelaer Lee in *Ut Pictura Poesis: the humanistic theory of painting*, Art Bulletin 22, no.4, accessed June 19, 2016, available as a PDF download at http://www.collegeart.org/pdf/artbulletin/Art%20Bulletin %20Vol%2022%20No%204%20Lee.pdf.

transept chapel of Santa Maria Novella in Florence, for example, shows the influence of *The Divine Comedy* only thirty years after its completion, with the groups of the damned labeled according to Dante's scheme. In general, however, treatments of contemporary literature in the visual arts, including *The Divine Comedy* and *The Decameron*, occur mainly in lavishly illustrated manuscripts affordable only to the wealthy. Botticelli's set of ninety-two drawings were prepared for an edition of Dante's *Divine Comedy*.

One fascinating case of an artwork drawn from contemporary literature with distinct *in situ* purpose is a set of four panels painted by Sandro Botticelli in the 1480s. These illustrate one of the stories from Boccaccio's *Decameron*, the collection of one hundred tales told by ten young women and men from well-to-do families to pass the time over ten days in a country villa to escape plague-ridden Florence. The paintings were commissioned by the wealthy Florentine Antonio Pucci for the wedding of his son Giannozzo to Lucrezia Bini in 1483 (though how, exactly, the paintings of Boccaccio's lurid tales are associated with an elegant and refined marriage uniting two wealthy and sophisticated upper-class families is an open question).[27]

The assignment for Day Five of the young people's sojourn is to tell stories about "lovers who survived calamities or misfortunes" and come to happy endings.[28] To illustrate the theme that "just as our pity is commended, so is our cruelty severely punished by divine justice," one young woman narrates the tale of a wealthy young man from Ravenna, Nastagio degli Onesti, and the strategy he uses to win over the affections of the woman who scorned his advances.[29] "Spending money like water" and "longing to kill himself out of sheer despair," Nastagio accepts the advice of friends and family to leave Ravenna. But he doesn't go far. He sets up a campground of fancy tents and pavilions only a few miles outside the city, replete with all the pleasures of the lifestyle of the rich and socially-significant (a strategy that will strike modern readers—and Boccaccio?—as ethically suspect). While Nastagio wanders alone one day in the woods "thinking about his cruel mistress," his "pleasant reverie" is broken by the appearance of a mounted knight chasing down a naked lady, stabbing her, tearing out her heart and entrails, and tossing them to his dogs. The knight explains to Nastagio that he and the

[27] The panels are of the size that would typically be placed above the wainscoting of a palazzo as the major decoration of a room. I follow closely the discussion of Patrizia Lee Rubin in *Images and Identity in Fifteenth-Century Florence* (New Haven: Yale University Press, 2007), 229ff.

[28] Giovanni Boccaccio, *The Decameron*, trans. G. H. McWilliams (New York: Penguin, 2003), 405.

[29] Ibid., 459.

lady are apparitions, condemned to the "pains of Hell," she "because she had sinned by her cruelty" and he for committing suicide in despair. Their punishment, "ordained by the power and justice of God," is repeated every Friday, when the knight must hunt down the lady like a wild beast. After enduring her gruesome torture, the lady rises again in one piece. The moral of the story, according to Boccaccio's narrator, is that this is the just punishment for women who reject their lovers.[30]

When the woman whom Nastagio desires, Miss Traversari, witnesses a later reenactment of this brutal affair, she sends a message to Nastagio that "she was ready to do anything he desired" to "avoid a similar fate." Their wedding occurs the following Sunday.

What's this got to do with the wedding of Giannozzo Pucci and Lucrezia Bini? Well, the first three of Botticelli's panel paintings commissioned by Giannozzo's father illustrate quite precisely the first part of the story. The knight chases down the maiden in the first; he slices her open in the second; and in the third panel, the same gruesome scene is repeated before the very eyes of the Traversari family at Nastagio's banquet in the forest. But in this scene, the figures around the table are clearly portraits of the Pucci and Bini families.

But whereas Bocaccio's narrator simply mentions, without description, the marriage between Nastagio and Miss Traversari as the happy conclusion of her tale, Botticelli (surely in consultation with his patron Antonio Pucci) gives the entire fourth panel to a depiction of the wedding feast. It is richly extravagant, held under a splendid loggia. The men are seated along the table on the right, the ladies along the left. The two tables serve as orthogonal lines of a composition in rigorously symmetrical single-point perspective. Again the characters in Boccaccio's tale are figured as members of the Pucci and Bini families, with Lucrezia Bini seated at the center of the women.

In her excellent discussion of the paintings, Patricia Lee Rubin details the social-political context of such marriages in Renaissance Florence in "the process of forging and maintaining the alliances that safeguarded the continuity of the family and its position in the city."[31] (In the painting, the coats of arms of the Pucci and Bini families are brought together under those of the Medici, the leading family of Florence.) In Botticelli's painting of the Wedding Feast, "Antonio Pucci and his friends and relations witness the happy ending to the story of Nastagio degli Onesti, when cruelty is conquered by compassion and savagery cedes to civility: a conclusion depicted in terms of festive sociability," comments Rubin, adding that "The

[30] Ibid., 462.
[31] *Images and Identity*, 236, 238.

panels commissioned at the time of the Pucci/Bini marriage show how images had a place in commemorating important events, in formulating identity, and in forming family memory."[32]

The work of the paintings was to invite the "real" family to place themselves inside Boccaccio's narrative so that the "real" wedding feast of the family becomes the "place of the narrative" where they achieve peace and social order. This function of an artwork occurs no differently in applying a story from secular literature to the life of a socially-prominent family than it does in the visual narration of stories from sacred literature in the settings of liturgy and devotion. Paintings with scriptural sources place their viewers into the narratives of Scripture. Paintings based on Boccaccio's work place their viewer into the narrative of *The Decameron*.

To sum up: storytelling artworks drew from existing sources familiar to those who commissioned the art. An inevitable aspect of viewing such works would involve spotting how the artist (in consultation with that artist's advisors) *interpreted* the source, as we have noted in Botticelli's interpretation of a story from Boccaccio. There can be no word-for-word literal equivalence when one is talking about "translating" from one medium into another.

In painting the apse of the Church of San Francesco in Arezzo, Piero della Francesca gives lots of space to a meeting between Sheba and Solomon. The source, Voragine's account in the *Golden Legend*, says only that "the queen of Sheba came to hear Solomon's words of wisdom." To go from a single line to a massive painting requires an act of interpretation. Bonaventure's authoritative *Life of St. Francis* provides hundreds of episodes. In painting the upper basilica of the nave in the church where Francis was buried, Giotto had space for only twenty-eight scenes. Selecting twenty-eight scenes from the text involved interpreting the vast multitude of stories and weighing their importance. The stakes were high.

These sorts of choices illustrate the ways in which painting scenes from a narrative provides interpretations of the source stories.

So what *episodes* from a written source were selected for a narration in visual images, and why? What details of *plot* and *theme* are emphasized in the painted work? Are these similar or different from the emphases of the source text? These are questions that an astute viewer in medieval and Renaissance Italy would already have in mind during any encounter with art in that world.

[32] Ibid., 237–38.

10

EPISODE, PLOT, AND THEME

I return to Margaret Visser's definition of narrative cited earlier in part three:

> A narrative—a story recounted in time—organizes events into meaningful sequences. When "the plot" in a story is told to us, we demand not just a jumble of facts, but a string or connecting line to join them, disclosing causes, consequences, even form. Often the "line" of connection in stories is pictured as a thread. (The word "line" itself comes from the Latin *linea*, a flaxen thread for making linen.) We speak of "spinning a yarn," and, if we become distracted, of "losing the thread" of the tale or argument. The word "text" is cognate with "textile" because a narrative is thought of as woven, out of threads.[1]

Visser's definition is informed (like all discussion of narrative in the Western tradition) by Aristotle's simple definition of plot in the *Poetics* as an action with a "beginning, middle, and end." A "narrative" is a set of episodes that have linkages so that together they form a single action. As that overarching action unfolds along its trajectory, we can see that some of the episodes form a beginning, others the middle, and others an ending or conclusion, at which point we can sigh (in either tragic grief or comic relief) with a sense that the story, at least this story, is over.

An "episode" is a small-scale event that may come to be seen as an element in a larger action. But a set of any old episodes alone, even if arranged chronologically, does not make for a plot. If a series of episodes is lined up so that we do not see any connective tissue binding them together, then we speak of the story-telling as "episodic."

The word *episodic* may be used non-judgmentally to describe genres in which no overarching "connecting line" is intended by the narrator or expected by the audience. The popular television genre of situation comedies has generally operated this way, with each week's episode standing alone as an independent unit not linked in any overarching plot that develops over the course of the season. But the term can also be used, in contexts when we are expecting a plot, to imply some fault in the construction of the

[1] *The Geometry of Love*, 31.

narrative. There are other possibilities. We may discover that the connective tissue is there, but not on the surface of the story. In detective stories the writer may invite the reader to join the detective in piecing together elements not obviously connected. Or we may discover that that the connective tissue that matters, that creates coherence, is not so much the stuff of action as it is of *theme*.

But here I've introduced a third term.

When we ask a friend to tell us what a story is *about* (the novel she is recommending, the movie he saw last night), we may be asking for a *plot* summary, a succinct account of what happens that highlights the main trajectory. But we may also be asking for another sort of *aboutness*; namely, what issues does it raise, what does it get us thinking about, perhaps what larger features of societal values or individual character are at issue in the events that unfold. For old literature teachers like me, this is just the basic distinction between *plot* and *theme*.

These distinctions are relevant for the literature of medieval and Renaissance Europe, which, as a whole, shows a propensity for "episodic" structure. An overarching plot certainly seems possible at the beginning of Boccaccio's *Decameron*, for example, when a group of seven young women from upper-class Florentine families meet in the Church of Santa Maria Novella, and decide to retreat from the plague-stricken city to one of their country villas. They invite three young men to join them. Maybe something will happen: jealous competition in love, mysterious deaths, an invasion of desperate victims of the plague. This setup is similar to Chaucer's *Canterbury Tales*, when the character "Chaucer," along with a bunch of other people making their Lenten pilgrimage to the shrine of Thomas à Becket in Canterbury, are gathered together into a single tour group by Harry Bailey the innkeeper. Maybe an adventure will happen along the way: adultery, a mysterious robbery, or a conversion that leads to a miraculous healing in Canterbury cathedral.

But in fact, the body of both these classic works of late-medieval literature is *episodic*. In the case of the *Decameron*, the young people share suggestions for how they might pass the time of their ten-day vacation in the country, finally settling on the pleasant pastime of telling stories to one another. All ten stories on each day must take up a common topic.

Some of these topics imply a theme, but the story-telling is mainly plot-oriented. Indeed, as in the tale that Panfilo tells on Day One to launch the whole game, the relevance of the plots to the stated themes is not always clear! Panfilo proposes "to begin by telling you of one of [God's] marvelous works, so that, when we have heard it out, our hopes will rest in Him as in something immutable, and we shall forever praise His name."[2] He then

[2] Boccaccio, *The Decameron*, 68–69.

recounts with gusto the story of an utterly corrupt notary, Ser Ciappelletto, whose rhetorically slick yet disgustingly hypocritical deathbed confession dupes everyone, including the gullible priest hearing the confession, to believe that he was a saint.

The tales for Day Three must take up "people who by dint of their own efforts have achieved an object they greatly desired, or recovered a thing previously lost," suggesting the theme that one can accomplish one's goals by using one's wits. Yet the previous day's tales concerned characters who suffered misfortunes before they unexpectedly—that is, in some cases through no wit of their own—are restored to happiness.[3]

In *The Decameron*, a principle of selection organizes the stories into groups, but no overarching story governing the entire sojourn develops. The young people, we might say, pay lip service to the importance of stories with sturdy moral themes, but the tabloid pleasures of scandal carry the day. Or as Boccaccio states in his epilogue, "No word, however pure, was ever wholesomely construed by a mind that was corrupt. And just as seemly language leaves no mark upon a mind that is corrupt, language that is less than seemly cannot sully a mind that is well ordered ... Stories, whatever their nature, may be harmful or useful, depending upon the listener."[4] Might Boccaccio's observation have been understood to be equally applicable to visual stories? That is a question to be taken up in this chapter.

In the case of Chaucer's *Canterbury Tales*, the same features of storytelling are at work, but more "organically" organized (we might say) than in Boccaccio's overtly-structured *Decameron*. Harry Bailey appoints himself as the master of ceremonies of a game in which each pilgrim takes his or her turn in telling a story to pass the time. Harry Bailey clearly intends to follow the social hierarchy in his ordering of who goes first and second and so forth—an order immediately subverted—but no "plot" develops that draws the characters into a collective action. And yet, astute readers as well as literary scholars can spot that the two tales that begin *The Canterbury Tales*, despite the fancy rhetoric of the aristocratic Knight and the low-life language of the working-class Miller, are in fact parallel stories with the same plot of two boys fighting over one girl. Chaucerian scholars identify groupings of tales—the "marriage group," for instance—that address a common theme.

Chaucer was an erudite writer well known in London society at the time, translator of Boethius's *Consolation of Philosophy* and member of a diplomatic mission to Italy, where he digested thoroughly the works of

[3] In Tale Six, for example, a son is thrown into prison for making love to the daughter of the master of the house, but "after the Sicilian rebellion against King Charles, the son is recognized by his mother, he marries his master's daughter, he is reunited with his brother, and they are all restored to positions of great honour" (155).

[4] Boccaccio, *Decameron*, 830.

Boccaccio. Comically, the tale of Sir Thopas that Chaucer puts in his own mouth, a tale firmly in the genre of the knightly quest, is so plotless and banal that Harry Bailey finally steps in to keep his group intact by shouting "No more of this! Thy drasty rhyming is not worth a turd." A couple hundred lines of narration, with no end in sight, no action even begun: Bailey's criticism is plot-oriented. So then the pilgrim Chaucer, pleading for another chance, goes to the other end of the spectrum with his theme-heavy Tale of Melibee, a long set of prosy moral lessons likewise with no clear end in sight. And yet the heavy-duty thematic material concludes the collection of stories when Chaucer places in the mouth of the humble parson a very long sermon about penitence, with detailed dissection of all the seven chief sins to assist these pilgrims in honest contrition and confession—which of course is the purpose of a Lenten pilgrimage.

The terms of the discussion apply equally to Dante's *Divine Comedy*. The reading experience can feel episodic, moving from one conversation to the next between Dante (the character) and the figures he meets along the way. But attentive readers begin to understand that they themselves are being invited to accompany the pilgrim Dante on a journey with a single overarching action of spiritual conversion and moral renewal modeled on the exodus story. The themes of the hellish effects of unconstrained sinful habits are revealed even in the spin-doctoring narrations of the damned. Conversely, the healing made possible through contrition and confession is revealed through the self-knowing narrations of saved souls completing their sanctification. Dante's journey pairs largeness of plot with density of theme, including discussions of every hot theological topic under the sun, from free will to whether prayers change God's mind.

The episodic structure typically at work in what we think of as the *literature* of the age equally marks the genre of *hagiography*, of pious biography with overt devotional intent. There, too, the distinctions I am making between episode, theme, and plot were familiar categories to readers of the period.

These categories are at least implicit in Pope Gregory the Great's authoritative *Life of Saint Benedict* (written around 600 A.D.). Gregory's narrative seems to follow a straightforward chronological sequence, easily divided into self-contained episodes. Although how best to define the guiding thread of the narrative may be an issue, Gregory's account "reads" with a sense of a story line, of plot, and several clear themes. For instance, we see the plotline of the process by which Benedict comes to apprehend his true calling to be a community-builder. After a period of silence and prayer in the wilderness, he gets talked into being the abbot over a group of recalcitrant monks who eventually try to poison him. He leaves them having learned his lesson. What lesson? As explained by Gregory, if Benedict had remained with these monks, "he would have been in danger of losing

sight of himself without finding them. . . . By searching continually into his own soul he always beheld himself in the presence of his Creator."[5] Gregory underlines the "attitude of the saints": "When they find their work producing no results in one place, they move on to another where it will do some good. . . . After blessed Benedict left that obstinate community he restored to life many another soul that was spiritually dead."[6] Immediately follows the episode recounting how Benedict built twelve monasteries that followed his own rule. These remain a local operation. But he comes to sense the larger scope of action to which he is being called, and moves south to Monte Cassino where the new movement of "Benedictine" monasticism takes root and, though threatened by Satan, flowers.

At a certain point in Gregory's narration (chapter eleven), Gregory steps back, noting, "Meanwhile Benedict began to manifest the spirit of prophecy by foretelling future events and by describing to those who were with him what they had done in his absence."[7] One of Gregory's modern commentators, Adalbert de Vogüé, marks this as "one of the major pivotal points" in the *Life*: "Abandoning the chronological order, Gregory gathers facts of the same kind into . . . two sections, and groups them together thematically."[8]

Other thematic groupings may be identified. A number of episodes, for instance, show Benedict's discernment of souls, his ability to spot any incongruence between a person's outward appearance and inward condition. Several episodes may be grouped together to demonstrate his care to know deeply the monks in his charge, especially the youthful ones, and to adapt his correction to their capacity and interior motivation. Indeed, this job of spiritual direction is the express topic of the second chapter in Benedict's *Rule*, "Gifts needed by an abbot or abbess":

> They should reflect on what a difficult and demanding task they have accepted, namely that of guiding souls and serving the needs of so many different characters; gentle encouragement will be needed for one, strong rebukes for another, rational persuasion for another, according to the character and intelligence of each.[9]

Interesting in this regard is that Gregory turns his readers to the *Rule of St. Benedict* in order to understand the *Life*: "If anyone wishes to have

[5] Pope St. Gregory the Great, *Life and Miracles of St. Benedict*, trans. Odo Zimmermann and Benedict Avery (Collegeville, MN: The Liturgical Press, n.d.), 12.

[6] Ibid., 14–15.

[7] Ibid., 31.

[8] Adalbert de Vogüé, *The Life of Saint Benedict, by Gregory the Great*, with Commentary by Adalbert de Vogüé (Petersham, MA: St. Bede's Publications, 1993), 77–78.

[9] *The Benedictine Handbook*, ed. Anthony Marett-Crosby and Patrick Barry (Collegeville, MN: The Liturgical Press, 2003), 18.

a closer knowledge of his life and habits he will find all the points of his teaching in this *Rule*, for the holy man could not possibly teach other than as he lived. Anyone who wishes to know more about his life and character can discover in his *Rule* exactly what he was like as an abbot, for his life could not have differed from his teaching."[10] That is (we might say), Gregory suggests the theme-rich text of the *Rule* as a key to understanding the sequentially organized, story-rich text of the *Life*.

Exactly this distinction between narrative sequence and thematic topics is made *explicit* by St. Bonaventure in the preface to his *Life of St. Francis*, one of the landmarks of hagiography.

Writes Bonaventure,

> This, then, is my principal reason for undertaking this task, that I may gather together the accounts of his virtues, his actions and his words—like so many fragments, partly forgotten and partly scattered—although I cannot accomplish this fully, so that they may not be lost when those who lived with this servant of God die. . . . In describing what God graciously accomplished through his servant, I decided that I should avoid a cultivated literary style, since the reader's devotion profits more from simple rather than ornate expression. To avoid confusion *I did not always weave the story together in chronological order. Rather, I strove to maintain a more thematic order*, relating to the same theme events that happened at different times, and to different themes events that happened at the same time, as seem appropriate.
>
> The life of Francis . . . is described in the following fifteen chapters . . .[11]

Among these topics are: "On the austerity of his life," "On his humility and obedience," "On his love of poverty," "On his affectionate piety and how irrational creatures were affectionate toward him," "On the fervor of his charity," "On his zeal for prayer," "On his understanding of Scripture," "On the efficacy of his preaching."

And yet I did not quote in its entirety that last sentence introducing the fifteen chapters. The whole sentence reads: "The life of Francis—in its *beginning, progress, and end*—is described in the following fifteen chapters." Here Bonaventure frames thematic material with the language of plot. All those chapters about Francis's humility and zeal and affectionate piety form the body of a narrative that begins with the stirrings that led to a single-minded love of God ("On his manner of life while in secular attire," "On his perfect conversion to God," and on the foundation, approval, and growth

[10] Pope St. Gregory the Great, *Life and Miracles of St. Benedict*, 74 (175 in the edition of Adalbert de Vogüé).

[11] Bonaventure, *The Life of St. Francis*, trans. Ewert Cousins, Classics of Western Spirituality (Mahwah, NJ: Paulist Press, 1978), 278.

of the Order), and whose ending is signaled by the episode of Francis's receiving the stigmata—the marks of Christ's wounds on his own body.

Plot and Theme in Visual Storytelling

Whether the relationships of episode to plot and of plot to theme apply equally to the boatload of *visual* narratives in the Renaissance is the question raised in this chapter. Did artists exhibit the *same kind* of attention to plot and theme as writers, conscious of the same distinctions? Did the intended audiences of visual narratives that "translated" well-known written narratives approach the artwork with the same expectations as they would the written source? How would a Renaissance person have understood the question, "what is this fresco cycle *about*?" What visual strategies were developed by artists to alert their intended audiences to linkages among episodes, either of action or concept, or both together?

The discussion that follows will not offer clean answers to all of these questions. In fact, I believe the issues raised here represent a still weakly-developed area of modern scholarship about premodern visual storytelling. That said, we can make good progress in learning how to *see* the narrative art of the Renaissance not anachronistically through the lenses of our own time but through the lenses shared by artists and their audiences, the shared "categories of the period eye" (in Baxandall's phrase).

The distinction between *episodic* works (that is, works composed of elements that stand on their own as apparently self-contained units, like each week's installment of a sitcom, or each tale in a given day of the *Decameron*) and those with a clear "plot" (to which each episode exists as a dependent and contributory element) has particular relevance for visual narrative. In verbal storytelling, we can make explicit the connective tissue with all sorts of verbal gestures: the rationality of effects, as in "and hence," or "Sure enough . . ." or "I was not surprised when he returned my call"; or by jumping over stretches of time to link episodes together, as in "The very next weekend . . ." or "Not until many years later . . ."

Consider this subtle example. In his *Life of St. Francis*, Bonaventure several times makes use of the refrain "Francis did not yet understand" to indicate the gap between the saint's obedience and understanding, to track the *plot* of Francis's maturing understanding of his mission and God's calling on his life.[12] But how can a painter or sculptor depict a character who

[12] For instance, "Up to this time, however, Francis was ignorant of God's plan for him. He was distracted by the external affairs of his father's business and drawn toward earthly things by the corruption of human nature" (Ibid., 187).

does not yet fully understand a purpose that is in the midst of unfolding—a purpose that the viewer is alerted to? I've suggested that Piero della Francesca's depiction of the queen of Sheba in the Legend of the Cross cycle evokes a sense that she is seeing distantly into the future to the fulfillment of the wood's destiny when it will become the cross on which the Savior of the world will be crucified. That is, she does understand a *telos* in the midst of its unfolding. Baxandall has suggested that the painters of Annunciations used subtle cues to convey whether the moment being depicted was Mary's "how can this be, since I am a virgin?" or her "Be it unto me according to thy word." But does Mary's acceptance mean that she understands the long-term implications of her obedience?

The narrator-in-words has all sorts of grammatical tools in her toolbox to "organize events into meaningful sequences," to use Margaret Visser's phrase. But in sequences of painted or sculpted episodes, the actual physical framing of each episode physically *contains* the art more concretely. When looking at sides of a polygonal pulpit, or bronze relief panels on a door, or architecturally distinct sections of a wall, the eye naturally stays within the borders. The viewer, we might say, can err by "reading" sections as discrete episodes without perceiving any larger connective tissue, or speaking of the sequence as telling a story when it doesn't, or being unable to say convincingly what the plot is.

Guides for tourists and scholarly discussions by art historians alike often play loosely with their terminology (it seems to me), speaking of a set of panels on a door or bas-relief panels on a façade or scenes on a wall as a "life of Jesus" when what ought to be obvious is that we are dealing with a severely edited "life" that focuses on a particular theme or story line. What we must take care to notice is the selection of particular episodes, and why these episodes have been chosen to the exclusion of other possibilities. A string of episodes does not necessarily compose a story, and if they do tell a story, the "thread" may not be obvious at first glance.

If linkages do exist, then the artist must introduce visual strategies that help the eye follow through, connecting one episode with another. And the artist must provide the cues and clues to how these linked episodes are elements of a coherent story. In the Passion narrative on the reverse of the Maestà, created for the high altar in the Siena cathedral, for example, Duccio repeats exactly the architectural setting in episodes that occur in the same location, such as two separate scenes that take place in Pilate's portico. Matthew's account of Jesus's interrogation before the high priest Caiaphas (Matt. 26:57–75) goes back and forth between the house "where the scribes and the elders had gathered" and "the courtyard of the high priest" where Peter "sat with the guards in order to see where this would end." To translate this back-and-forth movement between places, Duccio combines

two of the standard-sized square panels to create a sense of simultaneity between Caiaphas's interrogation of Jesus upstairs and Peter's denial of his Lord downstairs—with the black rooster appearing in the third panel. Taken together, such guides for the eye help us apprehend the cowardly absence of the disciples while the rulers of the kingdoms of this world play political football with the King of kings and Lord of lords.

The visual narrations of Bonaventure's *Life of St. Francis* by Giotto and his workshop in the Basilica of San Francesco in Assisi (around 1300) and Gregory's *Life of St. Benedict* by Sodoma and Signorelli in the Monastery of Monte Oliveto (around 1500) can surely come across as episodic. Both move in ordered chronological sequence around a clearly-defined space. Both are strongly framed as a series of self-contained episodes with no readily apparent visual linkages between them.

The fresco cycle about Benedict unfolds around the cloister of the monastery, with each scene fitting cleanly into one of the arched sections determined by the architecture. But on the second side of the cloister, there's a section of three episodes that all have to do with water.* In the first, Benedict responds to the complaint of several monks that their monastery, high on the side of the mountain, has no source of water and it's a great labor to descend every day to the lake in the valley to fetch water. Benedict prays all night at a spot above the monastery, piles some stones where he prayed, and the next morning directs the monks to the pile of stones, which now marks the spot of a bubbling spring of water that flows down the hillside.

The next episode concerns a laborer referred to as the "Goth" from the tribes in the north, not a monk but a faithful and beloved member of the community who one day is clearing away the briars along the lake to make fruitful soil when the head of his hoe flies off the handle and into the lake. In shame and remorse, he confesses his negligence to Benedict, who consoles him, and, arriving at the lakeside, sticks the handle into the water, raising it with the iron head reattached. Interestingly and clearly deliberately, Sodoma paints the stream flowing down the hillside in the first panel so that it enters the lake just at the place along the lakeside where the second episode occurs. Sodoma creates a connecting continuity between two scenes that the eye otherwise keeps separate.

The third episode occurs in the lake. The young monk Placidus loses his footing while filling a pail with water, and is drowning in the lake. Benedict sends Mauro to help Placidus, and Mauro, in his obedience and zeal to save his friend, runs right over the surface of the water to pluck Placidus out of the drink, not realizing what he has done until he's back on land. Sodoma links these two scenes similarly: the lakeside of the second scene appears to open out into the full lake in the third. Three scenes

flow together as naturally as the water that links them. But as readers of Gregory's *Life of Benedict* will notice, these three episodes (along with two more that follow shortly after) are what prompt the critical lesson in good reading that young Peter, the student to whom Gregory is narrating the life of Benedict, learns. He suddenly apprehends the parallels between Benedict's life and key figures of Scripture: Moses making water pour from the rock, Elisha drawing the ax-head out of the water (2 Kgs 6:4–7), and Peter walking on water to reach Jesus.

Another strategy for joining separate episodes into a story line, common in early paintings of the period and used effectively by the artists of the Renaissance, was to place several episodes in a single visual frame.

When one episode is larger or centrally located in the frame, and others rendered secondary by their placement on the sides or behind, then we read the featured episode as the central action. For example, in the panel The Tribute Money in the Brancacci Chapel, Masaccio includes three episodes from the story of Jesus's encounter with the collector of the temple tax (told in Matt. 17:24–27).* The episode that fills the middle of the fresco concerns the moment when the tax collector "came to Peter and said, 'Does your teacher not pay the temple tax?' He said, 'Yes, he does.' And when he came home, Jesus spoke of it first, asking, 'What do you think, Simon? From whom do kings of the earth take toll or tribute? From their children or from others?'" Set in the background at the left side of the panel, Peter follows Jesus's instructions to catch a fish and take the coin that he will find in the fish's mouth. And in the foreground but at the right edge of the panel, Peter places the coin in the hand of the tax collector.

Masaccio's visual design indicates that this is not a miracle story about finding coins in the mouths of fish but a story that focuses our attention on the thematic issue of whether or not the kingdom of heaven is a place where money-exchange is a means of signaling power and authority. The faces of the disciples, certainly Peter's, are stern; the issue is a hot one (and will remain so for the Church of which Peter was the first bishop, the rock on which it was founded). The actual paying of the tax is placed in secondary position at the edge of the scene.

Both strategies—providing directional clues that guide the eye from one episode to another and putting several episodes in one frame—are put to use with utmost skill in pulpits from the very beginning of the historical period that frames our discussion: those of Giovanni Pisano in Pistoia and Pisa, carved in the early 1300s (mentioned in chapter six).

When the panels of any of these pulpits are viewed quickly and head-on (as they are typically photographed for books) they can appear over-stuffed with figures. Jules Lubbock (in his book *Storytelling in Christian Art from Giotto to Donatello*) laments, as I have, that modern photographers

almost exclusively have worked from scaffolds erected directly in front of the relief panels, so that we get the impression of looking at them as if they were hanging at eye-level upon the walls of an art gallery. This is also true of the way frescoed chapels are photographed. . . . One has to make the effort to see these sculptures as they were intended.[13]

In fact, Lubbock demonstrates how Giovanni Pisano took into account not only the fact of the viewer's position looking up at the panels from the floor, but the movement of the viewer in following the unfolding of the story from episode to episode. For example, in the Pistoia pulpit, the first panel contains the three episodes of the Annunciation, the Nativity, and the Adoration of the Shepherds.* At the angle where the story begins stands the figure of the deacon, with the censer in his right hand (used to cense the Gospel book) and a large bound volume in his left hand—certainly the lectionary book itself.[14] When looking up at the panel from that point of view, the inaugural scene of the Annunciation comes perfectly into focus, with Mary drawing her hand to her breast in response to Gabriel's announcement that she will bear the Son of God. But as we follow the story, looking up at an oblique angle farther to the right to see the Nativity, the Annunciation disappears into the background. As Lubbock describes:

> Now we observe Mary lifting the veil-like blanket to look at Jesus and to display him. Mary the mother has become the centre of our attention and Giovanni has so arranged her body that from this angle she leans forward out of the surface of the panel, her breasts heavy with milk, and we look straight up into her face, turned slightly away from our gaze in order to inspect her child. . . . Mary and the baby Jesus are the focus not only of our attention but also of the ox and ass, the angels and shepherds, as well as of Joseph, Gabriel and the prophet on the right side of the arch, a circle completed by the spectator.[15]

But it can remain a question as to whether the episodes in such a work (even if visually linked) are parts of a clear story line. Take, for example, the large panels cast in bronze relief on Ghiberti's final set of doors for the Florence baptistry.

The panel at the top left of the door deals with the Creation and Fall, packing a lot into the space.* The scenes, in every possible gradient of relief, follow no regular pattern of movement. The most central figure is that of Eve being pulled out of Adam's side by God, but this is not in high relief. The scenes most dramatically foregrounded in high relief are the Creation

[13] Jules Lubbock, *Storytelling in Christian Art* (New Haven: Yale University Press, 2006), 85–86.

[14] Ibid., 91–93.

[15] Ibid., 100–101.

of Adam in the lower left corner and the Expulsion of Adam and Eve in the lower right corner. God's earlier actions of creation, implied by a disk of the cosmic spheres around him and the baton in his hand, is at the top of the panel, but set deeply in the background. Likewise in shallow relief is the scene of the Temptation, the serpent coiled around the tree talking with Adam and Eve, tucked back along the left side of the panel.

It is not so obvious whether foregrounding or backgrounding serves to narrate the story with deliberate emphasis on particular episodes.

In the panel given to the story of Noah and the Ark, the three episodes depicted on the panel all occur after the flood.* In very shallow relief in the upper half is the ark itself, which looks strange to modern eyes as an enormous pyramid with Noah opening a small window at the top. His sons and their wives are just emerging from the door, and a very few animals are making their way onto the drying land. In high relief in the foreground, in each of the bottom corners of the panel, are two events. In the bottom right corner is Noah's first sacrifice in thanksgiving to God for their salvation (Gen. 8:20). In the bottom left corner is the strange episode of Noah, "a man of the soil, the first man to plant a vineyard" (Gen. 9:20), becoming drunk on his new wine and lying with his loins uncovered, to the dismay of his sons who confer together in the center of the foreground. It would be difficult to pose with confidence what might be the reason, either of plot or of theme, for the juxtaposition of these two scenes in the foreground of the panel. Or is Ghiberti simply demonstrating (showing off, we might even say) his utter mastery of visual design, using perspective to give sense of depth even on a metal panel only an inch or so deep?

It is perhaps helpful to think of plot and theme on a spectrum. At one end would be works that are clearly plot-heavy—"all action"—but don't require the viewer to think about serious moral issues. (My wife supposes me to need some "mindless entertainment" when I pull an action thriller like *Die Hard* or *Lethal Weapon* off the DVD shelf on Friday evening, just for the dopamine effect of the car chase scenes.)

Toward the opposite end of the spectrum would be works of visual art in which theme dominates: all thought-stuff with no unfolding action at all, or at least no sequence of episodes that compose a plot.

Ambrogio Lorenzetti's Allegory of Good and Bad Government in Siena's town hall presents a complex scheme of the virtues and vices that lead to either the flourishing or subversion of the civic fabric and of the surrounding land as well. The townscapes and landscapes show the effects of town councils who govern for the commonweal or for personal interests, but no actual story unfolds around the room.

Similarly, the program of education by Andrea da Firenze on one of the four high-vaulted walls of the chapter house in the Dominican Mon-

astery of Santa Maria Novella in Florence has a historical dimension: St. Thomas Aquinas defeats or confounds the basic forms of heresies represented in the heretics at his feet; we can also turn to historical figures such as Tubalcain and Euclid as the primitive founders of the liberal arts now ensconced in the curriculum.* But the fresco is a conceptual diagram, not a story. However, the adjacent and central wall does tell a story, that of the Crucifixion, with episodes that begin at the lower left corner with Jesus's Triumphal Entry into Jerusalem on Palm Sunday and concludes in the lower right corner with Christ's Harrowing of Hell before he makes his resurrected appearance above ground, so to speak. The frescoes on a third wall provide a visual narration of the story of salvation but in an allegorical and conceptual mode that highlights the role of the Dominican teachers and preachers in placing believers on the straight and narrow path (well, its course zig-zags up the wall) and keeping them there, past the heretics and the temptations, to the gate where St. Peter holds the keys. We might locate such a fresco somewhere in the middle of the spectrum but clearly on the theme side rather than the plot side.

For another example, Raphael's so-called *School of Athens* frescoed on one wall of Pope Julius's library in the Vatican apartments does not give a chronological history of classical philosophy, nor a narrative about how all these famous philosophers ended up in the same atrium, conversing together, explaining, drawing and hiding drawings, and even refusing to participate.* Rather, the complex arrangement of figures unfolding from the central figures of Plato (finger pointing up to the realm of the ideal forms) and Aristotle (palm down toward the material world in which ideas are actualized) dramatizes not a narrative but a theme, namely, the unresolved dialectic and perhaps unresolvable dualism between form and matter, between the disembodied eternal and the corrupted material. The implication—the theme—is that the traditions of classical philosophy can never do justice to the theological mystery of the incarnation—of a fully human Jesus who is at the same time the perfect image of the invisible and eternal God.

Various narrative artworks operate at various places along the spectrum, with varying proportions of thematic density and linear sequence.

Take, for example, the scenes from the life of St. Peter frescoed on the walls of the Brancacci Chapel in Florence, with no fewer than three important fifteenth-century painters involved in the work. Peter's life as a whole would offer painters and their advisors a wide array of possibilities, some full of narrative drama. Even leaving out the melodramatic episodes from the apocryphal legends, Peter's appearances in the Gospels and the Acts of the Apostles include: the Calling of Peter and his brother Andrew to become fishers of men (Matt. 4:18–22); the Haul of Fish episode in Luke 5:5;

Peter's involvement in Jesus's healing of the woman with the flow of blood (Luke 8:45); the dramatic episode of Peter Walking on Water (Matt. 14:29–36); Jesus's Naming Peter as the Rock on which he will build his Church and giving Peter the Keys of the Kingdom (Matt. 16:16–20); and many others. Peter is the protagonist in numerous occasions in Acts, including his Dream of the Net Full of Unclean Beasts (Acts 10:9–23).[16]

In fact, the "principle of selection" in the Brancacci Chapel is clear enough, and falls firmly on the theme side of the spectrum. The program of this chapel, full of vivid narrative, includes every episode concerning money: the Tribute Money, Peter healing the crippled man asking for alms, Annanias and Saphira falling down dead for deceitfully reducing their contribution, Simon the Magician hoping to buy the power of the Holy Spirit, and Tabitha the cloth maker "who was always doing good and helping the poor." We can almost hear Jesus pronouncing the theme: "where your treasure is, there will your heart be also." Greedy people will not feel comfortable in this chapel if they have eyes to see and ears to hear its lessons.

Virtues and Vices as Thematic Principle

Frameworks like this one that keep the vices and virtues visible to individual and social consciousness are strongly present in the cultural landscape of medieval-Renaissance culture. (This fact doesn't mean that people were more morally virtuous in that age than in other epochs; simply that vices were recognized as such by the dominant modes of speaking and thinking and judging.) Virtues and vices certainly provide a strong and regular *thematic* framework in the *literary* narratives of the medieval-Renaissance period. The virtues and vices were understood as deeply rooted habits of the heart that shape a person's (or a civic community's) character, motivating action and guiding the person in a self-destroying, damning direction or in a direction that cooperates with God's work of sanctification.

The Divine Comedy of Dante provides the eminent example of a narrative with a clear and ever-present thematic scaffolding; first, of the *vices* of the appetites, the reason, and the will that have run their full course in the

[16] The frescoed ceiling of the chapel was destroyed in the terrible fire of 1771, but evidence suggests that the ceiling contained the scenes of the Calling of Peter and Andrew; Peter's Walking on Water to reach Jesus; Peter's Denial and his encounter with the resurrected Jesus who asked three times, "Peter, do you love me . . . Feed my sheep." See Steffi Roettgen, *Italian Frescoes: The Early Renaissance 1400–1470*, trans. Russell Stockman (New York: Abbeville Press, 1996), 94, 98.

lives of the characters in the *Inferno*. Then we encounter the characters in *Purgatorio* who have called on God's mercy, even if in their dying breath, and confessed with contrite hearts the drives and inclinations that have led them away from God, and seek God's help in turning around (in converting) the desires of their hearts into *virtues*. These souls willingly undergo the spiritual exercises that lead to a perfectly free will, able to love God and one another without any taint of sin or the pressure of the self-centered ego. The undoing of the vicious habits of the heart marks the pilgrims' route up the side of Mount Purgatory, with its seven ledges or cornices aligned with the seven so-called "Deadly Sins": pride, envy, wrath, sloth, greed, gluttony, and lust. Seven Beatitudes mark the restoration of the virtuous habits of humility, mercy, peacemaking, and so forth.

In one example from Chaucer's *Canterbury Tales*, the Wife of Bath calls her long autobiographical preamble to her tale a sort of "confession." But instead of confessing as an act of penitent self-knowledge that leads to change, the gist of the Wife's speech is to evade responsibility and to blame her propensity for sex on the circumstances of her horoscope:

> For certainly, I am dominated by the planet Venus in my senses, and my heart is dominated by the planet Mars. Venus gave me my love for pleasure and my wantonness, and Mars my sturdy hardihood. My ascendant was Mars in Taurus. Alas, alas! That ever love was thought a sin! I followed ever my inclination by virtue of my constellation. That made it that I could not withhold my chamber from any good fellow.[17]

The concluding tale of the collection is in fact the humble Parson's long and detailed sermon on the seven chief sins and all of their branches, and their virtuous opposites. His purpose is to exhort his hearers to make a good confession. For Chaucer's readers, the sermon provides the thematic framework for understanding the motivations of the pilgrims in telling their tales, and being able to discriminate between story-telling that tells the truth and narration designed to throw up a smokescreen, to evade an honest look at oneself. The same can be said of Dante's speakers. Characters such as Francesca and Ulysses in *Inferno* are rhetorical masters of spin-doctoring, of making excuses and saving face. The people whom the character Dante meets in *Purgatorio* all tell it like it is.

It is highly sophisticated irony on Boccaccio's part for the speaker of the first story in the *Decameron* to recount the utterly false confession of an evil and unrepentant man, ticking off one by one the seven chief sins in his life. The confessor-priest who hears this confession has no discernment to see through the smokescreen of the confessee's self-serving narration. As a

[17] Lines 609–618, my adaptation.

bad listener, the priest inversely models the spiritually-discerning ear that Boccaccio invites in his own readers.

I have already cited plenty of examples that suggest that this same *thematic* of the virtues and vices provides the moral scaffolding of the visual narratives of the age. We saw it in the practice of placing arrangements of virtues and/or vices on the bottom decorative level of a wall or a door or a pulpit. (Alas, most modern tourists hardly take notice of them, let alone identify them; nor are they often incorporated into scholarly discussions of the artworks.)

We noted that the four cardinal virtues and the three theological virtues *plus* Humility are placed at the base of scenes from the life of John the Baptist on the earliest set of doors created for the baptistry in Florence.* Elegant statues of six female figures representing the seven cardinal and theological virtues *minus* Temperance are placed at the corners of the hexagonal baptismal font in Siena.

Giotto's narratives of the Virgin Mary and Jesus frescoed on the walls of the Scrovegni family chapel in Padova includes, with labels, the virtues and vices lining the wall at eye-level; the three theological and four cardinal are on the right side, with their opposites on the left.* Foolishness is opposite Prudence, Fortitude opposite Inconstancy, Temperance to Wrath, Justice to Injustice, Faith to Infidelity, Love to Envy, Hope to Desperation. They present the thematic material of character that elucidates the actions depicted above. The figure of Caiaphas, for instance, rends his robe identically to how the figure of Wrath rips open his garment, suggesting (perhaps) that his righteous indignation at Jesus's blasphemy can be understood as unrighteous anger against God for sending a Messiah so unsuitably like that imagined by Isaiah and the prophets.*

In the Allegory of Good and Bad Government in the Siena town hall, the virtues and vices relevant for civic ill- or well-being are placed not in the decorative bottom level but form the very stuff of the main scenes on the wall, where the four cardinal virtues plus Peace and Magnanimity stand opposite the features of Tyranny: Deceit, Cruelty, Fraud, Furor, Division, and War.*

Here I refer again to a text that remains problematic for the scholars, but is germane to our discussion. In commending the good painter's capacity to create an effective *historia*, Leon Battista Alberti offers the example of the lost painting of Apelles about Calumny, the vice of slander, repeating at some length the description of the painting by the Roman poet Lucian:

> In the painting there was a man with enormous ears sticking out, attended on each side by two women, Ignorance and Suspicion; from one side Calumny was approaching in the form of an attractive woman, but whose face seemed

too well versed in cunning, and she was holding in her left hand a lighted torch, while with her right hand she was dragging by the hair a youth with his arms outstretched toward heaven. Leading her was another man, pale, ugly and fierce to look upon, whom you would rightly compare to those exhausted by long service in the field. They identified him correctly as Envy. There are two other women attendant on Calumny and busy arranging their mistress's dress; they are Teachery and Deceit. Behind them comes Repentance clad in mourning and rending her hair, and in her train chaste and modest Truth. If this 'historia' seizes the imagination when described in words, how much beauty and pleasure do you think it presented in the actual painting of that excellent artist?[18]

That is, Apelles couches a sophisticated thematic analysis of a *vice* in the form of a visual narrative. One interpretation of Alberti's slippery term *historia* is that a mark of high excellence in painting is when theme informs plot; as, in this case, when the vices and virtues informing an action are not lined up in a decorative border but integrated into the story.

From Thematic Structure to Parallel Stories

In this chapter, we've been dealing with the big narrative artworks that characterized a lengthy period of Italian cultural history. Such artworks existed in close relation to a source text typically familiar to the community for which the artwork was made. And, as in the source texts, the episodes composing such visual stories could exhibit variations of plot-stuff and theme-stuff. The relations between source, selection of episodes, and plot and theme are not always simple and clear. To conclude this discussion, we turn to a famously problematic case.

Twenty-eight episodes from the life of St. Francis are frescoed on the walls of the broad nave of the Basilica of San Francesco in Assisi. These large-format scenes, several meters high and wide, are ordered in a "U" pattern that begins on the wall to the right of the altar, moves back to and across the entrance wall, then along the left wall back up to the transept crossing. This enormous fresco cycle is located in the "upper" nave of the remarkable double-decker church built with remarkable speed in the decades following Francis's death (and canonization) to serve as the saint's burial place, and then as the mother-house of the order he founded. The immense project of decorating every square foot of both upper and lower churches was well along when this cycle of paintings was completed during

[18] Leon Battista Alberti, *On Painting*, trans. Cecil Grayson (New York: Penguin Books, 1991), 88–89.

the years around 1300—exactly when is a matter of debate. To be in the Basilica of San Francesco is to be "in" the place not of one narrative but of dozens, almost overwhelmingly so.

Many of the twenty-eight episodes depicted in this cycle are narrated in other of the thirteenth-century accounts of Francis's life than Bonaventure's "official" *Life*. Written by the fourth Abbot General of the Franciscan order in the 1260s, it is clear that Bonaventure's *Life of St. Francis* served as the chief reference for Giotto's work in San Francesco.[19] At the beginning of this chapter I referred to Bonaventure's prologue, where he provides a sort of table of contents of the *Life*'s fifteen chapters, indicating quite clearly that he will not follow a strict chronological order but rather a thematic order organized around the chief gifts and virtues that marked the holy man's life and death. So there was a clear organizing principle for Bonaventure's text, but what principal of selection determined Giotto's choice of twenty-eight episodes from the hundreds contained in his source book? That is the question.

Does the fresco cycle imitate the thematic organization of its source? One or two or three of the episodes from most, but not all, chapters can be found among the frescoed scenes. No episodes are drawn from chapter five, "On the austerity of his life and how creatures provided him comfort," or from chapter eight, "how irrational creatures were affectionate toward him."[20] The fresco cycle is clearly not organized, like its guidebook, in sections dealing with the same theme.

The fresco cycle seems to follow a progress marked by chronology. Perhaps we can see the painter keeping the same purpose as the source text, but translating thematic organization into plot organization. But still, can we identify clear principles of selection for the episodes chosen—as is easily done in the Brancacci Chapel, with its attention to the episodes in St. Peter's life that concern money? Unlike many of the beautifully illustrated books for children that draw together lots of the stories of St. Francis's friendly relations with birds and beasts, the twenty-eight scenes in the upper basilica do not show such clear and simple categorization.

An attentive viewer can spot a number of episodes showing Francis's obedience to church authorities: taking his dispute with his father to the

[19] Art historians are careful not to identify the painter of these frescoes simply as "Giotto." Although the series of frescoes clearly bears the mark of the great Florentine painter—almost certainly as the one given the commission—it is equally clear that he was not the principal painter of every scene. He may have left portions of the work to members of his workshop during times when he was away working on other commissions. But we leave this matter to the trained scholars.

[20] Interestingly, Bonaventure places the story about Francis preaching to the birds in chapter twelve, "On the efficacy of his preaching," rather than in chapter eight.

local bishop, and seeking papal approval for his new order, for instance, or reenacting the Nativity scene in the village of Greccio, for which, writes Bonaventure, "he petitioned for and obtained permission from the Supreme Pontiff."[21] One can appreciate that it was especially important for this radical group of wandering friars to be incorporated into the institutional structures of the Catholic Church as the order spread across Europe and entered its third and fourth generations. A clear statement needed to be made about who was in charge, and to whom this order was accountable. As another possibility, perhaps the number of miracles in the fresco cycle might have had the purpose of giving a sort of visual record or even a defense of Francis's quick canonization only several years after his death. Yet, in terms of proportion, the source text includes more miracle stories than the fresco cycle.

In the frescoes, Giotto includes the scene in which, on a hot summer's day while ascending a mountain to a place of contemplation, Francis hitches a ride on the donkey of a peasant. "Fatigued by the long and grueling journey" and "weakened by burning thirst," writes Bonaventure in his account of the episode, the poor peasant cries out to the saint, "I'll die of thirst if I don't get a drink immediately." Francis jumps down, prays earnestly, and directs the man to a rock where "you will find running water which this very hour Christ has mercifully drawn out of the rock for you to drink." Bonaventure then comments: "How amazing is God's condescension, which bows so easily to his servants! A thirsty man drank water from the rock by the power of another's prayer and took a drink from the solid stone." Bonaventure emphasizes the parallel between Frances and Moses, adding in another miracle when Francis saved some sailors "from the danger of starvation and death for a number of days" by increasing the small amount of food they had: "From this one could clearly see that just as the servant of Almighty God was *like Moses* in drawing water from the rock, so he was *like Elisha* in the multiplication of provisions."[22]

In fact, a recurring motif in Bonaventure's *Life of St. Francis* is pointing out the parallels between the deeds and character of Francis and those of the heroes of the Scriptures; "as if he were another Elisha, who had acquired the two-fold spirit of Elijah," for example. Even more frequent are Bonaventure's citations of the ways that Francis imitated the deeds of his Lord Jesus; "For in the power of the name of God, Francis, the herald of truth, cast out devils and healed the sick."[23] Francis's likeness to Christ is fulfilled in what serves as the plot-climax of Bonaventure's account: namely,

[21] *Life of St. Francis*, 278.
[22] Ibid., 248.
[23] Ibid., 285.

the account in chapter thirteen of Francis's receiving the stigmata, the marks of the wounds of Christ on his own hands, feet, and side. Bonaventure writes that "Francis came down from the mountain bearing with him the image of the Crucified."[24]

Does this growing into the likeness of Christ signal the plot of both Bonaventure's and Giotto's narratives? What if a viewer of the fresco cycle were to look up from the consecutive scenes of Francis receiving the stigmata and of his closest friends gathered around his deathbed, and notice that in an earlier fresco cycle of scenes from the life of Christ painted just above Giotto's cycle, the episodes of Christ's Crucifixion and the Mourning of his friends around his dead body are precisely above the parallel scenes from Francis's life, but in the opposite order, creating at that spot on the wall a sort of X pattern between the two cycles? Seeing this parallel between the death of Francis and the death of Jesus takes us to the final step in our exploration of the ways that medieval and Renaissance Italians understood the stories that meant the most to their communities, and thus understood the place of art in their lives.

[24] Ibid., 307.

11

PARALLEL STORIES, OR TYPOLOGY

I have used the phrase "parallel stories" a number of times in this book in reference to occasions when striking similarities are spotted or drawn by thinkers, writers, and artists of the medieval-Renaissance period between events that occur in different times or places to different people. Bonaventure observes that St. Francis "was like Moses in drawing water from the rock." In Gregory's *Life of Benedict*, young Peter's "ah ha!" moment occurs when he suddenly apprehends a distinct set of parallels between Benedict and various scriptural characters:

> This whole account is really amazing. The water streaming from the rock reminds me of Moses, and the iron blade that rose from the bottom of the lake, of Elisha. The walking on the water recalls St. Peter; the obedience of the raven, Elijah; and the grief at the death of an enemy, David. This man must have been filled with the spirit of all the just.[1]

In the first chapter, I highlighted the painters' strategy of organizing visual space to highlight parallels (sometimes inverse parallels) between episodes. The queen of Sheba and Empress Helena both kneel in worship before the wood of the cross on opposite sides of the chapel frescoed by Piero della Francesca; the stories of the rulers Theophilus and Nero unfold in three-part parallels on opposite sides of the Brancacci Chapel. In the second chapter, I highlighted how the lectionary is purposefully designed to draw out such bifocaled perception between readings from Old and New Testaments.

In fact, a particular attentiveness to parallel relations between actions or characters in different stories was one of the habits of mind, imagination, and perception that define the culture of medieval and Renaissance Christendom—one of the fundamental "categories of the period eye."

This lens was fostered and exercised by a way of interpreting the Scriptures that kept a keen eye out for parallels—or types—between the Old and

[1] Pope St. Gregory the Great, *Life and Miracles of St. Benedict*, 25–26 (chapter eight).

New Testaments. This play of mind became commonly labeled as *typology*, and involves seeing an Old Testament event or person or object as a fore-shadowing of the New, as a "type." A type is not an analogy that our poetic mind creatively invents and imposes on the facts, but rather is something understood to have been intended in the divine orchestration of history that an attuned mind and eye *discovers*.

The story of the Virgin Mary's birth to her barren and elderly parents Joachim and Anna places her birth in the sequence of miraculous births to old childless couples that mark God's design in history: Abraham and Sarah, Samuel's parents, John the Baptist's parents. Parallels between the descents of Orpheus and Christ into the underworld to retrieve their beloved are spotted in the early centuries of Christianity, as are parallels between the poet-singer-harpists Orpheus and David who can calm the forces of nature—which makes them like Jesus who calmed the storm with his word, "Peace, be still." In his *Oration in praise of Constantine* Eusebius (ca. 260–340) compares the singers:

> Thus, I say, did our common Saviour prove himself the benefactor and pre-server of all, displaying his wisdom through the instrumentality of his human nature, even as a musician uses the lyre to evince his skill. The Grecian myth tells us that Orpheus had power to charm ferocious beasts, and tame their savage spirit, by striking the chords of his instrument with a master hand: and this story is celebrated by the Greeks, and generally believed, that an uncon-scious instrument could subdue the untamed brute, and draw the trees from their places, in obedience to its melodious power. But he who is the author of perfect harmony, the all-wise Word of God, desiring to apply every remedy to the manifold diseases of the souls of men, employed that human nature which is the workmanship of his own wisdom, as an instrument by the melodious strains of which he soothed, not indeed the brute creation, but savages en-dued with reason; healing each furious temper, each fierce and angry passion of the soul, both in civilized and barbarous nations, by the remedial power of his Divine doctrine.[2]

The authority for seeking and recognizing parallels between events was un-derstood to be Christ himself, who speaks in this manner on several occa-sions recorded in the Gospels. In his conversation with Nicodemus, Jesus says: "And *just as* Moses lifted up the serpent in the wilderness, *so* must the Son of Man be lifted up, that whoever believes in him may have eternal life" (John 3:15 NSRV).

[2] *Oration in praise of Constantine*, trans. Ernest Cushing Richardson, Nicene and Post-Nicene Fathers, Second Series, vol. 1, ed. Philip Schaff and Henry Wace (Buffalo, NY: Christian Literature Publishing, 1890), http://www.newadvent.org/fathers/2504.htm, 14.5.

Matthew recounts the encounter between Jesus and "some of the scribes and Pharisees" who asked for a sign that he was the Messiah:

> But he answered them, "An evil and adulterous generation asks for a sign, but no sign will be given to it except the sign of the prophet Jonah. *For just as Jonah was three days and three nights in the belly of the sea monster, so for three days and three nights the Son of Man will be in the heart of the earth.* The people of Nineveh will rise up at the judgment with this generation and condemn it, because *they repented at the proclamation of Jonah, and see, something greater than Jonah is here!* The Queen of the south [Sheba] will rise up at the judgment with this generation and condemn it, because she came from the ends of the earth to listen to the wisdom of Solomon, and see, something greater than Solomon is here!" (12:38–42 NRSV, italics added).

In John 6, Jesus draws the parallel between the manna given to the Israelites in the exodus and the "true bread" of his own flesh, when the crowd follows him across the lake to Capernaum after having been fed by the few loaves and fish, asking Jesus:

> "What sign are you going to give us then, so that we may see it and believe you? . . . Our ancestors ate the manna in the wilderness; as it is written, 'He gave them bread from heaven to eat.'" Then Jesus said to them, "Very truly I tell you, it was not Moses who gave you the bread from heaven, but it is my Father who gives you the true bread from heaven. . . . I am the bread of life. Your ancestors ate the manna in the wilderness, and they died. This is the bread that comes down from heaven, so that one may eat of it and not die . . . and the bread that I will give for the life of the world is my flesh." (6:30–32, 48–51 NRSV)

The stamp of approval for the mode of biblical interpretation that keeps an eye out for parallel stories—this *hermeneutic* (as the theologians might call it)—comes from Christ. However, we might just as well note the relative infrequency of the times when Jesus draws an explicit analogy between himself and an Old Testament event or person, in proportion to the manners of speaking (telling parables, for instance) that mark his discourse as a whole.

The Epistle writers of the New Testament amplified (rather than setting aside) Jesus's own mode of interpreting Scripture. Perhaps we can imagine the disciples, their "minds opened to understand the Scriptures" (as Luke recounts Jesus's action on the road to Emmaus 24:45), as able and excited to see more clearly and fully in hindsight the multifold ways in which the life and work of Christ was the climax of a narrative that God had been "writing" episode by episode throughout history. In his first Epistle, Peter explains:

For Christ also suffered for sins once for all, the righteous for the unrighteous, in order to bring you to God. He was put to death in the flesh, but made alive in the spirit, in which also he went and made a proclamation to the spirits in prison, who in former times did not obey, when God waited patiently in the days of Noah, during the building of the ark, in which a few, that is, eight persons, were saved through water. And baptism, *which this prefigured*, now saves you—not as a removal of dirt from the body, but as an appeal to God for a good conscience, through the resurrection of Jesus Christ, who has gone into heaven and is at the right hand of God, with angels, authorities, and powers made subject to him. (1 Pet. 3:18–22 NRSV, italics added)[3]

In 1 Corinthians 15, Paul develops the reverse parallel between the first and second Adam: "For since death came through a human being, the resurrection of the dead has also come through a human being; for as all die in Adam, so all will be made alive in Christ" (1 Cor. 15: 21–22 NRSV).

The Epistle most fully informed by a sense of Old Testament events and people and objects as "shadows" and "types" of their fulfillment in Christ and the new covenant is (not surprisingly) the letter to the Hebrew believers—whose heritage could be expected to have trained their eye for such parallels. In chapter five, the writer parallels the priesthood of Christ with that other Old Testament figure whose priesthood was unique, namely Melchizedek:

> So also Christ did not glorify himself in becoming a high priest, but was appointed by the one who said to him, "You are my Son, today I have begotten you"; as he says also in another place, "You are a priest forever, according to the order of Melchizedek." (Heb. 5:5–6, 10 NRSV)

This parallel between Melchizedek and Christ occupies the entirety of Hebrews 7, concluding in Hebrews 8 with the term "shadows" applied to the priests of the old covenant who served (who performed their liturgy) "at a sanctuary that is a *copy and shadow* of what is in heaven. This is why Moses was warned when he was about to build the tabernacle: 'See to it that you make everything according to the *pattern* shown you on the mountain'" (8:5 NRSV).

The theologians and commentators of the age of the church fathers took the ball and ran with it, as we might say, finding and exploring typological parallels in Old Testament stories beyond the few explicitly drawn by Christ and the Epistle writers.

[3] This reference to Christ's "proclamation to the spirits in prison" is one of the passages understood to support the descent of Christ into hell between his death and resurrection.

It took only a few centuries for the theologians and commentators to schematize—and for the clergy and laity to digest—four levels of meaning: the literal meaning and three dimensions in which a historical episode might prefigure or foreshadow later events, or signify other and deeper levels of meaning beyond the literal. (1) The *allegorical* meaning of the story concerns its foreshadowing of events in the life and death and resurrection of Christ. (2) A second dimension of the type-episode, labeled as its *tropological* meaning, draws out those moral or spiritual lessons applicable to our own life. (3) Finally, the *anagogical* significance of the episode raises the stakes, prefiguring the final fulfillment of the story in a promised and hoped for but not yet accomplished heavenly kingdom.[4]

My simple metaphor for this multivalent way of viewing the Scriptures is wearing a pair of glasses with trifocal bands under the main lens. Looking through the ordinary lens we see the real events unfolding before us. Tip the head back a bit, and what is brought into focus is how the passage points us to Christ; tip a bit more and allow the passage to reveal its implications for our own lives; tip back a bit more to peer far into the distance and consider the culmination and fulfillment when God inaugurates the eternal reign of the Lamb.

What scholars now call the "figural interpretation" of the Scriptures according to the four levels of meaning remained an active principle of scriptural interpretation for a thousand years. Its summary in a simple rhyme indicates its ubiquity across all social strata:

> *Littera gesta docet, quid credas allegoria,*
> *Moralis quid agas, quo tendas anagogia.*
> The letter teaches what happened, allegory what you should believe,
> Morality teaches what you should do, anagogy what mark you should be
> aiming for (or, where you are going).[5]

Saint Thomas Aquinas provides an authoritative summary in the *Summa Theologiae*:

[4] See Henri de Lubac, *Medieval Exegesis*, vol. 2 *The Four Senses of Scripture*, trans. Mark Sebanc and E. M. Macierowski (Grand Rapids, MI: Eerdmans, 2000) for an exhaustive account. Several examples of the usage can be found in the section "The Doctrinal Formula," 33–39.

[5] Attributed to the Dominican friar Augustine of Dacia (circa 1260) and often cited. See Lubac, *Medieval Exegesis*, 1:1. Lubac cites another version on 272:

> Dicitur *historicus* quem verba ipsa resignant,
> Et *allegoricus* priscis qui ludit in umbris;
> *Moralis* per quem vivendi norma tenetur,
> Quid vero speres *anagogicus* altius offert.

For, as St. Paul says, "The Old Law is the figure of the New," and the New Law itself, as Dionysius says, "is the figure of the glory to come." Then again, under the New Law the deeds wrought by our Head are signs of what we ourselves ought to do. Well then, the *allegorical sense* is brought into play when the things of the Old Law signify the things of the New Law; the *moral sense* when the things done in Christ and in those who prefigured him are signs of what we should carry out; and the *anagogical sense* when the things that lie ahead in eternal glory are signified.[6]

The authoritative history and analysis of the "four senses of Scripture" is Henri de Lubac's magisterial study *Medieval Exegesis*, to which my discussion, and all recent scholarship about typology, is indebted. Modern *literary* scholarship is indebted to Erich Auerbach, whose essays offered a necessary corrective to a quite different modern understanding of "allegory" whereby a symbol or allegory no longer has any "literal" relevance once it has done its job of pointing the reader's or viewer's attention to the concept or idea it stands in for.

In the medieval view, actions in the past are not any less real or "historical" because they are fulfilled in later events.[7] Even so, they are understood not to enter into the fullness of their own meaning until a later event both confirms their place as episodes in a larger unfolding narrative and also supersedes them. Their status is modified from being climactic episodes in their own narrative to being preliminary episodes foreshadowing the true climax to come.

Take, for example, the bronze serpent set up on a pole by Moses, which brought healing from the plague to those Israelites who looked up at it. This pole was not a symbol drained of relevance once Jesus was lifted up on

[6]Cited by Giuseppe Mazzotta in *Dante: Poet of the Desert* (Princeton, NJ: Princeton University Press, 1979), 240–41, footnoting the translation found in the Blackfriars edition of the *Summa Theologiae* (New York: McGraw-Hill, 1964) of the original Latin [1a, q. 1, art. 10]:

Sicut enim dicit Apostolous ad hebr. "Lex vetus figura est novae legis," et ipsa nova lex, ut Dionysius dicit, est figura future gloriae." In nova etiam lege et quae in capite sunt gesta sunt signa eorum quae nos agree debemus.

Secundum ergo quod ea quae sunt veteris legis significant ea quae sunt novae legis est **sensus allegoricus***; secundum vero quod ea quae in Christo sunt facta vel in his quae Christum significant sunt signa eorum quae nos agree debemus est* **sensus moralis***; prout vero significant ea quae sunt in aeterna Gloria est* **sensus anagogicus***.*

[7]Erich Auerbach, "'Figura,'" in *Scenes from the Drama of European Literature* (Minneapolis: University of Minnesota Press, 1984), 11–76. "Moses is no less historical and real because he is an umbra or figura of Christ, and Christ, the fulfillment, is no abstract idea, but also a historical reality" (34).

the cross to bring healing to those who believe. Moses's action, and the action of the bronze serpent, really happened; it really marked God's patient care for his often-recalcitrant people in leading them from Egypt to the Promised Land. The long series of God's actions on behalf of his people are brought to their true climax, not to their erasure, in the actions of God's only begotten Son Jesus.

In a sense, the ability to see the changing status of an event as the trajectory of a plot becomes clear is the stuff of all *narrative capacity*. It is exercised, for example, in the genre of detective mysteries as we try to sort out the relevant clues from the irrelevant ones as the writer doles them out. The "penny doesn't drop" until the event occurs that reveals the "plot," retroactively confirming earlier episodes as relevant (or not).[8]

In fact, the set of typologically-interpreted stories referred to in the New Testament and expanded by the early church fathers did not remain a closed collection. Why not accept the possibility of much of the Old Testament being "typological"?

Although not mentioned as such in the New Testament, the story of the sacrifice of Isaac readily invites interpretation as a "type" of the sacrifice of Christ on the cross, and from two angles of vision. Abraham is asked to sacrifice his only begotten son, but is granted a reprieve. The Heavenly Father allows himself no reprieve in sacrificing his only Son. The substitutional ram in the Abraham story prefigures the atoning Lamb of God sacrificed on the altar of the cross. From one angle of vision, Isaac prefigures Christ. From another angle, the ram caught in the thicket is the type of Christ as the Lamb of God sacrificed in our place; Isaac prefigures *us*.

Views among theologians and commentators have varied on the question of how much, exactly, of the historical-literal events and personages of the Old Testament Scriptures were available to be looked at with the trifocals of allegory, tropology, and anagogy—even if the parallels between

[8]Coherent narration of our personal life follows the same pattern. One of my earliest memories (and likewise of Susan Johnson) was the traumatic event on Thanksgiving Day in 1958, when the middle daughter of the visiting Johnson family and I went out back after the big dinner to play catch—and to look after Susie's little sister. We set Nancy to retrieving the balls that we missed—which she did diligently, even the one that rolled into the slimy, slippery goldfish pond at the back of the yard. We screamed; someone ran to fish her out of the drink; her brand new pink winter coat was ruined; Nancy was carried upstairs to the bathroom by the mothers for a hot bath; and we received a memorable scolding. A big little event at the time, likely to be forgotten as the years passed—if our mothers had not maintained faithful friendship through letter-writing while the families moved around the country. Eventually, it became not the tragi-comic climax of Thanksgiving Day, but the earliest episode in my now oft-repeated plot summary of four decades of marriage: "so began a lifetime of getting in trouble together."

stories might not be obvious at first sight. One enormously significant example is the long and strong tradition in Catholicism of finding types of Mary—of the virgin who opened herself to God and opened her womb to the Holy Spirit yet remained a virgin—in the imagery of the Song of Solomon: "A *garden enclosed* is my sister, my spouse; a spring shut up, a fountain sealed" (4:12 KJV).

A further expansion of the idea could follow from Paul's statement in Romans 1:20: "For the invisible things of him from the creation of the world are clearly seen, being understood by the things that are made, even his eternal power and Godhead" (KJV). Why should not the "Book of God's World" as well as the "Book of God's Word" contain types and shadows?

That is, if God designed the unfolding of historical human time (sprinkling human history with signposts and signals), why couldn't he do the same with the created world of "nature"? An affirmative answer to this question underlies the long and popular medieval tradition of the bestiaries, which highlight even among the birds and beasts behaviors that parallel the actions of God. If there's no food for her young, the pelican was thought to pierce her breast with her sharp bill, giving up her own lifeblood for the sake of her beloved children. This example explains a feature often confusing to my students when they see a bird's nest atop the cross in depictions of the Crucifixion with blood spurting from a big bird's breast into the waiting beaks of the young. It's the pelican, sacrificing herself for those she loves. Such an image of the pelican is found in the painted border above Fra Angelico's frescoed Crucifixion in the chapter house of the Dominican Monastery San Marco in Florence.* Across town in the refectory of the Franciscan Church of Santa Croce, the pelican has built her nest on top of the cross itself. The same image is found in the border above the Crucifixion in the sacristy. And in the border immediately below the cross? A small image of the Sacrifice of Isaac.

But then, extrapolating further from Paul's argument in Romans 1 that "God's invisible qualities" have been "understood from what has been made, *so that people are without excuse*," why might we not expect to find "types" and foreshadowings of Christ even in the myths and literature of valued cultures such as ancient Greece and Rome, even if they were without the revealed light of Christ?

The question was lively and controversial from the church fathers on. Tertullian (ca. 200) gave the negative hard-line: "What has Jerusalem to do with Athens? The Church with the Academy, the Christian with the heretic?"[9] (Nothing, he implies.) Clement and the Cappodocian fathers

[9] Tertullian's question, from his *Prescriptions against Heretics* is cited and discussed by Nicholas Wolterstorff in an excellent essay entitled "Tertullian's Endur-

and Augustine took a softer or more nuanced line, recognizing worthwhile truths in the classical writers. In *On Christian Doctrine* (chapter forty, "Whatever has been rightly said by the heathen, we must appropriate to our uses"), St. Augustine develops his famous metaphor of the "Egyptian gold" that God instructed the Israelites to take with them on the exodus to be used in building the tabernacle.[10]

Myths and classical legendary heroes considered as such types have included figures such as Orpheus and Hercules. The plot of Virgil's *Aeneid*, with Aeneas's journey to found Rome, offered parallels with God's call to Abraham to journey to a yet unknown but true homeland, and of Moses's journey with the Israelites from Egypt to the Promised Land. Virgil's fourth *Eclogue*, with its prophecy of a virgin whose offspring will restore a golden age, was often cited as a sort of parallel type of Isaiah's prophecy of a virgin who "shall conceive, and bear a son, whose name shall be called Emmanuel," and as a sign that Virgil was responding to the best of his lights to what God in his providence had given all peoples to work with.

ing Question," *The Cresset*, Trinity [June/July] 1999, 6–17, accessed July 16, 2016, http://www.lillyfellows.org/media/1406/nicholas-wolterstorff-1998.pdf.

[10] Augustine of Hippo, *On Christian Doctrine*, trans. D. W. Robertson Jr. (New York: Macmillan, 1958), 75. The passage is as follows:

> Moreover, if those who are called philosophers, and especially the Platonists, have said anything that is true and in harmony with our faith, we are not only not to shrink from it, but to claim it for our own use from those who have unlawful possession of it. For, as the Egyptians had not only the idols and heavy burdens which the people of Israel hated and fled from, but also vessels and ornaments of gold and silver, and garments, which the same people when going out of Egypt appropriated to themselves, designing them for a better use, not doing this on their own authority, but by the command of God, the Egyptians themselves, in their ignorance, providing them with things which they themselves were not making a good use of; *in the same way all branches of heathen learning have not only false and superstitious fancies and heavy burdens of unnecessary toil, which every one of us, when going out under the leadership of Christ from the fellowship of the heathen, ought to abhor and avoid; but they contain also liberal instruction which is better adapted to the use of the truth, and some most excellent precepts of morality; and some truths in regard even to the worship of the One God are found among them.* Now these are, so to speak, their gold and silver, which they did not create themselves, but dug out of the mines of God's providence which are everywhere scattered abroad, and are perversely and unlawfully prostituting to the worship of devils. These, therefore, the Christian, when he separates himself in spirit from the miserable fellowship of these men, ought to take away from them, and to devote to their proper use in preaching the gospel. Their garments, also—that is, human institutions such as are adapted to that intercourse with men which is indispensable in this life—we must take and turn to a Christian use." (italics mine)

In the *Purgatorio*, Dante daringly imagines the first-century Roman poet Statius, author of the epic poem *Thebaid*, as having been set on the path of conversion to Christian faith by none other than his literary hero Virgil. Statius says to Virgil:

> . . . It was you who first
> set me toward Parnassus to drink in its grottoes,
> and you who first lit my way toward God.
> You were as one who goes by night, carrying
> the light behind him—it is no help to him,
> but instructs all those who follow—
> when you said [referring to the fourth *Eclogue*]: "The centuries turn
> new again.
> Justice returns with the first age of man,
> and new progeny descends from heaven."
> Through you I was a poet, through you a Christian. (22:64–73)[11]

Statius then explains how Virgil's words "did so accord with the new preachers"—the apostles in Rome—that he began to visit them, and became a believer, although lacking courage to reveal his newfound faith:

> More and more they seemed to me so holy
> that when Domitian started with his persecutions
> their weeping did not lack my tears.
> While I remained on earth,
> I gave them comfort. Their upright ways
> made me despise all other sects.
> I was baptized before, in my verses,
> I had led the Greeks to the rivers of Thebes,
> but, from fear, I stayed a secret Christian,
> long pretending I was still a pagan. (22:82–91)

This possibility of the compatibility of some of the teachings of the "virtuous pagans" of the classical world with Christian doctrine and ethics was taken up with gusto by the Christian humanists of the fifteenth century. Influential Florentine humanists such as the Christian-Platonist Marsilio Ficino and the poet Angelo Poliziano, for instance, enjoyed the patronage of the Medici family. Poliziano appears as the tutor of Lorenzo de Medici's children in the frescoes of the Sassetti Chapel, and Ficino (along with translating Plato into Latin) was tutor for the children of a cousin-branch of the family.

[11] Dante Alighieri, *Purgatorio*, trans. with notes by Robert and Jean Hollander (New York: Anchor Books, 2004), 489.

In all likelihood, Botticelli's famous paintings of the Birth of Venus and Primavera were commissioned by this Medici cousin as bedroom decoration for his teenage son so that, through the boy's tutelage under Ficino, the boy might be led from the pleasures of worldly beauty to the higher spiritual beauty of divine things. E. H. Gombrich cites a letter from Ficino to young Lorenzo di Pierfrancesco (with a sort of cover letter to the boy's tutors) in which Ficino "allegorizes" Venus and her Three Graces in various trinitarian categories. Venus, Ficino writes in one passage,

> is the mother of Grace, of Beauty, and of Faith. . . . Beauty is nothing but Grace, that is of three things which descend . . . from three celestial powers . . . [one of which,] the Grace of intelligence and eloquence turns contemplation mainly towards himself and kindles it with the love of divine contemplation and Beauty.[12]

Seeking such parallels between scriptural stories and characters and those of the classical world certainly provides the general context for the extensive depiction of classical writers (surrounded by scenes from their works) in the lower decorative zone in the San Brizio Chapel in the Orvieto Duomo. The question is whether Luca Signorelli's classical figures are intended more as counterexamples to the actions occurring on the main stage above them, or as foreshadowing types of those actions.

This question of just how many places typological parallels can be found has evoked differing responses in every epoch of the Church. At what point can such parallel stories be seen as arbitrary impositions with no reliable grounding in the literal-historical story? That is, how can we discriminate between inserting meanings *into* a story in a way that distorts them and apprehending significances divinely intended through careful interpretation?

Setting aside the "book of the world" or the books of the pagans, how far are we authorized to extend this principle of finding types and shadows of the things of Christ even in Old Testament personages and events? The unfettered search for a type in every verse was a bone of contention with the Protestant Reformers and their strong hermeneutic of *sola scriptura*

[12] "Botticelli's Mythologies" in *Symbolic Images: Studies in the Art of the Renaissance* (New York: Phaidon Press, 1978), 59. Gombrich cites the passage (59) in a letter by Ficino in which Ficino writes: "Just as the Christian theologians find four senses in the sacred word, the literal, the moral, the allegorical and anagogical, . . . so have the Platonists four modes of multiplying the Gods and spirits and apply a different mode of multiplication in different places as it is fitting." Pico della Mirandola includes among his 900 theses the statement that one may understand the "unity of Venus in the trinity of the Graces" (56); and the humanist poet Cristoforo Landino writes in his commentary on Dante's *Divine Comedy* that the trio of Mary, Lucy and Beatrice are three aspects of heavenly Grace, then citing St. Paul and David in support of the meanings of the three graces (57).

that emphasized the importance of the historical events themselves as set forth in the Old Testament. These same concerns go back to the church fathers. Even Origen, for instance, states forcefully:

> One should not suspect us of thinking that the Scripture does not contain real history, or that the precepts of the Law were not to be fulfilled in the letter, or that what has been written about the Savior has not sensibly taken place. . . . *The truly historical passages are many more numerous than those that are to be taken in a purely spiritual sense.*[13]

Finally, what limiting criterion would stop us from considering the possibility that even contemporary writers can write "typological" stories that include figures and actions that offer types and shadows, prefiguring (or should we say "post-figuring") the person and actions of Christ? Plenty of people in the circles of evangelical Christianity in which I was raised see the Chronicles of Narnia by C. S. Lewis operating in this mode, with Aslan the lion as a type of Christ, willingly allowing himself to be sacrificed on the White Witch's stone table in accordance with an old law, but rising again through the power of an even deeper law.

Indeed, one of the most oft-cited explanations of the fourfold levels of meaning in Scripture is given by Dante himself in the public letter addressed to his patron, "Can Grande della Scala, Vicar General of the Principate of the Holy Roman Emperor in the town of Verona," to whom Dante dedicated the *Paradiso*. There Dante explains that his own *Divine Comedy* should be understood as written according to the same pattern.

> And to make this matter of treatment clearer, it may be studied in the verse: "When Israel came out of Egypt and the House of Jacob from among a strange people, Judah was his sanctuary and Israel his dominion." For if we regard the *letter* alone, what is set before us is the exodus of the Children of Israel from Egypt in the days of Moses; if the *allegory*, our redemption wrought by Christ; if the *moral* sense, we are shown the conversion of the soul from the grief and wretchedness of sin to the state of grace; if the *anagogical*, we are shown the departure of the holy soul from the thraldom of this corruption to the liberty of eternal glory.[14]

[13] Cited in Henri de Lubac, *Medieval Exegesis*, 15. Lubac's discussion of the issue occupies the first section of vol. 2; see also vol. 1, 9.

[14] Translation from Dorothy Sayers' introduction to her translation of *The Divine Comedy* (New York: Penguin, 1949), vol. 1, 14–15. Scholars such as John Freccero, in his *Poetics of Conversion* (Cambridge, MA: Harvard University Press, 1988) and Giuseppe Mazzotta, in his *Dante, Poet of the Desert: History and Allegory in the Divine Comedy* (Princeton, NJ: Princeton University Press, 1979) show how typology is simply the stuff of Dante's imagination. The very Psalm that Dante uses to illustrate the lenses of typological interpretation in his letter to Can

Dante, that is, is teaching Can Grande how to read with typological lenses, and to do so not only when reading Scripture but when reading literature such as his own epic.

We saw this same lesson dramatized in Gregory's *Life of Benedict*—and made visually "legible" in Sodoma's fresco cycle at Monte Oliveto—when Peter, the young *discipulus* to whom Gregory narrates the life of the saint, suddenly speaks out at the moment of recognition of typological parallels. But we should note Gregory's teacherly adjustment to young Peter's apprehension of similarities between Benedict and these scriptural heroes: "Actually, Peter, blessed Benedict possessed the Spirit of only one Person, the savior who fills the hearts of all the faithful by granting them the fruits of His Redemption." Gregory's comment emphasizes that the first step in wearing typological eyeglasses is to see types of *Christ* in figures of the Old Testament such as Moses and Elijah and Elisha and David. This is the lens of allegory. Then one can see and understand the parallels between the saints and Christ as the product of their Christlikeness.

Moses foreshadows Christ. Saints, we might say, post-shadow Christ. What is added when the lives of the saints enter the picture are the multifaceted parallels between the saint and both the Old Testament type and Christ. Just as the biblical characters themselves bear moral lessons for the present-day believer, so do the lives of the saints, who themselves can serve as an inspirational model for imitation.

A saint's life is a saintly life because it is more clearly composed of the string of episodes that marks the narrative of Christ, or of the great figures of Scripture, than the average person's life. The saints are precisely those whose lives most fully embody an "imitation of Christ." Moses-like, Saints Benedict and Francis are vessels through which God provides water from a rock for thirsty people, the literal "rock" signifying Christ as the source of living water. They, in imitation of Christ, cast out demons and heal the sick in his name. Saint Francis's stigmata and his death can be paralleled with Christ's crucifixion and death. Some (especially from Protestant traditions) have suspected that such parallels between a saint and Christ detract from Christ's preeminence, making the saint a substitute for Christ. This is not how they were understood in medieval and Renaissance Italy. Rather, the parallels, the imitations, are signs of a person increasingly dead to self and alive to Christ, of Christ's indwelling in a way that increases imitation; being like Christ.

Grande—Psalm 113/114 "*in exitu de Egypto*"—is the psalm the saved souls sing as soon as they arrive on the shore of Mount Purgatory to complete the work of sanctification of their own character before ascending to join the church triumphant. All three dimensions of allegory, tropology, and anagogy are sharply relevant to them at that moment.

Typology and Visual Narrative

My purpose has been to show that this interpretive principle of typology became a deeply habituated category of the period mind and eye, not just of the scholars but across all social classes, supported by preaching and teaching on the cycle of the lectionary, built into liberal arts and theological education, and referred to by literary writers. It was the pervasive approach of commentary on the scriptural narrative and on the lives of the saints, as well as a means of seeking parallels between one's own life and the events and episodes and characters of sacred history.

Was this principle at work in *visual "commentary"* on Scripture and sacred literature? Would artists, their advisors, and their viewing publics have continued to wear their *typological lenses* when they were designing and looking at works of art? The answer is surely *yes*.

We can see that conclusion borne out by asking a further question: can we see artists intentionally designing artworks so that they evoke typological connections with other visual narratives in close proximity? Similarly, can we see evidence that the first audiences for this art exercised their typological habits beyond what was expected by the designers and decorators of the space?

Take the example of the upper Basilica of San Francesco in Assisi. Very few modern art historians, let alone guidebooks written for amateur viewers, describe Giotto's fresco cycle about St. Francis with any reference to the series of scenes from the Old and New Testaments frescoed earlier on the walls above Giotto's. The tightly focused eyes of formalism, of attention to the great artistic heroes of stylistic change, wear blinders that block out everything but the way Giotto's technique changed the course of stylistic development.

That narrow focus may keep us from imagining what people trained to wear the *typological lenses* of the premodern period could have seen as typological relationships between the scenes from the life of St. Francis presented on the main level and the scenes immediately above. A central theme of Bonaventure's *Life of St. Francis*—the source text for Giotto's visualized "life"—is precisely that the saint became so fully like Christ as to become a mirror of Christ, an *alter Christus*. As Bonaventure writes,

> just as [Francis] had imitated Christ in the actions of his life, so he should be conformed to him in the affliction and sorrow of his passion, before he would pass out of this world . . . he was to be totally transformed into the likeness of Christ crucified, not by the martyrdom of his flesh, but by the fire of his love consuming his soul. . . . When true love of Christ had transformed his lover into his image . . . Francis came down from the mountain bearing with him the image of the Crucified, which was depicted not on tablets of stone or on

panels of wood by the hands of a craftsman, but engraved in the members of his body by the finger of the living God."[15]

With that text in view, it is hard to imagine a visiting pilgrim in the fourteenth century, let alone a Franciscan friar totally familiar with Bonaventure's writing, looking up from the consecutive scenes of Francis receiving the stigmata and then of his closest friends gathered around his deathbed, without noticing the parallel scenes from Christ's life, in reverse order, directly above. Seeking the fullest possible union with Christ, Francis was given the gift of experiencing in his body the wounds of Christ. Giotto's design of the scene of the prostrate Francis—parallel to the picture plane, head to the left, feet to the right, with one of the brothers weeping at his feet—perfectly mirrors the design of the mourners gathered around the body of the dead Christ, just lowered from the cross. Mere coincidence?

The very reversed sequence, with Francis's life moving up the wall toward the altar and Jesus's life painted from the altar backwards, seems to emphasize the effect. The paired scenes create an X-pattern, a visual *chiasmus* (the rhetorical device discussed in chapter two). No definitive conclusion can be drawn about such juxtapositions without written testimony from local contemporary sources, but most instances of *visual typology* are so clear as to be unambiguous, once an audience understands the principles of medieval interpretation.

A closer look at the distinctions between allegory, tropology, and anagogy will serve to demonstrate the ways that various typological methods of thinking about stories operated in the visual arts.

Allegory

First, it was common to place an Old Testament *type* in purposeful proximity to its New Testament fulfillment. In chapter six I referred to the enormous *Armadio degli Argenti* in the Church of the Santissima Annunziata that Fra Angelico decorated with episodes from the life of Christ. At the bottom of each scene is the written reference to the relevant Gospel passage, and across the top is a reference to a prefiguring passage from the Old Testament.

One testament to the prevalence of this device is the immensely popular and widely diffused *Biblia Pauperum*, which might strike us today as a medieval version of a "graphic novel." Throughout the book, each image of an episode from Christ's life is flanked by images of foreshadowing scenes from the Old Testament. To cite just a couple of examples among the dozens:

[15] Bonaventure, *The Life of St. Francis*, 304–7.

On the page given to the Burial of Christ, the central image is of the entombment. To its left is an image of Joseph cast into the well, with the caption:

> We read in Gen. 37:24, that when the brothers of Joseph wished to sell him to the Ishmaelites, they stripped him of his coat, and threw him into an old pit. This Joseph is a type of Christ, who was thrown into a pit—that is, the tomb—when His friends took Him from the cross and laid Him in it.[16]

On the right is an image of Jonah cast into the sea to be swallowed by the fish, with the caption:

> We read in the book of Jonah, chapter 2, that when Jonah himself took ship to go to a place called Tharys, a great storm arose on the sea, and those who were in the ship cast lots among themselves; and the lot fell upon Jonah, whom they seized and threw into the sea; and a mighty fish straightway swallowed him, in whose belly he was three days and three nights. Jonah typifies Christ, who was three days and three nights in the belly of the earth.

The image for Epiphany of the three kings offering their gifts to the baby Jesus is flanked by images of Abner visiting David in Hebron and the queen of Sheba visiting Solomon, with the captions:

> We read in the second book of Kings, chapter three, that Abner, captain of the army of Saul, came to David in Jerusalem, that he might bring to him all the people of Israel, which were then following the house of Saul, which figured the coming to Christ of the magi, who worshiped Christ with mystic gifts.

and

> We read in the third book of Kings, chapter ten, that the Queen of Sheba, having heard the fame of Solomon, came to Jerusalem with great gifts to worship him. The queen was a gentile, which well figured the nations which came from afar to worship the Lord with gifts.[17]

A later example of clear and verifiable *allegorical* correlation between a series of Old Testament scenes running along one side of a nave and a parallel series of New Testament episodes on the other is seen, if often unnoticed, by millions of tourists every year in the Sistine Chapel. This place has become so associated with Michelangelo's ceiling frescoes that those

[16] *The Bible of the Poor [Biblia Pauperum]: A Facsimile and Edition of the British Library Blockbook C.9 d.2*, trans. Albert C. Labriola and John W. Smeltz (Pittsburgh, PA: Duquesne University Press, 1990), 41, 126–27. *The Biblia Pauperum* is available online as scanned facsimiles translated into English by Tamara Manning at http://amasis.com/biblia/index.html.

[17] Ibid., 17, 101.

who enter almost immediately crane their necks to look up, giving short shrift to the paintings on the walls. In 1481, five established painters—Perugino, Botticelli, Ghirlandaio, Signorelli, Rosselli—were commissioned by the pope who had built the chapel—Sixtus IV—to decorate the walls of the chapel with scenes from the life of Moses on the left (facing the altar) and scenes from the life of Christ on the right. Two panels concerning the births of the two figures are—or *were*—on the altar wall (later destroyed to make way for Michelangelo's monumental Last Judgment). Two paintings concerning the deaths of Moses and Jesus are on the back wall. Six scenes follow a mainly chronological sequence along each side wall.

A major restoration of these paintings in 1965 made legible again the set of phrases in the decorative band above the series that confirmed what was obvious enough. The paintings opposite one another operate as pairs exploring a common thematic aspect of the lives of Moses and Jesus. These captions are very likely the work of the pope himself. They turn up almost verbatim in a document prepared for a conclave of cardinals in 1513.[18]

The topics of these so-called *tituli* are more complex than simply lining up particular events in Moses's life that foreshadowed a parallel event in Jesus's life (of the sort spoken by Jesus in John 3:15). The typological pairing of the births of the two figures might have been conventional enough, although the caption has disappeared along with the paintings themselves, but the next scene on the Jesus side, his Baptism, is correlated unusually not with any scene concerning water but with several episodes narrating the young Moses's marriage to Jethro's daughter Zipporah and his departure to Egypt.

At the very center of the Moses fresco is the scene from Exodus 4 where he encounters an angel of Yahweh who rebukes him for not circumcising his second son Eliezer. Graphically depicted in the right foreground is the action described in Exodus 4:25–26: "But Zipporah took a flint knife, cut off her son's foreskin and touched Moses' feet with it. 'Surely you are a bridegroom of blood to me,' she said." The captions direct us to the likely interpretation intended for this ambiguous text from Exodus. God expects Moses's *observatio* of the old covenant, just as the law is respected by Jesus even as it is superseded by Christ's *institutio* of the new covenant in his blood.

The next pair of paintings comes under the rubric of *temptatio*. The scene of Christ's Temptation in the Wilderness is not surprising. But the parallel scene on the Moses side depicts multiple episodes not obviously related and not usually understood as a "temptation" that likewise violate

[18] Steffi Roettgen, *Italian Frescoes: The Flowering of the Renaissance 1470–1510*, trans. Russell Stockman (New York: Abbeville Press, 1996), 90.

strict chronology since they occurred before the circumcision of Moses's
son depicted in the previous panel. Steffi Roettgen summarizes the com-
plex arrangement of events:

> In the dramatic episode on the right, Moses . . . is killing an Egyptian who
> had struck a Hebrew. We next see him running away from us as he flees into
> the land of Midian, where the scene in the center of the picture is set. Moses
> is protecting the seven daughters of Jethro from the shepherds who try to
> prevent them from drawing water from the well. One of these daughters is
> Zipporah, whom Moses will marry soon afterward. In the background on the
> left the Lord appears in a burning thornbush as Moses watches Jethro's herds
> on Mount Horeb. Moses is next seen seated on the ground following God's
> command to take off his sandals for he is standing on holy ground. At the left
> edge of the picture Moses leads his family back from Egypt, carrying the staff
> God gave him as a symbol of his authority.[19]

One could say that the *allegorical* parallel is not so much the action of being
tempted as it is of being tested, of learning more precisely the calling given
to each character, the hinge-point that marks a period of preparation be-
fore launching into the real work.

The next pair of scenes unfold under the caption *congregatio populi.*
On the Moses side, the people of Israel have just passed through the Red
Sea, a scene (as Roettgen notes) "often associated typologically with the
Baptism of Christ."[20] The correlated scene from Jesus's life is neither the
Baptism nor, say, Jesus Calming the Sea of Galilee or Peter Walking across
the Water toward Jesus, but rather the Calling of the Disciples. Peter and
Andrew kneel in the foreground before Jesus, about to be made fishers
of men. The composition of the two pictures is similar: the two bodies of
water running down the center, with Moses and Jesus standing to the left
along the bank. The *titulus* draws our attention theologically to the parallel
between the gathering of the two peoples into a community with a purpose
under an appointed leader.

Ensuing pairs follow suit, revealing sophisticated parallels. The next in
the sequence is perhaps the most obvious: Moses and the Ten Command-
ments is juxtaposed with Jesus Delivering the Sermon on the Mount. The
caption: the *promulgatio legis,* the dissemination of the law.

The next pair—labeled *conturbatio*—has no typological tradition be-
hind it, but its theme would have every relevance for demonstrating the
God-appointed authority of the bishop of Rome. The episode on the Jesus
side depicts the scene from Matthew's Gospel (16:19) where Jesus gives the
"keys of the kingdom" to Peter. The parallel on the Moses side is the story

[19] Ibid., 91.
[20] Ibid.

(in Num. 16) of the rebellion of Korah against the authority of Moses and Aaron. Fire from the altar engulfs the rebels in the central scene; on the left they are being swallowed by the earth.

In sum, as Steffi Roettgen comments about the whole series, "The *tituli* reveal the essential thinking behind the concept, which is partially obscured by the somewhat puzzling parallels and not always apparent from the pictures themselves. These texts do not refer to the central event of a given picture, but rather provide a theological commentary on its various episodes."[21] In the terms we have been using in our analysis of medieval and Renaissance Italian art, we might say that the interpretation of Moses's life understood *allegorically* in the light of Jesus's life is less a matter of the *plot* or *character* than of the *theme*.

Tropology

We have seen that painters and audiences of Renaissance art expected their work to have an instructive and inspirational influence on the work of the communities under the gaze of the paintings around them. The exhortational purpose—applying lessons to one's own moral behavior—of paintings such as Lorenzetti's Allegory of Good and Bad Government in the town hall of Siena, surrounding the Council of Nine as they deliberate the welfare of the Comune, is overt. When lessons are drawn from the narratives of the Scriptures (and from the hagiographical lives of the saints), which the viewers are invited to apply to their own moral and spiritual lives, the term and concept of *tropology* kicks in.

The tropological intent of the small frescoes in each cell of the dormitory in Monastery San Marco, prompting and guiding the devotion of the occupant, is obvious enough. Be like the sisters Mary and Martha, eyes wide open and praying and studying the Scriptures, and not like the three disciples who fall asleep in the Garden of Gethsemane at their master's hour of need. Tropological devotion in these scenes is highlighted even further by the regular inclusion of a Dominican monk meditating inside the scene itself as a sort of model for the monk in the cell.* Consider the private suite reserved for the retreats of its generous patron Cosimo de Medici, mentioned in chapter seven. Frescoed on the wall of the inner room is the Adoration of the Magi, set in a simple rugged desert landscape, a scene in stark contrast with the exotic countryside frescoed on the walls of the family chapel in their palazzo down the street, where the Magi, splendidly dressed and accompanied by an enormous entourage, process ceremonially around

[21] Ibid., 90.

the walls.* In the cell in San Marco, there's no escaping the lesson about the only true and lasting use of wealth: lay it at the feet of Jesus.

The spiritual intent is explicitly personalized in the small anteroom. The subject of the fresco is that last word of Jesus, spoken to his mother Mary and the beloved disciple John from the cross, inscribed into the painting itself: "He said to His mother, 'Woman, behold, your son!' Then He said to the disciple, 'Behold, your mother!' From that hour the disciple took her into his own household" (John 19:26–27 NASB). Except that the painter Fra Angelico has made a name change in the gold halos. Instead of "John," the writing around the halo of the beloved disciple is "*Cosmas*," Cosimo.* When you—Cosimo de Medici—enter this cell, reflect on who your spiritual mother is and should be; take her into your own household. Place yourself in the scene of the Crucifixion and seek out the parallels with your own life.

This tropological intention is an essential ingredient in understanding why contemporary locations are so often integrated into the visual narratives from sacred literature and contemporary people are regularly included as participants in the narrative, at least as bystanders or as piously situated observers just outside the picture plane, such as Mr. and Mrs. Sassetti frescoed on either side of the Adoration of the Shepherds on the altarpiece.

In the scene from the Legend of the Holy Cross where Empress Helena watches as the three crosses are dug up, the city depicted by Piero della Francesca in the background must be identified (in the story) as Jerusalem—but it clearly represents contemporary Arezzo.* The cross may be "buried" outside our own city—as we avoid its implications for our lives—and any community has the opportunity to dig it up, bring it into the city, and test out its life-giving power.

My students often zero in on historical inaccuracies in the depiction of scenes and people. Jesus was born in a stable, not in the remnants of a decaying Roman edifice. Why the inconsistent and anachronistic mix of clothing styles, some in Bible-times robes and others in the fashions of the time?

Strict fidelity to the "literal" level of the text alone was seldom the principal purpose of the painter's work. Rather, just as in the verbal interpretation of sacred texts from the pulpit or in commentaries, the job of the artist is precisely to assist the viewers to place themselves in the scene and to discover the moral and spiritual implications for their own lives. "We were there when they crucified my Lord . . ." "We were there at the Birth of the Virgin, or the Annunciation, or at the Last Supper, or when St. Peter raised Tabitha from the dead," and so on. Placing the scene in a contemporary context was a key element of tropology in visual narrative.

An effect of this *tropological habit* (and one relevant for our own age, it seems to me) is to invest our own mundane and seemingly-historically-insignificant lives with significance and substantial reality. If we can see episodes in our lives that parallel those of Abraham or Isaac or Sarah or the three wise men, or St. Francis and St. Clare—heroes and heroines of sacred history, yet chosen not because they were superhuman but because they were folk no different from us—then our own lives are drawn into God's work of salvation through human history. Stated conversely, our own lives are plotless or narratively confused ("seen through a glass darkly") until they become informed by the paradigmatic narratives of Scripture and sacred history.

To be sure, drawing self-serving identifications or operating with mixed motives is always possible, then as now. We can puff ourselves up by manipulating parallels with scriptural characters to confirm our ego's directions. We can spot a parallel that suggests we are doing just fine. I gave alms to the beggar on the street, just like Peter. I included my favorite charitable nonprofit in my will, somewhat like the Magi. One can stage parallels to represent our lives as historically significant in a prideful and self-serving abuse of the method.

By what criteria, for example, could one determine whether it is an act of humility or of arrogance for the several Medici fathers and sons to play the role of the Magi in the splendid Epiphany Procession from Monastery San Marco to the baptistry, passing in front of their palazzo?

Benozzo Gozzoli's frescoes in the Medici family's chapel inside their palazzo highlight the family's association with the story of the Journey of the Magi, but there the portraits of the family are found in figures of the entourage behind the Magi, not *as* the Magi (unless the idealized figure of the young magi suggests an identification with young Lorenzo). The parallel clearly evoked in the chapel is that between the coming of the Magi and the coming of the Eastern Church to the Western Church for the Council of Florence in the 1430s. Are the Medici reminding their guests that they bankrolled the event, or is the effect to remind the churchmen and scholars of the West of the "gifts" they received from the representatives of the Eastern Church? After all, the humanist scholars of Western Christendom, and their patrons such as the Medici family, were indebted to the Eastern scholars who brought with them knowledge of Greek that opened up vast lost tracts of the classical heritage.

When the scriptural narrative of the painting's overt subject matter seems to stand in *typological* relation not to another scriptural episode but rather to an episode of contemporary history or politics, it would have been an interpretive challenge then as now to determine which narrative is being given primacy. If the Medici family uses artworks to associate the

Council of Florence with the Journey of the Magi, are they manipulating an authoritative scriptural narrative for the interests of personal propaganda, or are they making an effort to bring contemporary events under the evaluative light of scriptural norms?

I earlier described the fresco in the chapel of the Brancacci family in which the episodes of Peter's healing of the crippled beggar and his raising from the dead the cloth maker Tabitha are set on opposite sides of a Florentine street scene. Holding center stage in the panel, two elegant men, wealthy enough to be clothed in the most expensive and prestigious fashion of the day, stroll down the street looking at each other. How could one determine whether or not a moral critique is intended in Masaccio's depiction of these two men apparently oblivious to the two remarkable miracles occurring under their noses, one of which involves a woman in the cloth-making industry, just like the patrons who have funded the fresco cycle itself?

When a work of art was explicitly commissioned by a family for a place identified with the family, then the family would have been understood as the principal audience of the artwork. What if figures in a fresco cycle would be associated with the family, and yet the behavior of these figures seems to run counter to the moral lessons of the painting? How might such a situation be interpreted by those viewing the painting—remembering that the commissioned painter would not have been operating without the consultation of the patron? One possibility is that the patron was fully aware of the implications and accepted the decoration of the family chapel as a visual sermon to keep them on the straight and narrow. ("Don't let your wealth insulate you from the needs of the poor around you.")

There is no compelling reason to suppose bad faith on the part of Cosimo de Medici in having the Adoration of the Magi painted in his private retreat cell in Monastery San Marco where there was no one around to impress. The image may very well have served as a tropological reminder that the highest value of his wealth is in laying it at the feet of Jesus, as a reminder that he should be laying up treasures in Jesus's heavenly kingdom where moth and rust do not destroy and thieves do not break in and steal.

In the chapel of the wealthy banking family Scrovegni in Padova, for instance, Enrico Scrovegni calls for Giotto to focus on the Virgin of Charity precisely because he and everyone else knows that Enrico's father had been such a bad example of usurious moneylending that Dante chose the father to embody that sin in hell. In that case, there was a certain self-awareness on the part of the patrons that directly invited moral critique from the work he commissioned.

It is also possible that the patron wanted self-adulation—telling the painter to make them look good—which the crafty painter did, but with

modes of irony that are only apparent to the viewer who has eyes to see. Or the painter simply provided the flattery. An instructive, if problematic, example of this interpretive challenge can be found in Ghirlandaio's frescoed scenes from the life of St. Francis in the Sassetti family chapel in the church of Santa Trinità in Florence.

No one could *not* have noticed the presence of Mr. Sassetti's boss and patron, Lorenzo de Medici, standing at Sassetti's side in the scene of the Approval of the Rule of St. Francis, or, even more visually peculiar, the presence of the sons of Lorenzo ascending a staircase with their tutor Angelo Poliziano in the very foreground.* The anti-intellectualism (as we might call it) of the gospel simplicity of St. Francis's *Rule*, available to every untutored peasant and suffering leper, stands in stark contrast to the sophisticated classical learning evoked by the presence of a humanist poet and scholar.[22] Is Ghirlandaio following instructions to show off, on Sassetti's behalf, the prestigious circles of the patron? Is this an instance of brown-nosing (as we say nowadays) in paint—Sassetti ingratiating himself to the man to whom he owes his job and his wealth? Of course such rules of courtesy were deeply ingrained in the social intercourse of the time, and could be expected to be operative in the artwork which was itself a form of social and political currency. But would no one involved have noted the contrast with the utter rejection of power, prestige, and wealth explicit in the life and preaching of Francesco Sassetti's patron saint? Or is the thematic contrast in fact openly present, available for moral reflection by those with eyes to see and ears to hear? Or perhaps the decoration of a chapel with scenes from the patron's patron saint is so completely conventional for a family such as the Sassetti as to be irrelevant, serving merely as the frame for the real portraiture, the real narrative: look at the high social standing we have gained through our connections.

Another possibility is to understand this painting—or Masaccio's painting of the two well-dressed men strolling between the healed crippled man and the resurrected cloth maker—as a sort of moral litmus test for anyone looking at it.* If you, too, are drawn to the *bella figura* cut by the fashionable

[22] The theme is explicit in Bonaventure's account of the scene. At first Pope Innocent III "hesitated to do what Christ's little poor man asked because it seemed to some of the cardinals to be something novel and difficult beyond human powers." But one of the cardinals, "a lover of holiness and helper of Christ's poor," interjected: "If we refuse the request of this poor man as novel or too difficult, when all he asks is to be allowed to lead the Gospel life, we must be on our guard lest we commit an offense against Christ's Gospel. For if anyone says that there is something novel or irrational or impossible to observe in this man's desire to live according to the perfection of the Gospel, he is guilty of blasphemy against Christ." Bonaventure. *The Life of St. Francis*, 205.

gentlemen and pay little attention to the resurrecting of Tabitha, then you too are implicated. But if you follow the visual leads of the painting to turn your attention from the center to the edges, then the very action of viewing becomes a moment of turning from the worldly captivating to the spiritually nurturing—a moment, however small, of moral conversion.

The literature of the age is full of such moral criticism, subtle or not so subtle; criticism of the very sorts of people who would be numbered among the audience. Figures in Dante's *Inferno*, such as Francesca or Farinata or Ugolino, narrate their lives with a self-serving spin which, if the reader can read behind the spin-doctoring, prompts the moral critique. The descriptions in the General Prologue of the *Canterbury Tales* of the various pilgrims gathered at the Tabard Inn—descriptions put in the mouth of their genial fellow pilgrim Geoffrey—carry between the lines some serious moralized evaluation on the part of the author Geoffrey Chaucer, apprehensible to those readers with ears to hear.

My point is that we are dealing with a culture trained to look at visual art as well as Scripture and literature through *typological* lenses, with attentiveness to the lessons of the story for the moral and spiritual life of the individual—*tropology*—when they are in the place of visual narrative. I would argue that the people for whom these paintings were made would have had more, not fewer, "tools in their toolbox" for making quite sophisticated applications of the normative stories from Scripture and sacred history to their own lives—even if, humans being human, this capacity would have involved mixed or tainted motives.

I have mentioned Michael Baxandall's book *Art and Experience in 15th Century Italy* as invaluable in helping us recover a sense of the "categories of the period eye" by which viewers of that age performed aesthetic evaluation of paintings. What we need, and what modern art historical scholarship has only weakly provided, is an understanding of a parallel set of categories by which people once exercised "moral" evaluation of the actions of the figures in paintings. Although it is beyond my capacity in this book to delineate, with authority, such a set of moral lenses, I have attempted in this section to identify some of the instruments of *visual rhetoric* that would alert the viewer to look below the surface and to spot double meanings in visual narratives.

Anagogy

I have paid particular attention to the tropological dimension of Renaissance paintings because presenting moral and spiritual lessons for the individual viewer is a pervasive purpose of Renaissance art. The fourth

level of sense is what Aquinas called "the *anagogical sense* when the things that lie ahead in eternal glory are signified." This concern for the teleological, the eschatological, is evident in the regular movement of decoration toward the climax of the story.

When the life of a saint is the subject, visual narratives typically conclude with the martyrdom, or the apotheosis, or the crowning in heaven of a faithful servant. In the lower church of the Basilica of San Francesco in Assisi, for just one example, the four sections in the vaulting immediately above the main altar depict the Triumph of St. Francis and his three ladies of Poverty, Chastity, Obedience.

If the Virgin Mary is the subject, one can expect the scene at the highest point of the place to be her Assumption or her crowning in heaven. The mosaic scene in the highest pinnacle of the façade of the Duomo in Siena depicts the Coronation of the Virgin. In the Orvieto Duomo, also dedicated to the Virgin, the same upward movement toward Mary's Coronation is exhibited in both the mosaics on the façade and in the fresco cycle in the apse behind the altar.* Mary's earthly life is depicted on the side walls of the apse. The scenes on the east wall, directly behind the altar, present in upward movement the angel announcing to Mary her impending death; the death of Mary; the apostles taking the virgin to her sepulcher; Christ awakening Mary and taking her to heaven; Mary elevated to heaven in the presence of the disciples; the Assumption of Mary under the central arch; and her Coronation in the vaulting above.

If the story concerns the life of Christ, then the movement will be toward Resurrection and his Return in Judgment. The enormous altarpiece created for the Siena cathedral by Duccio is a Maestà, depicting the Mother of God enthroned in majesty under a glorious canopy, surrounded by angels and saints. The multi-paneled narrative on the reverse side narrates the events of the Passion, beginning with Jesus's triumphal entry into Jerusalem on "Palm Sunday." The Crucifixion is the central and largest scene, but not the last episode. The culmination of the story is the sequence of the Harrowing of Hell, the Resurrection, the *Noli Me Tangere* (John 20:17: "Jesus said, 'Do not hold on to me, for I have not yet ascended to the Father. Go instead to my brothers and tell them, "I am ascending to my Father and your Father, to my God and your God"'"). The final scene is that of Jesus's encounter with the two troubled disciples on the road to Emmaus. The bottom-left to upper-right diagonal that marks the direction of the scene leads the viewer beyond the panel itself, into the future. The subtle effect is to evoke a sense of the Supper in Emmaus, where Jesus reveals himself at the breaking of the bread, as a figure of the Eucharist and a foretaste of the Supper of the Lamb.

The narratives-in-mosaic in the ceiling of the Florence baptistry—stories from Genesis, of Joseph in Egypt, of the life of Christ—revolve

around the focal point of the Last Judgment high above the altar on the east side.* In the Scrovegni Chapel in Padova, the main narrative of the lives of Mary and Christ spirals down the walls from top to bottom. But the scene that concludes the whole decoration is again that of the Last Judgment, but in this case placed on the rear wall. One leaves the chapel after Mass with a vivid reminder of where one is headed, of the goal and conclusion of all things on earth. Michelangelo's famous frescoes of scenes from Genesis move chronologically along the ceiling of the Sistine Chapel from the east end above the altar toward the rear, ending with God's first "last judgment" of the Flood of Noah's time. The scene behind the altar, painted by Michelangelo twenty-five years after the ceiling, is the Last Judgment.

The grand narrative of salvation that stretches from left to right across the four panels on the façade of the Orvieto Duomo begins with the Creation and Fall. The second and third panels, framing the central portal, present the prophecies of a coming Messiah and the life of that Incarnate One from the Annunciation of his birth to his Resurrection. The fourth panel concludes the story with the Last Judgment.* Inside the Duomo, in parallel position on the right-most side of the right transept, is the Last Judgment depicted above and behind the altar of the San Brizio Chapel. Circling around the entry half of the chapel are episodes marking the end times before Christ's return in Judgment.

In sum, these patterns of seeing Old Testament people and events as foreshadowing Christ and the new covenant, of unpacking the story for its implications for the viewer's life, of gesturing persistently toward fulfillment, is the warp and woof of visual narrative from this period of Italian art. Visual art in the Renaissance takes on the big story of Creation, Fall, Redemption, Final Judgment, and the New Creation, and places the events in the lives of contemporary folk, rich or poor, as episodes contained in that grand narrative of salvation. History from beginning to end is charged with *kairos*. There is no escaping or ignoring the place of narrative in the age's understanding of history and in its art.

Conclusion

ART IN ITS PLACE

The primary purpose of this book has been to provide an account of a long period of European civilization when civic and religious art framed the places in which people lived, did their work, and experienced their own part in purposeful stories.

Three centuries of Italian culture in particular, from about 1250 to 1550, are recognized as having fostered an enormous number of artworks still considered masterpieces of the European heritage. It was an epoch in which the visual arts had a broad and approved social presence. All sorts of communities believed in the benefits of being surrounded by such art, and found ways to fund it. The highly trained artisans commissioned to make these artworks were valued members of society—although not after the modernist fashion as independent, countercultural, creative types best left to their own devices.

A goal of this book has been to help us recover a degree of sensitivity to the relationships once operative between the physical setting of installed artworks and the particular actions performed in those settings during an era when such sensitivity was cultivated across all strata of society.

The refrain repeated in each part of this book laments the general shriveling of such sensitivity. We have returned repeatedly to this statement:

> Most of us remain poorly equipped by our own cultural training to seek out, or even to expect, let alone to understand, the relationships once at work between artworks and their architectural, liturgical, and narrative settings.

Here I come clean. I think we ought to be putting art *back* in its place.

My concern is not only to understand the past but to foster change in the present and future. My hope is that premodern case studies like those explored in this book can provide prompts for looking with historically-informed eyes at how art operates in our own midst—or, rather, doesn't much operate *in our midst*. I wish to equip my readers to appreciate the capacity of art to articulate the purposes of the *places* in which they gather, to support the *work of the people* in and for the society in which they live, and to vivify the *stories* that inform and inspire their sense of identity.

These three *places* in which art once functioned happen to correspond—as I have suggested in each chapter—with three key places of loss or flattening in our own time. I lament not just the loss of art in *places* but the loss of a *sense of place itself* in contemporary culture. By this I mean the loss of distinct locations made to house and protect particular actions; of shared collective deeds that give purpose to a community's life; of significant stories (and here I don't mean fantasies) that provide the directional sense of beginnings, middles, and ends necessary for cultivating virtues of character, such as prudence (foreseeing future outcomes of present actions), fortitude (or what my father called stick-to-it-iveness), or temperance (of moderating desires and appetites so as to maintain fitness to reach the goal).

The erosion or leveling of designated space, of designed action (liturgy), and designed sequence (*kairos* or plot-time) are signals of the malaises too much with us in our own epoch. We suffer *acedia* or spiritual sloth. We suffer depression and resort to the violent and titillating distractions to which the enervated in spirit are easily addicted. We are witnessing the downsides of the idol of individualism, of rootless mobility, of loss of social cohesion, of the desperate loneliness of seeking community in cyberspace, and happiness through limitless casual sex and similar pursuits.

Even folk of sincere individual religious faith can easily, if unwittingly, succumb to the conditions that foster *flatlanders*, adapting to their culture when conventional behaviors are not obviously evil, interrupting real presence with a friend to respond to the ding of an incoming text message, slouching toward Bethlehem. (Perhaps I'm thinking of students even at my own Christian college turning their smartphones on, not off, as they slouch into the pews of the chapel for the Friday Convocation.)

If finding one's place and identity *in* places of clear purpose, of common work amidst a community, of grounded stories, can help address such malaises, then the old places of art have a new and present timeliness.

But I acknowledge the *hermeneutic circle* implicit in my argument. Which comes first—the art that shapes space as place, or the space that provides a place for the art? I call for a culture with *places* so that we can foster art that articulates the purposes of those places and inspires the actions they are built to house; yet I call for an *in situ* art that can foster the creation of places with clear and edifying purposes.

One jumps into this circle when and where one can.

We might suppose that having more—and more sophisticated and theologically astute—liturgical art in our churches would help us recover a ceremonial and sacramental view of life that would in turn promote more art. But of course such art would feel artificial without some prior sense of life as richly punctuated with occasions worth celebrating or grieving:

honoring a faithful servant, remembering a healing, celebrating an enduring marriage, asking forgiveness, marking the young person's entering into adulthood, and so forth. Only in that soil will art emerge as inevitable, as suitable, as necessary.

I am inclined to suppose that in the flat landscape—the more devoid of markers, the more pervasive the response of "whatever"—the circle must be activated not so much by an imposition of art as through the patient construction of patterns of living that create a desire for decoration. Having "chapter meetings" eventually calls for building a chapter house with furnishings suitable for the occasion and art that reminds, instructs, and inspires the gathered community to pursue that mission wholeheartedly. Intentional communities with a zone of ethical care (perhaps a safe house for trafficked women or a dining hall for hungry homeless people or a schoolroom for tutoring immigrants) will feel the need to surround those served with stories that confirm the possibility of new life, of something beyond the apparent dead end.

A movie such as *Babette's Feast* offers the counterpoint. The artful, ceremonial extravagance of Babette's feast given in love, beyond the capacity of the guests to appreciate, comes first. The dissolving of protective habits follows after, with the softening of the heart through eyes and mouth. The artful feast itself evokes the conditions for forgiveness and reconciliation and shared joy. Hearts burned as Jesus broke bread over supper at Emmaus, not along the road.

An assumption behind the growing movement of Community Art, for instance, is that creating wall murals in troubled inner city neighborhoods can be the pivot that helps turn things around, reminding the community of inspirational heroes, narrating a past and imagining a future, naming the vices that block renewal and the virtues necessary to sustain it. Art comes first.

Although surely art can be used to fashion and identify places of hospitality where diverse and even divergent communities find embrace rather than exclusion, places where "all peoples are blessed," I do not expect a newly-situated art to occur on a large scale through mega-movements in a society whose very pluralism and relativism inhibits shared story and common liturgy. Rather, the fostering of "forms of community" capable of cultivating a new *in situ* art for our own time is more likely to occur at the local level, among small collectives who can identify their purpose and share in liturgies that celebrate and enact that purpose. I allude to Alisdair MacIntyre's prescient final chapter in *After Virtue*, believing that his vision applies as much to the cultivation of a working art as it does to the (re) construction of "intellectual and moral life":

What matters at this stage is the construction of local forms of community within which civility and the intellectual and moral life can be sustained through the new dark ages which are already upon us. And if the tradition of the virtues was able to survive the horrors of the last dark ages, we are not entirely without grounds for hope. This time however the barbarians are not waiting beyond the frontiers; they have already been governing us for quite some time.[1]

There are plenty of opportunities, plenty of spaces, for localized actions that put art to work in real places. Sure, maybe we don't have many *chapter houses* nowadays. We have fewer monasteries, and we don't have many places of any sort where people committed to one another for the long haul sit down and face each other and exhort, remind, forgive, comfort. Many of the communities that can define themselves as "intentional" do not have places clearly demarcated for such liturgies of coming together. Those few definable communities who do have places where they *collect* themselves very often give little thought to how the design and decoration of their *chapter houses* can encourage them in their work. But this defines the challenge, not the impossibility.

To refer to my own vocational turf, I am struck by the general paucity of artwork in institutions of faith-based higher learning, and certainly of artwork with any obvious bearing on the missions typical of such colleges and universities: the cultivation of Christian character, the formation of a cohesive worldview, and the training of globally-conscious leaders, for instance. Why are there no equivalents to the *schema* of learning that fills an entire wall of the chapter house of the Dominican community in Santa Maria Novella in Florence? Is the problem that the seven liberal arts and the seven theological sciences have a demonstrable coherence that can be visually represented and explored, while the array of academic departments and the changing curricula of the modern *multi*-versity resist visual form? When any effort to revise a Christian university's core curriculum takes years of debate and discussion, the conditions for the creation of a mural such as that in the chapter house of Santa Maria Novella will be difficult to achieve.

And yet a couple years ago at my own institution, two graduating art majors (Anna Taylor and Garrett Ames-Ledbetter, both alumni of the semester program in Orvieto that provided the seedbed for this book) drafted a proposal for a series of wall murals for the new Science Center on campus.* The senior class agreed to fund the paintings as their gift to the College. The proposal was approved by the relevant administrators,

[1] Alasdair MacIntyre, *After Virtue*, 3rd ed. (South Bend, IN: University of Notre Dame Press, 2007), 263.

and the science faculty agreed to give the idea a hearing. The young artists spent several months in conversation with professors from all the departments, receiving their ideas and gaining consensus on an approach.

Several more months went into the creation of the series of large-scale panels. Each of these combined figurative and abstract elements which, together, set into almost cosmic play the fundamental patterns at work in each science. The mural has since been put in its place in the community. After all, most sectors of the community contributed to its making.

Finally, as I write this conclusion, my friend Bruce Herman has arrived at the Divinity School of Duke University to take up a commission to paint a Resurrection in one of the chapels. Having earned the appreciation of the dean for his theologically rich and visually complex treatments of the Passion, Herman was given the challenge to apply the same skill and sensibility to the mystery of the Lord's Resurrection.*

The hope peering between the lines of this book is that we might witness a proliferation of such artworks, commissioned by communities of all sorts, to be set to work in places of all sorts, giving mature and sophisticated visual expression to the grave challenges we face in our time, leaving their viewers "not entirely without grounds for hope."